MOSTLY MODERN

ESSAYS IN ART AND ARCHITECTURE

EDITED BY
JOSEPH MASHECK

HARD PRESS EDITIONS
Stockbridge, Massachusetts
in association with
HUDSON HILLS PRESS
Easthampton, Massachusetts

MOSTLY MODERN
Edited by Joseph Masheck

Coordinated by
Aleksandr Naymark

Copyright © 2014 Hard Press Editions
Published by Hard Press Editions
P.O. Box 176, Stockbridge, MA 01262
Publisher: Anne Bei
Founding Publisher: Jon Gams

Designed by: Jane McWhorter
Published in association with Hudson Hills Press LLC
P.O. Box 250, Easthampton, MA 01027
Executive Director: Daniel M. Farrell
Founding Publisher: Paul Anbinder

Distributed in the United States, its territories and possessions, and Canada by ACC Distribution
Distributed outside North America by Antique Collectors' Club, Ltd.
Printed and bound in China by Regent Publishing Services, Ltd.

(ISBN 10) 1-55595-392-1
(ISBN13) 978-1-55595-392-8

Cover Art by Ernst Ludwig Kirchner, *Friedrichstraße, Berlin*, 1914, oil on canvas, 125 x 91 cm.;
detail. Stuttgart, Staatsgalerie. Photo credit: Staatsgalerie Stuttgart.

Library of Congress Cataloging-in-Publication Data

Mostly modern : essays in art and architecture / edited by Joseph Masheck.
 pages cm
Includes bibliographical references.
ISBN 978-1-55595-392-8
1. Art, Modern. 2. Architecture, Modern. I. Masheck, Joseph, editor, honouree.
N6350.M68 2014
 709.03--dc23
 2014035127

TABLE OF CONTENTS

LIST OF ILLUSTRATIONS

9–1. Ernst Ludwig Kirchner, *Berlin Street Scene*, 1913–14, oil on canvas, 47.6 x 37.4 in. (121 x 95 cm.). New York, Neue Galerie, and private collection. Photo credit: Neue Galerie New York/ Art Resource, New York.

9–2. Kirchner, *Street, Berlin*, 1913, oil on canvas, 47.4 x 35.8 in. (120.6 x 91.1 cm.). New York, The Museum of Modern Art. Photo credit: Digital Image © The Museum of Modern Art/ Licensed by SCALA/Art Resource, New York.

9–3. Kirchner, *Friedrichstraße, Berlin*, 1914, oil on canvas, 49.2 x 35.8 in. (125 x 91 cm.). Stuttgart, Staatsgalerie. Photo credit: Staatsgalerie Stuttgart.

9–4. Kirchner, *Potsdamer Platz, Berlin*, 1914, oil on canvas, 78.7 x 59 in. (200 x 150 cm.). Berlin, Nationalgalerie, Staatliche Museen. Photo credit: bpk, Berlin/Nationalgalerie/Joerg P. Anders/Art Resource, New York.

9–5. Kirchner, *Circus Rider*, 1914, oil on canvas, 79 x 59.4 in. (200.7 x 151 cm.). Saint Louis Art Museum, Bequest of Morton D. May. Photo credit: Saint Louis Art Museum.

9–6. Kirchner, *The Belle-Alliance Platz in Berlin*, oil on canvas, 37.7 x 33.4 in. (96 x 85 cm.). Berlin, Nationalgalerie, Staatliche Museen. Photo credit: bpk, Berlin/Nationalgalerie/Joerg P. Anders/Art Resource, New York.

9–7. Max Missmann (photographer), *Potsdamer Bahnhof, Berlin*, 1910. Postcard.

9–8. Kirchner, *Two Women on the Street*, 1914, oil on canvas, 47.4 x 35.8 in. (120.5 x 91 cm.). Düsseldorf, Kunstsammlung Nordrhein-Westfalen. Photo Credit: Erich Lessing/Art Resource, New York.

10–1. Pavel Pepperstein, *Manifesto del Retrofuturismo*, 2006, watercolor and ink on paper, 6 ¾ x 9 ¾ in (17.5 x 25 cm.). Current location unknown. © Pavel Pepperstein.

10–2. El Lissitzky, *Part of the Show Machinery*, 1923, color lithograph, sheet: 21 x 17 ¾ in. (53.3 x 45.4 cm.), title sheet from: *Figurines: The Three-Dimensional Design of the Electro-Mechanical Show "Victory Over the Sun."* London, Tate Gallery. Photo: Tate, London/Art Resources, New York.

10–3. Kazimir Malevich, *Futurist Strongman*, 1913, graphite pencil on paper, 10 ½ x 8 ¼ in. (27 x 21 cm. outlined). St. Petersburg, State Museum of Theatrical and Musical Arts.

10–4. Malevich, *Sportsman*, 1913, pencil, watercolor and ink on paper, 9 x 8 ¼ in. (22.7 x 21.2 cm. outlined). St. Petersburg, State Russian Museum. Photo: Scala/Art Resource, New York.

10–5. Malevich, *Reciter*, 1913, watercolor, India ink, and charcoal on paper, 9 x 8 ½ in. (22.7 x 21.4 cm. outlined). St. Petersburg, State Russian Museum. Photo: Scala/Art Resource, New York.

10–6. Lissitzky, *Announcer*, 1923, color lithograph, sheet: 21 x 17 ¾ in. (53.3 x 45.4 cm.); plate 2 from *Figurines: The Three-Dimensional Design of the Electro-Mechanical Show "Victory Over the Sun."* New York, The Museum of Modern Art. Digital Image © The Museum of Modern Art/Licensed by Scala/Art Resource, New York.

10–7. Malevich, *Traveler*, 1913, graphite pencil on paper, 10 ¾ x 8 ¼ in. (27.2 x 21.3 cm. outlined). St. Petersburg, State Museum of Theatrical and Musical Arts.

10–8. Lissitzky, *Globetrotter in Time*, 1923, color lithograph, sheet: 21 x 17 ¾ in. (53.3 x 45.4 cm.); plate 5 from *Figurines: The Three-Dimensional Design of the Electro-Mechanical Show "Victory Over the Sun."* New York, The Museum of Modern Art. Digital Image © The Museum of Modern Art/Licensed by Scala/Art Resource, New York.

10–9. Malevich, *Pallbearer*, 1913, graphite pencil and watercolor on paper, 10 ½ x 8 ¼ in. (27 x 21.1 cm. outlined). St. Petersburg, State Museum of Theatrical and Musical Arts.

10–10. Lissitzky, *Gravediggers*, 1923, color lithograph, sheet: 21 x 17 ¾ in. (53.3 x 45.4 cm.); plate 9 from *Figurines: The Three-Dimensional Design of the Electro-Mechanical Show "Victory*

Over the Sun." New York, The Museum of Modern Art. Digital Image © The Museum of Modern Art/Licensed by Scala/Art Resource, New York.

10–11. Malevich, *The New One*, 1913, graphite pencil, watercolor, and India ink on paper, 10 ¼ x 8 ¼ in. (26 x 21 cm. outlined). St. Petersburg, State Museum of Theatrical and Musical Arts.

10–12. Lissitzky, *The New*, 1923, color lithograph, 21 x17 ¾ in. (53.3 x 45.4 cm.); plate 10 from *Figurines: The Three-Dimensional Design of the Electro-Mechanical Show "Victory Over the Sun."* Philadelphia Museum of Art. Gift of Dr. George J. Roth, 1953. Photo: The Philadelphia Museum of Art/Art Resource, New York.

10–13. Lissitzky, *Anxious Ones*, 1923, color lithograph, sheet: 21 x 17 ¾ in. (53.3 x 45.4 cm.); plate 4 from: *Figurines: The Three-Dimensional Design of the Electro-Mechanical Show "Victory Over the Sun."* New York, The Museum of Modern Art. Digital Image © The Museum of Modern Art/Licensed by Scala/Art Resource, New York.

11–1. Earle Brown, *Untitled (Denver 1951)*, 1951, oil on cardboard, 30 x 13 1/4 in.; with kind permission of the Earle Brown Music Foundation, Rye, New York.

11–2. Brown, "December 1952," excerpt from *Folio* (1952–53), as published with *4 Systems* (1954) in 1961, 11 15/16 x 16 3/4 in. © 1961 by Associated Music Publishers; print courtesy of the Earle Brown Music Foundation, Rye, New York.

12–1. Alan Johnston, *Wall Drawing*, Houston, Museum of Fine Arts, Law Building, 2001 (effaced by mid-2003), pencil on wall; wall dimensions 108 x 336 in. (274.3 x 853.4 cm.).

14–1. Unknown artist, *Portrait of John Donne*, c. 1595, oil on panel 77 x 62 cm. © National Portrait Gallery, London.

14–2. Rembrandt van Rijn, *Portrait of Jan Six*, 1647, etching, drypoint and burin, 24.5 x 19 cm. Hind 228, 4th state. © Trustees of the British Museum.

14–3. Gerard Dou, *Self-Portrait at a Window*, oil on oak panel, signed and dated 165[?] (final numeral illegible), 20.5 x 14 cm. Inv. 536. Salzburg, Residenzgalerie. Photograph: Erich Lessing/Art Resource.

15–1. Unknown photographer, Three female students smoking at Edinburgh College of Art, c. 1908. Edinburgh College of Art Archives.

15–2. Unknown photographer, Three female students with a mason's T-square and the artist Robert Burns facing forward, at Edinburgh College of Art, c. 1908. Edinburgh College of Art Archives.

15–3. Unknown photographer, Three female students with a mason's T-square and the artist Robert Burns facing left, at Edinburgh College of Art, c. 1908. Edinburgh College of Art Archives.

15–4. Unknown photographer, Three female students hanging by their fingertips on the entrance wall of Edinburgh College of Art, c. 1908. Edinburgh College of Art Archives.

15–5. Unknown photographer, *Portrait of Dorothy Johnstone*, 1909. Courtesy of the Sutherland family.

15–6. Unknown photographer, Group portrait on the main staircase of Edinburgh College of Art, 1908. Edinburgh College of Art Archives.

15–7. Drummond Young (photographer), Two students at the Trustees Academy in the Royal Institution building, Edinburgh (now Royal Scottish Academy), c. 1907. Edinburgh, Royal Scottish Academy Collections.

15–8. Thomas Annan, *Portrait of Margaret Macdonald Mackintosh*, c. 1895. Photograph. © National Portrait Gallery, London.

15–9. Unknown photographer, 'The Immortals,' with Charles Rennie Mackintosh; the sisters Francis and Margaret Macdonald in darker dresses at far right. Glasgow School of Art Archives.

15–10. Robert Burns (artist), *Natura Naturans*, 1891. Drawing. First published in Patrick
Geddes's *The Evergreen, A Book of Spring*, in 1895. Photograph by the author.

16–1. Wassily Kandinsky, *In the Black Circle*, 1923, 51 3/16 x 51 3/16 in., private collection.
© 2013 Artists Rights Society (ARS), New York/ADAGP, Paris.

16–2. Celtic coin in André Malraux, *Les Voix du silence* (Paris: NRS, 1951), illus. on p. 138:
"Région de la Somme." Courtesy of Éditions Gallimard/Livres d'art, Paris.

16–3. Andy Warhol, *Marilyn Diptych*, 1962, acrylic, 80 3/4 x 57 in., London, Tate Modern. © 2013
The Andy Warhol Foundation for the Visual Arts, Inc./Artists Rights Society (ARS), New
York.

Preface

What is this, a Festschrift or the proceedings of a symposium? Well, something of both; but really more of a book of essays. "Mostly Modern" was originally organized in January of 2012, at Hofstra University, as an informal day of lectures by colleagues and friends of mine from America and abroad, honoring my seventieth birthday. The organizer was Aleksandr (Sasha) Naymark, my colleague in art history. However, some of the present participants could not come to the symposium, Sasha and I thought of a book in which original and additional papers could be published with introductory comments from me as "respondent." Considering that the original occasion, with all its logistic complexities, was Sasha's endeavor, it seemed that, all the more with a considerably augmented roster of papers, I might edit the book myself.

The title alludes not simply to my own work on modern art and architecture as my main yet not only "thing," but more deeply to my sense, following Nietszche (who in this was following the antiquarian Sir John Lubbock), that the Neolithic was really the first modernity, entailing what had already been abstract (mainly so-called ornamental-abstract) art as against Paleolithic naturalism. This will entail an original separation of culture from nature, which will in turn identify me first of all as a structuralist, though one who appreciates post-structuralism too. Yes, to my mind, the "mostly" is almost as important as the "modern." In fact, I have always thought that answering "Mostly modern" to the question of my academic field was also a good excuse for being a generalist; so it is wonderful to see that my friends, as "modern" as they variously are, have come up with remarkable affinities across various fields of art history.

It is also interesting to see how their own particular interests interrelate across time, including several artists as well as scholars. There are two overlapping views of Cézanne, one more psychological and the other more phenomenological. There are even certain fortuitous parallels of motif, as where "two-light" windows are treated as far back as 1500 and in the mind of an artist drawing an unobtrusive mural on a wall by Mies van der Rohe. In social terms, we have the dress and deportment male "bohemians" in the seventeenth century, *versus* feminist art students "vamping" *symboliste* figure types a hundred years ago; and both metropolitan (Berlin) and provincial (Baltic) modernism in Eastern Europe. Two different approaches to the immensely important early modern movement Suprematism are entertained:

its supersession by an incipient Constructivism, and then its afterlife in a variety of postwar views.

Theoretical parallels obtain as well. The eighteenth-century Kant, who can be said to have yoked aesthetics up to epistemology, is met by the great nineteenth-century art critic Ruskin, who found the ethical impinging upon the aesthetic. Kant's concern with space may lead into the question of space in Le Corbusier's building sites, and even a novelistic architectural projection by Robbe-Grillet, where an unexpectedly scrupulous consistency is imaginatively vital to the fiction. Two critical *topoi* pertain to the breakdown of (ultimately, classical-academic) form in postwar high modernist abstract painting of expressionist ilk, evincing undisclosable, not even crypto-geometric forms. First, a once famous heuristic device of formal breakdown in classical numismatics by European barbarian tribes; and secondly, the pursuit of indeterminacy in painting and music, as written by a composer and performer as well as a painter.

Because we were so informal, two presentations cannot be published here. At the symposium Pellegrino D'Acierno delivered a beautiful piece that was really a performance: "Strange Loops; or, 'Where Were We?': My Boundless Conversation with Joseph Masheck; Featuring Loos, Tafuri, Cacciari, Duchamp, and Architecture Scenes of Seeing in the Cinema"—too unrepeatable "in the event," as the British say, to be confined to print. In a different way, Sasha himself was prevented by sheer lack of time from even speaking extemporaneously on his attempt to produce a general theory of style, "The Sine Wave of Design History," which he and I had liked to talk about and on which he is understandably still at work.

I am immensely grateful to Aleksandr Naymark, my learned colleague, for proposing the whole project and for planning the logistics of the symposium; and also to everyone who contributed to it, including Alexandra Halidisz, who spoke as my former undergraduate student, and to non-participating friends from overseas, and to those who otherwise contributed to this volume. I also thank my research assistants, Jeanette Sisk for text, and Ms. Halidisz for images and permissions, for their alertness and patience over the long haul. For the resources to produce the project, Sasha and I thankfully acknowledge the support of an anonymous donor; and of Hofstra University as well—both for the symposium on which this book is based—and for a grant from the dean's office of the Hofstra College of Liberal Arts and Sciences and a Faculty Development Grant from the University toward its publication.

Joseph Masheck
New York, 2014

Reintroducing Joseph Masheck: Different Forms of Formalism and the Geometry of Humanism

David L. Craven

A title in search of a text is how this paper began; but there were numerous historiographic hints in the commanding and cosmopolitan corpus of Joseph Masheck to guide my talk to completion. And let me be clear, the *oeuvre* of Masheck is impressive indeed. According to my rough calculation, his collected writings of "mostly modern" publications cover an uncommon range of artists, movements, media, period tendencies, and geopolitical regions—not to mention ontological concerns about the relationship of art to humanity in the most rarified and high-altitude sense, as, for example, in his short 2008 commentary on Ernst Bloch in the journal *Religious Socialism*.[1]

To quantify his corpus (and I can see Joseph wince as I use this word for someone so attentive to qualitative insights) would mean speaking of a *Collected Works of Joseph Masheck*—should such a project be undertaken—that would cover at least fifteen tomes because he has published at least twelve books, twenty-four key sections in joint-authored books, thirty-five catalogue essays, and well beyond 100 articles, review essays, and reviews, aside from having been editor of *Artforum* from 1977 to 1980, and more recently having founded a series of scholarly papers at Edinburgh College of Art (University of Edinburgh).

A critic who registered some notable insights into the exemplary achievement of Joseph Masheck was Donald Kuspit, in his preface to Masheck's well-named 1984 book *Historical Present: Essays of the 1970s*. But before I quote Kuspit on Masheck, I must cite a fine essay by Masheck on Kuspit, written only two years ago to include in a book that I co-edited with Brian Winkenweder, *Dialectical Conversions: Donald Kuspit's Art Criticism* (Liverpool University Press, 2011). For this anthology, Joseph wrote a very nuanced explication of how Kuspit's deployment of the philosophy of Kant was quite different from how Greenberg invoked Kant, so that a great deal was also illuminated by Masheck about diverse types of formal analyses or formalisms.[2]

Anyway, what did Kuspit write almost thirty years ago about Masheck that still provides a *punto de partido* today? Here I shall quote Kuspit:

> Masheck suggests that [in art] the medium [possesses] a metaphysical poetry capable of conveying a sacred content with the right handling. More

concretely, . . . as in the series of articles [he wrote] on iconicity, . . . Masheck shows how religiosity, not religion, comes to count in abstract art

Masheck has a rich sense of art history. He sees it almost as a matrix from which individual works of art emerge . . . Sometimes I think his enormous erudition, the ferocity of his scholarship, exists for its own sake. At other times I think it is a perverse way of outsmarting academic art history. . . . Even when Masheck tends to be what I think of as aimlessly informative . . . he conveys a subliminal sense of . . . art's power . . .[3]

An appropriate bookend for this astute observation by Kuspit is another one about Masheck made to me verbally by the legendary Meyer Schapiro during a series of interviews I conducted with him from 1992 to 1996. While we happened to be discussing the issue of "liberation theology" during the Nicaraguan Revolution, Schapiro—an agnostic, very much like myself—was intrigued to learn about this type of Christian socialism in Latin America. He promptly declared, "Joseph Masheck is the one to talk with about this. He is really bright. He is one of the very best students I ever had at Columbia."[4]

Fortunately, I was already able to tell Schapiro that, without as yet having met Masheck, I had already encountered an unlikely and intricate trail extending from Ad Reinhardt and Thomas Merton to Father Ernesto Cardenal—a celebrated poet and priest who was the Minister of Culture of the Sandinista Government in revolutionary Nicaragua from 1979 to 1988—thanks to a prefatory essay by Joseph Masheck in the December 1978 issue of *Artforum* for "Five Unpublished Letters from Ad Reinhardt to Thomas Merton and Two in Return."[5] As a result of this piece, coupled with some humorous biographical data elsewhere by Reinhardt, I had had little trouble connecting this New York School painter, and thus also Masheck the art critic, to liberation theology in Central America, in the course of my research.[6]

Moreover, this sui generis linkage in the Americas, between Masheck and intellectuals in Latin America, alerts us to a basic fact about just how international Masheck's reputation really is, how trans-nationally his reputational reach extends. I have counted at least a half dozen languages into which Masheck's work has been translated, along with an equal number of nations where his work has gained attention.

From here, though, I would like to do two things to sharpen, in particular, our sense for the distinctiveness of Masheck's critical voice over the past forty-plus years about what he has called "the fictive poetics of painting."

First, I shall perform a brief *explication de texte* of a famous essay by Masheck, "Robert Mangold: A Humanist Geometry," which appeared in *Artforum* in March of 1978 and was then republished at least a couple of times in 1984: initially, in the anthology *Looking Critically: 21 Years of Artforum*, edited by Amy Baker Sandback, and then in the aforementioned collection of Masheck's writings introduced by Kuspit, named the *Historical Present*.[7] That this article by Masheck would be widely circulated is justified, as the essay is a paradigmatic example of how Masheck

has for more than four decades written as "a generalist as well as a modernist, an unrepentantly historicizing art historian as well as a contemporary critic" (his words).

Second, I shall very briefly link this essay by Masheck to a classic text of his main mentor at Columbia University—namely, Rudolf Wittkower (1901–1971), a brilliant if now often overlooked German émigré who fled the Nazis in 1933 and who, while at Columbia from 1956 to 1971, wrote a remarkable set of books with enduring value to the discipline of Art History, including especially the McEnerney Lectures at the University of California, Berkeley, in March 1964, concerning non-Western influences on European art,[8] and another book that appeared posthumously in 1977, *Allegory and the Migration of Symbols*.[9] For here I hope to show how Masheck has always had an acute sense of the way that contemporary art is part of a larger historical continuum, rather than being some purported rupture with it, and, conversely, that he has shown how classic art of the past is extended, redefined, or even reincarnated, by contemporary artworks.

Impossible without the old art that preceded it, contemporary art is neverthe-less a key way of revisiting critically the prior visual discourses on which the older art was based. To be under-informed about either one of these moments in art history is thus to have a diminished grasp of both because the present tense of art must be understood, at least in part, by its past tense, even as the present tense also alters how we see that past. Or, to pose this conundrum concerning the prehistory of the present and the presentness of the past in literary terms, we need only recall a Joycean aphorism of William Faulkner in *Absalom, Absalom*: "Memory believes before knowing remembers." In a well-known essay on "Iconicity" that appeared in *Artforum* in January 1979, Joseph Masheck wrote something that relates to this:

> We apply certain notions from the earlier history of painting, especially religious painting, to present-day art, not to project meaning onto con-tent-less forms, but to inquire into integral contents in art, at a time when early modern aspirations to a transcendental function for painting have been revived.[10]

So, in this spirit, how did Masheck address "humanist geometry"—or the "geometry of humanism"—in his famous essay on Robert Mangold's paintings? He did so with an engaging obliquity that involved a non-normative formalism that stood, both then and now, as an eloquent counter to the ahistorical and soulless normative formalism of Greenberg and his disciples. Let's quote Masheck here and also savor the complexity as well as the rhetorical tone of his vintage prose:

> Robert Mangold has worked quietly and steadily toward a reductive but confident and affirmative kind of painting, as though moved by constructive doubt. Early in the 1960s Mangold painted flat, hieroglyphic works like *Red October*, 1962, with firmly curving forms in black, white, and gray, set smartly against an uninflected catsup-colored ground. A couple of years later came his "Walls," literally architectural reliefs in which colorism retracts in favor of a play of real light and cast shade, over

forms as innately abstract as those of a building. As mimetic carpentry, the wall pieces evoke the highly patternistic architectural photography of American early modernism . . .

Mangold's paintings are independently architectural in character. Their compressive units hang together in a unitary whole, like blocks in a wall or voussoirs in an arch, and resemble the vertical planes of architectural design, especially facades and planar ornamental features of classicistic architecture. This is most obvious in semicircular paintings of the later 1960s that compare with semicircular tympana . . . in both Italian Romanesque and also early and high Italian Renaissance architecture . . .

There are also similarities between Mangold's semicircular, protractor-like shapes and the wall paintings of Sol LeWitt. . . . Why? Because of the combination in Mangold of an insistent crispness of form with an almost unnecessarily pleasing, muted color. With Mangold there is a balance between rigor and delectation that could almost be called polite.

Color in Mangold is significant but unobtrusive, in accordance with the emphasis on form. It distinguishes one uniformly monochromatic painting . . . from another, but with more perceptual charm than that might suggest. . . . In other words, Mangold gravitates toward color of substantiality in a way that is almost as important to his painting as the distinct textures of metals are to any sculpture of elemental materials.

The semicircular paintings may further be juxtaposed with Mel Bochner's contemporaneous *Degrees (Straight Lines)* of 1968. Yet, Bochner's device is fundamentally the purely diagrammatic visualization of a geometric idea—that a straight line can be described as an angle (180°). As such, it has a certain anti-sensuality. . . .

Of all contemporary painters Ellsworth Kelly is in closest affinity with Mangold, not only in formal terms but also for a suave refinement of shape . . . although Kelly shapes the canvas by cutting off these corners where Mangold uses a drawn graphic line—a line that also produces a mild ambivalence when it suggests that *Untitled* [a painting] consists of two overlaid forms with opposed diagonals.[11]

Yet I must change direction here—despite the strong urge to read more of Masheck's luminous expository prose, which identifies what is (or was) radically contemporary about this artwork when it first appeared. In his supple and subtle explication there really is a sense of the "painting of modern life" in the most profoundly Baudelairean manner.

We must shift gears now to chart in reverse another equally significant dimension of Masheck's critical analysis. It is this unexpected level of meaning that, while declared throughout the essay, I have left unaddressed till now: this is the inter-image aspect of Masheck's analysis that just happens to link up with the seminal work of Rudolf Wittkower, especially concerning Wittkower's early multicultural concept of the diffusion of image/motifs and image/content along trans-national

and trans-historical routes. Cited discretely at the end of Masheck's essay on Mangold in the final footnote is a telling reference to Wittkower's landmark book *Architectural Principles in the Age of Humanism* (1949), although clues for it are spread, almost Inspector Lewis–like, throughout the Masheck text for what will be acknowledged fully only at the end.

If we back up to the first page of Masheck's ultra-contemporary analysis, in which he has expertly delineated a discursive field for Robert Mangold that seems to have emerged only yesterday, we discover some rather contrary claims that I find compelling—in which Masheck has shown how the pictorial field of Mangold is both radically new and yet deeply embedded in a long philosophical position about the nature of human existence indebted to Pythagoras as well as Plato and Aristotle.

Here I quote Masheck yet again, to underscore the multiple meanings of Mangold's paintings—meanings that were so astutely observed through Masheck's sharp-eyed optic that was clearly polished by Rudolf Wittkower's panoramic East/West purview, and extending to carpet paradigms and beyond. So, here is Masheck again, yet not, however, on the radical, unanticipated present, but on the unexpected preterite of the present moment. Let's read Joseph one last time:

> Semicircularity in Mangold's work is distinctly classical. It could be argued that the semicircular format is, in fact, the most classical format in Western painting. Raphael's Vatican frescoes display it in full strength (though it developed earlier): in *The School of Athens* we see it in planar analogy with the Roman (and modern Bramantesque arch). . . . At the opening of the 17th century the semicircular format asserts itself in the most germinal, and one of the most monumental, of all classicistic landscapes, Annibale Carracci's *Flight into Egypt* of about 1604. Furthermore, with Raphael and Annibale and all their heirs, Mangold shares in the specifically classsical (and form-bound) tradition of starting a work with systematic preparatory designs. . . .
>
> Mangold's *Circle In and Out of a Polygon II*, 1973, half square, half circular in form, with a semicircle drawn on the square half fused to a half hexagon drawn on the round, also relates in Renaissance architectural theory to Leon Battista Alberti's system of constructing regular polygons within a circle, illustrated in his *De Re aedificatoria*, written c. 1450.[12]

So, here we have a glimpse of much that has made the art criticism of Joseph Masheck invaluable and distinctive over the past four decades. To distill his position, I will contend the following: the radically new in art is so only by virtue of how it has engaged with the most compelling discourses of the past—just as the past is not simply over—because of how artists (like Robert Mangold) and art critics (like Joseph Masheck) have alerted us to an undeniable point: *the history of important art is as much about continuity as it is about discontinuity, as much about what is enduring as it is about what no longer endures.* Immortality in art is thus some ineffable, but nonetheless accountable, combination of the two, with the fate of humanity hanging gracefully in the balance.

1. The "Space … in Which I Find Myself": Kant on the Origin of Spatial Form

Terry F. Godlove

Modernists have speculated on possible Kantian underpinnings of cubist painting. Interested in the question, I organized, some years ago, an undergraduate seminar on cubism and drew up a list of pertinent passages in The Critique of Pure Reason *for discussion. With typical intellectual generosity, Terry Godlove, my colleague in Philosophy and a Kantian at that, came along. Recalling this also reminds me of first tackling the* First Critique *myself, and realizing that it is so "tight," so much about a single comprehensive but perhaps unexpected epistemology, that one may even get some way along with a misconception so long as it is consistent (like a piece of a puzzle that was almost right, just upside down!). Needless to say, Kant never saw a work of abstract art (though in his day a fan, the painter Asmus Carstens, experimented with personifying his concepts of space and time); but Godlove's reading of him shows up a major difference between representational and nonrepresentational painting: how with representation we have to itemize and synthesize what something is supposed to consist of in order for it to count as "one of those," "over there," and where that leaves us ourselves. If Descartes' making our demonstrable existence essentially mental is unsatisfying to Kant, what does it mean to project ourselves somehow more sensorially into a metaphoric space? It puts me in mind of Edwin Denby's characterization of George Balanchine's modern classicism in ballet as a quality of "spaciousness": "So space spreads in calm power from the center of the stage and from the moving dancer and gives a sense of human grandeur and of destiny to her action" (Dancers, Buildings, and People in the Streets, 1965). — J.M.*

My aim here is to pursue some Kantian themes in R. G. Collingwood's and Clement Greenberg's treatment of spatial form in abstract art. My thinking on these matters has been set in motion by Joseph Masheck's recent paper, "On Kuspit, Kant, and Greenberg."[1] At one point, Masheck is commenting on a passage from Collingwood's essay "Outlines of a Philosophy of Art" (1925). Here is the passage from Collingwood:

> The Impressionist doctrine that what one paints light was a pedantry
> that failed to destroy the painters it enslaved only because they remained

painters in defiance of the doctrine: men of their hands, men who did their work with fingers, wrist and arm, even (as they walked about the studio) with their legs and toes.[2]

Joe observes that Collingwood then "turns quite Kantian: 'What one paints is what can be painted; no one can do more; and what can be painted must stand in some relation to the muscular activity of painting it.'"[3]

Now, at first glance Collingwood's remark may well strike us as both unpromising and un-Kantian. To say that what one paints is what can be painted may seem to pack all the informative punch of a good tautology—rather like saying that sleeping pills work because of their dormative power. And what interest could the physiology of the body hold for the philosopher of the a priori? But I am with Masheck in thinking that Collingwood's remark is deeply Kantian and anything but tautologous. Embodiment does impose substantive spatial requirements that constrain the activity of painting—but to see the issues in a Kantian light we have to look, not to Kant's aesthetics as found in the *Critique of the Power of Judgment*, but to what he says about the ground of spatial form in the *Critique of Pure Reason*. From this discussion arises a puzzle about embodiment, to which I turn in concluding.

The section from the *Critique* that interests us is titled the "Metaphysical Exposition of the Concept of Space." For our purposes, two passages are especially relevant. First,

Space is not an empirical concept that has been drawn from outer experiences. For in order for certain sensations to be related to something outside me (that is, to something in another place in space from that in which I find myself), thus in order for me to represent them as outside <and next to> one another, thus not merely as different but as in different places, the representation of space must already be their ground. The representation of space cannot be obtained from the relations of outer appearance through experience, but this outer experience is itself first possible only through this representation. (A23/B38).[4]

Now this is one of the truly notorious passages in the *Critique*. Appealing to it is a little like trusting a compass to get you through a maze of magnets. Nevertheless, what is it supposed to show?

Like most recent commentators, I see the target as almost certainly a Leibnizian relational account of space. I cannot construct the representation of space from the relationships between objects of experience, as Leibniz argued. Rather, the concept of space falls out of a requirement that I enforce on all objects of my possible cognition—namely, that they reside at some distance from me, from the space in which I find myself.[5] In the literature it is customary to refer to this claim as the "apriority thesis."[6] For Kant, experience is the empirical cognition of objects. If

I must presuppose the representation of space *in* empirical cognition, then I cannot acquire it *through* experience; rather, it must be independent of experience, or a priori. Note also that an immediate consequence is that I can give space itself no representation, for it is not an object of experience.

In addition to the apriority thesis, Kant appears to be trying to establish a second claim about space—namely, its singularity. Thus, the second central passage:

> One can only represent a single space, and if one speaks of many spaces, one understands by that only parts of one and the same unique space. And these parts cannot as it were precede the single all-encompassing space as its components (from which its composition would be possible), but rather are only thought of in it. It is essentially single; the manifold in it, thus also the general concept of spaces in general, rests merely on limitations. (A25/B39)

When I speak of this or that region of space I abstract it from, as he says, "one all-encompassing space." Embodiment plays a crucial role here, for Kant's claim is that the singularity of space is tied to my projecting out my ongoing experience either physically (reaching, pointing) or imaginatively (shifting my attention). I do not "compose" a single space from bounded spaces as I go; rather, I see that every bounded space, no matter the size, is part of one encompassing or surrounding space. I see all at once that every region of space through which I could move is given, as Charles Parsons puts it, "with a 'horizon' of surrounding space."[7] The appreciation of the boundlessness of space is just the appreciation that I can go on locating objects at some distance from me; that as I move about there will be a continuous route, a path from where I am to what is affecting me or could affect me.[8]

Now, when we ask in a Kantian spirit about spatial form and its relationship to painting, we are asking about how these two theses—the apriority thesis and the singularity thesis—make possible a certain human activity. Recall Collingwood's remark that what one paints is what can be painted: I trust we are no longer tempted to read this remark as tautological. At least for creatures like us, what can be represented must be capable of being encountered at some distance from the subject and within a boundless horizon. To be sure, we can think about painters who work under a different set of constraints—ones for whom, say, thinking a brushstroke suffices to produce it, or ones who construct the space of their compositions as they go rather than encountering it as a given, unbounded expanse. The apriority and singularity theses are thus not built in to the very idea of painting—though it seems very plausible that they constrain its representational form.

Collingwood's own gloss on his remark is to say that we mustn't forget about "the muscular activity of painting." But if we are thinking along Kantian lines, that won't do. Muscles, fingers, wrists, arms, legs, and toes are only further objects in the world. As much as any other objects—brushes, pigments, canvas, middle-sized stars—they must conform to the conditions that make experience possible, including the requirement that they be located at some distance from where I find myself

(and so in one encompassing space). They are as subject as any other objects to the apriority and singularity conditions. This reminder affords us our first glimpse at the puzzle connected to my title. If not my body, what does Kant mean by "myself" in such locutions as "the space in which I find myself"? We will return to this question in closing.

I wish that at this point I could put Collingwood aside and produce a history of abstract art oriented along these two Kantian axes—one that would trace the way in which different historical movements come to grips with the spatial requirements of apriority and singularity. Because I find Kant's account of space very attractive, such a history would represent, it seems to me, more than merely an exercise in fitting together two pieces of cultural expression; it would be more than just a matter of seeing how this bit of art fits with that bit of philosophy. If Kant's account of space is on the right track, then what's at stake is how art, and painting in particular, has grappled with the requirements of spatial form. Period. Full-stop.

However, I am far from able to produce such a history. Instead, again following Masheck's lead, I want to look at some of Greenberg's remarks on modernism and on Cubism—remarks in which Greenberg can be plausibly read as inadvertently producing elements of just such a history.

In "Kuspit, Kant, and Greenberg," Masheck notes that Greenberg is capable of making rather elementary errors with regard to Kant's aesthetics. Greenberg's "famous notion of self-criticality is only a caricature of Kant." Again, Greenberg sometimes writes as though beauty, for Kant, could be produced by following certain rules.[9] Other commentators have taken a similarly dim view of Greenberg's appropriation of Kant's aesthetics, but none, as far as I know, has paired this assessment with the insistence that Greenberg writes, as Masheck puts it, "broadly in the spirit of the first *Critique*." How so?

In "Modernist Painting" (1961), Greenberg writes that "the old masters created an illusion of space in depth that one could imagine oneself walking into, but the analogous illusion created by the modernist painter can only be seen into; can be traveled through, literally or figuratively, only with the eye."[10] An interesting question is what Greenberg means by "an illusion of space." I take it he means, roughly, that we can imagine a continuous route for ourselves through what the painting depicts. Among the old masters Greenberg mentions are Alberti, Uccello, Piero della Francesca, and Leonardo. Thus, in Piero's *Flagellation of Christ,* we imagine ourselves navigating around the walls and columns, perhaps turning away from or walking toward one or another of the figures. Now, for analytical purposes, we can quite well speak of the creation of two spaces: an inner space in which Jesus is standing, and one outside where three figures in the foreground are standing. But from a Kantian point of view, the emphasis must fall on the observer, the one who imagines, as Greenberg says, "walking into" the space. More specifically, for present purposes, the emphasis must fall on what spatial requirements the observer brings

to that encounter. At least for human observers, the distinction between regions of space can be of *only* analytical or derivative use. For I know beforehand—a priori— that if I am to walk among them, the walls and columns are limitations introduced into one single expanse, and that what is out of sight behind the wall occupies a part of the same space as the one as I imagine to be occupied by the people and objects in the painting, and, of course, by me. How do I know this a priori? Because if I am able to walk around in the imagined space, I require that all the objects therein be located at some distance from where I find myself.

Here, I am moving freely between the context of the space of lived experience and the space of pictorial representation (between, as we say, physical space and picture space), but of course there is an obvious difference between them: In the context of lived experience, I may gesture or sweep out with an object that is itself located in space, say, my hand or a brush. By contrast, in the context of the Piero, I can only gesture or sweep out with my imagination. Put differently, I have a place in the world but not in the painting. Yet for our purposes this difference comes to nothing, for the imagination lies at the basis of each of these spatializing activities. When I imagine what is behind a painted wall or column I am doing the same thing and am bringing to bear the same spatial requirements as when I wonder what is behind the existing wall or post toward which I use my hand to gesture. In each case, I am projecting a continuous route from here (where I am) to there.

To find the real dis-analogy between the space of experience and that of painting we must pursue Greenberg's comment that modernist painting can be navigated "only with the eye." We will return presently to what this might mean. But first let us ask how Greenberg sees modernism departing from the old masters' treatment of space.

> Modernist painting is in its latest phase and has not abandoned the rep-
> resentation of recognizable objects in principle. What it has abandoned
> in principle is the representation of the kind of space that recognizable
> objects can inhabit. Abstractness, or the non-figurative, has in itself still
> not proved to be an altogether necessary moment in the self-criticism of
> pictorial art, even though artists as eminent as Kandinsky and Mondrian
> have thought so. As such, representation, or illustration, does not attain
> the uniqueness of pictorial art; what does do so is the associations of
> things represented. All recognizable entities (including pictures them-
> selves) exist in three-dimensional space, and the barest suggestion of a
> recognizable entity suffices to call up associations of that kind of space.
> The fragmentary silhouette of a human figure, or of a teacup, will do so,
> and by doing so alienate pictorial space from the literal two dimensional-
> ity which is the guarantee of painting's independence as an art.[11]

So, what modernism has abandoned is "the representation of the kind of space that recognizable objects can inhabit." Instead, it puts all the emphasis on the rep-resentation of objective forms. It would be difficult to identify more mainstream Kantian themes than these. Kant holds that space cannot be represented because it

is not an object of experience. This is an immediate consequence of the apriority thesis. If space were an object *of* experience, it could be encountered *in* experience and so could be represented. The question is not whether these thoughts or ones remotely like them motivated any particular painter. The point is exactly the other way around: Greenberg finds that modernist paintings themselves prompt the thought that all the action is in the representation of things in space and not in the representation of space itself—and this claim is deeply consistent with a Kantian approach to spatial representation.

In itself, the modernist abandonment of the attempt to represent "the kind of space" that we inhabit does not comprise a departure from the Renaissance masters—and for the most Kantian of reasons. The old masters themselves could not have represented that space, for, if Kant is right, it is not amenable to representation. Piero arranges walls and pillars in such a way that we have no trouble imagining a continuous path through, around, and beyond them. If only for this reason, Greenberg must be right to locate modernism's departure in its treatment of objects in space rather than in its treatment of space itself. But why does Greenberg insist on "recognizable objects" and "recognizable entities" that "exist in three-dimensional space" rather than simply "objects" and "entities"? The reasonably happy Kantians among us may be tempted to think that Greenberg intends "recognizable" as somehow *accounting for* the three-dimensionality of the objects and entities at stake—and that, with some degree of explicitness, the modernists were painting with this thought in mind. If so, then we are indeed close to Kant, for the next thought is that the three-dimensionality of cognizable objects is accounted for by appealing to the fact that I must locate all objects of possible experience at some distance from where I find myself. That Greenberg is at least entertaining this thought seems quite plausible. After all, if "recognizable" is to make any difference, it must be a difference that appeals to something about me, the one doing the recognizing. Kant's basic thought is that, so long as I posit an object of possible cognition—and don't forget myself, the subject, the one carrying out the activity of cognition—three-dimensional space will follow along after.[12]

Now, there is no point in exaggerating Greenberg's Kantianism here. In the quoted passage, he writes that the silhouette of a teacup "suffices to call up associations of" three-dimensional space—and talk of association is at least as amenable to psychological as to epistemological reflection. Is Greenberg writing at this point in a naturalistic spirit about a certain habit we have of associating objects of experience with three-dimensionality? Perhaps. But my interest is less in reading Greenberg's intentions than it is in pointing out how close we are to Kant's basic claim that the concept of an object in general does not contain the concept of three-dimensionality as a constituent (does not contain it analytically), and that to connect three-dimensionality to the general concept of an object *with necessity* we have to stir in the possibility of experience. (Thus Kant calls the possibility of experience "the highest principle of all synthetic judgment" [A154/B193].) That is, what is at stake for Kant is not merely the habit of associating objects of experience with three-dimensionality: at stake is the nature of the space we require of all

such objects if experience is to be possible. Such a reading of "association" would be continuous with taking "recognizable" as we did in the previous paragraph—as having strongly Kantian preconditions and consequences. On the other hand, the text does not rule out the possibility that Greenberg intends the association of three-dimensionality with recognizable objects in a purely naturalistic, psychological sense.[13] It is enough for my purposes to see Greenberg, while writing as an art critic, as being able to keep these epistemological issues in some sense active on the stage.

These Kantian themes are also present in an earlier piece on Cubism:

> All space became one, neither "positive" nor "negative," in so far as occupied space was no longer clearly differentiated from unoccupied. And the object was not so much formed, as exhibited by precipitation in groups or clusters of facet planes out of an indeterminate background of similar planes . . . The Cubists ended up doing with form what the Impressionists, when they precipitated their objects out of a mist of paint flecks, had only begun to do with color—they erased the old distinction between object-in-front-of-background and background-behind-and-around-the-object, erased it at least as something felt rather than merely read.

> Picasso and Braque started Cubism: Leger joined it. . . . By 1912 the main thing for him, as for Picasso and Braque, became to assert the difference between pictorial and three-dimensional space.[14]

The main Kantian move in the first paragraph is the recognition that the representation of space is unaffected by the presence or absence of objects in space. In fact, elsewhere in the Metaphysical Exposition, Kant notes that we can "never represent to ourselves the absence of space, though we can quite well think it as empty of objects" (A24/B38). If that is so, then the cubists—at least as Greenberg portrays them here—were right to stop differentiating between regions of space on the basis of whether or not they are occupied. This point may be considered fallout from the singularity thesis: If space is one, then the very notion of differentiating regions of space is, once again, derivative and metaphorical. If the Cubists made all space one, and the abstract painters abandoned the representation of space, either way we are, for practical purposes, treating space as a form under which we encounter objects rather than as an object itself or as built up from the relationships between objects.

Turning now to the last sentence: What is it to assert the difference between pictorial and three-dimensional space? I think the actual work that this distinction does for Greenberg can be illuminated by Kant's distinction between what can be thought and what can be imagined. Imagination is governed by what can be modeled (that is, made a model of)—modeled, as I have been saying, in the sense that I can construct a path to get there from here, from the space in which I find myself. (Of course, for practical reasons, the path may not be navigable—if only from the brevity of human life.) Any such path must be one in which, at any given point, I must be able to look left and right, forward and back, and up and down. And that

guarantees that the objects I encounter along the way must be three-dimensional, and that a rich array of prepositions must apply to them: above, around, before, behind, below, and so on. By contrast, thought is governed only by the principle of non-contradiction: I can *think* about escaping Piero's gallery by the fourth spatial dimension—the thought is not self-contradictory—but I cannot *imagine* it in the sense of projecting or constructing a route from here to there. (Thus, Kant calls the principle of non-contradiction "the highest principle of all analytic judgment" [A150/B189].)

With the distinction between what can be thought and what can be imagined we can now turn to "the difference between pictorial and three-dimensional space"— the main thrust, according to Greenberg, of Cubism. There is no problem with the *thought* of a world containing objects but in which it makes no sense for them to be arranged "in-front-of" or "behind-and-around" one another. The test for the coherency of thinking is contradiction, and there is no contradiction here. The difficulty arises only when I try to plot a route for myself through such a space. Thus, when Greenberg writes that the Cubists "erased" our three-dimensional intuitions "as something felt," I would like to think of this erasure as trading on the fact that thought outstrips imagination. I take it that the same point is central to Greenberg's appraisal of modernism. Greenberg says I can travel through a Mondrian "only with the eye." Here he is apparently seeing more clearly than Collingwood, who locates the ground of spatial form in the body, in "the muscular activity of painting." We have seen that this cannot be so, as the body too, like other objects of possible experience, must also conform to the conditions under which experience is possible. We cannot, then, appeal *to* the body to account for this requirement. By contrast, I take it Greenberg does not intend his optical language as a literal reference to a physical body part; I take it he means to say that we can travel through a Mondrian only in thought—a form of travel that may or may not include a spatializing component. It may mean that I am traveling through a purely conceptual space, a space through which I know (and know why!) I cannot project a path from the place in which I find myself, one in which the spatial relationships required by beneath, beside, between, and all the rest, cannot obtain. In Kantian terms, such a space is a logical but not a real possibility; it is what Masheck calls "metaphoric or virtually apparent space."[15]

Here, I am so far assuming that we cognize the elements of the Mondrian as pure geometric shapes or forms (lines and planes) and not as bits of three-dimensional pigment. Still, even taking them as pure geometric shapes, we are free to set them in a three-dimensional "picture space," into which space we can imaginatively project ourselves. Indeed, the painter Carl Holty speaks for many when he remarks that Mondrian "proved that color, volume, space and form were the results of contrasts in size and direction on a two-dimensional surface"[16]—and I take it that by "space" Holty means the three-dimensional variety. But of course both the Piero and the Mondrian are two-dimensional surfaces. How, then, do we cognize them differently? Continuing in our Kantian spirit, I think we are now in a position to give this question a fairly precise answer.

In Kantian terms, the difference in cognizing the Piero and the Mondrian comes down to the way in which parts and wholes figure into our experience of the world. Seeing either painting implicates, on any construal, an element of mathematical synthesis. That is, seeing either image unavoidably involves the cognition of pure geometrical form: in the Piero, outlines of columns and walls; in the Mondrian, lines and planes. In mathematical synthesis, the parts are "possible only in the whole." That is, I take in the whole line (line segment); only then do I speak of its constituent points. And this same form of cognition lies at the basis of our representation of three-dimensional space, whether in the Piero or in the Mondrian. In taking the picture space as three-dimensional I am taking it that, as I go on, I will always (at every moment) be able to look forward and back, left and right, up and down. The point is that, here again, the parts of space (the form of my going-on) are possible only in the whole. Here again we have to do with mathematical synthesis; the fact that I can make this judgment about space as a whole is further fallout from the singularity thesis. The difference between cognizing the work of the old master and the modernist is that taking in the Piero reflects an element of dynamical synthesis absent in the Mondrian. That is, when I see a column as this or that (white or vertical) I am taking it as the sum of its parts—the base, the shaft, the capital—here I am able to cognize the whole only by virtue of having cognized its parts.[17] The point, then, is that seeing the Piero involves both mathematical and dynamical synthesis, whereas seeing the Mondrian involves only the mathematical—even if, with Holty, we are seeing three-dimensionality in Mondrian's two-dimensional surface.

Greenberg is well known for the claim that modernism has attained a specifically Kantian form of self-criticality. The idea seems to be that, as Kant uses reason to diagnose a structural flaw in reason, so modernism uses flatness to overcome itself.[18] Many critics have found the comparison unconvincing—Masheck calls it "a Kantian caricature"[19]—and I am inclined to agree. But, although he got the details wrong, Greenberg was right to locate the Kantian diagnosis of modernism in the notion of self-criticality. In turning its back on the representation of empirical objects, modernism removes the element of dynamical synthesis from our appreciation of the work of art. But that then leaves only the contribution of the subject—that is, the mathematical synthesis underlying both the seeing of objects of pure geometry and of spatial intuition: self-criticality, we might say, of the highest order. What I see in the Mondrian I have put there myself.

———

I have been ascribing a mistake to Collingwood, that of making the body at the same time responsible for and subject to the requirements of spatial form. But what is the alternative? If not the body, what does Kant mean by "myself" when he says that I must locate objects "in another region of space from that in which in find myself"? On a charitable reading of the sort I have suggested, we can see Greenberg as avoiding Collingwood's mistake by trading his talk of the physical eye for talk about the limits of what can be imagined and what can be thought. But

this improvement, if it is one, threatens to saddle us with a Cartesian disembodied thinking substance, and that would be to trade one error for another. What then?

A clue, I think, is contained in my title. I *find* myself. Typically, when I find something it affects me in a literal way. I find a quarter in the couch cushions, and the act of seeing it includes being affected by it, even to my surprise. More generally, what is critical to Kant's theory of knowledge is the fact that I am open to being affected by a world I have not made. In *The Critique of Pure Reason*, when Kant comes to criticize Descartes' treatment of self-awareness, it is on the account of self-affection that Kant lays the most stress:

> The "I think" is, as already stated, an empirical proposition, and contains within itself the proposition "I exist." But I cannot say "Everything which thinks, exists." For in that case the property of thought would render all beings which possess it necessary beings. My existence cannot, therefore, be regarded as an inference from the proposition "I think," as Descartes sought to contend . . . The "I think" expresses an indeterminate empirical proposition, i.e., perception (and thus shows that sensation, which as such belongs to sensibility, lies at the basis of this existential proposition) (B423).

No doubt Kant's reading of Descartes' *cogito* is tendentious. Descartes says explicitly that neither does he intend nor does the argument require the syllogistic form [20]—but these issues need not detain us. For our purposes, the key point is Kant's claim that the *cogito* is an empirical proposition, albeit of an indeterminate variety. Now, for Kant, a determinate empirical proposition is one in which I apply a general term to what strikes me in sensation. Thus, I am affected and react, "apple." The term is general in the sense that it can legitimately be applied elsewhere should I find myself in a similar position. That is, it can be applied to other apples. Elsewhere in the *Critique*, Kant notes that, even when the object in question seems to be the only one of its kind, we still cannot rule out finding another answering to the same description (A657/B685).

But in my own case, when I react to being affected by, let us say, the activity of my own thinking, I am in a peculiar position. Kant continues,

> An indeterminate perception here signifies only something real that is given, given indeed to thought in general, and so not as appearance, nor as thing in itself (*noumenon*), but as something which actually exists, and which, in the proposition, "I think," is denoted as such.

So the peculiarity is not in the kind of existence (there is no parallel distinction in Kant to Descartes' *res cogitans* and *res extensa*). I "actually exist" in the same sense as an apple. The peculiarity lies in the account of perception adequate to characterize a judgment in which I am both subject and object. To start, Kant wants to rule out any account of perception which implicates some kind of noumenal existence; that is the point of his insistence that my existence is given in the same sense as ordinary empirical judgment: that it is forced on me, as he says, in sensation. But

neither can my own existence be characterized as a standard-issue appearance—for then generality appears not as a requirement but as a threat; that is, I could not rule out one day legitimately reacting "mine" to the thinking of someone else. Put differently, I would then have to endorse the incoherent thought that I might one day encounter in experience other instances of my own thinking—"other" in the sense that I require the activity of thought to cognize what, by hypothesis, is supposed to be another instance of my own thinking. This, again, is why "I exist" expresses an indeterminate rather than a determinate empirical proposition—it resists the test of generality.

Why "resists" rather than "fails"? Kant's thought seems to be that an exception to the generality requirement is unproblematic—is not a true exception—if we can see how it arises and if our account of what makes it nonstandard fits with our broader account of empirical knowledge. I take it that Kant is trying to provide just this kind of diagnosis with the remark that my own existence is "given to thought in general." If my existence were given to thought "in particular," I would be able to form a general concept of it, and I would be forced to embrace, as above, an incoherent prospect. Instead, the fact that my existence is given in sensation allows Kant to preserve his fundamental claim that sensation is required for the meaningful use of any empirical term, even as he points out that, in this instance, we have to deal with a term whose legitimate conditions of application can be satisfied by at most one object.[21]

In these few paragraphs I have left many issues in Kant's treatment of embodiment unclarified and others unmentioned. But I think it is clear enough that Kant is attempting to give an account of embodiment that generates the requirements of spatial form even as it allows us to treat the body and its parts as subject to those very requirements. Such an account, if it could be worked out and made reasonably precise, would allow us to trace the requirements of spatial form—in particular, the apriority and singularity conditions—to the fact of embodiment without tracing them to parts of the body to which those very requirements must apply. Thus, it would allow us to extend the apriority and singularity conditions to such human activities as painting without an unhappy appeal, as in Collingwood, to fingers, wrists, and arms. "What one paints is what can be painted; no one can do more; and what can be painted must stand in some relation to the muscular activity of painting it." If, with Masheck, we want to see Collingwood as taking a Kantian turn in this passage, then I think we must be committed to something like the account I have sketched here.

2. Ruskin's Critical Pathos

Andrew Ballantyne

Ruskin had been young when he embraced Turner's art with such fervor, and almost 60 when he rejected Whistler's with such distaste, so his rejection of Whistler is usually taken as a simple question of his flexibility hardening, and his purview narrowing, with age. Andrew Ballantyne has reason to think that for the great critic an important difference ran considerably deeper. He points up a common concern with the picturesque in both painters early in their careers. Even Ruskin's Modern Painters, *famous for its advocacy of Turner, sets out from the picturesque, which, however, harbored from the start "associations of ideas" in its "beautiful as a picture" representations. Without the association of ideas, Ruskin could not have framed the "pathetic fallacy"; but a work of art with nobly ethical pathos could have scope, as with Turner's* The Slave Ship, *1840. It's a wonderful as well as horrific painting, and we understand how that cannot derive from mere excellence of manual technique; but as moderns we are surprised that subject matter has so much to say about aesthetic value. It's nice that when Landseer was respectable and Turner almost disreputably peculiar, Ruskin rose to the latter's defense; yet a mourning dog by Landseer has "force of sentiment" in common with* The Slave Ship *whether we like it or not (and after Rauschenberg's artfully painterly 1955* Bed, *an as-is British artist's bed not as readymade so much as psychological souvenir). Has anybody before Andrew noticed that when even Turner offers nothing to be sentimental about, Ruskin has nothing to say? (This provokes me to suggest that, notwithstanding his wonderful writing, Ruskin made a hugely influential contribution to a first effective humanization of Christian values that, however, withered away into, not de-institutionalized radical religion but merely why-bother secularism.) Now we can understand how Ruskin's sense of pathos, could embrace Landseer, and even plausibly be extended to a postmodern work of utter pathos, yet simply not allow the taking of Whistler's lyrically pacific and virtually nonobjective aestheticism seriously.* — J.M.

In nineteenth-century England, there was no greater critic, in the public's view, than John Ruskin (1819–1900). His reputation was established and put on a sound footing with the publication of *Modern Painters* in 1843; grew thereafter; and

foundered after 1877, with bouts of mental illness and a high-profile spat with the artist James Whistler (1834–1903).

The quarrel between Whistler and Ruskin was heard in a court of law: Whistler accused Ruskin of libeling him in published comments about his painting *Nocturne in Black and Gold: The Falling Rocket*, exhibited for the first time at the Grosvenor Gallery in 1877 (fig. 2–1). The gallery had been set up by Sir Coutts Lindsay in Bond Street, a short distance from the Royal Academy, which it was seen to rival. It was

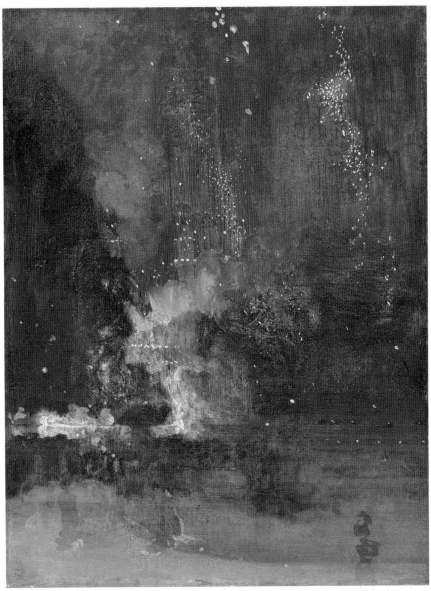

2-1. James A. McNeill Whistler, *Nocturne in Black and Gold: The Falling Rocket*, 1875.

a place where artists who were not academicians could exhibit their work to a very wealthy clientele who could pay good prices. Whistler was financially dependent on making sales to such people; and Ruskin's comments about his work went beyond being unappreciative of the particular painting, threatening Whistler's livelihood. "For Whistler's own sake," said Ruskin, "no less than for the protection of the purchaser, Sir Coutts Lindsay ought not to have admitted works into the gallery in which the ill-educated conceit of the artist so nearly approached the aspect of willful imposture. I have seen, and heard, much of Cockney impudence before now; but never expected to hear a coxcomb ask two hundred guineas for flinging a pot of paint in the public's face" (29:160).[1] The particulars of the subsequent trial have been well rehearsed and will not be discussed here.[2] The question that this essay will address is why Ruskin found the painting so objectionable.

There is the matter of detail and finish. Ruskin admired paintings by Burne-Jones that were on display at the same time as the finest that the age could produce. He praised Tissot's technique but lamented his subject matter; he praised Millais while lamenting the loss of his youthful zeal with the execution of detail. The painterly films of color on Whistler's canvas were without detail, and the execution looked spontaneous rather than painstaking. Ruskin however was quite capable of admiring rapidly executed sketchy paintings, if he felt that they had accurately caught whatever it was that it seemed essential to capture,[3] and he had made his name in *Modern Painters* with the rapturous appreciation of Joseph Turner (1775–1851), whose later work can have much in common with Whistler's. The attempt to capture the transient and vaporous effects of *Rain, Steam, and Speed: The Great Western Railway*, first exhibited at the Royal Academy in 1844, for example, stands comparison with Whistler's attempt to capture the arresting but fleeting impression made by the falling rocket. The reputation of both artists is now secure, and both paintings are in public collections: the Whistler in Detroit, the Turner in London— one of the few of his works to be on display at the National Gallery, rather than with the huge collection of his work at the Tate. *Rain, Steam, and Speed* is now seen not only as a good example of Turner's work but also as among his greatest achievements, and indeed its exceptional quality was recognized early. The novelist Thackeray said, "The world has never seen anything like this picture."[4] Ruskin said nothing about it.

When we look at Turner's work from a later age we can hardly help but see premonitions of things to come. There are times when *Rain, Steam, and Speed* seems to have more in common with Monet's "impressions" than anything by Turner's contemporaries.[5] However, such a perspective was unavailable to Ruskin: whatever it was that he saw in Turner's work, he could not have seen it as proto-Impressionism. It is indeed easy for us to look at Turner's work anachronistically, and to admire it in ways that would probably have been alien to Turner himself and surely to his patrons. Ruskin's view of Turner is accessible because it was laid out with such enthusiasm in *Modern Painters*: it is quite different from the view that we might attribute to Ruskin if we were to imagine that his admiration for Turner was more or less like our own.

Both Turner's and Ruskin's artistic sensibilities were grounded in the tradition of the picturesque, which had been theorized in the later eighteenth century, especially by William Gilpin, Sir Uvedale Price, and Richard Payne Knight,[6] whose ideas were already in circulation when Ruskin's father was a boy. The most philosophically sophisticated version of this line of thinking was Knight's *An Analytical Inquiry into the Principles of Taste* (1805). Knight drew on the aesthetics of such Scottish philosophers as Archibald Alison (*Essays on the Nature and Principles of Taste*, 1790), who had brought the theory into alignment with his own taste for picturesque neoclassicism. Knight was an authoritative arbiter of taste until he failed to recognize the merits of the Parthenon marbles when they were purchased for the nation in 1816, from which his popular reputation never recovered. Nevertheless, *Modern Painters* seems to follow Knight's example more than anyone else's, with its philosophically structured table of contents guiding the reader; in both cases, the general argument tends to be lost in the compelling detail of particular examples that seem digressive, so that one needs to refer back to the tabulated contents to be reminded of the drift of the argument.

Ruskin's sensibility had been formed in the picturesque through his father's enthusiasms. From infancy he was taken on picturesque jaunts, and his first published work is completely picturesque in its outlook.[7] He sketched regularly, and he had some tutoring on watercolor technique from Copley Fielding, in 1835 (35:213–15). Ruskin's father collected paintings by Fielding, Samuel Prout, and Turner, among others, and from an early age involved his son in the decision making. Although Ruskin would later repudiate some aspects of the picturesque, he never forsook the key principle of "the association of ideas," which he might first have learned about from Knight but which Knight himself relayed from Alison.

Anyone who finds his way into print as young as Ruskin did, and then carries on writing, is bound to leave in the writing a trace of the development of his thinking. What is odd in Ruskin's case is not only that he gave a single title, *Modern Painters*, to five books whose publication was spread across the years between 1843 and 1860, from when he was twenty-four until he was forty-one, but also that the five volumes do not really make a coherent work. Ruskin's views of things were subject to change. "All true opinions are living," he said in the preface to the final book, "and show their life by being capable of nourishment; therefore of change. But their change is that of a tree—not of a cloud" (7:9). He was a much more knowledgeable and sophisticated critic in the final volume than he had been in the first: the precision of thought is constant, but the outlook by the end was much more widely informed.

At the outset, then, *Modern Painters* is thoroughly immersed in the values of the picturesque; and the book's heroes are Henry Prout, Copley Fielding, and Turner, all known from Ruskin's father's collection. Just what did "picturesque" mean in the 1830s? Actually, its meaning and connotations had shifted. Back in the 1780s it had been associated mainly with William Gilpin and his "picturesque tours" to the Wye Valley and others parts of Britain. This meant traveling in search of views of natural scenery, and maybe ruins (such as Tintern Abbey) or other buildings that brought out the evocative qualities of a place. The idea was to find real places that looked

as good as pictures. The great thing about the Wye Valley, and the reason it became a tourist attraction in the eighteenth century, was that the steeply sloping banks at the sides and the distant views along the river ahead tended to make satisfyingly "pictorial" compositions, with foregrounds, middle grounds, and distances. Dutch landscape painters were admired, but the most esteemed old master landscapists were Poussin and Claude Lorrain, whose images of Italian scenery populated by classical figures could stir the noblest sentiments of the landed gentry.

Knight had pointed out that the word "picturesque" derived from the Italian *pittoresco* and meant "after the manner of painters," so that "picturesqueness" was not exactly in the landscape but in the mind of the viewer. Hence, someone who was familiar with the work of the exemplary landscape painters would be able to recall them—maybe subliminally—when looking at real scenes, particularly when they took on a harmonious coloration, when gilded by the subdued light at sunrise or sunset, or if there was a fine mist.[8] (Logically speaking, if the word "picturesque" means "after the manner of painters," then the last thing it should be applied to is paintings; nevertheless, it was.)

The kinds of landscapes and sights that were sought after on picturesque tours could not in those days be fixed as photographs, but they could be sketched and worked up into paintings. Turner's early career was built on such topographical work, such as his detailed 1794 views of Tintern Abbey moldering, with vegetation growing over the ruin in an impeccably picturesque manner. The directives for how to select landscapes that evoked pictures turned back into records of those scenes in paintings. There is a danger, with such reflexivity, of the paintings' becoming parodic as they start to record the aspects of the world that have been found already to look like pictures, and this is rather the state of "the picturesque" as seen in the hands of the minor artists of Ruskin's youth. For amateurs, there is something appealing about learning to paint "after the manner of painters," because it means that one's efforts look like the work of established artists: it demonstrates a proficiency within the cliché system of a certain artworld. However, the artists whose work stands out as innovative and distinct will emerge from one tradition or another by doing something that is not quite in the manner of the artists who have gone before; then, however, such work must be, seemingly by definition, less "picturesque."[9] When Ruskin had lessons from Copley Fielding, whose work he continued to admire and praise, he was taught about the production of conventional images. He describes his initial excitement, when he was shown the technique, but then that first reaction subsided.

> Copley Fielding taught me to wash colour smoothly in successive tints, to shade cobalt through pink madder into yellow ochre for skies, to use a broken scraggy touch for the tops of mountains, to represent calm lakes by broad strips of shade with lines of light between them (usually at about the distance of the lines of this print), to produce dark clouds and rain with twelve or twenty successive washes, and to crumble burnt umber with a dry brush for foliage and foreground. With these instructions, I succeeded in copying a drawing which Fielding made before me, some

twelve inches by nine, of Ben Venue and the Trossachs, with brown cows standing in Loch Achray, so much to my own satisfaction that I put my work up over by bedroom chimney-piece the last thing at night, and woke to its contemplation in the morning with a rapture, mixed of self-complacency and the sense of a new faculty, in which I floated all that day, as in a newly-discovered and strongly buoyant species of air.

In a very little while, however, I found that this great first step did not mean consistent progress at the same pace. I saw that my washes, however careful or multitudinous, did not in the end look as smooth as Fielding's, and that my crumblings of burnt umber became uninteresting after a certain number of repetitions (35:215–16).

The most powerful influence of the picturesque on Ruskin was in the first instance in its characteristic subject matter. The landscapes with mountains, lakes, ruins, cottages, and trees continued to furnish his imagination throughout his life, sometimes as a focus of attention, sometimes as background. In the second place, but ultimately more importantly, the practice of drawing came to be for him a vital discipline, even when it ceased to be directed toward the making of pictorial compositions. In 1857, Ruskin published a treatise, *The Elements of Drawing*, which gives practical guidance about sketching and opens by making it clear whom he is and is not addressing:

If you desire only to possess a graceful accomplishment, to be able to converse in a fluent manner about drawing, or to amuse yourself listlessly in listless hours, I cannot help you: but if you wish to learn drawing that you may be able to set down clearly, and usefully, records of such things as cannot be described in words, either to assist your own memory of them, or to convey distinct ideas of them to other people; if you wish to obtain quicker perceptions of the beauty of the natural world, and to preserve something like a true image of beautiful things that pass away, or which you must leave; if, also, you wish to understand the minds of great painters, and to be able to appreciate their work sincerely, seeing it for yourself, and loving it, not merely taking up the thoughts of other people about it; then I can help you, or, which is better, show you how to help yourself (15:25).

For Ruskin, drawing was a way of intensely contemplating a fragment of the world: a form of meditation. It was as much a spiritual discipline as a way of conveying practical information, of tuning in to the manifest part of the universe. The whole point of drawing and painting was to apprehend a truth about appearances, so as to convey some truth about the world. The concept of truth is at the core of Ruskin's idea of art, and it dominates the opening pages of the first volume of *Modern Painters*, which, while it was being written, was called *Turner and the Ancients* (3:xxxi). There is no doubt that Turner is the hero of the work whose title changed after negotiations with the publisher to the evidently more

marketable *Modern Painters: Their Superiority in the Art of Landscape Painting to All the Ancient Masters Proved by Examples of the True, the Beautiful, and the Intellectual, from the Works of Modern Artists, Especially from those of J.M.W. Turner, Esq., R.A.*

Turner came from a modest background—his father was a barber—but the brilliance of his draftsmanship was recognized at an early age, and he had been elected as an academician in his early twenties—the youngest-ever member. Ruskin first encountered his work in the vignettes of Samuel Rogers' *Italy*—a mediocre poem by a wealthy man who gave it a lavish presentation.[10] Turner was already fifty-seven and was coming to the end of his long period of tenure as the Royal Academy's Professor of Perspective. His early work included very detailed topographical and architectural perspectives that were absolutely assured and superbly skillful. His later paintings became entranced by the effects of light, and involved much less detailed rendering, yet evoked space and elevated sentiment through the use of washes of color with deftly placed elements here and there that made them surprisingly compelling. The real subject matter in the paintings is formless or shifting and hence impossible to transcribe directly to the page or canvas: in Turner's mature work, one senses the heaving mass of water in a rough sea or the power of a storm in swirling clouds, the vertiginous drop of a depthless chasm, or the sheer, blissful radiance of the sun. His reputation among the greatest of artists is now absolutely secure, but in his own lifetime things were different: he attracted admirers, but there were detractors too, and during Ruskin's late teens it seemed to him that the detractors might be in the ascendant.

Ruskin was rapturously receptive to Turner's work and delighted when his father started to buy it, although John James was, at least at first, cautious about the prices he would pay. When John reached the age of twenty-one, his father gave him stocks that produced an income of about £200 a year—at a time when a laborer in steady employment would earn less than £8 a year and be able to get by on it—and he spent £70 of the first year's allowance on a Turner watercolor of Harlech Castle (35: 257–58). When *Modern Painters* was published in 1843, it took its leave of Turner by describing him as the angel of the Apocalypse—the "angel standing in the sun" at the end of the Bible (Rv 19:17).[11] This image was dropped from later editions, out of sensitivity that it might seem idolatrous, but there is no doubt that it was sincerely felt, and one of Turner's last paintings would be an image of this angel, which thus remains associated with him.

On the New Year's Day after the publication of *Modern Painters*, John James gave his son a Turner oil painting, *The Slave Ship*, which he received with rapture (fig. 2–2) (35:318–19). He had already written about the painting, having noticed it as "the chief Academy picture of the Exhibition of 1840" (3:571). He explains in a footnote that the ship "is a slaver, throwing her slaves overboard. The near sea is encumbered with corpses" (3:572n). That is all. The full title—"Slavers Throwing Overboard the Dead and Dying—Typhon Coming On"—clarifies the content of the image, as did the accompanying poem (of Turner's own composition) in the catalogue:

Aloft all hands, strike the top-masts and belay;
Yon angry setting sun and fierce-edged clouds
Declare the Typhon's coming.
Before it sweeps your decks, throw overboard
The dead and dying—ne'er heed their chains
Hope, Hope, fallacious Hope!
Where is thy market now?[12]

Slavery was already illegal in the United Kingdom, and in 1840 there was active political debate about extending that illegality throughout the whole British Empire (with legislation to that end passed in 1843). The continuing slavery in the southern states of the U.S.A. was eventually resolved in the Civil War, of 1861–65. In Turner's painting, the action demonstrates the callousness of a commercial logic that has become indifferent to the lives and hopes of the humans who have become mere spoiled goods, dumped at sea. The dead and dying slaves are in the foreground of the painting, but they are treated vaguely; and the real energy of the painting is in the depiction of the weather. The coming "typhon" (typhoon) resonates with the Biblical proverb "For they have sown the wind, and they shall reap the whirl-wind" (Hos 8:7), which has passed into ordinary British usage as "reaping the whirl-wind," with the suggestion that a major calamity has been brought on by its victims. "Typhon" was also the name of the Greek god of winds, so there is a suggestion of the presence of divine power in the approaching storm, and retribution of justice. With hindsight, one might see the American Civil War as the whirlwind that was sown in events such as the one depicted; but again, Turner was not to know that. He did however have a sense that there would be a day of reckoning for this crime, or at least that such a day would be deserved.

Ruskin's commentary does not draw out any of the moral purpose that might be read into the story but instead writes as if the morality is in concentrated solution in the salty waters of the sea. In this instance, it is not that the painting brings to mind noble associations of ideas, but that (in Ruskin's description) it is the sea itself that is noble.

I think, the noblest sea that Turner has ever painted, and, if so, the noblest certainly ever painted by man, is that of the Slave Ship. . . . It is a sunset on the Atlantic after prolonged storm; but the storm is par-tially lulled, and the torn and streaming rain-clouds are moving in scarlet lines to lose themselves in the hollow of the night. The whole surface of sea included in the picture is divided into two ridges of enormous swell, not high, nor local, but a low, broad heaving of the whole ocean, like the lifting of its bosom by deep-drawn breath after the torture of the storm. Between these two ridges, the fire of the sunset falls along the trough of the sea, dyeing it with an awful but glorious light, the intense and lurid splendor which burns like gold and bathes like blood. Along this fiery path and valley, the tossing waves by which the swell of the sea is restlessly divided, lift themselves in dark, indefinite, fantastic forms, each casting

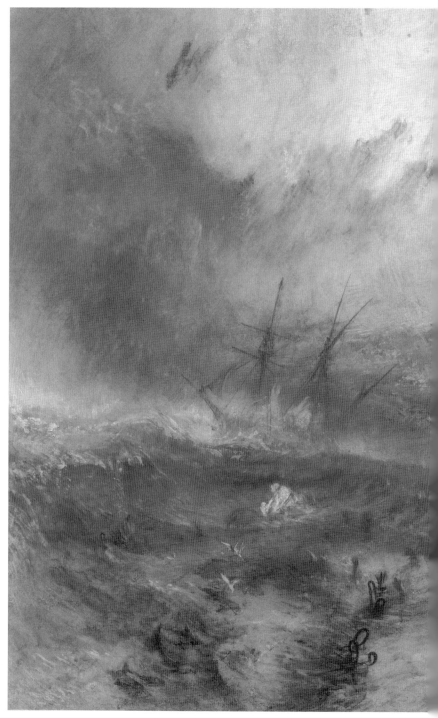

2-2. J. M. W. Turner, *Slavers Throwing Overboard the Dead and Dying; Typhoon Coming On ('The Slave Ship')*, 1840.

a faint and ghastly shadow behind it along the illumined foam. They do not rise everywhere, but three or four together in wild groups, fitfully and furiously, as the under strength of the swell compels or permits them; leaving between them treacherous spaces of level and whirling water, now lighted with green and lamp-like fire, now flashing back the gold of the declining sun, now fearfully dyed from above with the indistinguishable images of the burning clouds, which fall upon them in flakes of crimson and scarlet, and give to the reckless waves the added motion of their own fiery flying. Purple and blue, the lurid shadows of the hollow breakers are cast upon the mist of the night, which gathers cold and low, advancing like the shadow of death upon the guilty ship as it labors amidst the lightning of the sea, its thin masts written upon the sky in lines of blood, girded with condemnation in that fearful hue which signs the sky with horror, and mixes its flaming flood with the sunlight,—and cast far along the desolate heave of the sepulchral waves, incarnadines the multitudinous sea.

I believe, if I were reduced to rest Turner's immortality upon any single work, I should choose this. Its daring conception—ideal in the highest sense of the word—is based on the purest truth, and wrought out with the concentrated knowledge of a life; its color is absolutely perfect, not one false or morbid hue in any part or line, and so modulated that every square inch of canvas is a perfect composition; its drawing as accurate as fearless; the ship buoyant, bending, and full of motion; its tones as true as they are wonderful; and the whole picture dedicated to the most sublime of subjects and impressions (completing thus the perfect system of all truth, which we have shown to be formed by Turner's works)—the power, majesty, and deathfulness of the open, deep, illimitable Sea (3:572–73).

The dominant colors of the sunset in Turner's painting, around which the composition revolves, are red and gold, the colors of blood and money—exactly the things that are central to the depicted incident. The image is full of sentiment and associations of ideas, but in Ruskin's tour de force it presents a completely accurate and truthful rendering of a natural scene. The intensity of Ruskin's language would make no sense without the moral import of the depicted scene, but that moral content is left unremarked. Maybe it seemed too self-evident to need a commentary to spell it out, and his description is certainly a response to it, even though that is not quite explicit. The adjectives regularly invest things described with properties that they cannot literally have. A ship cannot be "guilty"; waves cannot really be "wild," or at least neither "fitful," "furious," nor "desolate." In actual fact, Ruskin himself coined the term "pathetic fallacy" for this type of language, citing Charles Kingsley:

They rowed her in across the rolling foam—
The cruel, crawling foam.[13]

"The foam," says Ruskin, "is not cruel, neither does it crawl." "Pathetic" here means "relating to feelings," and it is a fallacy because the feelings in question are misattributed to inanimate things that certainly do not have those feelings. Ruskin does not argue that it is necessarily wrong to use such language, because it can be expressive. In moments of strong feeling one's rationality is temporarily unhinged—the foam seems cruel, the ship seems guilty—and the sense of heightened emotion is conveyed to the reader, who notices, maybe subliminally, that the language itself has become unhinged.

Ruskin's analysis of the "pathetic fallacy" should be enlisted as part of the history of "affect theory" as we have come to know it.[14] He does argue that such "pathetic" use of language should be sparing, and classifies writers in the following groups. There are those who have no use for the pathetic fallacy because they have no feelings, and therefore feel no need to express them. Then there are others who make too much use of the pathetic fallacy; in their hands, the world seems to be full of feelings, but it can easily turn into whimsy, and there is no sense of reason in the writing. Ruskin puts Alexander Pope's verses in this latter category, seeing them as definitely "minor" in their poetic achievements, however polished they might be as performances in verse. But the pathetic fallacy becomes interesting when the poet's reason has been established and the power of reasoning is evident in the descriptions of emotionally manageable events. Only then, when reason can be overcome by emotion, does the "cruel foam" start to have an appropriate effect; and note that that effect is to convey the emotional state of the poet, not the emotional state of the foam. Some of the most powerful poetry, says Ruskin, is written without the poet becoming unhinged, in this way. Both Homer and Dante, for examples, convey the emotional states of others (the people mentioned in the poems) without the poet's own voice becoming emotionally involved. Their capacity for reason enables them to hold the scene at arm's length, and to convey the passion without becoming embroiled in it (5:208–12).

In his discussion of the pathetic fallacy, Ruskin wonders how it is that we can find it so appealing when it is not true, if truth is one of the hallmarks of merit in anything (5:204). He concludes that "the pathetic fallacy is powerful only so far as it is pathetic, feeble so far as it is fallacious, and therefore the dominion of Truth is entire" (5:220). Ruskin distanced himself from "philosophers" and did not intend to write like one (5:203).

Turning back to the description of *The Slave Ship*, clearly Ruskin was writing in this "unhinged" register, responding in an appropriate way to the story of a commercial atrocity and the approach of a whirlwind. The subject is overwhelming for Ruskin's declaredly limited capacity for rationality. He wants us to know that he is overwhelmed by this subject, because he wants us to know that he passionately feels and cares about the plight of these slaves and the abolitionist cause. The wind and the waves are not in themselves "noble," but the abolitionist cause is noble. The ship is not actually "girded with condemnation" by the red sky, the color of which is not inherently a "fearful hue." These are Ruskin's projections onto the scene, and they are entirely appropriate associations of ideas. The title of the painting and Turner's

poetic fragments give some hints as to how the scene should be seen, and Ruskin enthusiastically participates in the collaboration.

Turner himself made use of the pathetic fallacy in making the sea and sky match the heightened mood that is melodramatically appropriate to the mass murder. As an alternative, for example, it would perhaps have been possible to depict the incident on a calm sea with a clear sky, which might have brought out the coldness and cruelty in the decision on the part of its perpetrators in following a narrowly commercial logic. The violence of Turner's colors and the turbulence of the sea do not depict the mood of the villains but of the viewers of the canvas. For "us"—the sympathetic viewers—the story is upsetting and the picture dramatizes the upset. Its horizon is not horizontal, as if we too are at sea and off balance. The scene is magisterially depicted as if it were a natural occurrence. Turner was better able than anyone to depict the formations of clouds and swells: Ruskin's category of truth telling is not undermined. Also, in Turner's technique there is the kind of sublime detachment that Ruskin attributed to Homer and Dante, but which Ruskin himself could not manage: his writing is appropriately and willfully unhinged, but Turner's painting is impeccable. In it very many rapid brushstrokes in overlapping colors build up an effect of blurring that helps to convey the impression of the shifting forms. There is nothing crude about it—no angry lashing out with the brushes, no collapse of technique. The bodies in the foreground can barely be made out, except for a hand and a leg; there do seem to be chains there, and some fish presumably feeding on the corpses, but oddly depicted, as if on the surface of the water. They are lost to Ruskin's view as he dwells on the way in which the colors of the sky are scattered but reflected in the heaving water—a naturalistic effect, but produced here by meticulous artistry. So the scene conveys to us, and stirs in us, the heightened emotion and unhinging horror of the scene, through a careful rendering executed rapidly but in a mood of protean calm.

The impeccable artistry could be admired, but for Ruskin that was never enough, and never quite the point. "Painting, or art generally, as such," he wrote, "with all its technicalities, difficulties, and particular ends, is nothing but a noble and expressive language, invaluable as the vehicle of thought, but by itself nothing" (3:87). Failure to attend to the difference between an artist having an impeccable technique and actually having something worthwhile to say lays a critic open to "every form of coxcombry, and liable to every phase of error" (3:87). A brilliant technique is a prerequisite, in the way that a poet must be able turn a phrase, but it has to be harnessed to some worthy subject matter if it is going to succeed as a work of art. Ruskin makes his point with admirable clarity by giving a description of just such a masterly work. It has prominence because it is the first description of a modern work in *Modern Painters*, so it sets the tone for what is to come.

> Take, for instance, one of the most perfect poems or pictures (I use the words as synonymous) which modern times have seen—the "Old Shepherd's Chief Mourner." Here the exquisite execution of the glossy and crisp hair of the dog, the bright sharp touching of the green bough beside it, the clear painting of the wood of the coffin and the folds of the blanket,

are language—language clear and expressive in the highest degree. But the close pressure of the dog's breast against the wood, the convulsive clinging of the paws, which has dragged the blanket off the trestle, the total powerlessness of the head laid, close and motionless, upon its folds, the fixed and tearful fall of the eye in its utter hopelessness, the rigidity of repose which marks that there has been no motion nor change in the trance of agony since the last blow was struck on the coffin-lid, the quietness and gloom of the chamber, the spectacles marking the place where the Bible was last closed, indicating how lonely has been the life—how unwatched the departure of him who is now laid solitary in his sleep;—these are all thoughts—thoughts by which the picture is separated at once from hundreds of equal merit, as far as mere painting goes, by which it ranks as a work of high art, and stamps its author, not as the neat imitator of the texture of a skin, or the fold of a drapery, but as the Man of Mind (3:88–89).

Landseer exhibited this picture at the Royal Academy in 1837, and it was an immediate popular success (fig. 2–3). An engraving of it sold well, and the image is still in popular circulation as a greeting card. For art critics, though, it is a problem. At some point during the twentieth century, the image started to look hackneyed, and

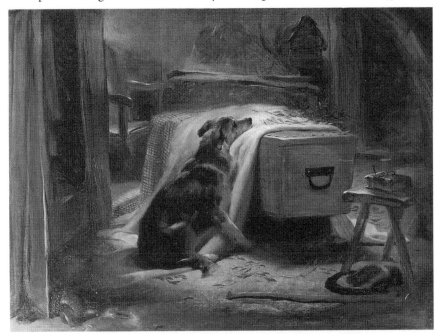

2-3. Sir Edwin Landseer *The Old Shepherd's Chief Mourner*, 1837.

more than that, trashily sentimental. The technical execution is of course brilliant; but no one would now want to claim that Landseer was a prominent exemplar of the "Man of Mind." If his reputation is to be salvaged, it would have to be by persuading us that we should be less squeamish about having sentimental reactions

to things, and that investing our dogs with quasi-human emotions is a legitimate activity for us high-minded folk as a way of demonstrating to one another our fine sensibilities. So far, at least, Landseer's reputation as a serious artist (as opposed to a skillful technician) seems irretrievable, and he remains completely beyond the pale. In 1964 Kenneth Clark compiled a selection of Ruskin's writings (*Ruskin Today*) that made no mention of Landseer, nor of other artists that Ruskin admired, such as David Cox. Copley Fielding is mentioned only as Ruskin's teacher, and Samuel Prout and David Roberts more for their shortcomings than for the moments when they inspired Ruskin.[15]

No; the best strategy for rehabilitating Ruskin's reputation was to concentrate on his enthusiasm for Turner. Ruskin's love of Turner's paintings has redeemed him in the eyes of the critical establishment since the 1960s. But when Ruskin first published *Modern Painters* it was the other way around: Turner was the questionable inclusion in need of defense. The other artists were popular and mainstream. Landseer was being collected by Queen Victoria, who had her portrait painted by him more than once. When we look at Turner's work, we are inclined to see it as visionary and "ahead of its time" because it seems to anticipate the Impressionists and therefore seems to belong more with the future than its own time. But in order to see Turner as Ruskin saw him we need to bear in mind that the way of looking was formed by way of the picturesque and the kinds of painting that sat comfortably in bourgeois drawing rooms, such as his father's at Herne Hill.

Looking back at Ruskin's enthusiasm for *The Slave Ship* we can see that part of the appreciation is in the skillful technique, but that is to be taken for granted. The thing that makes *The Slave Ship* the work of a "Man of Mind" is the fact that it permitted Ruskin to project into the scene the associations of ideas that elevate the subject matter into something that has moral worth. Feeling sympathy for slaughtered slaves is a nobler kind of sentiment than looking fondly on a mournful dog; but it is sentiment nonetheless. Ruskin saw in Turner the sentimental force that he saw in Landseer. There are paintings by Turner where that sentiment does not seem to be in place, where the whole point of the picture seems to be to arrest an effect of the light. Significantly, where such paintings are concerned, Ruskin falls silent. He has nothing to say about *Norham Castle*, nor about *The Burning of the Houses of Parliament*; *Rain, Steam, and Speed*; *The Angel Standing in the Sun* . . .

Imagining how the arguments that are set out in *Modern Painters* would have worked for Ruskin's first readers is now straightforward. He begins with the claim that public opinion is not a good judge of new painting, but that if something sustains a place in public esteem over centuries as fashions come and go, then that work undoubtedly has merit (3:79ff). The best judges of new paintings are experts who have studied art and who know what they are talking about. Ruskin of course, despite his youth, which he initially kept hidden by publishing anonymously, was setting himself up as such an expert. His arguments now often seem tendentious, but we are inclined to find an argument dubious if it reaches a conclusion that we are unwilling to accept. If the conclusion is that we have to accept a sentimental daub as evidence of Landseer's towering genius, then we demur. However, if we

have found Landseer's remarkable painting of the profound bond between a man and his working dog a genuinely moving experience, then we trust Ruskin's judgment a little more for having acknowledged its rare qualities. In fact, throughout, Ruskin's taste could be taken to be middlebrow and populist, with Turner as the exceptional case. For the unargumentative kind of reader, the book ensured at the outset that it was taking a thoroughly elitist view of art; but then as the judgments about individual modern painters came through, the reader would in all likelihood find those judgments unchallenging. He or she would feel like an expert, so would find that Ruskin had excellent taste, and would then be inclined to acquiesce in the over-the-top enthusiasm for Turner. However, not all of Ruskin's readers would react in that way.

Actually, what is lively in *Modern Painters* is not so much its endorsement of some artists as its denigration of others. It is this that establishes a distinct character to Ruskin's taste, and the taste of his generation, and distances it from the enthusiasms of the late eighteenth century that were lingering on among "the followers of Sir George Beaumont." Beaumont had been an accomplished amateur painter, a collector of old master paintings, and the champion and patron of John Constable. It was he who proposed the formation of a National Gallery, donating his own collection of paintings on condition that John Julius Angerstein's collection be bought for the nation, and that a suitable building be constructed to display the works. In 1838, the National Gallery opened its doors in still-new Trafalgar Square, with relatively few works to show. It was Beaumont's belief, and not only his, that British art would be improved if artists' tastes were improved by exposure to old masters. In the preface added to the second edition of *Modern Painters*, Ruskin said,

> Sir George Beaumont . . . furnishes . . . a melancholy instance of the degradation into which the human mind may fall, when it suffers human works to interfere between it and its Master. The recommending the color of an old Cremona fiddle for the prevailing tone of everything, and the vapid inquiry of the conventionalist, "Where do you put your brown tree?" show a prostration of intellect so laughable and lamentable, that they are at once, on all, and to all, students of the gallery, a satire and a warning. Art so followed is the most servile indolence in which life can be wasted (3:45).

Art imitating art, losing sight of nature, loses its way:

> [W]henever hereafter I speak depreciatingly of the old masters as a body, I refer to none of the historical painters, for whom I entertain a veneration, which though I hope reasonable in its grounds, is almost superstitious in degree. Neither, unless he be particularly mentioned, do I intend to include Nicholas Poussin, whose landscapes have a separate and elevated character, which renders it necessary to consider them apart from all others. Speaking generally of the older masters, I refer only to Claude, Gaspar Poussin, Salvator Rosa, Cuyp, Berghem, Both, Ruysdael, Hobbima, Teniers, (in his landscapes), P. Potter, Canaletti, and the various

Van somethings, and Back somethings, more especially and malignantly those who have libelled the sea (3:85).

In other words, when Ruskin speaks depreciatingly of the old masters, he means more or less the collections of Beaumont and Angerstein newly on show as the nation's art collection. For him the established taste of Beaumont's generation seemed overly conventional. Knight had mentioned three excellent modern paintings: Benjamin West's *Death of General Wolfe*, Joseph Wright's *The Soldier's Tent*, and Richard Westall's *Harvesters Sheltering from a Storm*. Their reputations have not lasted, but they all work by depicting scenes of pathos, whether the death of a major military leader, an injured soldier facing penury in a makeshift shelter with a wife and infant dependent on him, or agricultural laborers anxious for their harvest which could be ruined by a raging storm. In these instances it is the association of ideas rather than the arrangement of pigment that gives the paintings their moral character. It is precisely this aspect of painting that Ruskin carried forward, finding new examples of pathos and moral feeling in the works of his contemporaries here, and later with the Pre-Raphaelites. The painters' skill in representation was to be harnessed for the sake of the moral sentiment, and the paintings' value lay in the successful expression of that moral sentiment.

While Ruskin was able to attribute this sentiment to Turner's landscapes, this was an aspect of art that Whistler repudiated. He gave his paintings titles that refer to the dominant pigments rather than the subject matter. Perhaps the closest he came to the expression of sentiment in his paintings was in his portrait of his mother (1871) to which he gave the principal title *Arrangement in Grey and Black*. The *Nocturne in Black and Gold* (subtitled *The Falling Rocket*) had no discernible moral content. It depicted a firework—not a natural atmospheric occurrence that might be seen as God's handiwork—burning itself out over Cremorne Gardens, a popular pleasure-garden in Chelsea, where a fashionable crowd went to make merry with dance, music, food, drink, and sometimes fireworks. In Ruskin's terms, it was worthless; and the sketchiness of the execution, which one might admire as painterly bravura, seemed to him slapdash, as well as outrageous given the high price attached.

Of course we have learned to look admiringly at Whistler's work, and now we have greater problems with the sentimentalism so evident in the work of his Ruskin-approved as well as Royal Academy–approved contemporaries. The aim to make non-referential artworks that were things of beauty was mainstream in the art world during the twentieth century and is a well-established position. It is less characteristic now in contemporary art, where the aesthetic charge of associated ideas is often more significant than the response to the art-object as a thing-in-itself. For example, one of the best-known works by the Royal Academy's current professor of drawing, Tracy Emin, is an at-first ordinary looking unmade bed (fig. 2–4). In fact, it is presented not as an ordinary bed, but as "My Bed"—the artist's own, and in the state that it was in after the artist had been in it for several days with suicidal depression. It is not presented as a morally uplifting fable; but one is invited to have

strong feeling in response to it, not because of how it looks but because of what we are told it is. The idea of representation, which Ruskin took for granted, is entirely bypassed: the work requires no rendering, hence no graphic skill, as the objects are not represented but are presented as themselves. The designation of the artwork here is an act of editing or curatorship: deciding that "this" (and not "that") is the artwork. The price of *My Bed* has not been tested on the art market since Charles Saatchi bought it in 1998 for £150,000, but it has been speculatively estimated to be worth ten times that amount given its current status.[16]

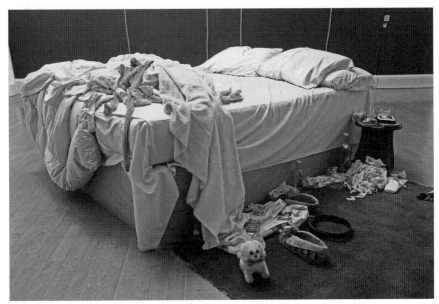

2-4. Tracey Emin, *My Bed*, 1998.

Many aspects of this work Ruskin would surely deplore; however, the key technique of using associations of ideas to bring about a strong aesthetic response means that the work has more in common with Landseer than with Whistler. For Emin as for Ruskin, the language of art is the means to deliver the message, which for Emin is an emotional charge whereas for Ruskin it would have been more moralistic and spiritual. The messages are different, and so is the craft technique (readymade versus painting), but the appeal to sentiment is as strong for Emin as it was for Landseer. Turner's late landscapes can be viewed in a Whistlerian way and be found as such to be very satisfying indeed, though to see them in such a way is to see them anachronistically. Turner himself had helped his viewers to see sentiment in some of his pictures, by exhibiting them with evocative titles and fragments of verse. Ruskin amplified these hints and made Turner into the greatest of the artists in his group of modern painters who were suited to furnish the homes of the sentimental bourgeoisie of Victorian England. Ruling out Whistler makes it only all the more consistent to connect the dots from Ruskin to Turner to Emin.

3. Cézanne's Oedipal Complex: His Father's Throne and His Lover's Son

Brian Winkenweder

How promising it is to encounter today an enthusiastic Cézannean and, to my eye at least, a reasonably orthodox Freudian, in a scholar of the younger generation, and not one out to cut the culture heroes oedipally down to size by showing their feet of clay, either. Brian Winkenweder noticed that Cézanne, through his twenties and thirties, drew and painted his father reading a newspaper, and he has sought the implications of this. It turns out that there is more to the matter than the low-level tension of a son impinging on his businessman-father's restiveness and the latter's submitting on condition of being able to kill the time by reading the paper; more, even, than a situation of uncommunicative intimacy while the son kept secret his wife and child. The landed, conservative father was the personified establishment whose placation, attainable only by restraint, would one day be rewarded by inheritance. Is something of this drama implicit in the images? Winkenweder knowingly assumes a personal-iconological stance, yet he proves conscious of form as well, considering that everything "in" a painting is paint taking specific form (and there is at least the implication, not present in some politically correct art history, that if Cézanne were not their author, these paintings might hold merely sociological interest). It is impossible to summarize the fine-grained implications seen, for example, in the political substitution of one newspaper prop for another. However, as an analytically alert art historian, Brian shows himself more visual than commentators who haven't cared which of several van Gogh shoe paintings they argued symbolically about, and who would likely have treated these images of the same artist's "old man" just as generically. — J.M.

[The] local paper read to the last letter of the last advertisement.... [1]

Only attunement to art in the spirit rather than the letter of psychoanalysis is convincing. The point is, there is no escaping psychoanalytic attunement to art, but art sidesteps any definitive psychoanalytic interpretation.[2]

Throughout the 1860s and 1870s, Cézanne sketched and painted his father Louis-Auguste Cézanne on many occasions.[3] In nearly every image, the father reads a newspaper (in a few drawings the elder Cézanne appears to be sleeping). The recurring newspaper in this series suggests that Cézanne invested this symbol with personal iconographic significance. These numerous works provide insights into the son's relationship with his father. Over the course of five years (1857 to 1862), the son struggled with his father for permission to be an artist. Monsieur Cézanne, a stern, grouchy patriarch, demanded that his son study law or banking— not painting.[4] Cézanne's correspondence with his childhood friends, particularly Émile Zola, provides documentary evidence of this battle of wills,[5] and the letters help to decode the special iconological function of the newspaper in Cézanne's early painting as an emblem of his strained relationship with his father.

In notes for the novel *La Conquête de Plassans* (1874), of the series "Les Rougon-Macquart," Zola describes the elder Cézanne as "mocking, republican, bourgeois, cold, meticulous, stingy . . . sustained by his wealth, [he] doesn't care a rap for anyone or anything."[6] Because Cézanne remained financially dependent on his father throughout his life, conflict was constant. Such economic stress was exacerbated by the existence of a lover and a son who remained hidden from the father until shortly before Louis-Auguste Cézanne died.[7] Given that Cézanne's mother and sisters conspired with him, the conflict between father and son emotionally taxed the entire family. Nonetheless, scholars have not used this information to fully explicate Cézanne's various paternal portraits. For example, Theodore Reff's 1963 article "Cézanne's *Dream of Hannibal*" deciphers a poem Cézanne composed in a letter to Zola and relates the poem to Cézanne's struggle with his father, but he never connects it to the portraits.[8]

In the landmark essay "The Apples of Cézanne," Meyer Schapiro decodes Cézanne's apples "as a displaced erotic interest."[9] Schapiro's essay challenges decades of formal analysis by interpreting the significance of the symbols embedded in Cézanne's work. Previous scholars considered Cézanne's apples to be a fully determined signifier—mere assays in form, in Lionello Venturi's analysis: "The prevailing interest has been the study of form. This may be symbolized by the picture of apples."[10] In the early years of Cézanne's development, the objects depicted and subjects portrayed in his paintings are not incidental. Furthermore, the symbols in these paintings *do* lend themselves to Freudian analysis. Cézanne, the son of a banker, exemplifies many of the conditions of nineteenth-century bourgeois European families typical of Freud's patients, and Cézanne's struggle with paternal authority anticipates and typifies Freud's theory of the Oedipus complex.

During the mid-nineteenth century, portraits of people reading newspapers were common, rendering the prop a benign cliché; however, in Cézanne's paintings the newspaper is not an incidental prop. I dispute John Rewald's commonsense explanation of the presence of the paper: "It would seem that [Louis-Auguste Cézanne] agreed to pose provided he could read."[11] In this essentially formal interpretation, the newspaper is dismissed as an incidental trifle that appeased the sitter while he suffered the artist's gaze. The peripheral objects in Cézanne's early

work do not merely serve a formal function, however: the painter selected them carefully, and they create a personal tropology uniting many of his early canvases.

I argue that Cézanne deliberately spun a complex web of intertextuality. Furthermore, not only are his paintings in question highly autobiographical, but his dual rebellion against his father and the art academy drives the plot. Cézanne's boisterous youth, however, was not revolutionary; he did not wish to overthrow his father and the academy, but, rather, to borrow Sartre's description of Baudelaire, to "preserve the abuses from which he suffers so that he can go on rebelling against them." Sartre's analysis of Baudelaire aptly describes Cézanne as well: "He always shows sign of a bad conscience and of something resembling a feeling of guilt."[12] Cézanne deliberately placed his father at the center of his work from the late 1860s so as to reconcile his personal ambitions with his father's expectations: with his guilty conscience, he simultaneously sought to impress and insult his father. He recognized a divide between what his peers wished for him to become, especially his childhood friend Émile Zola, and what his father demanded from him. Ultimately, Cézanne followed his friend's advice, but because of his life-long economic dependence on his father, his rebellion was awkward and incomplete. As a result, Cézanne's portraits of his father serve two functions: to honor and degrade.

Gabriel Weisberg wrote of Cézanne's early autobiographical impulses: "During the 1860s, Cézanne's choice of theme became completely autobiographical. His ability to use himself as his subject matter carried painting in a radical direction." [13] However, our knowledge of Cézanne's biography is redolent with mythological exaggerations and distortions—scholars must rely on few surviving letters and many firsthand anecdotal and marginally reliable accounts of Cézanne. Robert Niess addressed the insufficiencies of Cézanne's biography: "The greatest difficulty is lack of knowledge of the true Cézanne . . . whose varying portraits are about as contradictory as can be found for any famous figure. We know something of his late years, less of his middle period, and still less of his youth."[14] Because of the dearth of reliable primary documents, art historians must be content to understand Cézanne's life largely through his paintings.

In 1866, Cézanne painted *Portrait of Louis-Auguste Cézanne, Father of the Artist, Reading "L'Événement"* (fig. 3–1). Scholars agree that Cézanne changed the masthead from *Le Siècle* to *L'Événement* after initially completing the work in homage to Zola, who wrote scathing reviews of that year's Salon as *L'Événement*'s art critic. Beyond acknowledging Cézanne's tribute, no scholar attempts to further explain why, or indicate when, he reworked this portrait. Suggesting that Cézanne's portraits of his father characterize the artist's respect and admiration, Rewald points out that the newspaper establishes a link between father and friend but stops short of exploring the metonymic implications.[15] Advancing Rewald's work, Weisberg has determined that the newspaper indicated the artist's "hopes for . . . parental approval."[16] In contrast, Sidney Geist reads the portrait as proof of Cézanne's "harsh" view of his father.[17] The present essay contends that Weisberg's and Geist's interpretations, though contradictory, are equally correct.

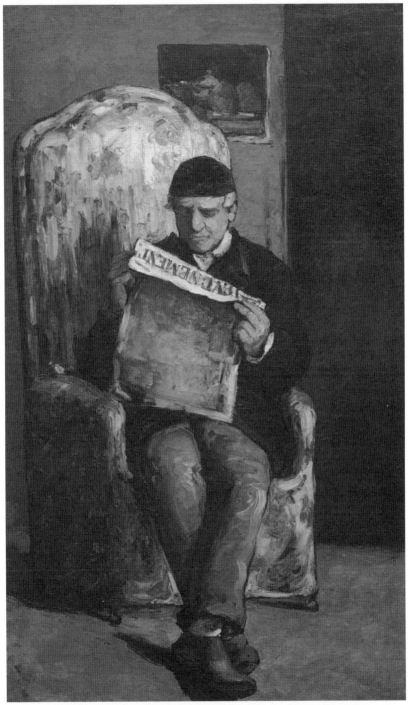

3-1. Paul Cézanne, *Portrait of Louis-Auguste Cézanne, Father of the Artist, Reading "L'Événement,"* 1866.

In 1859 Cézanne enrolled at the University of Aix-en-Provence to study law and at the École de Dessin to take life drawing courses; his father paid the tuition. As a young man, Cézanne struggled to reconcile his own desire to be an artist with his father's demand that he be a lawyer. In a letter to Zola, Cézanne writes in verse: "Alas I have chosen the tortuous path of Law. / —I have chosen, that's not the word, I was forced to choose."[18] Zola's letters repeatedly urged Cézanne to demand that his father allow him to be an artist. In a letter to Baptiste Baille, a mutual friend, Zola acknowledges a polarity of influences forged between himself and Cézanne's father: "As long as M. Cézanne, believing me to be a vile schemer, sees that his son associates with me, he will feel exasperated with his son. . . . If Paul is not prepared to open his father's eyes, then I must think of doing it myself."[19] Cézanne's paternal portraits illustrate these polarized influences. Again in 1859, Cézanne *père* paid a man to serve in his son's place in the military; Paul, twenty at the time, must have felt a tremendous obligation to please his father. To become an artist required a rebellion but could not be an outright revolt.[20]

In 1861, Louis-Auguste allowed his son to go to Paris to study painting at the Atelier Suisse—a loosely organized artist's collective where Cézanne met such important figures as Pissarro and Renoir. Yet he did not adapt to Paris; he returned to Aix after six months and accepted a position at his father's bank. However, he failed as a banker, too—the columns of his ledgers were filled with sketches and verse. In 1862, Cézanne's father again allowed his son to focus on painting, perhaps after reading in the bank's ledger, "The banker Cézanne does not see without fear / Behind his desk a painter appear."[21] Still, Cézanne was reluctant to renounce his father's fortune and thus needed to avoid the appearance of a revolt.

Cézanne's first portrait of his father, painted in 1862, depicts him full-length, in profile, reading a newspaper. Curiously, this portrait hung amid a series of allegorical murals Cézanne painted in the salon of his father's house, the Jas de Bouffan. The portrait's placement between *Summer* and *Winter* brazenly disrupts the continuity of the mural program: on one hand, the Four Seasons are a timeless reference to annual cycles; on the other, the newsreader is time-bound, involved in the events of the day. Roman portrait busts, in some folk traditions, were placed in such an arrangement to form a funeral tableau; perhaps Cézanne, well versed in Latin language and culture, referred to this ancient custom in anticipation of his father's funeral. The inappropriateness of this arrangement must have been obvious to Cézanne. If so, this violation of decorative propriety is a joke directed at the father's aesthetic and intellectual ignorance. After all, the artist signed his murals "Ingres, 1811." [22] By placing his father at the center of his most ambitious work at this early stage in his career, Cézanne is emboldened to symbolically center his father in his next phase of work.

Cézanne's second portrait of his father emphasizes the newspaper's presence: its rectilinear form anchors the composition, as all lines either parallel it or converge on it. Monochromatically rendered, the newspaper is pure painterly expression, in a void that penetrates the father's corporeal physicality. The artist made no attempt to accurately render the back page of the mid-nineteenth-century Parisian newspaper,

which was customarily filled with columns of rectangular advertisements, and here it simply blocks and diminishes the father's pictorial presence. He treats the paper as an ideological shield, an obstacle separating the two men. Despite Cézanne's obsession with his father as a subject, the painter's gaze never meets that of the sitter. Originally, *Le Siècle*, a conservative paper, acted as a silent mediator between the father and son; however, by repainting the masthead to *L'Événement*, a liberal paper, the painter stages a protest against his father and his values. Cézanne clearly hoped that his father liked the portrait for its formal properties without understanding its underlying symbolism.

We know from letters that Cézanne was a habitual and engaged newsreader. An 1868 letter to Numa Coste, a friend from Aix, twice refers to the press: Cézanne laments missing the "noise" of Henri Rocheforte's *La Lanterne* and complains, "I have no amusements but family and a few copies of *Siècle* where I find unimportant news."[23] Such interest in the news may not always have obtained: in an 1859 letter Zola writes, "We shall not talk politics; you never read the papers as I allow myself to do, and you would not understand what I want to tell you . . . and suggest that you sometimes read *Le Siècle* because these are strange times."[24] Zola named this paper because he knew that his friend's father read it. Cézanne's interest in *La Lanterne* is significant: it affirms his developed preference for the most extreme of liberal papers compared with the editorial conservatism of his father's preferred one. Rochefort's radical, accusatory *La Lanterne*, printed on bright orange paper, ridiculed every public figure in France.[25] Robert Simon revealed that *Imagerie d'Epinal*, salacious, colorful, and cheap publications from the 1860s, served Cézanne as source material for his pornographic and violent imagery. He claimed, "Cézanne's use of dangerous popular themes and ignoble styles constituted an insult aimed at the inescapable docility of high art and its avant-gardes."[26] This insult is evident in the 1866 portrait in which his father acts as an emblem of the bourgeois status quo. To make his father read *L'Événement* is an act of protest against the patriarch's control. Cézanne's oedipal struggle unfolds on two fronts—both the patriarchal institutions of the family and the art academy offered Cézanne targets for the pent-up bile arising from his struggle to secure independence.

The young artist concealed numerous intertextual connections between the 1866 portrait and other paintings executed during the late 1860s. These allusions consistently protest the father's moral authority. Most important, Cézanne constructed this symbolic subtext after initially completing the portrait. The repainting of the masthead belongs to a series of gestures that satisfies the artist's desire to rebel against his father. Cézanne treats his father, and the chair he sits in, as an emblem of society's repression of individual expression. By creating a personal iconography that only a few friends would understand, Cézanne protested society's repressive forces.

Playing off a homonymic anagram, *L'Événement* establishes a link between Cézanne's portraits of his father and his depictions of violence and pornography. Throughout the 1860s, Cézanne painted numerous violent and pornographic images, which Stephen Eisenman attributes to "an unresolved Oedipal

nightmare."[27] This type of imagery parallels themes in Zola's 1867 novel *Thérèse Raquin*, an essay on the sins of adultery and murder as committed by Laurent, a character loosely based on Cézanne. Laurent's description of his fictional father parallels Cézanne's family drama:

He sent me to college with visions of using me later on as a lawyer. . . . For two years I pretended to attend lectures so as the get the twelve-hundred-franc allowance father forked out. . . . Dad found out I was telling fibs. . . . As I could clearly see death by starvation looming ahead, I chucked art to the devil and looked for a job. The old man is bound to die one of these days, and I'm waiting for that so as to live without doing anything."[28]

Thérèse Raquin, a scandalous success, was published the same year Cézanne painted for Zola, *L'Enlèvement*—a generic, mythological rape scene.[29] Cézanne plays on the anagrammatic properties of the words l'événement and l'enlèvement. I propose that Cézanne repaints the masthead while painting the gift for Zola to allude to his inability to repress the desire to usurp the father's authority. L'événement means event, or occurrence, but it also means a climax or emergency, and Cézanne's portrait emphasizes these ancillary meanings; l'enlèvement translates roughly to rape, but not solely as sexual penetration: rather, it connotes the classical sense of a carrying off or abduction. This intertextual reading is supported when Cézanne's *couillarde* technique and the paintings *Ouverture du Tannhäuser* and *Portrait of the Painter Achille Emperaire* are considered in this program. Each of these works further attests to Cézanne's intent to illustrate his rejection of his father's expectations.

Cézanne's portrait of his father reading *L'Événement* is described by Antoine Guillemet in a letter sent to Zola on November 2, 1866, that also describes the work *Ouverture du Tannhäuser*: "When he returns to Paris you will see some pictures that you will like very much; among others an *Ouverture du Tannhäuser* . . . then a portrait of his father in his big arm chair, which looks very good . . . the father looks like a pope on his throne, were it not for the *Siècle* that he is reading."[30] Sir Lawrence Gowing, curator of *Cézanne: The Early Years*, dates the *Ouverture* to 1869–70 and maintains the 1866 dating for *Reading L'Événement*. Gowing's reasoning for the disparity in dates between works clearly linked by this letter is that three versions appear to have been painted (with only one extant today). Apparently, Cézanne worked on this family grouping from 1864 to 1870. It is likely that Guillemet's letter refers to one of the previous efforts; however, because of Cézanne's predilection for reworking and destroying canvases, *Ouverture* can be seen as the culmination of an ongoing project. In the initial effort, the father was reportedly seated in his "throne"; in the 1866 version, Louis-Auguste is replaced by Fortuné Marion, a man Guillemet describes as an atheist: "He . . . tries to demonstrate to us that God never existed."[31] In the final version, neither father nor friend sits in the chair. This ongoing struggle to produce a family group portrait served as a point of intersection in which the influence of his friends and social sphere penetrated and disrupted the calm of family and the domestic domain. That Cézanne removed his

father from this composition is a further testament to his ongoing oedipal struggle. I believe that in 1867, while in Paris, Cézanne reworked both paintings mentioned by Guillemet as he painted *L'Enlèvement*.

At the same time, Cézanne finishes his portrait of Achille Emperaire sitting in his father's papal throne. Cézanne paints his father in October of 1866 and paints Emperaire in January 1867; we know this because of Guillemet's letter and because Emperaire wears winter clothes and uses a foot warmer. Cézanne's revision of his second paternal portrait must occur while the artist lives in Paris in early 1867. Moreover, this alteration dramatically shifts the intent of the portrait from being reconciliatory, as Weisberg interprets it, to being rebellious. Through the metonymy of the father's throne, these works mock Cézanne's bourgeois father. Achille Emperaire, a fellow painter from Aix, sold pornographic sketches to college students. Therefore, this "throne" is forced to listen to Wagner's *Tannhäuser* and support the malformed body of a bohemian pornographer. It is a sacrilege against the father. In these paintings from the late 1860s, Cézanne asserted his fierce independence and insurrectionist impulses through his tropes as well as his techniques.

Couillarde, a crass word for virility, is Cézanne's own term (applied thirty years later) for his thickly impastoed surfaces painted with a palette knife. This term underscores Cézanne's aggressive, sexual energy of this time. Gowing described the style as violent: "It demonstrated that the force of handling involved a freedom, indeed violence."[32] Above the father in the 1866 portrait hangs a "manifesto of the new style,"[33] a still life executed in 1865 that "asserts [the son's] presence in his father's house."[34] Sidney Geist suggests that the pear in the still life, positioned directly above the father's head, functions as a pun. "Poire," the French word for pear, also means fool in French slang, and "pero," Provençal for pear, sounds like "pere," French for father.[35] This iconography was initially popularized by Charles Philipon in *La Charivari*, a satirical publication. Geist's reading emphasizes a willful attempt to disgrace the father, but in contrast, Gabriel Weisberg contends that the still life is a plea for acceptance: "The artist wanted his father to be at ease with his most recent creative efforts."[36] In view of Cézanne's guilty conscience, perhaps both readings are acceptable. Weisman is correct—Cézanne wanted to impress his father with his technical talent. And yet, Geist too is correct—Cézanne wanted to insult his father through this personal symbolism.

Repainting the masthead from *Le Siècle* to *L'Événement* in early 1867 dramatically shifts the intent of the portrait from one of reconciliation, as Weisberg contends, to one of confrontation and rebellion. The textual change underscores Cézanne's awareness of the newspaper's symbolic value. *L'Événement*, a politically left-leaning paper founded by Victor Hugo, introduced Zola to the French reading public.[37] In 1866, Zola published scathing reviews of the art academy's annual salon in this newspaper. During April and May, Zola wrote several articles denouncing the jury and the faculty of the École *des Beaux-Artes*. In their place, he sang the praises of the "*nouvelle*-École," especially Manet and a rebellious tribe of "light" painters who were soon known as the Impressionists. Zola planned more than a dozen articles to advance his position; however, owing to the furor fostered by the

initial installments, Zola was forced to cease publication well shy of completing his mission. Determined to be heard, Zola published the entire series as a pamphlet: *Mon Salon*. Although Zola does not discuss the work of Cézanne in his articles, he does write an open letter to his friend as an introduction. Zola pointed to his aesthetic discussions with Cézanne as the source of his diatribe against the art establishment: "For nothing in the world would I destroy them [the published articles]; by themselves they are not worth much, but they were, so to speak, the touchstone by which I tested the public. Now we know how unpopular our cherished ideas are."[38] The repainted masthead is Cézanne's gesture of gratitude to Zola for the author's praise, encouragement and counsel.

Cézanne's 1886 portrait of his father and the constellation of related works constitute an essay in generational conflict. Cézanne's 1867 portrait, *Achille Emperaire, Painter*, confirms Cézanne's interest in insulting his father through symbolism. Cézanne painted "Achille Emperaire Peintre" in bold stencil lettering above his portrait of his friend. The typeface, the same as for the letters Cézanne painted for the masthead of *L'Événement*, offers a further connection between these portraits. Gowing contends that Cézanne uses the Bodoni typeface as a symbol of authority: "The banner heading of the newspaper is an integral part of the design of the picture. The thick and thin of the Bodoni-type lettering establishes the authority of the reader . . . and it led the way to the emphatic verticals of the stencil lettering which announced the authority of *Achille Emperaire*."[39] Cézanne explored his nascent authority by posing his friend in his father's chair. By inscribing the title in this unprecedented manner, Cézanne practices claiming his independence (from both his father and the academy) and his expertise as legitimate.

Another painting dated to 1866, *Cabaret of Mother Anthony* by Renoir, also depicts *L'Événement*. Both artists paint the letters in the same font, so perhaps we can safely assume that *L'Événement*'s masthead in 1866 was set in Bodoni. However, Renoir paints only the first four letters—"L'Eve"—alluding to our first mother, Eve; whereas Cézanne carefully paints each letter. Renoir's masthead does not disrupt his composition; in contrast, Cézanne makes the masthead the focal point. Renoir painted his in the beginning of April, 1866, just as Zola's reviews of the Salon were appearing.[40] It is likely that Cézanne saw this work on his arrival in Paris in January 1867. These two friends met regularly at the Café Guerbois during early 1867. Cézanne may have decided to change the masthead in his father's portrait after seeing Renoir's work.

Cézanne's paternal portraits collectively counter the hegemony of the elder Cézanne and can be interpreted as covert acts of violence against him; these paintings insult M. Cézanne and the capitalist economy he represents. Weisberg interprets the 1866 portrait as a reconciliatory effort on the son's behalf: "Cézanne added certain details to the work as if hinting that he hoped for an eventual reunion."[41] In contrast, I contend that the recurring motif of the newspaper in Cézanne's portraits operates as a symbol of Cézanne's superego during a protracted oedipal struggle to gain independence and respect from his father.

Meyer Schapiro's psychoanalytical reading of Cézanne relies on Freud's *Interpretation of Dreams* and reads the canvases as if they are the manifest content of a dream built on alliteration, puns, anagrams, and unexpected relationships. Schapiro's analysis of Cézanne's apples led him to consider Cézanne's sexual fears and surmise, "He could not convey his feeling for women without anxiety."[42] This methodology is extended by Theodore Reff, who delineates three forms of Cézanne's fear of women—an "overt sexual desire . . . a violent aggressiveness . . . and an ironic adoration."[43] Thus far, scholarship has focused on Cézanne's profound sense of guilt but only in regard to his obsessive neurosis concerning women. T. J. Clark's essay "Freud's Cézanne" applies theories of the "primal scene" and the Oedipus complex to Cézanne's series of large bathers, but again, to speculate primarily on Cézanne's feelings toward women.[44] To date, scholars have yet to assess Cézanne's unresolved Oedipus complex in relation to his father.

In the Oedipus complex, the male child perceives the father as an obstacle to his sexual desire for his mother, and therefore he wishes to kill him and yet fears for him. To rid the psyche of the desire to kill the father and fornicate with the mother, the male, according to Freud, develops "either an identification with his mother or an intensification of his identification with his father. We are accustomed to regard the latter outcome as more normal."[45] At this stage in the child's development, the superego is formed as a father-substitute: "The superego arises . . . from identification with the father taken as a model. Every such identification is in the nature of . . . sublimation."[46] Yet, in Cézanne's case, given his oedipal excesses, the outcome was abnormal. Cézanne rebelled against his father's authority but never revolted; he never murdered his father but produced subtle phantasmagoric imagery wishing for such a result instead. Zola's character Claude, based on Cézanne, vocalizes such a fantasy: "One morning, the old man was found dead in his bed, struck down by apoplexy. In his will he left an income of a thousand francs a year to Claude, with the power to draw on the capital when he was twenty-five."[47] To an extent, Clark's use of psychoanalysis for Cézanne supports my conclusions. He claims that the Barnes Foundation's *Large Bathers* "is a staging of the moment of the Oedipus complex at which the threat of castration is so intense and overwhelming that the male child is unable to take the exit into repression—and instead remains frozen in a world, where, in spite of everything, the Father is absent and the phallic mother's return is awaited."[48] This interpretation of *The Large Bathers* corresponds with my reading of the 1866 paternal portrait. Cézanne's sense of self, his superego, developed during the initial stages of the popular press's usurpation of paternal authority. During the Second Empire, the growing invasion of the public sphere into the domestic domain precipitated a condition in which many males were "unable to take the exit into repression."

The artist never identified with his father—Cézanne's defiance of his father disrupted the repressive nature of his superego, stimulated his will to rebel, and aggravated his guilty conscience. Clark suggests, "If I saw it as necessary or possible to psychoanalyze Cézanne, I would hazard a guess that in his case the moment never did dissolve, and that the late *Bathers* were his effort to reconstitute a world

of sexuality which, at some level, he never left."[49] The superego normally forms upon the dissolution of the Oedipus complex; however, in Cézanne's case, the superego remains untethered and is free to search for a substitute model. Freud describes the relationship between the Oedipus complex and the superego:

> The super-ego . . . is not exhausted by the precept: "You *ought to be* like this (like your father)." It also comprises the prohibition: "You *may not be* like this (like your father)—that is, you may not do all that he does; some things are his prerogative." This double aspect of the ego ideal derives from the fact that the ego ideal had the task of repressing the Oedipus complex; indeed, it is to that revolutionary event that it owes its existence. Clearly the repression of the Oedipus complex was no easy task . . . his infantile ego fortified itself for the carrying out of the repression by erecting [the father] within itself. It borrowed strength to do this . . . from the father, and this loan was an extraordinarily momentous act. The super-ego retains the character of the father, while the more powerful the Oedipus complex was and the more rapidly it succumbed to repression (under the influence of authority, religious teaching, schooling and reading), the stricter will be the domination of the super-ego over the ego later on—in the form of conscience or perhaps of an unconscious sense of guilt."[50]

Cézanne's superego never "borrows strength" from his father—he never identifies with him to any significant degree. In Cézanne's case, the superego is not constructed on a paternal model; rather, its formation can be attributed to his peers and the popular press—they are his authority, religion, education, and reading material.

Throughout the nineteenth century, boundaries between public and private spheres collapse as a result of mechanical improvements in the printing press. As a consequence, forces external to the family exert an influence that supersedes and even conflicts with the values and authority of the parents. Herbert Marcuse, describing conditions endemic to the twentieth century in *Eros and Civilization*, modifies Freud's concept of the superego by claiming that in the age of mass media, the father's authority has been usurped: "The superego is loosened from its origin . . . and the traumatic experience of the father is superseded by more exogenous images. As the family becomes less decisive in directing the adjustment of the individual to society, the father-son conflict no longer remains the model-conflict."[51] Marcuse's application of social phenomena, especially the popular press, as it relates to Freudian psychology, provides an explanation for Cézanne's paternal portraits. Cézanne's iconographic newspaper can be understood in terms of Marcuse's modification of Freud's definition of the superego: "The experts of the mass media transmit the required values; they offer the perfect training. . . . With this education, the family can no longer compete."[52] As the public sphere exerts a greater influence in the domestic arena, the psychological functions of the Oedipal complex (the creation of the superego and its attendant *conscience*) invariably

mutate to accommodate the contestation between the popular press and the father.

This contestation occurs during adolescence and early adulthood, not during infancy—these are the ages in which one's superego has yet to ossify and remains vulnerable to "exogenous forces." Although the superego's control over repression, conscience, and guilt is established during infancy, the reemergence of repressed material during puberty (extending through early adulthood in Cézanne's case) is exacerbated as social forces exert an influence on his bourgeois family. Generally, during puberty, the adolescent child breaks away from the father's and society's domination; the son replaces the father as a moral authority: "The processes of puberty lead to the liberation from the father as a necessary and legitimate event ... the son leaves the patriarchal family and sets out to become a father and boss himself."[53] Although Cézanne does become a father (and boss), he also remains financially dependent upon his father. Yet Cézanne was never financially stable because he also shields his lover and their illegitimate son from his father. Cézanne's letters, especially throughout the 1870s, detailed explicitly his requests for a larger allowance from his father. In many cases, Cézanne's friends and family members acted as intercessors on his behalf. This economic dependence exacerbated Cézanne's sense of guilt and manifested itself in his paternal portraits, as simultaneously a plea for his father's respect and an excuse for the son's disrespect.

For Cézanne, the pleasure principle did not transform into the performance principle. In essence, by refusing to work as a lawyer or banker, and by studying painting instead, Cézanne never fully sublimated his libidinal urges: "Artistic work, where it is genuine, seems to grow out of a non-repressive instinctual constellation and to envisage non-repressive aims."[54] Given Cézanne's privilege as the son of a wealthy banker, he was able to pursue a vocation that never provided him with any notable monetary reward throughout his life. Even though Cézanne's portraits coyly mock his father, the elder Cézanne deserves credit for financing his son's career: "The father, the first object of aggression in the Oedipus situation, later appears as a rather inappropriate target of aggression."[55] Cézanne, thanks to his father's support, was able to isolate himself from society and intimately study painting. However, Cézanne did not remain oblivious to the public sphere—rather, he remained, throughout his life, a reader of newspapers and printed matter. In Cézanne's correspondences, he reports what he reads, mentioning obscure publications such as *Le Rappel*, *Le Voltaire*, *La Vie Moderne*, or *l'Art Libre*, and well-known ones, such as *Le Petit Journal*, *Le Figaro*, or *Gil Blas*.[56] Cézanne, interested in reading periodicals, anticipates Marcuse's update to the "classic psychoanalytical model" as defined in the essay "The Obsolescence of the Freudian Concept of Man":

> The classical psychoanalytic model, in which the father and the father-dominated family was the agent of mental socialization, is being invalidated by society's direct management of the nascent ego through the mass media. ... This decline in the role of the father follows the decline of the role of private and family enterprise: the son is increasingly less dependent on the father and the family tradition in selecting and finding a job and in earning a living.[57]

Cézanne is a proto-marcusean subject: he selected his own job but, as a result, became increasingly *more* dependent on his father. He could not rationalize his guilty conscience; his "nascent ego" remained ungoverned by the superego and, during the 1860s, was free to challenge all forms of social authority. Cézanne's resolution of the Oedipus complex is proto-marcusean because progressive elements of the mass media do influence his conscience, even as his father exerts some influence over his superego. In other words, neither left-wing newspapers nor the father solely controlled Cézanne's moral sensibility—both did. Cézanne's rebellion against his father coincided with and paralleled his rebellion from the Academy. Cézanne directly challenged the artistic conventions and institutions of his day and celebrated his *persona non grata* status.

Once, when asked what he would submit to the annual salon, Cézanne famously responded, "A pot of shit!" One such painting, a now-lost nude, was submitted alongside *Achille Emperaire, Painter*, in 1870 and reinforced Cézanne's interest in mass media and its correspondent imagery. Analyzing Cézanne's fifty-five paintings and drawings of violent or licentious subjects, Robert Simon claimed, "There is a clear relationship between certain of Cézanne's more enigmatic, anxiety-ridden and horrific early pictures and various kinds of nineteenth-century mass media and popular images."[58] Although Cézanne's nude submission is lost, a description of the canvas remains that mentions a picture in the background: "on the black wall hangs a small picture, which seems to be an undoubtedly genuine *Image d'Epinal*."[59] *Imagerie d'Epinal* was mass cultural imagery "following no apparent esthetic principles."[60] In Simon's analysis, Cézanne was determined to disrupt the high cultural aesthetics of the academy; therefore, he was invariably drawn to such mass cultural visual ephemera.

The strategy of including a picture within a picture recalls Cézanne's *couillarde* still life in the 1866 paternal portrait, further connecting this lost painting to the constellation of works revolving around this portrait.[61] Curiously, this painting is also known because of an *Album Stock* caricature of Cézanne published in 1870. The *Image d'Epinal* "on the black wall" is reduced to mere stick figures but was significant enough to be included in this parody. It occupies the same position as the still life in the 1866 portrait of the artist's father. While seeking approval from both, Cézanne also tried to see what he could get away with. In view of the annual refusal of his canvases by the Academy's salon selection committee, it would seem he experienced more success with his father.

Cézanne's third portrait of his father, dated variously as 1870 or 1875–76, is a much smaller work than its predecessors: 22 by 18 inches, compared to 66 by 45 inches for the 1862 portrait and 79 by 47 inches for the 1866 version. The father's profile echoes the first canvas's composition but depicts only the head and shoulders. The newspaper is present only as a convention: Cézanne calls no attention to it. Although the void at the bottom left corner signifies the newspaper, Cézanne eliminates the newspaper's physicality. Unlike the iconographical presence of *L'Événement* in the 1866 portrait, this newspaper is ghostly—a message foreshadowing death. If Cézanne imagined his father reading Zola's columns in 1867,

perhaps he imagined his father reading his own obituary in 1875. To demonstrate Cézanne's continued ill-will against his father, Geist points out that the wallpaper decoration serves as a maw attacking the father's head: "The large motif to the left of the father's cap delineates a monstrous, open-mouthed head which threatens that of Louis-Auguste."[62]

During the 1870s, Cézanne continued to sketch his father. His oedipal struggle intensified, and his superego, constructed by the popular press, compelled him to dishonor his father. Cézanne's guilty conscience was exacerbated in 1872, when his lover, Hortense Fiquet, gave birth to a son—Paul Jr. Cézanne hid his young family from his father while at the same time pleading with him for a larger allowance. Furthermore, Cézanne's mother, sisters, and friends assisted in the conspiracy. In this clandestine context, Cézanne deliberately played his father for the fool. Rewald implies that the elder Cézanne knew of his son's family, but "the painter . . . steadfastly denied his paternity, even in the face of overwhelming evidence."[63]

In a sketch from the late 1870s, Cézanne drew his father dozing, turned the paper around, and sketched his son, representing an introduction of grandson to grandfather, since the two were not allowed to meet. Cézanne also sketched versions of Hortense Fiquet's head and his father's head converging in a similar manner. This is the only way that Cézanne's family met his father until 1886, shortly before Louis-Auguste Cézanne died. Cézanne's numerous paintings and drawings of his father illustrate Freud's oedipal complex and anticipate Marcuse's media-based theory of the superego. Cézanne rebelled against his father's authority, but not against his money. As a result, Cézanne's guilty conscience forced him to simultaneously conceal his desire to kill his father and reveal his desire for parental approval.

The iconography of the newspaper in Cézanne portraits of his father responds to the encroachment of the public sphere into the domain of the family and anticipates Marcuse's analysis of this phenomenon. Mass media's usurpation of the father for control over the superego is dramatically illustrated, not once but repeatedly, by Cézanne. Twenty years after Cézanne's first portrait of his father, the artist returned to the subject, in 1879–82. Echoing the 1866 portrait, Cézanne presented his father frontally sitting in his "papal throne." The angle of the newspaper is considerably foreshortened, but it remains a strategically placed void dominating the center of the composition. The newspaper, rendered as a blank void, neuters the father's phallus; it emasculates the elder Cézanne and thereby eliminates his power and authority. The popular press does not influence Cézanne in a manner that is fully marcusean. Cézanne is not a programmed consumer—he does not live in an era of "dozens of newspapers and magazines that espouse the same ideals."[64] Cézanne is proto-marcusean in that he lives during a brief historical moment in which the superego was a battleground between the public and private spheres. The popular press was not powerful enough to fully usurp the father's authority; the social process that Marcuse describes is in its initial development during Cézanne's adolescence and early adulthood. The artist's superego is in conflict between the restrictions of his father and the opportunities offered by the radical elements of the popular press. During the 1860s in France, the forces of the mass media had not yet coalesced in

a manner equivalent to the historical situation Marcuse analyzes. Unlike the latter half of the twentieth century, mass media did not serve as a primary advertising arm of corporate enterprise and advanced capitalism. Instead, numerous political positions competed for the attention of news consumers. Cézanne's superego was not under the influence of a mass-market distribution of generic news bearing the same editorial imprint, because no such editorial conformity existed in nineteenth-century French newspapers.

4. Two Bodies

Steven Henry Madoff

Can it be thirty-five years since Steven Henry Madoff signed up for my course in Modern Art? By the time we were colleagues in art criticism, I must have told him that as an undergraduate I too had been torn between going on in English and becoming instead—this would have amused him as it always amused me—what the old British Museum library catalogue, conspicuously at a loss for a word, called a "writer on art." (The same catalogue normalized a famous foreign artist as "Buonarroti, Michael A.") Back then, I was surer than he that I really wanted the history of forms, ideas-in-material, at once diachronically and synchronically apprehended. Ironically, my study of English only supported this "dialectical formalism"; for, thanks to the New Criticism, my "English Literature" had been blessedly devoid of so-called literary history. For his part, Madoff was patient with my skepticism toward his enthrallment by a certain French belletrist named Barthes. I wonder if he knows that because of the utter seriousness with which he always deferred to Ezra Pound I wasn't worried about him at all. The present narrative, part of a larger project under way, has an ultimate hermeneutical purpose. I know because I myself was once, as Steven's teacher, bowled over by pressing on in the French original, for the surprising joy of it, with that fellow's essay on the Eiffel Tower. Here and now, the sheer lyricism of thought unfurled serves to usher along (as Dewey might say) observations, insights, so seemingly aptly, so practically concretely, true, that our only surprise is they do not seem exhaustible. — J.M.

Two bodies. Well, at least two. Bodies that are part of a proto-history of interdisciplinary practice and network thinking. Bodies embodying the instability of identity, spatial orientation, time—even of the textures of bodies. So, a touching moment in a letter Rainer Maria Rilke writes to his wife from Paris. The date is October 19, 1907. Nearly a year to the day has passed since Paul Cézanne died. "I'm sure you remember . . . in *The Notebooks of Malte Laurids Brigge*," Rilke writes to Clara, "the place that deals with Baudelaire and his poem: 'Carrion.' I was thinking that without this poem, the whole trend toward plainspoken fact which we now seem to recognize in Cézanne could not have started; first it had to be there in all its inexorability. First, artistic perception had to overcome itself to the point

of realizing that even something horrible, something that seems no more than disgusting, *is*, and shares the truth of being with everything else that exists."[1]

Baudelaire's poem rhymes the rotting corpse of an animal covered with maggots found bursting in the sun with a meditation on love and the fate of every person, no matter their beauty, no matter our devotion. "Do you remember the thing we saw, my love, / That beautiful, soft summer morning, / The stinking carcass at the turn in the path, / On a bed of stones."[2] What Rilke sees in this equivalence is a leveling, the apprehension of an old propriety and of venerable hierarchies broken down. Baudelaire gives permission, in a sense, to Cézanne and to other artists after him to move without hindrance across "everything else that exists," which is to find in things a new network of relations, a distribution of significances now flowing over the opened plane of potentiality. Rilke's radical "*is*" foreshadows the fundamental idea of networks as events in which meaning and interpretation are dynamic, revocable, contingent, and conditional, determined by protocols whose codes are given to continual revision.[3]

Baudelaire was a poet whom Cézanne valued deeply, but the painter's understanding of the equivalence of things begins in a more direct indebtedness to the Impressionists and to his mentor and friend Camille Pissarro. In fact, equivalence in Cézanne's case is not about disgust. Just the opposite, it is about the pleasure of the eye, the eye and the mind caught up in a particular relationship to time. That relationship is captured in the word "spontaneity," the spontaneity of the hand recording the movements of light and shadow. We take spontaneity for granted. We have mobile devices whose speeds are the consequence of this very need to steal the eloquent fluidity of time and hold it: lightweight cameras with blindingly fast shutters, video cameras and phone cameras, digital voice recorders, and now all of them combined in single devices. For the Impressionists, the visual revelation of spontaneity was new.

But an asterisk needs be placed on "spontaneity"—"spontaneity*." Whim, impulse, the presumption of freedom from determinism must be questioned. For example, Slavoj Žižek notes in relation to Hegel, and to Kant before him, a retroaction, a contract beforehand with the self, at the heart of the spontaneous. "According to German Idealism," Žižek writes, "when we act 'spontaneously' in the everyday meaning of the word, we are not free from but prisoners of our immediate nature, determined by the causal link which chains us to the external world." Our impulses, he continues, are always a dance between our sensations determining our actions and a consciousness of this determination, such that we're always responsible for what seem to be unfettered reactions, which are always already a choice bound to the limits of the self, just as they scrape across the experiences of others in all the relations in which obligation finds us.[4]

Impressionism seen through this lens took on a triple task. There was the burden to undo previous painting's routinized deliberateness, while beneath the surface of this "free" hand quoting the quickness of the light were two other weights: the phenomenological weight of bound being in the chains of animal response

and, simultaneously, the social order of modernity's bourgeois experience critiqued through *plein air* painting and addressed ultimately by the Impressionists as an aporia, an unsolvable and contested landscape mutating in the material throes of industrial capitalist change.[5] In this implicit sense of conflict and loss was an aching precession, the rearward trail of nostalgia for the health of nature confronted by the trajectory of the machinic, the nonorganic, of an ultimate externality with which the self and nature could no longer seem to form an abiding circuit.

It is a well-rehearsed chapter in the history of modernism that Cézanne struggled heroically to find those sensations that were truest to his experience of nature. In a letter to his old friend, the novelist Émile Zola, dated October 19, 1866, he writes: "You know, any picture done indoors, in the studio, never equals things done outdoors. In pictures of outdoor scenes, the contrast of figures to scenery is astonishing, and the landscape is magnificent. I see superb things and I must resolve to paint only out of doors."[6] There are indoor eyes and outdoor eyes. From this moment forward in Cézanne's work a rupture opens in the history of art making that will not close again. This is a rupture in the stillness of representation; cuts in the surface of continuous time and the advent of multiplicity; the body that becomes more than one, its organs mysteriously transmuting, riven by heightened, ramified senses; a phenomenology of the *open*. Pissarro intuits this jumping momentariness in Cézanne's art in a letter from November 21, 1895. What made Cézanne's landscapes so supple, he writes, was that "Sensation is there!"[7]

Where is it? In the work. No doubt this is what Pissarro means: the representation, the transfer. But of course it is first in the body. Sensation is the feeling body in its home. We can say about art that it is most fundamentally, though not most ideationally, about the body's organic attraction to the worldness of the world as a generator of physicalities embodied in artifice to create resemblance, recognition, recollection, which form our sense of placefulness. (If the teleology of disruption and discontinuity so crucial to modernism argues against this placefulness, it always presupposes it.) The physicality of this presence in being is the home of sensation, as the body is the living sign of this presence that is an infinitely conscious receptor. Around this reception, the conventions of enclosure have come to stand. Each organ has its boundaries of tissue by which it preserves itself. Each person has his or her borders of physical feeling: pain feelings and pleasure feelings, with subsets of hot, cold, wet, dry, intoxicated, sexually released, of pierced or enclosed. Each group has its borders of fellow-feeling, hostility, incursion, lawfulness, and the unlawful. Each society has its borders of civitas. Sensations and borders are intrinsic to one another. The representation of sensations, which is how we come to the subject in the work of Cézanne, is a questioning of this relationship of sensation and the conventions by which the borders around physical objects and feelings are represented and redefined to recollect them or imagine their recollection or note their disruption.

So I come back to spontaneity*—now with an asterisk—and its conflicted relationship in Cézanne's art. On the one hand, as Joseph Masheck notes, Pissarro's influence on Cézanne to catch the swiftness of light is obviously there in the work.

But as Masheck says, "Even *en plein air,* C spent much time making scrupulous adjustments to a particular painting; so that as regards its 'rate' of construction, its real-time execution, such a work might not be considered spontaneous at all. . . . He releases himself from any obligation of impressionist spontaneity in the interest of formal contrivance."[8] Cézanne's contrivance, his reading of spontaneity as an unending labor toward a very different offering of what Rilke called "truth" (and one that shares a likeness with Žižek's description of spontaneous acts), tests the painter's body and presses it toward de-articulation and re-formation—and leads to the formation of another modernist body equally given to diffusion, displacement, and corporal ventriloquism: Marcel Duchamp.

But to add another consequential layer to this thinking, I return to Rilke's radical "*is*" in which an assumption is made about being, and specifically the apparent assumption that there is a common essence that flows through being—this "*is*" that "shares the truth of being with everything else that exists." The problem of truth here will wait momentarily in order to pay close attention to this "everything else," to the *distribution* of a shared code, a complicity of common matter imputed to all things. In an entirely different context, Louis Althusser's proposition of "expressive causality" speaks to the fundamental question of "is," of essence and structure, and more specifically to what he calls the "effectivity of a structure on its elements."[9] Expressive causality is Althusser's nomenclature for illuminating a process of material visibility and material effects on the world that originates in an essence, a core originary thingness, and makes itself apparent in the world as phenomenal elements whose *essential* structure is just that, a formation based on a universal, stable interiority of Being. It's as if this ontological entity, this ether, dark matter, or base code is born from an Absolute, which, unsurprisingly in Althusser's writing, ties a knot between Hegelian and Marxist concepts of causality and determination.[10] But I mean to speak in plainer terms to say that expressive causality is a useful way to capture the notion that there are essences that manifest themselves in complexes of things, or so humans have long imagined. These things form networks of relation, communicating as nodes linked in dense connections of experience. They are *expressed* from the essence, rippling into the world, altering its connections and consequently the networks themselves in continual flows of self-reflexive emendation. Things change things.

Rilke's imagining is that Cézanne has made this expressive causality visible, has represented it, implicitly proposing a double-state of stability: first, a uniform essence that flows through everything that exists; second, the stabilized stillness of fixed material, of paint on canvas, which brings into visibility the reified phenomenon as a caused form, a concretion of essence. That hard-won concretion is the fruit of responsibility as that form of spontaneity that always recognizes in itself a duty, a requirement, a commitment, a contract with the self that bows to its own nature all the while it wants to step out of the self, to communicate its responsibility, the responsibility of seeing and making. It is a causal relation with nature and with other selves, an ethics. In network thinking, there is no longer a closed interior; no form is sealed, no protocol is final, no exterior boundary finalizes a totality; what

is interior and exterior are not wholly divisible; and discontinuity is a hymn to the nature of "is." So it must be asked, in the context of the Impressionism Cézanne leaves behind, what is imagined as the steady state of essence at the core of Being? Cézanne answers.

Here is his *Still Life with a Ginger Jar and Eggplants* (1893–94; Metropolitan Museum of Art). The outlines Cézanne uses around the objects in his picture are heavy—for example, the dark boundary that marks his lemon's place on this densely patterned blue tablecloth that is so folded, so terrain-like. The rendering of these two objects deeply engages the lemon's being as a thing unto itself, a representation of a thing very physically real, and that representation brought into contact with another thing in its evocation of thingness, which is of course another representation, a roiling pattern that is not only "fabric" but also a visualization of abstractness. The contrasting presence of phenomenon and idea, far from whim, far from stealing the quickness of light and atmosphere, is a contrivance that argues for the deliberated representation of the potency of the visible in relation to some *thing* underneath, a non-retinal inwardness, a noumenal life that, as Althusser says of essence, indicates "the existence of the structure in its effects."[11]

Roger Fry, the turn-of-the-century art critic who coined the term postimpressionism, went too far when he spoke about Cézanne's profound ability to see matter with a distanced eye, writing of his "complete detachment from any of the meanings and implications of appearances."[12] No, it is Cézanne's detachment that *allows* him to understand the implications of appearances and, in the spirit of expressive causality, hints at that is-ness animating and structuring phenomena. Nonetheless, Fry senses an eruption in appearances, and it is here that the stability of essence suggested by Rilke, as if it were an unperturbed flow along a flat plane of connectivity, begins to trouble. That roiling tablecloth is the effect of Cézanne's insight into what lies underneath, inside, and around him, around us. It is an interior confluent with its exterior, a living inconsistency breaking up the homogeneity of a totalizing force. Every object in the picture is precarious, at once drawn into a network of connectedness and seeming to float peculiarly in isolation. Each thing would seem to have its own life, and the network of *Still Life with a Ginger Jar and Eggplants* distributes this agency among its parts so that its wholeness as an image depends, as I say, not on the consistent behavior of its elements, its nodes, but on their differences, their contrariness, their characteristic multiplicity and sense of otherness. They refuse a system of closure, while nonetheless abiding together, organized and controlled.[13]

One such control is time—time is one essence expressing itself in the phenomena of the objects we see here. A temporal wind blows through, an unsettling. This lemon's outline is of course a delineator of space, yet it lives as well in a symbolic order. It tells us that what is a line is not a line only; it's a sheath, a barrier, an impregnability. This darkened outline is an index of time that burdens and relieves the artist's imagination. It signifies the organic object held still in a moment between ripening and rotting. It is juxtaposed with this blue cloth that is both inert and yet tumultuously folded, as if it, too, is caught in a moment of mysterious

transformation. (Meanwhile, in the tablecloth's shape there is the strange tracing of a vessel, as if it shared a deeper material contiguity with other things in the picture.) The lemon is a sign of successive time, time flowing forward from new to ripe to rotting fruit, in which the internal and unseen palpable material of the lemon, its pulp and juice, the thingness of its matter and being are the fuel of time's engine.

Yet time is not simply successive either. The tablecloth's elaborate folds suggest movement, while it is nonetheless obviously fixed in place, even heavy, so that the overall effect is a curious one of simultaneous stasis and flow. Time is folded in on itself, a perturbation, an inconsistency that adds to the growing sense of the pervasive turbulence of thingness in the picture. Time-as-essence is a protocol in the picture, controlling and facilitating relations among the painting's objects. Time seems to distribute its agency to each thing, some flattening out before the eye, some fully volumetric, some appearing solid, while surface incidents suggest erosion and ethereality here and there. Where is this Rilkean *is*, this seamless continuity of matter? In its place is tension, flow, disruption, and autonomy. So typical of networks, the structure of these relations in Cézanne's picture is a multiplicity of mutually joined and antagonistic elements that can't "avoid ruptures, withdrawals and separations. . . . Multiplicities are not defined by the elements involved but rather by the interstice, the space in between the elements, which simultaneously both connects and separates these elements; it is what links them and separates them, incessantly forging and dissolving the relations between them."[14]

A question of essence emerges: "Inside" these things that populate the still life, is there another level of what might be called a value of energy, a *quale* that is the essence whose effects are the elements we see, fistules of material expressiveness bursting up from the surface of Being? And what do we make, then, of the painting's richness of palpable things and the equally apparent presentation of things shifting, dematerializing before our eyes? What is the state of essence to be inferred here? Not an evenness of all that exists, but a Being-state that is clumped, broken up, and uneven. Time itself would seem not just a flowing forward and not just a suspension, but involuted, unclear, perhaps bidirectional, perhaps recursive. What is the "truth" of matter here? If it is the effect of an essence, it is possible to imagine an infinite regression of what lies beneath every level of facticity, so that what swims before our eyes is precisely this deliberately contrived *imprecision* of material fact and time, of essence in a state of continually buckling formation and re-formation. Such possibilities are the *against* in Cézanne's picture, the going-two-ways, the implicit chaos and equally nascent meshwork of overlap: a still life that isn't still; a painting lush with the flesh of time that also imagines time folding in on itself, suspended; a painting not of time singular but of the multiplicity of time(s); a painting of things present and things dissolving. Look at the blue wall, wrapping strangely along the upper half of the picture, with its shadow half-dissolved, as if the wall itself were caught between states, caught in a dreaming space that loosens; a wall still aching to become.

But this impression of destabilized matter isn't merely an abstraction about time's plurality. It is a consequent of times that are physically captured in the

numerous points of view from which Cézanne painted the picture and then compressed them, folded them together into a single representation, a representation implicit with polarities and juxtapositions. We see a plate that holds its fruit, but a plate at an angle that suggests that it carries out its task of carrying through a contrarian physics of suspension in which physical law has another canon; where the lemon, which is one of seven essays on roundness in the picture, is so heavy with flesh, juice, color, acid, and smell, at the same time that it also presents a lightness that isn't weight; a richness that isn't only the opulence and fullness of its sensual meat but is also the meat of a philosophical abstraction. Space is not uniform among these pots and fruits, fabric, tables, and a wall that seems to warp inexplicably. Nonetheless, spatiality here is unitary, locked into a nodal relationship of interlinking parts that pull inward toward a noumenal suggestion of immanence. To kneel here before the power of Cézanne's "little sensations," as he called them, is to bear witness to a believer in the phenomenal who has gone in, as Heinrich von Kleist said in the context of his "Essay on the Marionette Theater," through the backdoor of Paradise, through knowledge to innocence or, more precisely, to fresh seeing, where all palpability has ascended to spirit and yet breathes fruit, breathes matter, *is* matter, is outside of time and yet within it, and will not give up the fullness of time and matter.

What I take to be the message concerning Being, of essence and phenomena, in Cézanne's *Still Life with a Ginger Jar and Eggplants* is that the internalization of Impressionist spontaneity leads to an ethics of limitation with which and against which the body recognizes its obligation and, in Cézanne's extraordinary case, seeks a way through to a second body. It is the remarkable stubbornness, melancholy, and heroism of Cézanne to work in the orbit of this visual struggle with the monsters of time and sensation, of intrinsic and apparent chaos joined to a will toward the most peculiarly imagined harmony and wholeness, which would seem to describe a network aesthetics. For the wholeness of networks without any totalizing components within them is a topology much in keeping with Cézanne's gathered objects. A network is a causal platform on which actions of relation unfold, actions whose unitary ambition is not won through homogeneity but through the presence of nodes exhibiting their differences. Fistules, I called them above, to evoke clumps of energy restlessly in play with one another. Such wholeness through difference is crucial to network aesthetics, and Cézanne's picture is not simply a representation of nature, a record of facticity, but as I've said, a representation of relations themselves, of interrelated multiplicities with the most profound personal encoding, dredged from the painter's deep well of observation and inference in which everything is recognized as unstable and alive, including representation itself, and beyond it, essence and phenomena.

This is the heartbreaking character of Cézanne's work. He's like Beckett's Didi and Gogo who wait for Godot, never acknowledging that Godot is the unending susurration of time's waves wearing away and building and wearing away. Cézanne is the painter of the multiplicity and unfinishedness of Being unto death. He can never resolve the disjunctions of phenomena, though he is always seeking (an

impossible) consistency. His is an inquiry into essence and a study of matter as both gorgeous and terrifying, caught in the loop of aggregation and dissolution, of re-creation and de-creation and creation again. In this embrace of a more fundamental sense of the matter-flow out of essence, we can see the kernel of the interdisciplinary impulse, of the expression of the multiplicity of experience as it will soon emerge in the history of other art—Dada, for example, Duchamp for another. Such are the hollows in mark making and object making in which multiplicity pools, tied to warring heterogeneities laid out as contestations of energy.

As I've said, the great juggernaut of the Impressionists' painting *en plein air* was their invention of a way to record sensation as presence, to find a surface of appearance closer to the dancing, skittering brilliance of light as the mind apprehends it. Yet the way in which Impressionist spontaneity worked on Cézanne was toward a different lesson for the future. Burdened by an immense sense of the limitations of himself, spontaneity became a recognition of impulse as struggle, of the self in difficult relation to the world and to others, of things elementally in relation to other things as never *simply* harmonious, all things shuddering, harnessed, released, clotted, breaking open, of integration without totalization. For Cézanne, the jots and specks of the scintillated surfaces of Impressionism descend downward and inward as a flaking morphology of the self, an auto-geology whose record of a volcanic interior is made visible in the world, like Althusser's expressive causality, as an attempt to find in multiplicity a new unitary construction, a new kind of assemblage.

This is what we see in *Still Life with a Ginger Jar and Eggplants*, with its multiple viewpoints fused in a single image. It was no less so in his work *en plein air*. If sensation was there, as Pissaro proclaimed, it was there to advance precisely the condition of the multiplicity of elements whose separations are incessantly dissolved. This palpable sense of the multiple is elaborated on by the phenomenologist Maurice Merleau-Ponty in his essay, "Cézanne's Doubt." He writes, "The task before [Cézanne] was, first to forget all he had ever learned from science and, second *through* these sciences to recapture the structure of the landscape as an emerging organism. To do this, all the partial views one catches sight of must be welded together; all that the eye's versatility disperses must be reunited; one must, as [Joachim] Gasquet put it, 'join the wandering hands of nature.' 'A minute of the world is going by which must be painted in its full reality.' His meditation would suddenly be consummated: 'I have my *motif*,' Cézanne would say, and he would explain that the landscape had to be centered neither too high nor too low, caught alive in a net which would let nothing escape. Then he began to paint all parts of the painting at the same time, using patches of color to surround his original sketch of the geological skeleton. The picture took on fullness and density; it grew in structure and balance; it came to maturity all at once. 'The landscape thinks itself in me,' he said, 'and I am its consciousness.'"[15]

Is the landscape a multiple projection issuing from Cézanne, or is Cézanne a projection of the landscape? He answers in this phrase, "The landscape thinks itself in me." It is not, at least for the moment, that interior and exterior are without boundaries. These agents exist alongside one another. But then the Other

penetrates in reply, "and I am its consciousness." Is that to say that he is the expression of this essence? Perhaps. That is still unclear. In any case, the landscape and Cézanne exchange a common code. His self and the selves of nature's objects are joined in a hybrid subjectivity. Not a fragmentation, a network, an economy of power relations, a tension between nodes, a distribution of agency between two bodies, between many bodies.

Merleau-Ponty continues, "The lived object is not rediscovered or constructed on the basis of the contributions of the senses; rather, it presents itself to us from the start as the center from which these contributions radiate. We *see* the depth, the smoothness, the hardness of the objects; Cézanne even claimed that we see their odor. If the painter is to express the world, the arrangement of his colors must carry with it this indivisible whole, or else his picture will only hint at things and will not give them the imperious unity, the presence, the unsurpassable plenitude which is for us the definition of the real. That is why each brushstroke must satisfy an infinite number of conditions. Cézanne sometimes pondered hours at a time before putting down a certain stroke, for, as [Emile] Bernard said, each stroke must 'contain the air, the light, the object, the composition, the character, the outline, and the style.' Expressing what *exists* is an endless task."[16]

But this is still a description of what exists as exterior. This putting down of the stroke only sees the hand and the canvas as a finalizing process and a final surface, an impermeable membrane of the executive act in its formal presence. Cézanne's mark making is an instrument of porosity; it drills little holes in the phenomenal. He asserts that all the objects in his gaze erupt in a flow that seeps among the layers of matter and beneath it, inside it. This is a self-consciousness that, as we know from Hegel, is always dependent on the other—"only when each in its own self through its own action, and again through the action of the other, achieves this pure abstraction of being-for-self."[17] These fruits, this light and shadow, this pot, or a figure in a landscape, or the landscape itself, each *thinks* itself in him, has agency and cause, and he thinks himself in them, all of their times, their phenomenal skins shrinking and shifting, their outsides (where time is visible) and their insides (from which their sensual properties radiate) becoming virally akin, progenitive.

In reading Merleau-Ponty, it seems that each stroke, as Bernard suggested, had to embody so many aspects of the transfer from essence to artifact that there is an enormous downward pressure, a compacting of thought and feeling into the visual, and with this downward pressure a sense of completion of the experience. But in looking at Cézanne's work, particularly in his mature images from the late 1880s until his death in 1906, I sense the raw, the ripped open, the quality of the image as something that does not totalize but keeps visible within the picture the constant shifting back and forth between fragment and whole, between himself and nature. The phenomenal perpetually turned inside out, as if the picture were an oscillating I/it machine, has its complement in the visual drift of objects in the pictures themselves, which is to say their manifestation of Cézanne's internal need. Responding to a question from Bernard about Classical artists, Cézanne answered, "They created

pictures; we are attempting a piece of nature." When Bernard asked, "But aren't nature and art different?" Cézanne replied: "I want to make them the same."[18]

The painting as Cézanne conceives it wants to do away with the impermeable. His goal is multifold: to erode the separating tissue between image and his experience, welding multiple experiences together in a single image, in a reinvention of the self; to make a picture that's as alive and changing as nature; to dismantle the painter as a body, as a boundaried thing, and fuse it with nature; to dismantle the picture and its hierarchies of planar division and make it a piece of nature, which is to say, to get rid of its single point of view and its stasis, the stolid stasis of the eye/I (an extraordinary arrow that shoots toward the distant future of installation art); to dismantle the single stream of time and aggregate times in the picture; to loosen the painting from the frame and the self from the frame of its own flesh and have the viewer receive this art as a piece of nature, were this possible. The permeable, the seeping, the erosion of boundary, the dilating possibility/dream of the self that isn't alongside the other but combines with it and yet is still somehow individuated . . . this is a true derangement—a movement away from the orderly row or line—a little bit of madness. The philosopher Quentin Meillassoux writes in an argument about necessity and contingency, "We are no longer upholding a variant of the principle of sufficient reason, according to which there is a necessary reason why everything is the way it is rather than otherwise, but rather the absolute truth of a principle of unreason. There is no reason for anything to be or to remain the way it is; everything must, without reason, be able not to be and/or be able to be other than it is."[19]

There is in Cézanne's imagining some ground between reason and unreason. His desire is so hard earned, proceeded toward in a relentless manual inquiry. Nor is his imagining of this I/it, self and landscape, uniquely his in his time, and certainly not afterward. In 1874, two decades prior to Cézanne's completing *Still Life with a Ginger Jar and Eggplants*, Gustave Flaubert published *The Temptation of Saint Anthony*, a novel he labored over for twenty-five years. Cézanne knew the novel well. It was a source for his painting of the saint's temptation, executed in 1874–75. [20] Toward the end of the final version of the story, Flaubert writes: "Plants are now no longer distinguished from animals. . . . Insects identical with rose petals adorn a bush. . . . And then plants are confused with stones. Rocks look like brains, stalactites like breasts, veins of iron like tapestries adorned with figures." Roger Caillois, in his remarkable essay "Mimicry and Legendary Psychasthenia," from 1935, in which he talks about a disturbance in "relations between personality and space," cites the Flaubert passage and comments on it in a way that aligns with what Cézanne imagines for himself. "In thus seeing the three realms of nature merging into each other, Anthony in his turn suffers the lure of material space: he wants to split himself thoroughly, to be in everything, 'to penetrate each atom, to descend to the bottom of matter, to *be* matter.'"[21]

This same ontological fluidity and tumult of transformation exists in Cézanne's re-vision of himself. He said to his contemporary and friend from Aix-en-Provence, the French art critic Joachim Gasquet, whom Merleau-Ponty referred to, "Personally, I'd like to lose myself in nature, grow again *with* nature, *like* nature,

have the stubborn shades of the rocks, the rational obstinacy of the mountain, the fluidity of the air, and the warmth of the sun. In a green my whole brain would flow in unison with the sap rising through a tree's veins."[22] Once again, the landscape is thinking itself in him. He is modeling a network of affiliation and distribution, but what he desires is still something more viscous, an associative hematology: blood = sap, or rather blood + sap = the redistributed hybrid Cézannescape. There are the two bodies, then: Cézanne's, with his own agency, and the Cézannescape's, with its loosely described new consciousness. In this he is reminiscent of Gilles Deleuze and Félix Guattari's complexly theorized "Body without Organs." They turn to a passage in William Burroughs's *Naked Lunch* as example: "No organ is constant as regards either function or position, . . . sex organs sprout everywhere, . . . rectums open, defecate and close, . . . the entire organism changes color and consistency in split-second adjustments."[23] They tie the Body without Organs (BwO) to concepts of schizophrenia, of "desiring-machines" whose production rises from the amorphous, opaque, primordial BwO envisioned as miraculously self-generating. "Machines attach themselves to the body without organs as so many points of disjunction, between which an entire network of new syntheses is now woven, marking the surface off with co-ordinates, like a grid."[24] Elsewhere they write that the BwO "reveals itself for what it is: connection of desires, conjunction of flows, continuum of intensities. You have constructed your own little machine, ready when needed to be plugged into other collective machines."[25]. In other words, networks and protocols. They could have been talking directly to Cézanne, and they could also have been describing attributes of network aesthetics that count among its principal characteristics the connection of intensities (nodes and links) among bodies of difference, implanting, intersecting, so that new multiplicities of meaningfulness are assembled.

Another painting: the large *Bather* (1885) in New York's Museum of Modern Art. The figure approaches a quasi-geological formation in the sharp cut of his elbows, in the way that his left foot is flat against the gray rock he's standing on, as if he's actually formed from it and emerging into the air. But that gray suffuses the bather's flesh anyway, just as the landscape on the right of the figure has a fleshlike color. And there, under the figure's chin and below his right shoulder, is that green that Cézanne uses to evoke plantlike growth, though no specific bush or grass is articulated. The bather is that plant, too, and that rock. His left nipple is barely perceptible; it's hardly there. He has already shifted into something hybrid. His right nipple is a diamond-shaped shard, as much stone as skin. Like Burroughs's imagined hyperbody, Cézanne's bather is sprouting, his flesh one thing and other things, a rendering of Flaubert's imaginings and Caillois's thinking about space, which has as much agency as its human occupants and swallows them, pulls them into a state of dematerialization and re-formation, just as there is an urge in some to become that Body without Organs, that nodal entity among other heterogeneous entities whose divergent subtopologies are linked in a network, subsumed.

The *Bather*'s meshwork of animal, rock, and flora includes the sky as well, which takes on the same narrow range of hues—you can see a touch of that sky next to

the green just beneath the figure's right shoulder. Paint's pure materiality takes on a highly imagistic quality, with its shimmer around the body and in the air embedded in the flatness of the brush's marks. Time, too, is embedded: an implicit human time of the figure walking, and also of the hand that marks time in the brushstrokes put down across the canvas; the time of that rogue node, the viewer-agent, to observe; the geological time of rocks, which is the infinitely slower temporal flow of the earth in perpetual formation and re-formation; climatological time, with its rapid, fluctuating, cyclical changes; and diurnal time, the time of day reported in the sky.

The flesh of Cézanne's bather is brought into equivalence with each element of the landscape, things speaking to other things. When Merleau-Ponty writes in *The Visible and the Invisible* "every relation between me and Being, even vision, even speech, is . . . a carnal relation, with the flesh of the world" and "the presence of the world is precisely the presence of its flesh to my flesh," Cézanne's bather and his landscape are well described in their collective, networked Being-state.[26] This collectivity only intensifies as Cézanne comes to the end of his work. Flesh, of course, is not simply a unidirectional simile, a likeness that runs from human to landscape. In the phenomenology conceptualized by Merleau-Ponty, flesh as such is that sheath of Being that is manifest between all entities in connection through space; it is the essence of spatiality as a fundamental connectivity. The fleshness of the world permeates. So we see in *The Gardener Vallier*, done in 1905–06, and in *Seated Man* from the same years, the penultimate and last year of Cézanne's life. In both, the Cézannescape is instantiated in the continuous miscegenation of marks flowing across the plane, the *Seated Man* all the more fully picturing the flesh of the world in its conjunction of flows, in the continuum of intensities.

Yet this flesh of the world was already suggested in the intervening years between the *Bather* and these late figures—for example, in *Rocks in the Park of the Chateau Noir* (1898–1900; Washington, National Gallery of Art), where one sees the myriad little interlocking colored planes whose near blur presents the movement of matter's mutability, the conviviality of one material presence speaking to another. The expressive causality of a noumenal presence that sheds its light in matter is underlined by Cézanne in the most retinal way in the picture. He replaces the use of chiaroscuro with the deployment of contrasting hues placed consecutively to create a blanket of equal illumination so that the semblance of a unified presence emerges. "I produce my planes with the colors on my palette," Cézanne said to Gasquet, "do you follow me? . . . You have to see the planes . . . clearly . . . but fit them together, blend them. They must turn and interlock at the same time . . . I sometimes imagine colors as great noumenal entities, living ideas, beings of pure reason. With which we can commune. Nature isn't at the surface; it's in depth. Colors are the expression, on this surface, of this depth. They rise up out of the earth's roots; they're its life, the life of ideas."[27]

Reason is rooted deeply in this thinking, but so is the unreason that Meillassoux asserts, the proposition that anything can *be*, even a man's body that melts into the thingness of nature that is itself conceived as an equivalent subjective agent, such

that they are simultaneously separate and joined, sprouting, rhizomatic, inconsistent, nomadic, horizontalized as nodes in a network. Empiricism is drawn out through the retina, while an inward recalibration of the empirical data takes shape as a philosophical idea about the nature of Nature. In his ambition, Cézanne is always looking over his shoulder, assuming all positions of perception and sensation at once, so that the paintings in their look of volatile and mobile Being, of essence and its effectivity, seem to continuously unfold and refold themselves in acts of reformed collective existence. Everything is seen in the act of assembling itself, just as Cézanne constantly struggled to enter oblivion, in the anthropologist Marc Augé's use of the word: to forget the habits of seeing from the past, from the conventional state of being merely human, and to rebegin, to embody another radically different subjectivity fused with nature that "opens up into every possible future without favoring a single one."[28]

Of course, this BwO is an idealized extreme, just as the ambition to fuse oneself with the landscape is. "You never reach the Body without Organs," Deleuze and Guattari say, "you can't reach it, you are forever attaining it, it is a limit."[29] And so, as Merleau-Ponty notes, just a month and a day before Cézanne's death on October 22, 1906, the painter is still in turmoil, still striving at the limit to meld his art and his self with nature, to make a painting that in its desire to turn the preconceptions of seeing inside out is a Body without Organs. On September 21, 1906, Cézanne writes in a letter to Bernard, "I was in such a state of mental agitation, in such great confusion that for a time I feared my weak reason would not survive. . . . Now it seems I am better and that I see more clearly the direction my studies are taking. Will I ever arrive at the goal, so intensely sought and so long pursued? I am still learning from nature, and it seems to me I am making slow progress."[30]

He couldn't possibly arrive there. That place, like the BwO, is a field of immanence, roiling beneath that Rilkean "*is*" in a state of continual potentiality and progeniture. Nonetheless, he gives permission in art, as Rilke understood in his own way (however incomplete), to a state of extreme equivalency. The onto-phenomenological proposition of Cézanne's work to record the liquid, viscous, shape-changing condition of matter and self, pressing far beyond Impressionism's spontaneity, leads in its reasoned unreason, in its bleeding of thing into thing, in the distributed communicative code of the flesh of the world from essence to phenomena, to the question of representation's own stability as a singular, unified species of thing in the world—a question that Marcel Duchamp soon would answer.

5. The "Solomonic Window" in Renaissance Scotland and At Large

Ian Campbell

Motifs are hardly unique to the mimetic or representational arts: they occur as well in music and even architecture. One might even say all the more purely in music and architecture, as without mimetic responsibilities forms show their motival essence in pure recurrence. It is quite something to discover, isolate, and define such an architectural motif as the type of window split into two parallel vertical "lights" or openings that Ian Campbell finds identified with the Temple of Solomon as memorialized in late to post-medieval Christian architecture. For him this motif came to notice in the context of the first architectural incursion of the Renaissance into Britain, at the splendid castle of Stirling, sometime "capitol" of Scotland. Campbell looks back to the late medieval period, after practitioners of music conceived of their art as so new as to qualify it as such: ars nova, "new art"—as I learned before I was a full-fledged modernist from Rudolf Wittkower's lectures on the Renaissance, only to have this confirmed by Matei Călinescu's Five Faces of Modernity (1977). Wittkower considered Campbell's "barleycorn" columns "Solomonic" (e.g., the baldacchino of St. Peter's), which can now be joined by Solomonic windows. Ian shows a keen sense for the visual evidence of mechanical reproduction 400 years before photography, here in woodcuts. An art-historical problem that might have been merely antiquarian and local to the northwestern fringe of Europe offers potential for critical illumination wherever forms of postmedieval European architecture may be found. — J.M.

―――――

The pleasure at being invited to give a paper at the symposium for Joseph Masheck was quickly dissipated by doubt: what could I offer to a man of mostly modern tastes? Then I remembered that he had not long before pointed out our mutual connection with Rudolf Wittkower, Joe having been a doctoral student of that master, while in 2010–12 I held the eponymous guest professorship at the Bibliotheca Hertziana in Rome. Wittkower's fascination for Solomon's Temple was in part the inspiration for an article Aonghus MacKechnie and I published in 2011, revealing that the Chapel Royal at Stirling, in Scotland, built in 1594, almost

certainly by the founder of modern Freemasonry, William Schaw, was a copy of Solomon's Temple as well as the earliest Renaissance church in Britain.[1] The present essay grows out of that article and introduces the concept of solomonic windows by association with the Temple of Solomon.

MacKechnie and I argued that, besides having the exact dimensions of the Temple, the forms of the main door and the windows of the Stirling chapel derived from illustrations of Solomon's Temple (fig. 5-1). The windows on the main façade

5-1. William Schaw, Chapel Royal, Stirling (Scotland) Castle, 1594.

are "biforate"—that is, each is divided by a colonnette into two round-headed "lights"—originally with a painted roundel or plaque above, and all set within a semicircular arch. The forms of these windows compare well with those in a woodcut from a mid-sixteenth-century version of a major Latin Bible first published in Germany in 1481 by Anton Koberger, which included an immensely popular late medieval commentary by Nicholas of Lyra illustrated with woodcuts.[2] The woodcut illustrating the prophet Ezekiel's vision of a future restored Temple (chapters 40 to 42) shows the rear elevation of the Temple, with three windows to each of three storeys (fig. 5-2),[3] which we argued was the source of the two groups of three windows at Stirling, on either side of the central door. However, this left me wondering if the solomonic connection could account for windows in certain Scottish buildings from much earlier in the sixteenth century, three in particular.

The first is King's College Chapel, Aberdeen, whose foundation stone, according to the inscription on the west door, was laid on April 2, 1500, to serve Scotland's third university, founded by William Elphinstone (1431–1514), bishop of Aberdeen. [4] There, the west window and those on the north side, all pointed and filled with Flamboyant tracery, are divided by prominent—and ungainly—central mullions (fig. 5–3). The second building is the Great Hall of Stirling Castle, the most ambitious secular building of its period in Great Britain, the exterior of which appears to have been finished around 1501 for James IV.[5] All four walls of the hall are punctuated by pairs of windows that look rectangular from inside, even though outside each is topped by a shallow arch. In addition, the bays flanking either side of a raised platform or dais

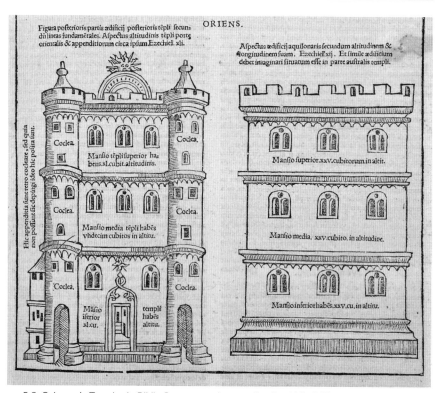

5-2. Solomon's Temple, *in Biblia Sacra cum glossa ordinaria et Nicolai Lyrani expositionibus* (Lyons, 1545).

5-3. King's College Chapel, Aberdeen (Scotland), 1500.

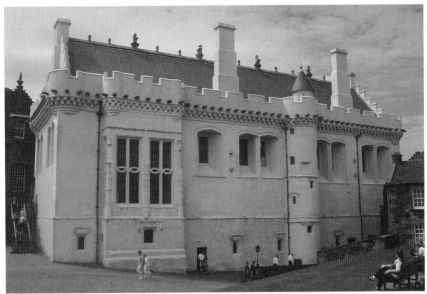

5-4. Great Hall, Stirling Castle, c. 1500.

have pairs of two-light windows (fig. 5–4). The third building is Falkland Palace, in Fife, where the windows of the chapel on the front façade are strikingly simple paired

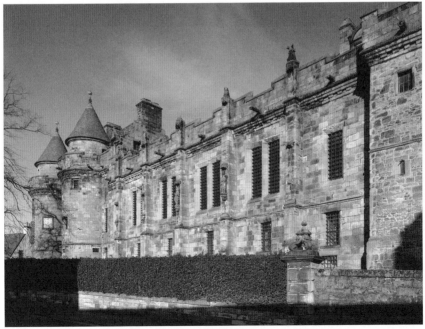

5-5. Chapel, Falkland (Scotland) Palace, c. 1540.

rectangles divided by a central mullion (fig. 5–5). In their present form, they probably date from a remodelling of the palace between 1537 and 1540 by King James V, though

they may follow the general lines of earlier work that had been initiated in 1501 by his father, James IV.[6] While the forms of these three sets of windows differ, they all share the general characteristic of what could be described as "twoness."

The King's College windows have been compared with some in Netherlandish churches dating from shortly before, though in none is the central mullion so emphatic. [7] Those at Falkland resemble some in France at a chateau, Villers-Cotterêts, built around 1533 to 1537 for François I, whose daughter King James V married in 1537. [8] So is there any need to posit a solomonic association? Well, in the case of King's College, it is already there. The claimed date of its foundation, April 2, corresponds with that of Solomon's Temple; the dimensions of the building seem to be based on those of the Temple; and as I have argued elsewhere, the form and position of the tomb of Bishop Elphinstone are meant to evoke the Ark of the Covenant. Moreover, a similarity has been pointed out between the building abutting the south side of the chapel and a woodcut in the Koberger Bible illustrating the structure that abutted the side of the Temple, as described in 1 Kings 6:10. Elphinstone gave his 1498 copy of the Bible with the Nicholas of Lyra commentary and the Koberger woodcuts to the university in 1512, where it is still preserved.[9]

However, there is nothing in the two main biblical descriptions of the Temple (1 Kings 6 and Ezek. chs. 40–42) to suggest that its windows had two lights or were paired.[10] The Latin *Vulgate*, which St. Jerome translated directly from the Hebrew text, has *fenestras obliquas* in both places, which can be rendered as "splayed windows," while the parallel passage in the Greek version of the Old Testament, the Septuagint, can be translated as "hidden peep windows."[11] Nor do Nicholas of Lyra's *Postilla* or the great compilation of patristic commentaries, the *Glossa Ordinaria*, suggest the windows might have had two elements or might be paired, although the *Glossa* discusses the Temple's two doors.[12] Koberger's illustrator appears to have confused the description of the Temple with a detail of the "House of the Forest of Lebanon" (Solomon's Palace) in 1 Kings 7:4. In the account in the Greek Septuagint (fuller than that in the Vulgate), we read that the palace had three storeys, and "*chora en chora*" three times. "*Chora*" can be translated as "space" or "opening."[13] The translators of the King James Bible (1611) render the phrase as "light against light."[14] Exactly what that means is not obvious, but it looks as though Koberger's illustrator has used it to show the Temple windows with two lights separated by a mullion. A small vesica ornament prevents the mullion from reaching the top of the window, but nevertheless the window's "twoness" is obvious, and it was, I propose, the inspiration for the thick mullions dividing the large windows on the west and north sides of King's College Chapel.

For the rectangular windows at the Stirling Castle Great Hall and the chapel at Falkland Palace, the source seems to be the same passage in 1 Kings, but it includes the following verse, where it is stated that the doors and post, with the windows, were square (1 Kings 7:4–5). The accompanying woodcut in the Koberger Bible shows the interior of the hall with pairs of rectangular windows (fig. 5–6), not unlike those of the Stirling Castle Great Hall (fig. 5–4). As Solomon was the archetypal wise king, what could be a better model for royal residences than his palace?

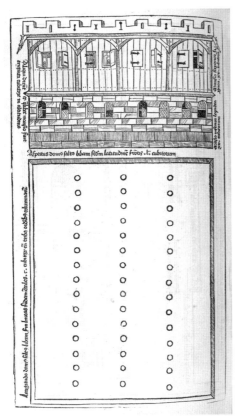

5-6. Solomon's Palace, Nicholas of Lyra, *Postilla super totam Bibliam* (Nuremberg, 1481).

Having established, I trust, that Solomon was the inspiration for this group of Scottish buildings, can we see his influence elsewhere? The French chateau would be an obvious candidate, with its windows very similar to those at Falkland, but how much further back can we go?

The question not yet addressed is how Koberger's illustrator knew of the "*chora en chora*" Greek reading, as Nicholas of Lyra was commenting on the Vulgate, which lacks this passage. By the later fifteenth century, knowledge of Greek was beginning to spread in western Europe, so it is possible that whoever guided the illustrator knew the Septuagint.[15] The earliest use of the term *bifora* (literally, "two openings or holes") is found in Ovid, and visual evidence of it includes a first-century AD relief in the British Museum, *Bacchus Visiting Icarius*, where a house in the background has two windows with two lights (not arched).[16] In early Christian architecture, arched *bifore* do occur, but so do arched windows of more than two lights, and it is difficult in most cases to attribute any significance to them. An exception is the *bifora* in S. Maria delle Grazie in Grado, which takes pride of place in the apse, and probably dates to the fifth century.[17] Nothing is known of the decoration of that heavily restored church, so no particular meaning can be imputed, but the position strongly suggests some importance.

One wonders whether early medieval manuscripts offer any helpful evidence. The fictive architecture, often combining *bifore* and *trifore*, which commonly frames canon tables or other lists in early manuscripts of the Bible has convincingly been connected by Carl Nordenfalk with real buildings, such the church of the Holy Apostles in Constantinople.[18] Among these early manuscripts is the *Codex Amiatinus* (in Michelangelo's Biblioteca Laurenziana, Florence), which the Northumbrian abbot Ceolfrith set off to present to the pope in Rome in 716, before dying on the way.[19] We know from the *Life* of Ceolfrith that it was one of three *pandects* (huge, complete Bibles—the *Amiatinus* runs to over one thousand folios and weighs seventy-five pounds) created, probably in the 690s, in emulation of the *Codex Grandior*, a Bible commissioned by Cassiodorus in the mid-sixth

century, which Ceolfrith had brought back from Rome in 678. Some of the first eight folios of the *Amiatinus,* which form a gathering, are judged to be copied from Cassiodorus' codex, and among them we find on folio IVv the books of the Old and New Testaments listed in two columns and framed by a very fine *bifora.*[20] There is also a magnificent diagram of what appears to be a composite of Moses' Tabernacle and Solomon's Temple[21]; however, the present arrangement of the manuscript leaves is modern and does not necessarily follow the original order.[22] We know from Bede that the *Codex Grandior* also had an illustration of the Temple, which Meyvaert considers followed immediately that of the Tabernacle; if we accept his ordering, the *bifora* immediately preceded the Tabernacle/Temple, as if it were an entrance, and it may have already had a significance in the sixth century, or led to an association between the two in the minds of later readers, just as the "barley-sugar" or "candy-cane" columns surrounding the high altar in Old St. Peter's only took on "solomonic" associations in the High Middle Ages.[23]

Biforate windows first begin to assume a more prominent position in the Romanesque period. They appear in west towers such as that raised around 1000 over the porch of an older church at Monkwearmouth, in England, and often in such great German "westworks" as at Corvey Abbey, in Germany. [24] They also occur in central towers between naves and chancels such as that at Jarrow (ca. 1075) or at Anzy-le-Duc.[25] In Italian churches we find them in eastern apses and towers such as the abbey of S. Antimo, in Tuscany, while in the late Romanesque or early Gothic west front of Ferrara Cathedral the central porch has biforates on spirally fluted colonnettes, supported in turn on paired intertwined columns at ground level to which others have attributed solomonic connotations.[26] No one has suggested why biforates gain popularity in the Romanesque period, but it may be significant that the biforates at Corvey Abbey are in the upper stage added to the original westwork dating from 885, which has an inscription equating the church with the Heavenly Jerusalem.[27] This suspicion is strengthened by Abbot Suger's likening the chevet at St. Denis, built from 1140 to 1144 and lit by Gothic biforates or two-light windows, to Mount Zion, a synonym for the Heavenly City.[28] Nicholas of Lyra in discussing Ezekiel's vision of the Temple specifically equates it with the Heavenly City.[29]

Biforates or two-light windows become so common in Gothic buildings, sacred and secular, that in most contexts specific meanings are unlikely. Occasionally, however, as in the Palazzo Vecchio in Florence, begun in 1298 as the communal seat of government, one wonders if the original three-storey elevation with rows of biforates in the two upper ones, is deliberately recalling Solomon's Palace. After Michelozzo "quoted" the Palazzo Vecchio biforates on the Palazzo Medici in the 1440s, the type becomes standard in Florentine Renaissance palaces, so that again, one cannot infer specific solomonic associations, but in late fifteenth-century Rome, one can indeed do so. Round-arched biforates are a leitmotif in buildings associated with Pope Sixtus IV and his family, including the rebuilt church of S. Maria del Popolo and the new cathedral of S. Aurea at Ostia. We also find flat-topped biforates used on residential parts of buildings.[30]

The fact that Botticelli used Sixtus' Ospedale di S. Spirito to represent the Temple in his fresco of the *Temptation of Christ* in the Sistine Chapel might be thought to establish the solomonic association. Irritatingly, however, he depicts the windows as three-lighted (triforate) rather than biforate! Nevertheless, in other features of the Sistine, the connection is less ambiguous. Eugenio Battisti established a half-century ago that the dimensions of the Sistine match those of the Temple given in 1 Kings.[31] More recently, Arnold Nesselrath has pointed out that the palmette frieze running between the painted curtains in the lowest stage of the walls and the middle stage of frescoes matches that shown on Perugino's representation of the Temple in the background of his fresco showing *Christ Giving the Keys to St. Peter.* [32] In light of these allusions, I propose that the arched biforates of the upper stage of the Sistine Chapel can also be read as referring to the Temple, and that if this is so, it is virtually certain that others would have known it and emulated it elsewhere.

The traffic of clerics between Rome and Scotland was considerable in the late fifteenth century, but two key figures, in particular, could have been conduits for the transmission of ideas. One was George Brown (1436–1515), who was consecrated bishop of Dunkeld in Rome in 1484, after reportedly making many friends in the papal curia including the future Pope Alexander VI.[33] The other was William Elphinstone who, visiting Rome as bishop of Aberdeen in 1494–95, obtained from Alexander the bull for the foundation of King's College, and as Chancellor of Scotland he was James IV's closest adviser at the time the Stirling Castle Great Hall was being erected.[34]

One last building must be mentioned, which may be a link between the Scottish and Roman examples, as it may well have been seen by Scots on their way to or from Rome. The Petit Palais in Avignon was remodelled by Giuliano della Rovere between 1481 and 1496, and it included a new façade in three stories (fig. 5–7). The principal floor is marked by the use of so-called Guelph windows, with a single

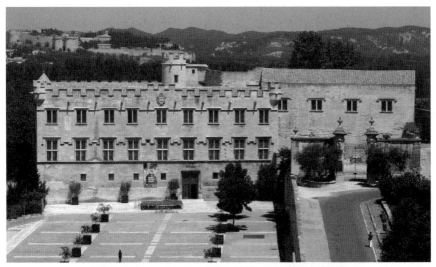

5-7. Petit Palais, Avignon, begun 1323, remodeled 1481-96.

mullion and transom, which had come into prominence in the 1450s and 1460s in a series of buildings, all with papal connections.[35] But it is the upper storey that interests us for its biforates with flat tops, recalling not only those in Rome but also the windows of the Great Hall at Stirling and the chapel at Falkland, while the battlemented parapet with corner turrets, found also on the Stirling hall, is reminiscent of the Koberger woodcuts of the Temple and Palace. Have we then an allusion to Solomon's Palace? Once elected pope as Julius II, Giuliano was certainly, in new St. Peter's, trying to emulate Solomon, but it looks as though he may have already been trying here at Avignon.[36]

Although some of the discussion remains speculative, it is my conviction that there is enough cumulative circumstantial evidence to introduce the term "solomonic window" into architectural history, to illuminate not only a few buildings in Renaissance Scotland but also many as yet to be acknowledged, wherever they may occur throughout the whole of Christian architecture.

6. Le Corbusier's Middleground

Deborah Gans

The seriousness of Deborah Gans's concern with the contribution of Le Corbusier as virtually the Vitruvius of modern architecture has little to do with formalism or stylistics, no doubt because as an architect she so appreciates the master's artful "solutions" (to restore a word that has fallen into biz-talk) to the specific problems of actual building situations. Even as her practice has extended to built dwellings for the dispossessed and projects for temporary emergency housing, she has been sufficiently sustained by her direct study of the works of the sometimes now supposedly all too "utopic" modern master to have produced a unique handbook covering its entirety at first hand—The Le Corbusier Guide (1987), now in its third edition—as well as teaching for years a Corbusier seminar in the School of Architecture at the Pratt Institute, in New York. It is easy to say that architecture should respond to social need: it is not so easy to go ahead and make it do so without giving up on what some would consider the art part, which has its own life-inspiring function, as the literally shameless humanism of the master's Vers une architecture (1923) still tries to tell us when we are not being too narrow-minded to understand. In its understated comprehensive sweep, this essay shows how Deborah's own working interest in such matters is by no means a puritanical a case of theory instead of art. — J.M.

Le Corbusier painted every day and considered painting the primary generator of all his work. Still life was his initial, and ever a primary, genre; and his still lifes are composed of standard type-objects (*objet types*) refined by simplification through use, such as wine bottles and glassware, and in the later work, found objects from nature that evoked poetic reaction, such as stones, bones, and shells (termed *objets à réaction poétique*). Both sets of objects established an intimate and tactile relation with the world. Type-objects derive from a direct encounter with the body, such as a hand on a glass or a torso in a chair; objects of poetic reaction are similarly scaled to touch but function in relation to the psyche rather than the needs of the body. This object language with both its categories constitutes the foregrounds of the paintings. The backgrounds suggest architectural settings, through devices like

doorframes, or landscapes, through hillock-shaped curves, as in the artist's definitive *Still Life with Many Objects* of 1923 (Paris, Musée National d'Art Moderne).

Influenced by the thickened spatial field of Cubism, though rejecting its fragmentation of the object, Le Corbusier and his compatriot in the invention of Purism Amédée Ozenfant developed the methodologies "marriage of contour" (*marriage à contour*) and "rhyming" (*rhyme*) to manipulate the classic binary between foreground and background.[1] In marriage of contour, one outline defines two contiguous objects, as with adjoining puzzle pieces, even if the objects are not depicted as co-planar. Rhyming is the repetition of a figure like the O's of bottles' mouths across the canvas such that they read as a flat pattern irrespective of their various depths in the field of objects. By these devices, foreground violins and distant mountains coalesce, as if entangled in a dense mat. This is a charged field, a middleground belonging exclusively neither to the foreground table nor to the distant landscape, that simultaneously holds the form together and keeps the pieces identifiably apart.

This middleground has a role in Le Corbusier's architecture in the framed space of the strip window. In a famous contretemps over windows between Le Corbusier and his mentor Auguste Perret, Perret argued for the vertical "French" window because it placed the body in relation to the full range of landscape's near, middle, and far ground. He found the *fenêtre à longeur*, or horizontal strip window, of Le Corbusier, to be optically unnatural because it frames only a truncated middleground.[2] And so it does—most purposefully, in order to cast an even light across a surface. Placed high in the wall to avoid the interruption of furnishings, and extending across the entire wall surface, the strip window excises the view of the ground below and of the immediate landscape, intensifying the light within the frame. Often the glare so created separates it from the darkened wall as a glowing stripe floating ambiguously in the space of a room. Set within the strip are supporting vertical mullions that divide the windows into frames like those of a film, ordered from side to side with cinematic effect. The strip window replaces the traditional spatial sequence of interior to exterior, perpendicular to the frame, with a spatial sequence of views along its length at a constant distance. This simulated sequence in time is quite distinct from the implied distance from near to far in the frame of Perret, which belongs more to the static gaze. One might say that Corbusier's window belongs more to the eye of a man on the move.

Le Corbusier's *homme type*, the generalized inhabitant of his ideal villas and of his proposed urbanism, is this man on the move, empowered by the automobile. Automobile man is the client for Villa Savoye, where the ground floor is famously designed for the turning radius of the car, and a ramp at the core of the house keeps the inhabitant in constant motion, and with the strip window in Madame Savoye's bedroom conceived (though not thusly executed) as analogous in shape and position to the window of her car.[3] Car window and strip window are indeed complementary lenses: each excises the ground that locates our exact position and asserts the primacy of a procession of events in time at an ambiguous but constant distance determined by the height of the window and the speed of passage.

La Ville contemporaine or "The Contemporary City" (1922), which was the focus

of the architect's urban thinking and writing during this period, was likewise cali-brated to the speed and demands of the car. "A city built for speed is built for suc-cess," Corbusier declaimed.[4] In his perspective drawings of this city, nature and built form are in the reverse of his paintings, and more in the tradition of a pasto-ralist landscape, but one that gives special emphasis to a middleground. Among the residential apartment blocks, raised pedestrian promenades look out across parks whose ground is unseen beneath our observing viewpoint, toward a distant city of prismatic office towers. The intimate world of the Parisian sidewalk as celebrated in cubist paintings of newspaper and wine bottle gives way to urban form seen at a distance. The inhabitant gazes out to a landscape middleground of indeterminate beginning and size. In the far ground, a grid of towers of identical height establishes the horizon. At this distance, according to Le Corbusier, the right angle that is the ordering device of reason and perspective trumps the ergonomic curves of bodily function and gesture. The geometry of the town plan depends on this optical and rational projection of order. Even the horizon is understood not as part of nature but as a geometric projection constructed through architecture. (I refer specifically to his rendering of the city in *The City of Tomorrow* [1924], where towers, all of the same height, placed in a line at a distance define the horizon.[5])

In part, the criticisms of this corbusian urbanism of the tower in the park are also a critique of this structure of vision with its loss of foreground, the discomforting ambiguity of its ascendant middleground, and its rationalized distance. But for Le Corbusier, this middleground was a conceptual necessity that linked new technol-ogy to spiritual wellbeing. It was nothing less than the field of becoming, between two dialectical poles of *nature morte* (still life) and death itself as connoted in the stillness of the horizon. In his late *Poem to the Right Angle*, Le Corbusier explicitly describes the life force of the vertical axis of man on the move and the death force of the horizontal resting place, synthesizing his philosophy with his geometry.[6] In that to live *is* to move, it is not surprising that for him architecture's origin is not the canonical primitive hut but the nomadic tent, which he presents as both the first house and the first tabernacle in his treatise *Towards an Architecture* (1923) by telling the story twice and changing the tent's function. First, the nomad stakes his compound in the shape of a double square, and erects his tent as a golden rectangle within it. When he literally pulls up stakes to move on, only the pure geometry, "the pure creation of the mind," as Corbusier puts it, remains.[7] In constant motion between point of origin and final destination, the nomadic existence takes place in conceptual middleground. In the Radiant City of 1932, which supersedes the Contemporary City, Le Corbusier describes his urban inhabitant as "the modern nomad" who is property-less and free to move among housing blocks set in a con-tinuous verdant landscape that Le Corbusier dreamt would cover all of Europe. He first discusses this urban nomad in *The City of Tomorrow* (1925) where he speaks of labor as open to the move, and modern man as having to be ready with his baggage in hand. But the idea takes on even more prominence in his later conception of the Radiant City, where the inhabitants are explicitly without property.[8]

In his conception of a Radiant City (planning from 1924), Le Corbusier critically

reformulated the optical structure of the earlier Contemporary City. The Radiant City is a diagram of order, not a plan per se, that allows the urban figure to adapt to various regional and landscape conditions. The eponymous book *The Radiant City* (1935) consists of a series of case studies of the diagram applied to numerous existing towns—including St. Die, in France; Algiers; and Zlin, Czechoslovakia. Not only do these plans allow mountains and sea, and existing historic centers, to mitigate the role of a totalizing geometric order of the kind to which the towers of the Contemporary City belonged. They also alter and redefine the middleground, which takes on a social and civic role missing from the landscape field, and with it, a new spatial definition. In Le Corbusier's plan for the post–World War II reconstruction of St. Die, for example, an auditorium, theater, museum, hotel, cafes, and shops are placed along shifted axes of view and movement on an open plaza forming the public center of a city otherwise organized as slabs in a park. Similar ensembles, often defined with the architect's recognizable building tropes of a squared spiral museum, an auditorium wedge, and a planar slab of offices, anchor the plans for Bogata and Strasbourg.

Although for Le Corbusier this civic ground is implicit from the beginning of architecture in the nomadic tent, where the temple or house stands not exposed in the wilderness but within a palisade, the Athenian Acropolis is his precise model of a precinct to which all other, more mundane precincts are analogous. In *Towards an Architecture*, he directs us that the temples of the Acropolis are meant to be seen at a distance, a distance that the precinct as such defines. Only through this middleground do the relations of temples to landscape, to each other, and to the supplicant, unfold. The middleground sets the temples up against the background of Pentelicus and Piraeus, mountain and sea. It sets up the foreground space of ritual procession and activity outside the temples—themselves as closed as still life objects, being entered only by the priests.[9]

At the Punjab capitol complex of Chandigarh, Le Corbusier created a kind of test for the power and limits of the precinct as a structure of space. He described it as though a mortal battle fought between himself as foreground and the mountains as background, to establish a collective space dedicated to democratic order in a new state. To place the buildings, he had white and black masts moved across the site as he watched. As he described it, "The problem was no longer one of reasoning but of sensation, matter of occupying a plain."[10] All the usual aspects of banal townscape that would have intervened—parking lots, thoroughfares, and service courts—he sunk behind and below the precinct, which he then separated from the city proper with mounds. Between the buildings, which he had set at the outer limits of his plain, he created a series of rhyming and intermediate monuments and landscapes, which have never been completed. Together they were to produce what he called *espace indicible*: inexpressible space, or space impossible to dimension—not because it is big, although it is of great dimensions, but rather because it shifts in our reading between near and far, distance and presence, like the painterly middle space of his early still lifes. Indeed, the patterned bas relief of the plaza employs both rhyming and marriage of contours in its interlocking pools and

gardens. For example, the crescent-moon-shaped crown of the governor's palace at the far northern edge of the complex, when seen from in front of the artificial mound of the war memorial, collapses into a singular figure of a reclining horned bull that belongs to neither location.[11] Adding to the elusiveness of the space is its temporal and climatic dimension: the sun and shadows shift the footprint of the tower, the monsoon rain that fills the vast water pools before the assembly building doubles its volume in reflection, and then the sun then takes it away.

Always a dialectician, Le Corbusier counters these positive civic middlegrounds with his negative construct, the labyrinth, an endless in-between space that demands a state of continual movement but threatens to never deliver one to a distant destination, or to return one to the foreground from which one departed. This is the spatial conceit of the *musée à croissance illimitée*, the infinite museum, a flattened spiral gallery that was to keep expanding with the expansion of knowledge. The architect included this museum type in all his planned civic cultural complexes, and some have been built in reduced form: in Tokyo, Chandigarh, and Ahmadabad. Hovering in another kind of middle space, meaning above the ground, and entered from below, the building type has no discernable entry threshold and conceptually no exit. It closely resembles the archaic form of a labyrinth encountered by Theseus in his search for the Minotaur, which was not a maze but a coil. In Le Corbusier's late paintings, the iconography of the Minotaur and the bull dominates a "Taureau" series along with recurring images of rope coiling in labyrinthine fashion among still-life objects. Borrowing from surrealist imagery, these paintings explore the negative capability of a middleground to undermine both the rational order Le Corbusier associated with optical distance and the sense of familiarity associated with ergonomic intimacy. Rather than bind near to far, this makes for a bridgeable gap. In writing about the space of Ronchamp, Manfredo Tafuri describes a spiraling around the building that delivers the pilgrim at last to the church interior, only to have the floor tilt away and the center not hold: "a programmatic loss of center," Tafuri writes, "his art in search of its own origins."[12]

In his *Talks with Students*, Le Corbusier writes that town planning concerned our "man on the move" the moment he got up from his chair and left the table.[13] The house is actually absent from this proposition. Rather it is implied as the first of many thresholds that our man encounters on getting up. Moving man experiences the house, the garden, the street, the city, the highway, the landscape, as part of an unending phenomenon of daily life—a continuity of space linked to the continuity of human experience in which the middleground is constantly unfolding. Perhaps, however, this reading of the binding power of space overlooks a crisis embedded in the text, for to be seated is a condition of intimacy, domesticity, and privacy, in an Edenic or "ur" condition of body, object, and space. Our man stays seated at the table until sated, until the needs and desires that can be met at the table are fulfilled. It takes another intention, a new desire or an act of will to push away from the perfected world and go—who knows where. For Le Corbusier tells us only that he leaves, not where he ends up. Between the table and the world beyond is an existential break, a rupture that calls forth the moving man of the middleground.

7. Adhering to the Text: Notes on the Observation and Description of a House in a Novel

František Lesák

The following reflections, deriving from František (or Franz) Lesák's Textreue *(Faithfulness to Text), published in conjunction with his 1997 retrospective at the National Gallery in Prague, concern his effort to somehow realize in consistent spatial projection the elusive architectural setting of Alain Robbe-Grillet's 1957 novel* Jealousy. *There, psychological interaction inside a room peered into from without challenges consistent spatio-architectural imagination, not just the literary imagination that often contents itself with a mere setting for characters. Let's face it, we abstract-art folks don't really much like novels, with their presumptuously representational, linear descriptiveness. Here, however, something else happens, with space that is actual but only inferred. Modernism generally welcomes contrivance, but* Jealousy *offers the tight logic of a hostile witness. Hence the dogged element in Lesák's present title: risking the role of mere illustrator, this modernist spatial artist, committing himself to the challenging text, has managed to tease the architecturally implicit out of the text's perversely paranoid common sense.*

Lesák recalls this Robbe-Grillet project in "Precision as a Virtue, as a Necessity, and for Its Own Sake"(Á. Moravánszky and O. W. Fischer, eds., Precisions: Architecture Between Sciences and the Arts, *2008). Situating it there in the context of his earlier work highlights, I think, this artist's special sculptural concern with the property of extension, that is, with neither mass nor volume per se but rather with extension as sheer material measurability. This matters here because it is of the essence of verbal fictions to provoke the imagination to fill out the lack of dimensional extension, while what in "adhering to the text" in his dutiful phrase, piques his imaginative curiosity is the logic of the setting: posited things impinging upon one another in a space which must be worked out. As trying as this "merely verbal" account may be to track, there is mounting conviction behind Lesák's objectification of Robbe-Grillet's tantalizing "neo-realist" fiction against the wily strength of its ever evasive, though admittedly exquisite, literariness. — J.M.*

In my view, a brief summary of the novel under consideration—Alain Robbe-Grillet's *La Jalousie* (1957), in English *Jealousy*,[1]—should convey the following. Although the reader is introduced successively to seven characters which he can list as they proceed, he never directly encounters the main protagonist, who, however, is indirectly ever-present. This protagonist is the person who relates the events comprising the novel. The progression of the plot does not seem to affect the chronicler; he merely follows events or anticipates them. His existence is enigmatic: he is omnipresent without providing any sort of self-portrait whatsoever. A living space allotted to him in the novel is never entered, and is ultimately deprived altogether of description. The very existence of this space became evident only by the calculation of an equation in the course of the projected reconstruction work that I have carried out on the house.

We presume that the protagonist is a man because the jealousy referenced by the title of the book is clearly male jealousy. Driven by it, this unknown character (husband? lover?) spies through the slats of the venetian blinds partially screening the windows from within, and registers the quality of the rooms and the events occurring inside them. The author uses no tricks: no sleight of hand makes the character appear and disappear suddenly. Instead, the author renders him permanently invisible from start to finish, as if shrouded in a magic cloak.

The Observer and His Task

Throughout the novel the author provides a precise protocol or successive sequencing of events and an exact list documenting the objects observed. The conditions that the reader has to adhere to if he or she wants to form appropriate images of the situation being described are very precise and only allow for a minimum of deviation. The novel is a picture book in that it consists for the most part of the conveyance of visual manifestations, but it is a closed work, like a coloring book whose user was given only one possible way to complete a picture of the objects and facts described. Alain Robbe-Grillet has dispatched an observer and assigned him with a double function: first—and the reader is entirely clear about this—to compile a protocol of his observations, which constitutes a major part of the novel. The observer's second function is fulfilled as one proactive protagonist among others, in the latent form of being there. While the first role that the author has allotted him, that of precise observation and reporting, is evident to the reader, the fulfillment of his second task, that of being personally involved in events, can only be established on the basis of discreet indicators. For only only some of the *corpora delicti*, only specific props, enable the reader to envisage the existence of the observer who is being drawn into the plot of the novel.

Reconstruction by Means of Illustration

If as a novel *La Jalousie* is graphic—that is, a sequence of descriptions of images that I only need to draw as I envisage them on the basis of the text—then this activity, the novel's illustration, is a conventional mode of art that has always been around, and nothing extraordinary. What is special in this case is that in a sense the

text already illustrates itself, consisting as it does mostly of descriptions of visual occurrences, of the relating of images. Here an objection arises to the excessive information, to the all-too-exaggerated redundancy of visual and linguistic illustration.

The idea of reconstructing the house that plays such a key role in the novel, and of using the extensive descriptive passages available to do this by placing what exists and what one supposes to exist alongside one another, seemed to present itself to me as self-evident. I would even wager that Robbe-Grillet intended to inspire the reader to collect the individual fragments of text—pictorial fragments, fragments of the house—as parts of a jigsaw puzzle that shows a house growing as pieces are added.

Observational Technique and Attentiveness

Robbe-Grillet describes observations through an adjustable zoom lens which he controls: from a wide-angle view that shows a whole section of countryside, down to a telephoto lens that focuses clearly on the smallest details. The author continually changes the location and the angle of view so as to treat with great stringency the descriptions and observations made wherever the observer's current position might be.

The events are organized by Robbe-Grillet as if on a multiple-set stage: something is happening at the same time in many different places, and even where nothing caused by people is happening, the author's observer finds visual information worth reporting. He needs only to point a spotlight or his zoom lens at an object to direct attention to it; he needs only to record the object as being of significance to reinstate it as an event and make it available for description.

The observer also extends to the reader an offer to interest him or her too in selected objects and events.

The reader might not want to accept this offer when he or she poses the question of why attention is being drawn to this situation specifically, to this object in particular, and why the same attentiveness could not apply to another area. Such a reader might want to be able to demand a different selection here, what with so many possibilities, whereas house, characters, setting—all this has been conceived with care. Yet the reader is dissatisfied because he thought the same degree of attentiveness to one thing meant exercising a simultaneous disregard of other items; so he demands precisely what has been omitted: the disregarded.

The observer's methods of observation and description are to be thanked for this immodest demand; for ever since becoming involved in precise description, he has highlighted objects and given them significances. Not wanting to accept that this should happen only with one selection of items, the reader demands an engagement with all the objects: a presumptuous demand extended to include everything.

How should the reader be persuaded to go along with the arbitrariness in the selection of what is cited, persuaded to accept the existence of precisely *this* item and to concur with the observer on the attractiveness of the item concerned?

The reader is not to be helped when he or she insists on also exposing to description unilluminated places that have not fallen under the reporter's field of

vision. (Nevertheless, he insists on this because he conceives that the listing of the characteristic traits of an object or situation should be exhaustive to establish its identity, and demands such exhaustiveness.) He can only presume, without having confirmed, that there are essential elements not included in the data-acquisition grid designated by the author.

What the reader must be satisfied with is not exactly a paucity of information, for the author often changes the site under observation. Repeatedly he constitutes new spheres for surveillance and then expands these. His descriptions of events speak of the use of all the senses of perception. Only because he serves the reader so well and with such precision could this author figure turn into a malcontent insisting on non-existent rights, becoming self-indulgent and making further demands.

A House under Observation

Speaking of *an* observer is not meant numerically; it should not be presumed that that there is only one single observer here.

For whoever compiled the observation protocol appears to have been at many different places at the same time, or at least had the capacity to be so. He has kept many locations permanently occupied, taking his place like a theatergoer who could justifiably assume that if only he waited long enough at any one, something eventful would pass before his eyes in due course, shoved as it were into his field of vision.

Hence one can presumably envisage one observer keeping several locations under surveillance to report on what is currently happening from the respective places, or one can envisage several observers permanently stationed, preoccupied with waiting until their posts are activated in order to commence their task and then deactivated again when the action moves elsewhere.

But even if there are indeed several observers distributed around multiple observation posts, who then commence jotting down their observations when events begin to build up and images are imposed in front of them on their pictorial level, in their faces, no difference can be ascertained in the information conveyed from what it would be if only one observer were compiling it at different locations. For the language used in the protocol is always the same, as if a uniform descriptive vocabulary had been agreed upon.

The recording of simultaneous activities, however, is only possible with appropriate technical facilities that would ensure consistency of surveillance. Observation posts would need to be strategically positioned and secure; the spaces where activity occurs must be manageable and capable of being seen from the post positions at any time.

The observer's position can be given precisely: it is easily calculated using geometry, presuming that everybody who is visually and acoustically aware deliberately looks for a position with symmetry for his or her sensory organs—eyes and ears—and maintains the appropriate observational distance in relation to the object being focused upon. The relevant passages of text can easily be used as aids in the reconstruction, and as we are dealing with an observer actually at work, and not with some thought experiment positing creatures who somehow hover in the rooms and

see through walls, eye level and associated perspective can be readily construed.

A preliminary question regarding the observation technique should be posed: to what extent is the observation protocol altogether factual, given that everything, we are told, is an eyewitness report, or to what extent are we not dealing here more with a mix of facts and speculation, because somebody was standing behind a wall and could only speculate on events occurring out of sight?

Regarding the form of surveillance, the text should be examined for evidence of one approach or the other: of whether it be direct, candid and self-declarative, or carried out secretly with stolen glances, through cracks and slits, i.e., as a voyeuristic act with deep psychological roots. The text would have to be examined for evidence of one approach or the other.

The Subject of Observation

For the author, surveillance as a subject here exclusively concerns the house and immediate surroundings. This constitutes the primary and dominant structure for persons' acts. Here, a preemptive remark: the material presence of the architectural form—the cause-and-effect relations constituting that by which the protagonists and their physical activities are surrounded—is so apparent that the impact of specified components would still register if their material presence were dissolved away. The architecture's being thus rendered invisible would only be appreciable on the basis of the protagonist's actions—as inseparable from this architecture. I emphasize this distinction in order to be able to determine more accurately which hierarchic elements comprise the novel. Here the dominant position of the architecture is indisputable: not only does it form the basis for situations and actions, and cause them; but it is also privileged as the element considered most worthy of description, posing a question as to function. Stairs, for example, are regarded differently by the builder who made them, by an observer who sees how they work, and again by the author Robbe-Grillet, who delivers a description of their visual manifestations transpiring as textural features.

An Interest in Observation, and Observational and Descriptive Techniques

As long as the stage is empty there is no action, nothing happens. The observer can preoccupy himself with scrutinizing the backdrops and the stage furnishings carefully. He makes a selection from whatever catches his eye; he compiles an assortment of objects that are carefully examined and described. From the architectural object—the house and its composite elements—he selects parts that relate to its structure and spatial parameters while also showing an interest in the surfaces of objects. He wants to establish the spatial relationships between those parts of the house that define its three-dimensionality; to record distances and structural interrelationships by virtue of the apparently correct supposition that, in describing an object or a situation, he is also providing a memorable image of the item concerned.

The description of visual events reveals both new levels of depth for the broader view and detailed closeups whereby the observer can increase the sharpness of his observations still further when describing surfaces. He makes no distinction in his

descriptions between animate and inanimate objects. The mode of description remains the same throughout: seating arrangements, relationships, even the very surfaces of people are viewed no differently from the structure and texture of the house and surrounding countryside.

By accuracy of detail in this descriptive method and by skillful generation of memorable images the author effects in the reader a sense of empathy and transparency regarding his description's validity. He conveys a sense that this description is appropriate and reliable; hence the reader has the impression of being in a position to draw accurate conclusions from the details given.

The reader's high regard for the validity of precisely this description could be lessened if, as already suggested, he were to begin to find fault in the fact that not everything present is included in the description, that on imagining the images on the basis of the description, perhaps the omissions would be especially missed as possibly even more significant than what was included. He or she might also, however, take it as a deficit in something forced upon him or her as reader that the observer's decision as to position might not have been the right one and was certainly not the only possible one. However, that then becomes a predefined position from which to see an object repeatedly and from where alone the reader has to envisage it from then on, so that this mental image becomes a constant, marked by the depiction of an object seen from the one location the reader is always allotted by the observer. The reader has to make do with an object that he will reconstruct on the basis of a mental image evoked by a passage of text.

As reader, however, I can turn the disadvantage of having a particular fixed image of an object to an advantage when I exploit this rigidity as a safeguard of the object's identity, whereby nothing will start to move, let alone go out of control, at least not in the time I need to make a model of the object: one that will subsequently provide me with all the insights and perspectives that are withheld in relevant passages of the novel. It will then be possible for me to put the object into multiple locations and to render it observable from many different positions. In this way, the object— regrettably only in the form of a substitute model yet nevertheless accurate as such—is freed from the given of always having to be seen from only one and the same position. Beyond this, the reader can only hope that the observer was also waiting for significant situations, ones that he knew how to differentiate from insignificant, unimportant situations consequently disregarded in the description.

As a reader, I am willing to assume that the right choice was made from the many visual facets that an item provides, and that all the facts registered by the observer's sensory apparatus would also be significant input parameters. I also rely on the observer's having made correct decisions as to what is susceptible to description and relevant.

Demands for Accuracy

The author has assigned a careful observer to describe the house, its structure and facture, and has led me to pose questions about the house. In doing so he has

trained the reader to be in control, conditioning him or her to check the accuracy and truthfulness of the description. Had he not started out with such methodical precision in his observation and description, he would not have established such stringent standards; then one would not pursue him with even more exacting methods of control to assess accuracy or inaccuracy. Somebody wanting to deliver a precisely stated message runs the danger of being subject to verification himself; in contrast, somebody coming with a nebulous, imprecise or merely vague message is in a better position, as the standard of his account is lower from the outset and he promises nothing that he cannot deliver.

Yet one can also demand more accuracy from somebody who wants to pass on a message that is only imprecise and vague.

An increase in the accuracy of the observation and the account can be achieved by both the person who compiled the observation protocol and the reader as well. The reader might have to be given the idea that such a precise recording of observations can actually obtain, but then in the controlling and know-it-all manner of one who wants to know even more precisely, he can insist on increased accuracy in the observation.

He will definitely be in a position, having the technical capacity, to claim the right to check the information and examine it as he receives the contents of the observation protocol. Then everybody else could increase the precision of his or her discriminatory ability. Accordingly, the reader can further improve his level of accuracy, and as a controller become presumptive, mercilessly critical, and exacting on receiving the message delivered.

The reader who is empowered to verify accuracy becomes a controller, but what does he or she have at his or her disposal for such verification? The description! How will the reader, how *can* the reader, verify its correspondence with reality? He could do so if a comparison could be drawn between an observation report, taken together with its descriptive protocols, and reality. Under what preconditions would this be possible? Only if he were to find conditions identical to those encountered by the initial observer.

Even though the reader is only an observer by proxy, a mere recipient of messages, he makes demands. The reader now calls for total, absolute precision.

Precisely because details are listed, what is omitted from the list and description becomes conspicuous through its absence.

Instead of being impressed by the narrative technique, which is a descriptive technique, the reader quickly becomes accustomed to this method and demands still more. He rightly insists on knowing what other visual characteristics the object possesses, since, despite precision of detail and concentration on visual phenomena, the author is incapable of saying everything. Nobody could list these characteristics in totality without relying exclusively on the establishment of the identity of an object by listing and describing all observable information. The list would be endless. Instead of being visibly impressed by the wealth of detail, the reader criticizes the incompleteness of the account of what is observed.

A Novel as Building Plans

From the outset I regarded the book as the building plans for a house, as instructions on how to reconstruct it.

The plans are provided by the description of the characteristics of the individual elements: a space, a roof shape, or the position of a column. Such characteristics are similarly the interface between and areas of contact with other elements. (Accordingly, the kitchen has a door to the dining room and a second door to the courtyard, from where there is also a door into the dining room, and so on.) They subsequently form the logical interfaces to the other parts of the building.

7-1. František Lesák, *Adhering to the Text* (series), 1995.

7-2. Lesák, *Adhering to the Text* (series), 1995.

My reconstruction work is based on an inductive, speculative approach in the course of which the separate elements of the house took shape according to the details given in the book until they matched the description. Only then were they assembled piece by piece, like building blocks, to give the whole house.

It is not difficult to complete the house with the text of the novel as a building manual. One only needs to read attentively, compiling and writing down details of the shape, position and surfaces of the elements of the house, and attribute this information to the individual spaces.

For example, thirty-four details of the bedroom are spread over nineteen pages of the book. Combined with the comments on the other rooms and objects, and proceeding logically—a room or an object in the room has specific characteristics that exclude other characteristics; its form of existence is, for example, deduced along the lines of: *if* x *and* y, *then not* z—the structure of the house slowly emerges as the first phase of the reconstruction process.

The Building Blocks are Complete

The novel is a set of building blocks, a jigsaw puzzle, where the individual pieces, individual events, described, only form a picture of the whole when put together.

Alain Robbe-Grillet has not left out anything that would be required for a reconstruction. In the cumulative descriptive process whatever is initially omitted is added later, even supplemented, in fragments. Determining characteristics of the individual elements are described piece by piece.

Equally additive is the process of collecting descriptive details scattered throughout the text, leading to the assemblage of the material and the physical manifestation of the building blocks, the fitting of the parts into a whole—into the complete form of the house.

Settling into the Copy of the House

I have completed a reconstruction of the house according to the author of the observation report: an extension of the house's existence in the novel into reality (fig. 7–1). This house now stands. It is empty, without occupants, as they were not included in the reconstruction. The reconstructed house is new; it is freshly completed. It does not yet have an aura, or any patina of age (fig. 7–2).

I regard the absence of occupants as problematic. They have a strong presence in the house as described: proportionally, they are just as involved as its structure and material texture. On the one hand, they have been a major factor not to be ignored; yet on the other, their absence is useful for an unprejudiced exploration of the rooms. I now look around the house properly, all alone. In the copy of the house I can study all of the views, angles, etc., that are not included in the text, the ones that the author still owes me.

Now the same house exists twice. I have built a house by completing a copy of an unknown building. I can either use it in the same way that it is used in the novel, or I can keep the functions open and use it in my own way without mimicking what anybody else does.

8. Nationality and Modernity in Early Twentieth-Century Baltic Art

S. A. Mansbach

We think of the three geographically small Baltic countries as a practically interchangeable set, a peripheral "inconsequence." But if Estonia and Latvia seem like little moons in a European cultural universe, this is no doubt because they have hardly been "free radicals," falling now under the German, and now the Russian, empires. (Lithuania is different: once the largest country in Europe [yes!], its historical connections were long with Poland.) Here, Steven Mansbach, a specialist in the modern art of Central and Eastern Europe—he is one of the strongest advocates for the East European origins of Dada—expands recent research on a certain conveniently cosmopolitan Latvian-Jewish woman sculptor who developed as an artist in Estonia, returned to Latvia, and finally moved to Britain, where she, Dora Gordine by name, attained considerable recognition. We learn, for example, of Latvian sculptors and artists with more Paris-attuned than Soviet-radical educations who became aware of Berlin modernism, even as the nationalism extending from World War I through the interwar period saw ancient Latvian motifs, newly archaeologically accessed, ornamenting a bourgeois china pattern in the 1920s. (Didn't Lenin say, around the time of the developments surveyed here, that nationalism ought to be merely the first stage of internationalism?) Branching out from the career of Gordine (whose bronzes, to my mind, resemble the Flemish Mannerist sculptor Adriaen de Vries), Mansbach is able to explore the rootedness of modernism in specific cultural conditions as well as the interplay of "home" cultural awareness in tandem with cosmopolitan modernism. — J.M.

The modern Anglo-Latvian sculptor Dora Gordine was fortunate, if not always politically so; and we are fortunate that her popular, if not avant-garde, success has occasioned research that increases our understanding of the situation of modern art in the early twentieth-century Baltic states.[1] Like others of her class, religious background, and national affiliations, Gordine (1895–1991) and her family were challenged by political instability, economic setbacks, and dislocation. Yet, as a young artist, she studied in some of Europe's most innovative and supportive

schools of the time; for early in the past century in the northeastern corner of Europe, education in the arts was remarkably sophisticated. In the newly independent Baltic states of Estonia and Latvia (less so in Lithuania), as well as in a recently consolidated revolutionary Russia, dynamic new forms, pedagogical methods, and public displays of modern art were being advanced.[2] Young Dora Gordine profited from this situation during her student years in what became Latvia and Estonia,[3] and it is to Baltic artistic achievement that I want to draw attention. What took place, particularly in the modest geographical compass of Estonia and Latvia in the early 1900s, had consequences in the world beyond, even in Britain, to which Gordine immigrated and where she achieved signal success as a broadly progressive sculptor.[4]

Despite profound differences in language, history, and ethnicity, the Baltic states pursued parallel paths in their attempts to fashion national identity through a modern art. These efforts were often opposed by an entrenched Baltic-German nobility and by expansionist Russian and later Soviet policies, not to mention the conservatism of indigenous groups. In Latvia and Estonia, the visual expression of nation and self drew on the respective countries' mid-nineteenth-century national awakenings, which in each case involved principally literary and musical manifestations of decidedly local language, literature, religion, and folksong. Newly validated national literature and music, celebrating native traditions, curiously created conditions for the emergence of more strikingly modern visual manifestations that would help delineate each nation's contemporary cultural identity while gaining international currency in the modern mainstream.

When Dora Gordine was born in Libau, in the province of Courland, Latvia had been a province of Russia for a century. The tsar's absolutist practices had rewarded the Baltic-German nobility and furthered the oppression of both indigenous Latvians and the Jewish middle-class minority to which Dora Gordine's family belonged. Her family, however, participated in the articulation of new possibilities through which to counter the political, commercial, and cultural disenfranchisement that Jews as well as Latvians had long endured.[5] For an aspiring native artist such as the painter and theoretician Voldemārs Matvejs (1877–1914), better known in the West by his Russian name Vladimir Markov, opportunities for training and public reception were fairly circumscribed, as the cultural authority of folk literature and folk music eclipsed the historical role of the visual arts. Yet this very absence of a commensurately rich visual heritage would prove advantageous for allowing Latvian artists to open themselves freely to outside influence. Thus modern art was part of the Latvian national awakening, as evidenced in the energetic canvases of Jānis Valters (1869–1932), and served as a foundation for later progressive painters and sculptors.

Although Latvia would prove fecund for modern artistic development, especially in sculpture, let us follow the Gordine family as it relocated to Estonia's capital at Tallinn only a couple years before the outbreak of the First World War. From the charting of Dora Gordine's early development by Jonathan Black, Brenda Martin, Frank Lloyd, and others,[6] much has been learned about Dora's and her older

sister Anna's early exposure to art. However, further attention to how this artistic environment developed might account for the considerable role of Latvian figures in the history of modern art in Western Europe, even in the United Kingdom.

In Estonia, the principal figure for the development of the modern visual arts was the painter Kristjan Raud (1865–1943), who, issuing from peasant stock and denied the opportunities reserved for the Baltic-German elite, came indirectly to art, securing admission to the St. Petersburg Academy only in his late twenties. Dissatisfied with Russian academicism, he matriculated at the Düsseldorf Academy and later enrolled in Anton Ažbé's art school in Munich, where he would have encountered many aspiring young modernists from Bohemia, Slovenia, Croatia, and Serbia, but also Russia—including Wassily Kandinsky. After a few years, Raud transferred to the Munich Academy and was influenced there by the Jugendstil aesthetic, especially for its suitability as a vehicle for the national symbolism he prized. While in Germany he also came into contact with Edvard Munch's work as well as the Impressionists', so that as a teacher, on his return to Estonia just before the Gordine family arrived there, Raud was in possession of a panoply of styles, and for many of the successors to the national-awakening movement, the innovative teaching methods he brought were appropriate means by which painters and sculptors could maintain a connection with the national past while affirming a commitment to their own time. His long, active career as a painter, as a graphic artist, and especially as a teacher exemplifies an influential Estonian artistic characteristic: a frequent oscillation between forms of consummate modernism and a distinctive neo-romanticism.

Raud's success in preparing Estonia to be receptive to Western influences while sustaining nativist themes had a profound effect, particularly on a band of slightly younger and aesthetically adventuresome artists, some of whom would found the first studio school in Tallinn. Much of the impetus for this pedagogical project and for the artists' search for new modern means of expression that nonetheless encompassed the past came from the influential literary group Young Estonia (*Noor-Eesti*).[7] This cohort of writers influenced every aspect of Estonian culture, as they sought a modern idiom to express the longing for independence not only from Baltic-German and Russian control but also from academic constraints. All were under the age of twenty-five at the time of the group's founding, just as the 1905 revolution against tsarist autocracy was changing the cultural and political impress of the Russian Empire, and their influence on the visual arts extended until at least 1914, when war broke out across Europe.

The years of World War I were trying for Estonia and for the Gordine family. Although Dora's brother Leopold had enlisted in the tsar's cavalry, the family appears to have had divided loyalties. The problem was that national independence was favored by neither of the principal warring parties: the tsar's armies sought to maintain the Russian empire, whereas the German forces, supported by many from among the resident Baltic-German population, had little interest in promoting Estonian liberation. Nevertheless, military reverses and privation on the Eastern Front would eventually advance the cause of independence-minded Estonians. The

Russian revolution of 1917, in no small measure provoked by the grave military situation, began the process that would help the Estonian people—and the nation's modern artists—to fulfill their national and cultural ambitions. With the Bolshevik seizure of power in St. Petersburg, Estonia was declared an autonomous republic of the new Soviet federation. However, in elections for the Estonian Constituent Assembly, held in the post-revolutionary month of November, the local Bolsheviks were resoundingly defeated; then, on February 24, 1918, Estonia declared national independence, but the following day German troops entered Tallinn, and the new government was forced into exile.

Peace did not come to Estonia, even with the eventual defeat of the Central Powers later that month, nor were the dreams of its committed intelligentsia realized. Within months of the German surrender, Soviet troops entered the country. With the assistance of the British fleet and volunteers from the Scandinavian countries and Finland, Estonian soldiers and irregulars drove out the invading Soviets in February 1919. No sooner were the Bolsheviks overcome, however, than a second German attempt was made to take control of the Baltic. Along with Latvian allies, who were facing approximately the same conditions, the Baltic natives succeeded in routing the Germans and their local supporters. One last attempt by the Russians to seize the northern Baltics was repulsed, and finally, on February 2, 1920, Bolshevist Russia was compelled to recognize Estonian independence.

During this prolonged and violent period of the nation's political birth, Estonia's small cadre of intellectuals and artists was waging a cultural war against defiant insiders as well as aggressive outsiders in an effort to articulate a modern art appropriate for a new nation. The center of these heroic efforts was not the capital but Tartu, a town with a distinguished tradition for supporting art. In this ancient university town located in the country's interior, prominent writers, painters, and sculptors gathered in 1918 to found an association for progressive Estonian culture, PALLAS. Its Pallas School, which was to become one of the core institutions of the Estonian avant-garde, promoted no single or dominant style of modernism; rather, it encouraged experimentation with the advanced idioms of Paris, Moscow, and Berlin, thus becoming possibly the most comprehensive academy of modernist effort in Europe. Eventually the Pallas group transformed itself into a loose Group of Estonian Artists, which, like its predecessors, rejected a formal program, instead collating, around 1924, a booklet of poems that served as a kind of informal apology for the geometric abstraction that engaged the interest of the associated sculptors. Henrik Olvi (1894–1972), for one, endeavored to translate the cubo-constructivist architectonics of contemporary painting into sculpture—significantly, in the traditional Estonian medium of wood rather than the decisively modern media of concrete, steel, or glass. Juhan Randsepp (1896–1984) was impressed by the authority of abstract forms to communicate a contemporary message of newness and rational possibility after the social and material destruction of the war years.

The Estonia in which the likes of Gordine encountered art was this environment of experimentation and, more significantly, tolerance of competing aesthetics and of both traditional and innovative strategies.

Yet, as impressive as the aesthetic inventiveness in Estonia was, it was outshone by nearby Latvia, which in the early twentieth century was the cosmopolitan center of culture in northeastern Europe. The Latvian national awakening, contemporaneously with Estonia's, had likewise been led by literary figures, followed by painters and sculptors animated to some extent by German romantic tradition. As the writers sought to codify national oral tradition into a modern, formalized idiom, ambitious artists sought to represent native themes in contemporary visual forms. A greater number of artists were based in Riga, the capital, than in either Estonian Tallinn or Tartu, and Latvia's sculptors and painters maintained a similar rich repertory of styles that fully exploited the currents seen elsewhere in Europe. For the artists of both nations, diversity, expressivity, and freedom of experimentation were common practice. Nonetheless, Latvia's singular war-time trauma deeply and distinctly affected the country's painters and sculptors.

As Latvia strove for independence during the second decade of the century, it was beset by the conflict of World War I, which affected the Baltic intelligentsia, and especially artists, in contradictory ways. Whereas many had risen up against the tsarist authorities and their Baltic-German supporters in 1905, and continued their opposition in the years immediately after, Latvians proved, however reluctantly, loyal to the tsar when the World War broke out in 1914. When the armies of the kaiser advanced into Courland, Latvia's history-rich western district and the original home of the Gordine family, more than a third of the population fled to Russia rather than live (again) under Teutonic domination. In 1915, eight regiments of Latvian riflemen were created, which soon distinguished themselves as the premier units in the tsar's army, notwithstanding the continued promotion of nationalist objectives. Most of the Latvian riflemen were socialist, and, in fact, in 1917 they provided the decisive military force in the Russian Bolsheviks' seizure of power.

Even more so than in neighboring Estonia, the period of 1918 to roughly 1920 witnessed relentless warfare between contending outsiders and among various political and social groups of Latvians. Artists, remarkably, played central roles in galvanizing the warring parties to heightened sacrifice and, it must be admitted, brutality.[8] Finally, in August 1920, six long years of war came to an end with Latvia consolidating its existence as an independent nation.

The wars had taken a heavy toll: massive destruction with havoc for an intelligentsia rent and demoralized by shifting allegiances. Both mourning for incalculable losses and celebration of future possibilities shaped the work of painters and sculptors. One of the first progressive artists responding to the challenge—to create a modern culture that could at once transcend the tragic past and serve an emerging new world—was Jāzeps Grosvalds (1891–1920). The modern art he witnessed in prewar study trips to Munich, Paris, Italy, and Spain, where he encountered fauvism, postimpressionism, and cubism, as well as naturalism, was wholly incongruous for an artist in war-ravaged Latvia. In his work exhibited in Riga, Grosvalds chose not to emulate Western trends but rather to articulate a native style appropriate to contemporary circumstances, as is evident in his *Refugees*, 1917 (fig. 8–1). Here, neither personal heroism nor national salvation is pictorially promised. The

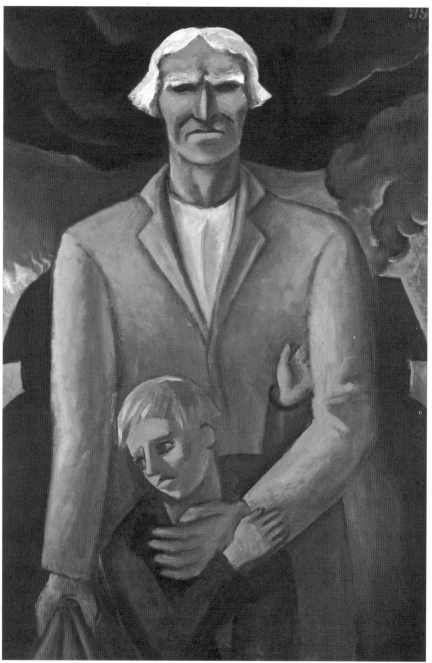

8-1. Jāzeps Grosvalds, *Refugees*, 1917.

devastation and dislocation of war are soberly rendered. The muted palette and hierarchy of figures encourages reflection rather than action. Similar in subject, mood, and historical resonance to Grosvalds' canvas is Jākabs Kazaks' (1895–1920)

version of *Refugees* (fig. 8–2), of the same year; but to people in the same sorrowful human plight Kazaks introduces clearly evident geometric and stereometric forms in the masklike visages of a refugee family. The device reflects the awareness of Latvian modernists of the time of African art,[9] and nowhere more so than in the sculptural work of the remarkable Marta Liepiņa-Skulme (1890–1962).

Marta Skulme belonged to the foremost family of Latvian artists, a family of four generations of painters and sculptors. In her *My Family* (ca. 1918) (fig. 8–3), the creative blend of the familiar and the exotic is registered in a strikingly primitive manner, and the woodcarving shows a debt to Picasso, Modigliani, and the contemporary Russians with whom she studied in St. Petersburg and Kazan. Sturdy tree trunks attest to the rootedness of the family, and nation, in native soil, and affirm an organic modernity with the family

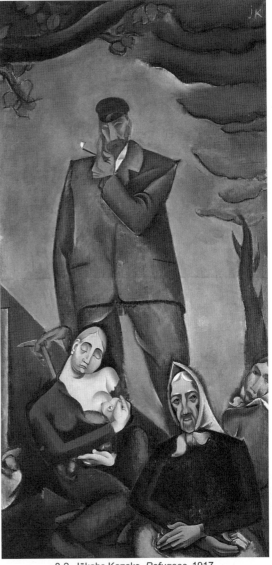

8-2. Jākabs Kazaks, *Refugees*, 1917.

members, as if masked, integrated with the enveloping tree trunk. Significantly, the reliance on natural materials—wood rather than steel, plastic, or concrete—and the use of traditional methods—carving rather than assembling—were conscious strategies to reconcile past and future, the local and the universal.

Skulme's modernist nativism was indebted to the reductive style and carving practices pioneered in Latvia by Teodors Zaļkalns, who trained first in the renowned Stieglitz Central School for Technical Drawing in St. Petersburg, and afterward in Emile Bourdelle's Paris atelier. Zaļkalns became committed to a simplified structure, often geometrically determined, through which to manifest the inner workings of

8-3. Marta Liepiņa-Skulme, *My Family*, c. 1918.

nature. In a series of "Fugitives" parallel to the simplified figures in Grosvalds' con-
temporaneous works on the same theme, Zaļkalns presented a tectonic three-dimen-
sional form—carved from native granite, and reduced to essential planes—such as,
as the sculptor once remarked, a Latvian peasant might set up in his barn. Within
two years, Zaļkalns had pushed his concern with spatial tectonics to a new level of
accomplishment in a series of busts of Russian composers, such as *Portrait of Modest
Mussorgsky*, 1918–19 (fig. 8–4), their planar forms summarizing basic physiognomic
details. Although the principal motive was the artist's own independent investigation
into the primary geometric structures that underlie nature and especially the human
form, the younger generation of avant-garde sculptors chose to see Zaļkalns' work as

8-4. Teodors Zaļkalns, *Portrait of Modest Mussorgsky*, 1918-19.

an aesthetic bridge between Latvia's indigenous modernist essays and the more developed cubist forms of France and Russia.

Hence, somewhat unintentionally, the classically trained and Renaissance-oriented Zaļkalns stimulated the advancement of three radical artists. Emīls Melderis, Kārlis Zālīte-Zāle, and Marta Skulme, too, like most of their colleagues,

received their education in Russia, principally in Kazan and in the various academies and schools of St. Petersburg—only afterward spending time in Berlin and, sometimes, Paris. Following in the path of Zaļkalns, Melderis wedded his work simultaneously to innovative forms and native (i.e., peasant) tradition. His black-granite portrait of the writer Pāvils Rozītis is a likeness of one of Latvia's most talented authors, presented with prominent eyes, smoothly attenuated mouth, and masklike, geometric nose against a broad, almost simian frontal plane—features exaggerated to resemble an iconic image from the primitive past. The bust is indebted both to Zaļkalns' *Mussorgsky* and, in the polished stone planes of the shoulders and neck, to the cubist figures of the Baltic-born Jacques Lipchitz (1891–1973). The archaizing of the figure, so typical of Latvian avant-garde sculpture of this period, can be traced in part to the painter-theoretican Matvejs, who, under his Russian alias of Vladmir Markov, published an enormously influential booklet for modern art throughout Europe: *Isskusstvo negrov* (in German, *Neger-Kunst*; "Art of the Black Man"), at St. Petersburg in 1919. Celebrating the wood sculpture of black Africa for the simplicity of its forms as stripped to the pith of plastic essentials, and for its consequent emotional resonance, Matvejs helped Latvia's sculptors achieve a monumentality and clarity in their work. He considered the double source of modernist inspiration, indigenous and foreign, to be most clearly manifest in the works of Zāle and Marta Skulme.

Like other modernists, Zāle overcame lingering Latvian antipathy toward Germany and went in 1922 to Berlin, where he spent two productive years. A series of quasi-abstract portrait busts and figures executed there visibly profited from his contact with the large number of Russian, Hungarian, and other Eastern European modern artists active in the German capital. Indeed, from the Russian-born Ivan Puni, around whom many from the Baltic States and Russia gathered while in Berlin, Zāle very likely received encouragement to experiment with constructivist forms, as is especially evident in facial details. Having studied in Kazan, Moscow, and St. Petersburg, with well-placed Russian contacts as a result, Zāle participated in Berlin's extremely influential First Russian Art Exhibition in 1922, where many visiting British artists and critics encountered his work. Equally important in locating Latvian modernism in the West—and, reciprocally, Western modernism in Latvia—was Zāle's role as an editor of *Laikmets Saturs* ("Contemporary Times"), whose four issues promoted an aesthetic synthesis derived from Matvejs. Through a fusion of the primitive spirit with the needs and tempo of modern times, Latvian artists maintained that academicism and the mechanical recording of reality could be overcome; and in response to the philosophic call for deeper, more searching representation, Zāle introduced to his audience the forms of synthetic cubism, along with those of its diverse avant-garde practitioners whom he came to know while in Berlin.

Also active in Berlin in 1922 was Liepiņa-Skulme, then on a German study trip to deepen her understanding of cubism and its successor styles, which, like most of her contemporaries in the Baltic and in Britain, she had known at home mostly at second hand, principally through journals published in Paris. With a plaster

Abstract Figure (fig. 8–5), clearly influenced by the work of Lipchitz, and an inventive bronze-patinated *Guitarist*, Skulme transcended her earlier wood carvings expressive of primeval Latvian tradition. The *Guitarist* achieves by means of cubism a creative conjuncture of Western modernism and native archaism. Throughout the first half of the 1920s, Skulme continued to make use of this twinning of traditions to elaborate a monumental style commensurate with the demands of the time. In 1924 and 1925, she began focusing her attention on designs for Riga's projected Freedom Monument, a symbol of national pride and political self-realization. A model (destroyed), displaying forcefully geometric architecture and prominent schematization of the figure, was one of her last works to synthesize cubism with representation and modernist means with a nationalist thematic. From this point on and through the 1930s, the cubism that had been instrumental in her maturation as an artist was replaced by figurative content similar in style and subject to those of Dora Gordine of the same period (fig. 8–6, Dora Gordine, *Javanese Dancer*, 1927–28; fig. 8–7, Marta Skulme, *Portrait of a Woman*,

8-5. Liepiņa-Skulme, *Abstract Figure*, c. 1922.

1930). What probably motivated the shift in Skulme's practice was her growing interest in archaeological finds on Latvian soil, an interest shared with other artists. In 1929, yet another competition was held, the third since 1922 and Skulme's entry for the Freedom Monument. This time Zāle proved victorious, though with a relatively conservative design whose most radical feature may be its nineteen-meter monolithic travertine column surmounted by a cast-bronze figure with the symbolic three stars of Latvia above.

Experimental forays into cubism were typical of several members of the Riga

Left: 8-6. Dora Gordine, *Javanese Dancer*, 1927-28.

Above: 8-7. Liepiņa-Skulme, *Portrait of a Woman*, 1930.

Artists' Group. But for Marta Skulme and her family members, cubism had been essential to the bringing about of modernism. In works on two-dimensional supports, on porcelain, and especially in the three dimensions of sculpture, the admixture of cubist-derived idioms and native references resulted in a visual vocabulary appropriate to a new nation and a new era.

Unlike the British situation, in which the public largely ignored modern artists' aestheticism, Estonian and Latvian artists shared a sense of national struggle with their public. The still all-too-recent World War, civil strife, and material privation affected the aesthetic freedom of artists as well as what audiences expected to see. Governmental grants for artistic education, seen as essential to the projection of a national self-image, were restrictive: governments offered generous support to artists if they were willing to forswear study sojourns to Germany and Russia, those erstwhile enemies but also the homelands of progressive art. In consequence, most of Estonia's and Latvia's art student travel in Dora Gordine's generation was by default to Italy, France, or Britain. In this regard, the Baltic artists differed from, say, Czech or Romanian artists, almost all of whom eagerly sought training in Germany, France, or Italy.

Discouraged during the early years of the 1920s from recognizing Russia or

Germany as beacons of modern culture, the citizens of the newly established Baltic Republics looked evermore to Great Britain, where the social-democratic Labour Party was emergent, as a living example of how a democratic state might function in the modern world. After all, the British fleet had helped secure Estonia's freedom from German and Russian advances during the long years of civil war, and it was the British government that persisted in its economic and political support of the young Baltic nations during their critical first years of independence. For Latvia, attachment to Britain might be characterized as an elective affinity. In addition to the material support that the Baltic state received from the then British Empire, even the imperial character of the donor would have mattered, as we shall see.

To supply a history for the newly constituted republic, Latvia sought out a glorious past. The government sponsored archaeological excavations to show that a "Latvian" presence in the region had predated both Teutonic and Slavic conquerors. Aspects of this campaign are even evident in the painting of porcelain plates by Romans Suta, in which the geometrically abstract forms, primitive figuration, and earthen hues of the border (fig. 8–8) can be related to pottery excavated in the early 1920s, with these design components brought forth in Paris, where the

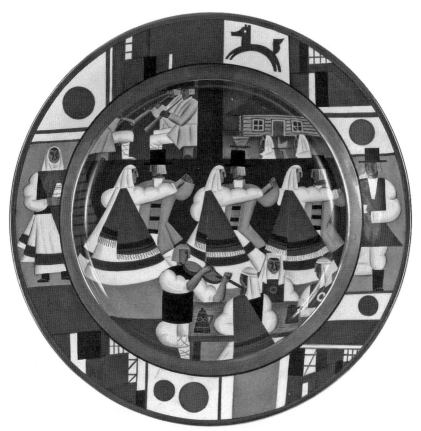

8-8. Romans Suta, porcelain plate (*Wedding*), 1925-26.

101

plate was exhibited at the 1925 Exposition Internationale des Arts Décoratifs et Industriels Modernes as an explicitly contemporary aesthetic invention.[10] But in addition to looking inward, or rather, downward, the new democratic Latvian government celebrated the remarkable "micro-imperial" activities of its province of Courland, the birthplace of Dora Gordine and home of her forebears, because in the seventeenth century its enterprising duke Jacob Kettler (reigned 1641–1682) had established a modest but profitable empire with colonies in the New World and Africa. Competing with Dutch, British, French, Spanish, and Portuguese colonial empires, the tiny Duchy of Courland held for much of the century the island of Tobago, in the Caribbean, as well as creating a trading and colonial presence in Gambia on the west coast of Africa. In the early 1920s, the duchy's former glory gave the new nation a unique chapter for its history books, one sometimes casting Latvia as an imagined cousin of the England of the British Empire.

Britain was more generally a model for the Baltic states, not only for material purposes but also in that the United Kingdom was perceived as the exemplary political democracy, with its long history of freedom and comparatively modest territory, and furthermore for its educational system, especially for the liberal arts at Oxbridge and for engineering and the sciences in Scotland (where Dora's brother Leopold had studied). By contrast, America, which had inspired both Soviet Russia and Weimar Germany with its staggering productivity and inventiveness, was perceived as too historically different to serve as a model of emulation. Despite art's being the one respect in which the Baltic republics did not see Britain as a paragon, Dora Gordine established herself in England as an artistic figure, as the realist sculptor Benno Schotz (1891–1984) did in Scotland, having emigrated to Glasgow in 1912 from his native Estonia. But from the Baltic perspective, these figures were rather exceptional and not the most radical. Because most of Estonia's and Latvia's artists felt that Britain remained artistically provincial, few established productive relationships with London's dealers or fellow artists there. However, England was to become the European center of activity for Central and East European artists from the mid-1930s onward: the founder of the Bauhaus, Walter Gropius (active in Britain from 1934 to 1937); the Hungarian-born László Moholy-Nagy (1935–1937); and Naum Gabo, from Russia (1935–1946), were among the hundreds of avant-garde sculptors, designers, painters, and architects who sought refuge from Nazi (or Stalinist) totalitarianism in Britain.

For Baltic sculptors, however, fate was mostly unkind. Already by the mid-1930s, local artists were discouraged by the authoritarian regimes in Estonia and Latvia from displaying their work. The progressive associations that had sustained a modern cohort of painters and sculptors were in advanced decline, and a severe economic depression curtailed governmental support of art. Nonetheless, work for private clients continued. For these and other reasons, the majority of the respective nations' sculptors and painters elected to remain in Estonian Tallinn or Latvian Riga. This proved a fateful decision: When the armies of the Soviet Union unexpectedly surged across the border in autumn 1939, the artists, along with the rest of the citizenry of these small republics, were pinioned between the aggressive regimes

of a resurgent Germany and a renascent Russia. Reprising the history of twenty years before, the two Baltic nations were repeatedly invaded by both principal contending powers, with factions of Latvians and Estonians not infrequently allying themselves with one power or another for local advantage.

As before, all the Baltic countries suffered grievously. Now, however, the destruction of the Second World War, unlike that of the first, was not followed by a consolidation of newly independent republics where art was given heady responsibilities and singular opportunities. Rather, the post–World War II reality was a period of severe constraints on aesthetic as well as political expression. It would be a good number of years before a new generation of modern Estonian or Latvian artists could again feel free to pursue new art in Northeast Europe, or to enjoy the opportunities that Dora Gordine had been offered.

9. Framing Movement: Kirchner in Berlin

Charles W. Haxthausen

When Georg Simmel's "The Metropolis and Mental Life" (1903) analyzed the impact on consciousness of the agitating bustle of the modern city, such destabilizing activity was already apparent thanks to the French Impressionist painters of the 1860s and '70s. Provoked to scrutinize the great German Expressionist Ernst Ludwig Kirchner's Berlin cityscapes by a critique of the most famous German Expressionist film, The Cabinet of Dr. Caligari *(1920), Charles Haxthausen (long concerned with Carl Einstein as an insightful Expressionist critic aware of French art) has a revelatory insight. In one work in particular,* Friedrichstraße, 1914, *the process of describing movement is seen passing over into a conveyance of movement direct and full-fledged. It is as if Kirchner were poetically challenging the new "spatial dynamism," as Panofsky put it, of the literally moving "motion picture" or "movies." And it is still exciting today, a century later, to see how Kirchner could suddenly, on a certain day, in a certain work, precipitate out of his rendering a conviction of immediate kinetic activity much more expressionist than in the static scenography of* Caligari *(and thus did Kirchner's expressions of 1914 become a formidable precedent to the Abstract Expressionism of 1954). I am reminded too, that as Kirchner was painting* Friedrichstraße, *Heinrich Wölfflin must have been working on his* Principles of Art History *(1915): there the sea change in Renaissance "tactile" to more modern Baroque "visual" form evokes not only Monet's Impressionism as suited to the urban hubbub but also the motif of a wheel turning too fast to have visible spokes in the spinning-wheel of Velázquez'* Las Hilanderas *(which "Mark" Haxthausen reminds me that even today I remember Meyer Schapiro's referencing fifty years ago in a course in Impressionism). — J.M.*

———

In a 1970 newspaper essay marking the fiftieth anniversary of the ground-breaking expressionist film *The Cabinet of Dr. Caligari*, the German film critic Frieda Grafe made a provocative observation. The real authors of the film, she wrote, were those who were responsible for its fantastically distorted sets, the art director Hermann Warm and the painters Walter Röhrig and Walter Reimann; "the director Robert Wiene was not much more than a studio functionary." In the film Warm was

able to realize his concept of film as "drawing brought to life." Yet for Grafe such a conception was marred by a fundamental contradiction:

> When one senses movement in expressionist paintings it has to do with the frame, with the arrested movement that threatens to explode it, with the tension between stillness and movement. To animate this kind of painting amounts to eliminating its basis. Just as photography surpassed naturalism, in Caligari the painting of movement is extended *ad absurdum*.[1]

Let me put Grafe's argument in a slightly different way: in Caligari the set designers adopted formal devices that expressionist painters had deployed to generate movement in their static medium. The introduction of actual motion into a filmic tableau undermined these devices' very reason for being, rendering them pointless, and betrayed a fundamental misunderstanding of the cinematic medium.

Grafe made no mention of Ernst Ludwig Kirchner or of any other painter in her short newspaper piece, but her observations conjured up for me Kirchner's remarkable paintings of urban life from 1913–15, the years of the Berlin street scenes that were the subject of a 2008 exhibition at New York's Museum of Modern Art.[2] His paintings, more than those of any other artist, exemplify what Grafe called that "arrested movement that threatens to explode" the frame, that "tension between stillness and movement." Grafe's remarks, moreover, call to mind how central the issue of movement was in visual representations during the years before the First World War: one thinks inevitably of the chronophotographs of Etienne-Jules Marey; the paintings and sculptures of the Italian Futurists, such as Umberto Boccioni, Giacomo Balla, and Luigi Russolo; the writings of Henri Bergson; but also of the young medium of cinema, sometimes referred to in German during these years as *Bewegungsbilder*, or, translated literally, "movement-images."[3] Kirchner's Berlin paintings are seldom discussed in this context, and that is precisely what I want to do here, hoping to demonstrate that his own approach to this problem was singular and thoroughly original within the pre-War avant-garde, as he produced some astonishing paintings that merit a privileged position in the history of the period.

———

"My painting is a painting of movement," Kirchner wrote in a sketchbook at the end of the 1920s.[4] He later elaborated on this declaration:

> I was born near a railway station. The first thing in life that I saw were the locomotives and trains in motion, I drew them when I was three years old. Perhaps that is why it is above all the observation of movement that stimulates me to creation. From [movement] comes the intensified feeling for life that is the origin of the work of art. A body in movement shows me many different aspects, these fuse within me to a unified form, to an inner image.[5]

Given the centrality that Kirchner attributed to the experience and representation of movement in this and other texts, it is surprising that so few commentators have examined this aspect of the Berlin street scenes. Together, the paintings chart a significant development in this regard; indeed, the series can be seen as a kind of laboratory in which, using a single theme, Kirchner experimented with various pictorial devices for evoking the flux and vitality of contemporary urban life.

In the paintings of his early, Dresden, period, movement may be suggested by Kirchner's motifs, as distinct from his formal means, or, alternatively, by a fluid and rapid execution, especially in his drawings, lithographs, and etchings, or through seizing on intensely rhythmical movements, as in his *Panama Girls*.[6] These motifs become even more prominent during Kirchner's years in Berlin, to which he moved from Dresden in October 1911. It is there, stimulated by the urban energy of the German capital, that he responded passionately to the challenge of capturing the dynamism and *perpetuum mobile* of modern urban life in a visual medium that was, in contrast to the ascendant and then not yet quite respectable medium of cinema, inherently static. We can see such efforts already in Kirchner's paintings from 1912, his first full year in the city.[7]

Consistent with his statement linking his feeling for movement with his childhood drawings of locomotives, one of the ways in which Kirchner sought to evoke movement in his paintings and prints was through the inclusion of vehicles—trains, trams, automobiles, and horse-drawn omnibuses, all of which were a feature of the Berlin streets at the time that Kirchner was representing the city. The young architect Walter Gropius wrote that "the motif of movement is the defining motif of our time." The automobile, train, and airplane had "become symbols of speed. ... Technological form and artistic form have fused into an organic unity."[8] The critic and theorist Georg Lukács remarked that, thanks to the cinema, "the automobile has become poetic, as in the romantic excitement of a speedy auto chase."[9] Kirchner clearly shared this feeling for the poetry of these new motor vehicles, including them in his paintings and prints when nearly all of his contemporaries were still ignoring them; we find more trains and trams in his works than in those of any other major artist of his time; trams appear already in the paintings of his Dresden years, including the first of his street scenes.[10] He incorporated various vehicles in five of the eight Berlin figural street scenes—a horse-drawn omnibus in *Berlin Street Scene* (we can see a man boarding it, the number 15, on the left and the horses on the upper center; fig. 9–1), a tram in *Leipziger Straße with Electric Tram,* and automobiles in *Five Women on the Street,* in *Street, Berlin* (fig. 9–2), and in *Friedrichstraße* (fig. 9–3).[11] I suspect that Kirchner intended these to function as signifiers of movement, of urban flux and dynamism.

In *Friedrichstraße,* which I reckon to be either fourth or fifth in the sequence of Kirchner's seven large Berlin street scenes, and which he cited as one of the three he believed most successful,[12] there is something new: the rear section of the automobile that is rolling out of the frame is no longer merely a *signifier* of movement; its wheels, by means of their dynamic, circular forms, *generate*

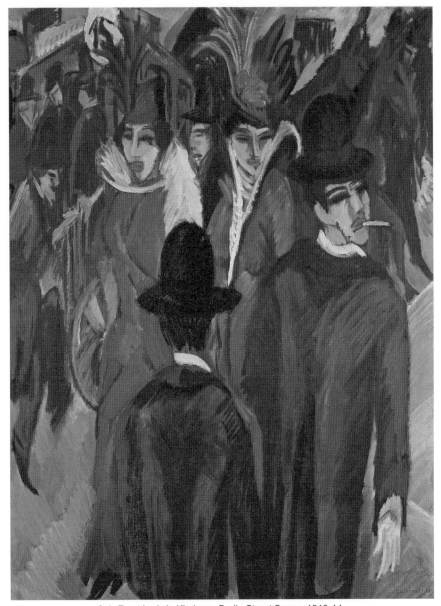

9-1. Ernst Ludwig Kirchner, *Berlin Street Scene*, 1913-14.

movement, injecting a surge of energy into the composition. Their centrifugal force sweeps up the women and men in its current, focusing and intensifying their forward thrust. This movement is reinforced by the parallel curves of the men's legs in the background, which rhyme with the hatchings that are spun off the rotating wheels and even with the sweeping arc of the curb. One need only compare the painting with the three other Berlin street scenes with vehicular motifs to see the much greater dynamism of *Friedrichstraße.*

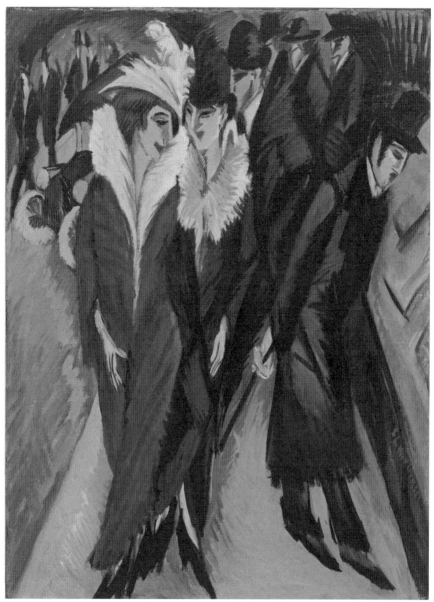

9-2. Kirchner, *Street, Berlin*, 1913.

This shift from relying on *images* of vehicles for the suggestion of motion to creating an effect of movement in the picture by plastic means is carried even further in the largest and most ambitious of Kirchner's Berlin street scenes, *Potsdamer Platz* (fig. 9–4). Here it is all the more striking since in *Potsdamer Platz* not a single vehicle is to be seen—a noteworthy absence since the area had supplanted Unter den Linden and Friedrichstraße as the veritable center of Berlin and was the busiest intersection in the capital, if not in Europe—by 1910, five thousand trams a day

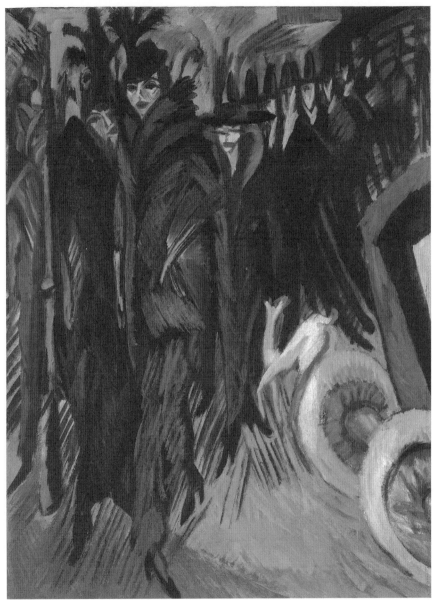

9-3. Kirchner, *Friedrichstraße, Berlin*, 1914.

were crossing the square.[13] Might Kirchner have omitted vehicles in this painting because, building on *Friedrichstraße*, he had discovered that he no longer needed to include vehicles as signifiers of motion? That he had now discovered a strictly *formal* means of generating movement in the composition itself? Certainly the dynamic circular motif assumes even greater prominence in *Potsdamer Platz* than in *Friedrichstraße*. Here we have the traffic island tilted up to such a degree that it is almost parallel to the picture plane—it becomes like a millwheel, vigorously

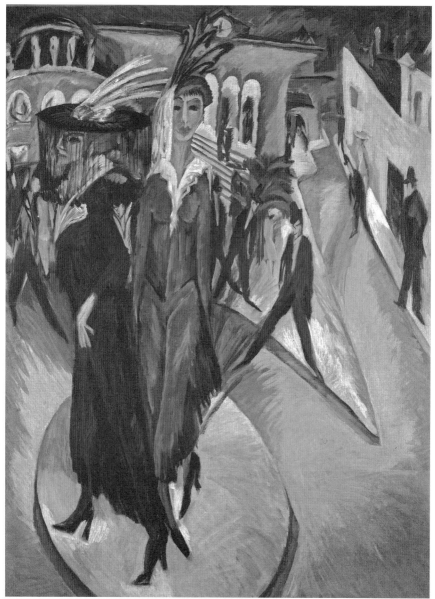

9-4. Kirchner, *Potsdamer Platz, Berlin*, 1914.

churning out currents of surface energy. The counterclockwise motion seems propelled by the spiky shoes of the woman in black, sucking the attenuated legs of the two men traversing the street into its vortex.[14]

Yet the most remarkable work in this regard, and the most dynamic, does not belong to the series of Berlin street scenes. It is *Circus Rider* (fig. 9–5), a painting that in ambition and scale forms a pendant to *Potsdamer Platz*—at 2.0 by 1.5 meters each they are Kirchner's largest canvases of 1914.[15] As I have written elsewhere,

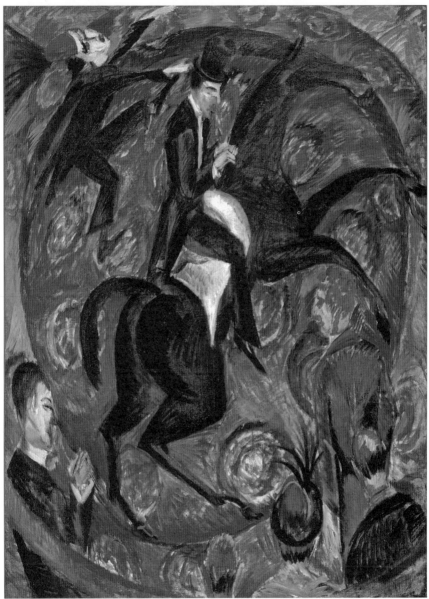

9-5. Kirchner, *Circus Rider*, 1914.

Kirchner "has reduced the size of the circus ring and tilted it so drastically that it becomes a vertical plane. Thus it appears not as the ground on which the rider and clown perform, but as a prop in their act, a circular treadmill spun by the horse's hind legs, which seem to push against what is, after all, the side wall of the arena! Magically, the clown soars above the elegant rider."[16] Working counter to this swirling motion are the curved brushstrokes, producing a counterclockwise eddy that moves against the rightward thrusts of clown and rider, with a velocity that

appears to distort the features of the spectator on the lower left, producing a powerful churning motion.

Kirchner has deployed another important formal device here, which has to do not with the movement of the object but with the movement of the viewing *subject*. In a long, undated autobiographical text from sometime after 1926, he wrote: "One considers a picture to be what one can see from one point in space with a single view. That is a major limitation. This is how I do it: I move and collect the sequence of images within myself to an inner image. This I paint."[17] In other words, Kirchner makes it clear that he is not only capturing the movement of the objects themselves, but also incorporating his own changing relationship to them as he moves through space. As early as 1912 he had been drastically tilting up the ground plane to achieve a taut two-dimensional structure in his paintings, but a comparison of *Circus Rider* with his earlier *Woman Circus Rider* of 1912 clearly shows the difference in approach—and in effect; the earlier picture presents a single viewpoint, adapted to the exigencies of the picture plane;[18] in the later painting there is no fixed vantage point: we look straight on at the figure of the circus rider—his elegant black silhouette evokes Greek black-figured vase painting—even as we seem to be catapulted upward to look down, as though from a lofty trapeze, on the crowd and arena. The dynamism of the whole is enhanced by our seeming to move in space, viewing the scene from drastically shifting perspectives, not merely moving around the motif laterally, as happens in cubist painting, but *vertically*, sometimes assuming viewpoints that Kirchner could never have experienced himself.

Arguably the richest, most brilliant example of Kirchner's use of multiple viewpoints is his *Belle-Alliance Platz in Berlin*, also of 1914 (fig. 9–6). The motif itself, a public plaza at the southern end of Friedrichstraße, is entirely level terrain. It is in the form of a rondel, or circular park, graced by a Corinthian column crowned by a winged victory commemorating the Battle of Waterloo, in which the Prussians were allied with the British in the defeat of Napoleon. Not only has Kirchner tilted the ground plane upward, emphasizing the circular shape of the rondel; he has also incorporated a number of different viewpoints: we gaze up into the vaulting of the arcade on the right, while viewing the opposite arcade on the left from a slightly elevated angle, then soaring sharply upward to look down onto the circular plaza, even as the zooming perspective of the buildings on the far side of the square places us back at street level. Kirchner's elevated viewpoint achieves two things here: by tilting the plaza upward he creates a dynamic circular movement in the painting, but the experience of dynamism also extends outside the picture to us, its viewers. Although our bodies are stationary, we nonetheless feel vicariously jerked about as our eyes register these sharply conflicting perspectives.

This effect anticipates a passage in Erwin Panofsky's 1936 essay on film, in which he cited as one of the "unique and specific possibilities of the new medium" the "dynamization of space." In a movie theater "the spectator has a fixed seat, but only physically, not as an aesthetic subject. Aesthetically, he is in permanent motion, as his eye identifies itself with the lens of the camera which permanently shifts in distance and direction."[19] This description is equally apt for Kirchner's *Belle-Alliance*

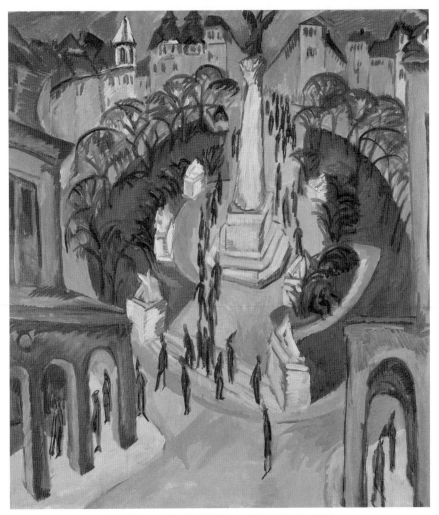

9-6. Kirchner, *The Belle-Alliance Platz in Berlin*, 1914.

Platz, even though his painted image remains fixed. Moreover, in the years in which Kirchner was achieving these effects the "dynamization of space" described by Panofsky had not yet been fully realized in cinema: montage was still in a primitive stage; the movie camera was still essentially static, unless it was attached to a moving vehicle, as in the cinematic "phantom rides" of that era, or in certain chase scenes that incorporated those same jolting shifts of viewpoint that characterize Kirchner's boldest Berlin paintings of 1914.[20]

Kirchner used this multiple perspective to brilliant effect in *Potsdamer Platz* (fig. 9–4)—indeed, the painting can seem almost like a composite image, a montage of different views that have been compressed and fused together into a continuum. We see this more clearly when we look at a photograph of the square more or less as it looked when Kirchner painted it and from the street-level perspective from which

he would have viewed it (fig. 9–7). The tripartite station façade has been reduced to only its central section, its two-storied loggia in turn reduced to one story rendered in the reddish color that was present only in the flanking wings. Tightly juxtaposed with this façade was the newest architectural addition to the square, Haus Potsdam, opened in 1912, which included a cinema and the two-story, 2500-seat Cafe Piccadilly. Kirchner eliminated the street, Köthener Straße, which separated the two structures, placing this building cheek by jowl with the central station façade, rhyming the base of its cupola with the shape of the woman's black hat. Although the cityscape is laterally compressed, the beholder's viewpoint is again distended vertically. We encounter the central figure straight on, at her eye level. Yet as we look upward to the cupola of Haus Potsdam on the left, as though from street level, the ground seems to tilt precipitously beneath us; then on the right we soar upward to gain an elevated view of the receding street, with the human figures drastically reduced in scale.

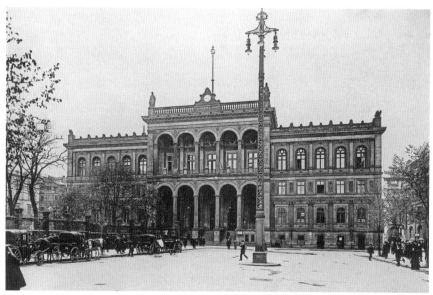

9-7. Max Missmann (photographer), *Potsdamer Bahnhof, Berlin*, 1910. Postcard.

I have thus far had little to say about an additional factor that gives Kirchner's paintings a sense of movement—his long, rapid, often spiky brush strokes function not merely as an indexical trace of the painting's execution but inject a directional graphic energy into the composition (he thinned his paint with benzene to achieve greater fluidity in handling, adding wax to give it a matte finish[21]). We have already noted this quality in *Friedrichstraße*, and here in *Potsdamer Platz* we see a vortex of strokes whirling around the circular traffic island.

This dynamic *facture* is especially striking in Kirchner's third street scene from 1914, *Two Women on the Street* (fig. 9–8). Here, too, he dispenses with vehicular signifiers of movement, relying instead, like a de Kooning *avant le lettre*, on the fierce velocity of his brushstroke, its force so powerful it seems to distend the

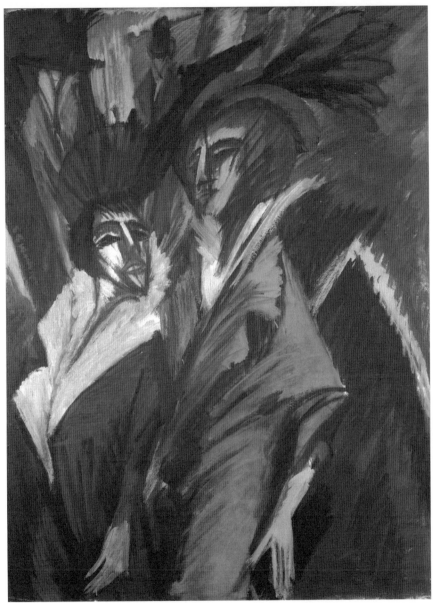

9-8. Kirchner, *Two Women on the Street*, 1914.

features of the woman in orange. Instead of introducing a churning, centrifugal motion to generate movement in the picture, Kirchner distorts his forms to subordinate them to a pervasive pattern of dynamic chevrons. Notice, too, how the pink curb has been heaved up, parallel to the picture plane, producing an upward counter-thrust to the downward thrust in the figures. This device Kirchner also used in his seventh and last Berlin street scene, and his only one from 1915, *Women on the Street*.[22]

As I noted at the beginning of this essay, the representation of movement was an intense preoccupation during the pre-War years, and in conclusion I want briefly to situate Kirchner's Berlin paintings in this larger context. The chronophotographs of Marey, which captured bodies in motion a fraction of a second apart, inspired Marcel Duchamp, the Futurists, and others to apply this knowledge to the static art of painting. Marey probably inspired Henri Bergson to wrestle with the problem of the relation between movement, perception, and thought in his *Creative Evolution*, published in 1907. There he observed,

> The body is changing form at every moment; or rather, there is no form, since form is immobile and the reality is movement. What is real is the continual *change of* form: *form is only a snapshot view of a transition.* Therefore . . . our perception manages to solidify into discontinuous images the fluid continuity of the real [original emphasis].[23]

Yet Bergson's ultimate model in thinking through this issue was not Marey but cinema, the film strip of still images to which, as he puts it, movement has been added by the apparatus, the cinematograph:

> Take a series of snapshots of [a] passing regiment and . . . throw these instantaneous views on the screen, so that they replace each other very rapidly. This is what the cinematograph does. With photographs, each of which represents the regiment in a fixed attitude, it reconstitutes the mobility of the regiment marching. It is true that if we had to do with photographs alone, however much we might look at them, we should never see them animated: with immobility set beside immobility, even endlessly, we could never make movement. In order that the pictures be animated, there must be movement somewhere. The movement does indeed exist here; it is in the apparatus.[24]

Although Bergson acknowledges that everything is in flux, in this passage from *Creative Evolution* he seems to assume that the viewer is *passive*, immobile. This corresponds to the model adopted a few years later by Duchamp (in *Nude Descending a Staircase*) and the Futurists for representing movement; the viewing subject is static, the object is in motion. Duchamp complicated this somewhat with his *Sad Young Man on a Train,* in which he described two movements, "the idea of the movement of the train, and then that of the sad young man who is in a corridor and is moving about; thus there are two parallel movements corresponding to each other."[25] Nevertheless, although the implied viewer may be moving with the motion of the train, his body is presumed to be otherwise static.

One wonders if the static position of the cameras that recorded Marey's chronophotographs and the usually fixed camera of early cinema had influenced Bergson's speculations here, for in an earlier book, *Matter and Memory* (1896), he had posited an *active*, mobile perceiver, whose body acts on the objects perceived: "I note that the size, shape, even the color, of external objects is modified as my body approaches or recedes from them," he wrote. "[Objects] send back, then, to my body, as would

a mirror, its eventual influence; they take rank in an order corresponding to the growing or decreasing powers of my body. *The objects which surround my body reflect its possible action upon them.*"[26] This is an experience conveyed by Robert Delaunay's dynamic, fractured, and ultimately fantastic images of the Eiffel Tower done from 1910 to 1911, in which the structure seems to be viewed from the abruptly shifting multiple vantage points of someone who has conquered gravity—here we also find that vertical distension of the viewing field that Kirchner will adopt a few years later. Writing in the 1920s, the German critic Carl Einstein interpreted the Cubism of Braque and Picasso phenomenologically, as the product of a succession of perceptions of the motif by the artist moving around it in space. [27] Yet in the case of Delaunay, Braque, and Picasso, the objects perceived by the implied mobile subject are essentially *static* (I concede that Delaunay's clouds imply movement, but *they* are not the main motif here).

With Kirchner, on the other hand, what we get is an attempt to represent the movement of the perceiving body in its shifting relation to other moving objects, in pictures that, far from being the immobile "snapshots" that Bergson saw in the optically static image, vividly evoke the passage through time and space even as they are contained within a static frame. Both subject and object are in movement, interacting in a nervously charged yet ecstatic dance, and this dynamic interaction distinguishes Kirchner's representation of movement in these Berlin paintings from the approaches of his contemporaries. As the artist himself claimed, this constitutes a high point of his artistic achievement—and to that I would add, of early modernism as well.[28]

10. Utopian Violence: El Lissitzky's
Victory Over the Sun

Christine Poggi

One of the most fascinating themes of classic early modernist art is the shift between Kazimir Malevich's formalist Suprematism in painting—which grew out of Russian Futurism before the 1917 revolution and managed to continue in what could be called a "dialectical idealist" manner through the Civil War—and the Constructivism, more materialist, though less and less dialectically so, of what became in late 1922 the Soviet Union. El Lissitzky, Malevich's erstwhile disciple, holds special interest in this as a transitional figure. Now Christine Poggi's perspicacious visual scrutiny shows a 1923 suite of Lissitzky prints, of which only one (The New Man) *has been well known, having something in common with a significant current in Russian art today: thematically extending Malevichian modernism while "roasting" it as precedent. Indeed, this telling set of costume designs for a puppet version of the Suprematist iconoclastic "opera"* Victory Over the Sun, *paralleling, character to character, Malevich's own costume designs, amounts critically to a spoof or burlesque, given the original as already Futuristically "in the face" of a normal, prerevolutionary audience. As to the great transition: these designs were concieved around the time Lissitzky had come up with his profoundly transitional "Proun," or "Project for the Affirmation of the New," a modality conceived as "transfer station" between painting and architecture, on which he addressed the Institute of Artistic Culture, Moscow, home of the most hard-nosed Constructivists, in 1921. Then in 1922, soon before publishing the drawings as a print portfolio in Germany, he and Ilya Ehrenberg started the periodical* Object, *whose outlook was itself "a compromise," according to Christina Lodder, between fine art and extreme Constructivist positions* (Russian Constructivism, 1983). *Poggi's analysis of Lissitzky's designs shows them not as mere toys sending up already playful characters, but instead as comprising a plateau of transition out of his "in-between" ideo-aesthetic position into full-fledged Constructivism as of the later 1920s. — J.M.*

———

The Russian pavilion at the 2009 Venice Biennale presented a group exhibition under the resonant title "Victory Over the Future."[1] Referring to the legendary Futurist opera of 1913, *Victory Over the Sun*, the pavilion cast a retrospective, satirical eye on the utopian ideals of the early twentieth-century avant-gardes, especially Futurism and its offspring, Suprematism. As such, the pavilion participated in the widespread interest among contemporary artists in the critical potential of the reenactment, which has spurred the restaging of many paradigmatic avant-garde works of art in circumstances that put them in a new light.[2] Raising issues of historical (re-)construction and personal memory, identification and transformative agency, these reenactments comment on both past and present, sometimes blurring their outlines, sometimes allowing us to measure the distance that opens between them.[3]

Andrei Molodkin's installation *Le Rouge et le Noir*, for example, invoked the title of Stendhal's novel of 1830 and its incisive portrait of Julien Sorel's pursuit of power and wealth, even as it gave a new, contemporary meaning to red and black. On entering the exhibition room, the viewer encountered a set of long plastic tubes pumping blood-red liquid and black oil through two twelve-inch, translucent casts of the *Nike of Samothrace*, so that this symbol of victory seemed to pulsate with a strange, simulacral life. Yet the low rumbling of the electric pumps and the exposure of the tubes transmitting the fluids revealed the simple mechanism of this illusion. Three magnified images of the two Nikes projected onto a large screen further enhanced the sense of Wizard of Oz–like spectacle, creating a grandiose, multiplied vision that nonetheless remained hygienically insulated, unavailable to touch or smell. Juxtaposing the red and black Nikes, the images on the screen conjured forth the relentless flow of oil and blood, rendering explicit the political and economic nexus of petrol and violence, life and death. F. T. Marinetti had famously invoked the *Victory of Samothrace* in the first Futurist manifesto of 1909, declaring its beauty to be superseded by that of a speeding racecar.[4] Here the *Victory* returned as an uncanny vehicle propelled into the future by sordid dreams of wealth and power as much as by gasoline.

In a more whimsical but no less ironic vein, Pavel Pepperstein transformed the abstract utopian emblems of Russian Futurism and Suprematism into absurdist flags, monuments, stadiums, bridges, airports, and cities of the future. Kazimir Malevich's nonobjective, functionless *Black Square* of 1915 makes an unexpected appearance as a mute, mysterious sign of utopia in *The Monument to the Biosphere and "The Black Square."* Rendered in delicate watercolor, ink, and sometimes ballpoint pen on paper, and with quaint handwritten titles and charming slogans, Pepperstein's series titled *Landscapes of the Future* mocks the heroism of Futurist and Suprematist rhetoric and formal devices as if they constituted a kind of anachronistic science fiction. His *Manifesto del Retrofuturismo* (fig. 10–1) assembles a crowd from familiar characters in fairy tales, children's books, and cartoons, including an escargot, a dinosaur, a Musketeer, a saint, a wizard, a fish, and a young girl who may be Alice from *Alice in Wonderland*. A cat reads the manifesto before this delightful but hardly revolutionary multitude as strange, toy-like space ships and

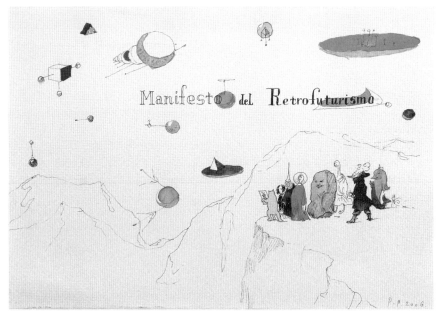

10-1. Pavel Pepperstein, *Manifesto del Retrofuturismo*, 2006.

satellites whizz through the sky. At the Russian pavilion, these watercolors were hung on the black walls of a dimly lit, black, cubic room that contained another black cube at its center. Against these dark walls, small neon signs in blue announced the dates—mostly far in the future—of the scenes depicted in the drawings. This installation, an inversion of the modernist white cube, evoked the utopian space of Malevich's *Black Square*, or perhaps the sunless universe dramatized by the Futurist opera *Victory Over the Sun*, but here the black cube had morphed into a kind of subterranean disco, with Pepperstein's rap music blaring from the corner speaker.

Such works convey a keen sense of negation mingled with lingering fascination as they return to the symbols and monuments of the Russian avant-gardes of the past in order to reposition them as emblems of *retro-futurismo*. It is as if the future imagined by Russian Futurism, Suprematism, and Constructivism could take on a sinister or fantastic status only once its dreams of mastery over nature and time had been unmasked by the disastrous history of Soviet Communism and Stalinism.

This is, of course, not the first time that Russian Futurism has been the subject of critical reframing or even negation. In this essay, I will focus on an earlier instance in which avant-garde Futurist themes and formal idioms were subjected to strategic reenactment and made newly relevant to a different historical moment. El Lissitzky's 1923 lithographic portfolio of designs for a new production of *Victory Over the Sun* (fig. 10–2) constitutes an important exemplar of how an artist working in the period following the 1917 October revolution in Russia reinterpreted the founding myths of his Futurist predecessors. This portfolio, executed for the Kestner-Gesellschaft while the artist was living in Hanover, itself reprised a series of gouache and ink drawings with collage of 1920–21. Lissitzky had made these

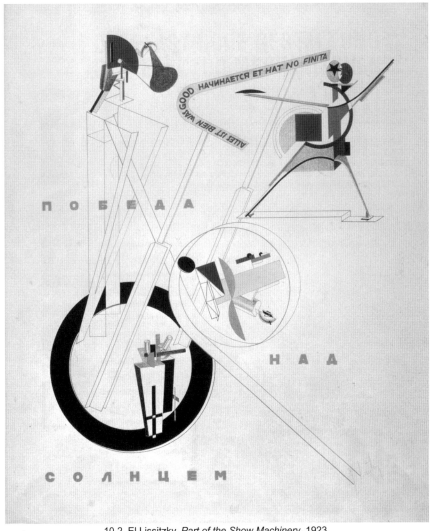

10-2. El Lissitzky, *Part of the Show Machinery*, 1923.

drawings in Vitebsk, where in 1919 he had assumed the post of teacher at the People's Art School along with his friend and colleague, Malevich. If the gouache and ink drawings addressed an initial audience that included Malevich and the group of students who gathered in 1920 under the title UNOVIS (Champions of the New Art), the lithographs were intended to appeal to an international set of private collectors attuned to Constructivism as a style and sympathetic to Soviet Communism as a social ideology and practice.

Lissitzky's drawings, and the later set of colored lithographs, picture a set of puppet figurines intended to be realized in the form an electromagnetic show. Like the 2009 Russian pavilion, the portfolio takes its title from the 1913 Futurist opera originally sponsored by the Union of Youth in St. Petersburg, and produced

through the collaboration of the poets Alexei Kruchenykh and Velimir Khlebnikov, composer Mikhail Matiushin, and Malevich as set and costume designer. Through his puppet designs, Lissitzky revisits this earlier avant-garde work in order to inscribe it into a new narrative of historical rupture and rebirth occasioned by the Communist revolution. The critical space opened by the reenactment of a pre-revolutionary theatrical model allowed Lissitzky to reflect on the legacy and aporias of Russian Futurism's earlier myths of triumph over natural law, tradition, reason, and "femininity." His portfolio implicitly asks how these myths, rhetorical strategies, and visual devices should be understood in the postwar, post-revolutionary context.

It should be noted that, unlike some of his Russian Futurist predecessors, Lissitzky refused to position his work within a nationalist framework. Active in Germany during the early twenties as a cultural emissary, propagandist, and participant in Constructivist, Dada, and Expressionist circles, he attended the First International Congress of Progressive Artists in Düsseldorf in May 1922. Having arrived in Berlin at the end of the previous year, Lissitzky had assisted with the preparation of the "First Russian Art Exhibition," held at the Galerie van Diemen. In 1922, he and writer Ilya Ehrenburg launched the international modern art journal *Veshch/Gegenstand/Objet*, in which Malevich's Suprematism appeared, but merely as a precursor to the newer Constructivism. Lissitzky conceived Constructivism as a broad, unifying artistic category that could embrace a diversity of practices, from De Stijl to Dada, rather than as the very emblem of revolutionary Russia, as maintained by many Moscow theorists and poets. In these and related endeavors, he sought to address a pan-European intelligentsia of artists, poets, architects, designers, collectors, and other members of the public. Lissitzky's activities in Berlin, Düsseldorf, Hanover, and elsewhere can also be seen as attempts to promote Constructivism as the flexible, universal, machinic visual language of modernity, as opposed to what he perceived as a more limited tendency called Productivism. The latter, emerging as a dominant artistic force in Russia at the end of 1921, had declared the death of easel painting in favor of functionalism, integration with industry, and the new role of the artist as a visionary engineer and state propagandist. Lissitzky's puppet portfolio, executed at the behest of the Kestner-Gesellschaft, a private art company in Hanover, thus constituted a complex set of negotiations among competing identities and aesthetic allegiances.

Working in the early twenties, at a time when the ideal of an electromagnetic theater of kinetic lights and objects had captured the imagination of an international avant-garde, Lissitzky fantasized a *Victory Over the Sun* for de-subjectified puppets whose bodily form would instantiate their relation to the world of nature, machines, speed, and electricity. His vision of an electromagnetic theater undoubtedly also responded to V. I. Lenin's famous slogan of 1920, "Communism is Soviet power plus the electrification of the whole country."[5] Lissitzky's lithographs for nine figurines remained unrealized—he had hoped that others would find a way to produce his puppet show. Converted to miniatures, they re-conceive Kruchenykh's *Victory Over the Sun* in the register of children's play, rendered in the seemingly

universal language of pure geometric forms and colors, as well as through the evocative power of well-known objects and mechanical elements.

Lissitzky's figurines for *Victory Over the Sun* transform the original Futurist opera of 1913 in terms consonant with Constructivist and Communist ideals while retaining its original Futurist narrative extolling the violent conquest of nature and time symbolized by a battle of Strongmen, Time-travelers, Sportsmen, and Aviators against passéist, enemy forces, and by the capture and imprisonment of the sun.[6] In the context of Kruchenykh's *zaum*, or transrational text, the sun represents the old, Apollonian world of clear visible appearance, of order and logic governed by the (now superseded) laws of causality. Regulating the revolutions of the earth, the sun further stands for cyclical, measurable time rather than the infinite, liberated vector of Futurist temporality. Perhaps more surprisingly, for Kruchenykh the sun also signifies the feminine world of sentiment and passion, which must be extinguished, wounded, uprooted, hidden, buried, and contained—all actions that occur in the opera. In the opening scene, a Futurist strongman proclaims, "Sun, you gave birth to passions / and burned with your inflamed ray / We will throw a dustsheet over you / And confine you in a boarded-up concrete house!"[7] As the author later explained, the single female role in the opera was eventually dropped, "in an attempt to pave the way for a male epoch, to replace the effeminate Apollonians and slatternly Aphrodites."[8]

Kruchenykh composed his opera in two "actions," the first with four "pictures," or scenes, the second with two. The first action recounts the tale of the capture and interment of the sun by a band of Futurist Strongmen, although this central event occurs offstage; the second presents a vision of the future in an unspecified location called "Country Ten," the last vignette taking place in an underground concrete house, whose windows open only onto the interior, and from which there is no escape. The story "ends" when an airplane crashes onto the set, the laughing Aviator survives, and the Strongmen reappear, declaring that "the world will die but for us there is no end!"

Malevich's costume designs for the 1913 production of *Victory Over the Sun* conceived most of the characters as robust, earthbound figures, bearing a clear filiation to his earlier images of Cubo-Futurist peasants and woodcutters. Although Malevich imagined their bodies in terms of an articulated sequence of simple, geometric shapes and volumes, a sense of *zaum* or alogical fantasy intervenes to divorce them from the world of streamlined, functional forms. Given masklike visages, or no faces at all, the identity of the characters becomes legible through the interrelation of costume and gesture. Malevich's *Futurist Strongman*, for example, is built of stacked cone-like volumes, shaded to create a rhythmic interplay of irrationally modeled and linked elements that nonetheless cohere around a stable, centered, vertical axis (fig. 10–3). Vigorous, declarative drawing, devoid of subtle nuances or delicate passages, does as much to convey a sense of the Strongman's virility as his frontal stance and clenched fists. Malevich's *Sportsman*, by contrast, appears in profile, captured in mid-stride, his body constructed through the intersection of strong vertical and diagonal vectors (fig. 10–4). Here, the artist generates his alternately

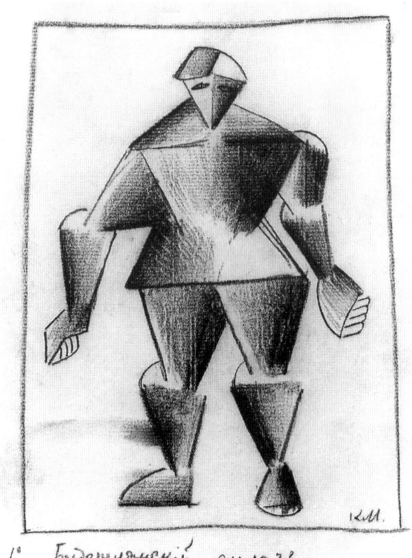

Бузэти лэнскій силаи

4-2 ии ичи

10-3. Kazimir Malevich, *Futurist Strongman*, 1913.

flat and volumetric forms through the systematic reduction of line to simple, basic strokes, and of color to yellow, green, and deep blue, along with black and white. With only one visible arm, and an eccentric overall shape, *Sportsman* seems inspired by costumes for medieval pageantry and folk theater as well as by the two-dimensional knaves and jokers on playing cards. As Fredric Jameson notes in *Archaeologies of the Future*, modern utopian fantasies frequently reveal a lingering nostalgia for

medieval folk tales and festivals, with their organization into clear ethical binaries of good and evil. For Jameson, it is peasant culture in particular, with its fairy tales, trickster figures, and omnipresent magic, that "constitutes a fundamental negation and repudiation of its aristocratic masters."[9] This may explain why Malevich's costume designs for *Victory Over the Sun* paradoxically annex what appear to be the magical signs and emblems of peasant folk culture to symbolize the struggle of Futurist Strongmen against the regressive forces of nature and reason, and, by implication, of the Russian aristocracy.

If Malevich's figures for *Victory Over the Sun* encourage associations with the authenticity, simplicity, and vigor of peasant life, Lissitzky's tend more toward

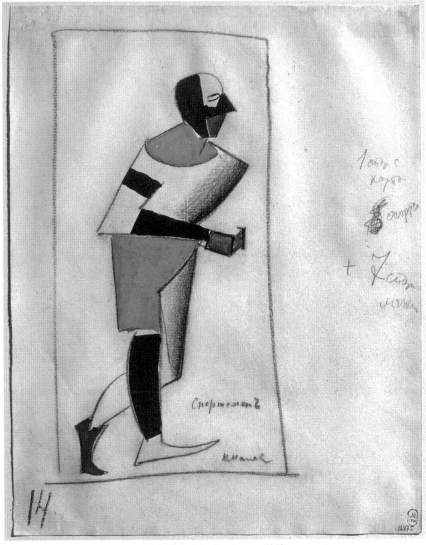

10-4. Malevich, *Sportsman*, 1913.

science fiction, although a strong current of fantasy can be detected in both. As we have seen, Lissitzky first rendered his figurines for *Victory Over the Sun* in gouache, watercolor, ink, and collaged papers, the delicacy of his medium evoking the realm of children's drawings and fairy tales. He probably intended them as a riposte to Malevich's own restaging of *Victory Over the Sun*, with costumes by Vera Ermolaeva, in February 1920 at Vitebsk.[10] If this is the case, Lissitzky's series of figurines can be read as a demonstration of how a Constructivist and Communist would re-conceive Malevich's earlier, still primitivist visual vocabulary, which Ermolaeva's costumes had largely preserved.[11] Seeking to give his puppets a more dynamic, technological configuration, Lissitzky fused body, posture, and gesture into tightly

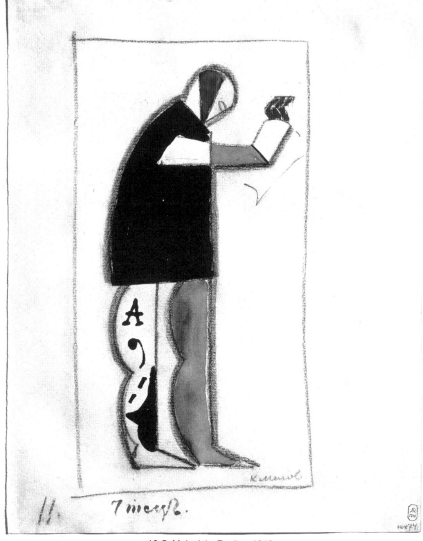

10-5. Malevich, *Reciter*, 1913.

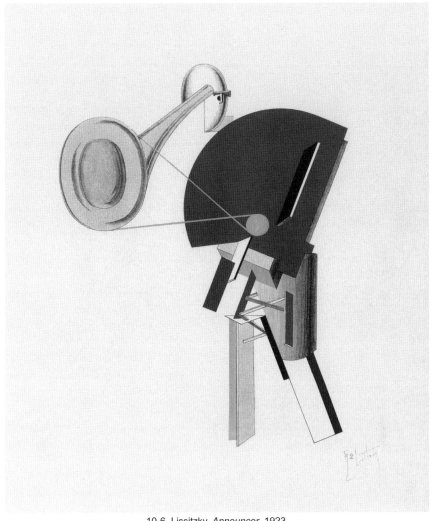

10-6. Lissitzky, *Announcer*, 1923.

unified but inorganic assemblages of inventively comingled parts. Frequently his characters appear as complex hybrids that have been incongruously integrated with the machines that multiply their Futurist powers. As such, they defy ideals of scientific engineering in the cause of increased efficiency promoted by Communist theorist and poet Aleksei Gastev, as well as emerging notions of "productivism" in the arts.[12] Instead, these figurines propose an alternative, nonproductive poesis, offering new mythic prototypes for the men of the past and future.

Lissitzky constructs his *Announcer*, for example, by grafting together the simplified, iconic shapes of an oval head—from which springs a large, diagonally projecting megaphone—and a red torso that is also an uprighted piano (fig. 10–6). These elements are improbably held aloft by a system of scaffolding that doubles as the figure's legs. Part podium, part musical instrument, and part loudspeaker,

this Announcer's corporeal form advertises his function, enhancing the language of precisely rendered geometry with mimetic references to the world of familiar, sound-emitting and amplifying objects. By contrast, Malevich's *Reciter* (a role originally played by Kruchenykh himself) seems rooted in place along the strong vertical axis established by his right profile (fig. 10–5). The figure's arm crosses his body to terminate in a raised hand that iterates a rhetorical gesture familiar from the conventional forms of Roman oratory as codified by Quintilian, Cicero, and others. Yet this bodily *gestus* seems ultimately frozen in space and time. Indeed, the actors in the 1913 version of *Victory over the Sun* were instructed by the text to perform with stiff, robotic movements, and to recite their lines slowly and mechanically, with pauses between syllables to interrupt the flow of meaning. For Kruchenykh and Malevich, unlike the Italian Futurist impresario F. T. Marinetti, becoming machine-like paradoxically entailed a process of deceleration, of assuming halting, disjunctive, and inexpressive vocal rhythms in preparation for the advent of a dehumanized world.

Malevich's *Traveler* closely resembles his *Futurist Strongman*, although the artist has given him open hands (fig. 10–7). The sparks that flair along the edges of his body seem to evoke a wind-blown arrival by airplane, as indicated in Kruchenykh's text. These sparks also bear a striking resemblance to Hermann Schnauss' "electrographs" of the electricity coursing within the human hand, which had been republished in 1912, and may serve as a visible manifestation of the Traveler's magnified powers.[13] In contrast, Lissitzky renders flight in *Globetrotter in Time* by intercutting fragmented human forms with those of an airplane, depicting a single schematic leg, propellers, the airplane's wheels and struts, and various simplified volumes and planes of a head (fig. 10–8). The links between these elements, often merely a matter of contiguity or overlapping, remain inorganic and

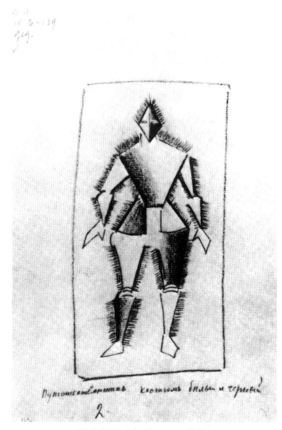

10-7. Malevich, *Traveler*, 1913.

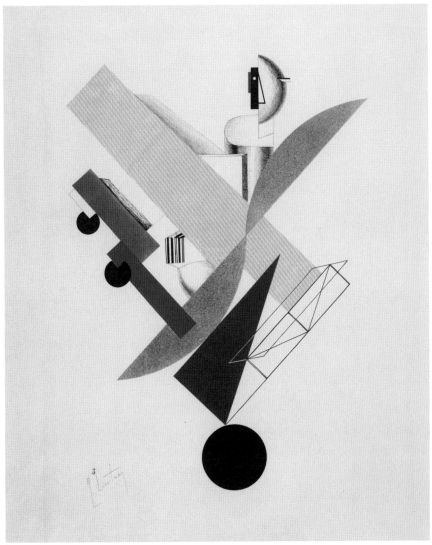

10-8. Lissitzky, *Globetrotter in Time*, 1923.

ambiguous, suggesting contingent and mobile configurations. Resting on the toes of one foot and precariously balancing on a black ball, Lissitzky's Globetrotter seems to look simultaneously outward toward the viewer and toward the right, where presumably the future lies waiting. His vision and movements are constituted through geometric forms and dynamic vectors with little mass or weight.

Seeking solidity rather than speed and multi-directionality, Malevich posed his *Pallbearer*, the figure who will bury the defeated sun, so that he addresses the viewer with frontal immediacy. In a play of figure/ground and light/shadow reversals, he rendered the Pallbearer's right eye as a nearly square blue form against a white ground, while on the left side of the face, these relations are inverted so that the eye

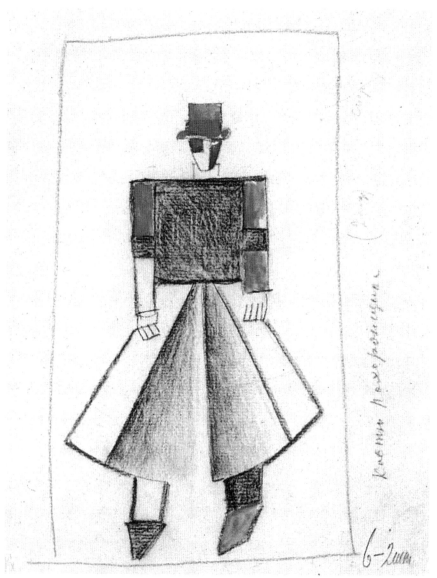

10-9. Malevich, *Pallbearer*, 1913.

appears as a narrow white oval against a blue ground. The black square, symbol of the sun's eclipse and burial, appears as his torso, where it evokes a casket (fig. 10–9). Lissitzky makes such metaphorical readings more explicit, constructing his gravediggers as coffins marked by crosses, with two spliced yellow spheres suggesting the eclipsed sun (fig. 10–10). Only partly visible under the body-as-coffin to the left, a yellow circle appears to have been partly inumbrated, cast down, nearly buried. Yet its double, a yellow half-circle, hovers before the Gravedigger's head, blocking or perhaps transforming his vision; in a complex formal arrangement,

it also partly overlaps a smaller red circle with a black dot in its center and a black rectangle that seem to represent his eyes. Like a kind of prism, the yellow half-circle causes displaced fragments of the circle and rectangle to appear within its yellow borders, now converted into white forms. Lissitzky's *Gravediggers* thus enact the battle to capture, darken, and bury the sun through their very forms, through the contest of light and dark, circle and square or rectangle, and the mutual effacement or eclipse of figure and ground. But visualizing this moment in the story when the Gravediggers bury the sun also depends on mimetic references to those objects that drive the narrative—the sun, coffin, cross, and top-hatted pallbearers. In exemplary modernist fashion, Lissitzky links narrative and formal structure.

Similarly, in creating *The New*, Lissitzky translated Malevich's brightly colored, boldly rendered shapes (fig. 10–11) into an aerodynamic body that performs a

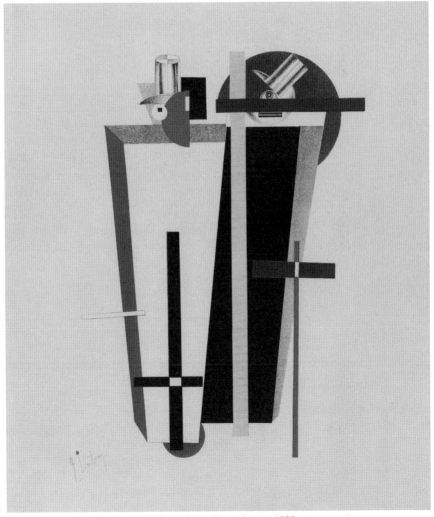

10-10. Lissitzky, *Gravediggers*, 1923.

131

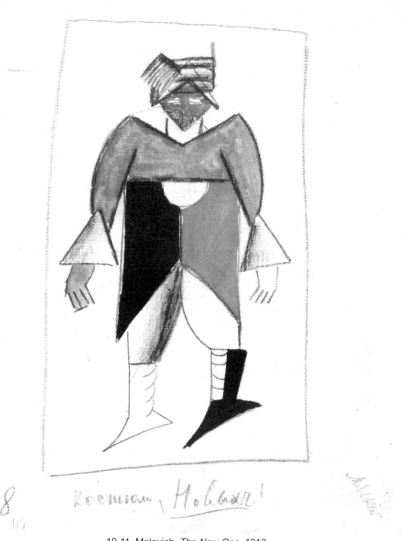

10-11. Malevich, *The New One*, 1913.

thrilling forward leap into the future (fig. 10–12). Rather than convey a sense of peasant strength and invincibility through a display of sheer weight and mass as Malevich had done, Lissitzky rewrites his figure as pure movement. He also seems to reinterpret Leonardo's *Vitruvian Man*, whose outstretched arms and legs are inscribed within a perfect square and circle, as a nexus of asymmetrical vectors. Instead of picturing the ideal commensurability of the human form and geometry, as Leonardo had done, Lissitzky's *The New* implies the capture of infinite, measureless space. Displaced from its function as external limit or frame, the square, now a brilliant red, becomes the animating center of the male body, an emblem of Communism and motor of a heroic trajectory into the future. The spliced halves

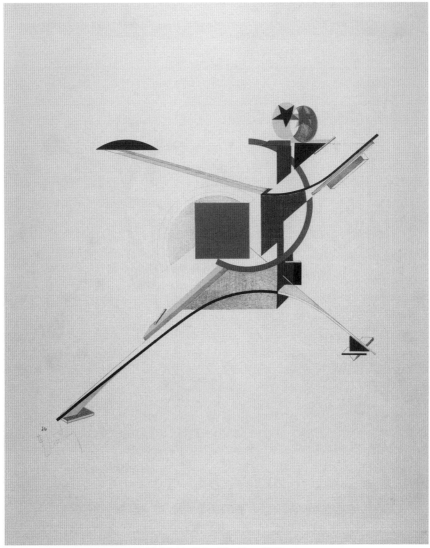

10-12. Lissitzky, *The New*, 1923.

of a circle in gray and black rotate around this red square, echoing and inverting the curved profile of the open stance of the legs below, and linking the square to the figurine's head and its twinned stars in red and black, signifying Communist Russia and a multiplied vision of the future. The slender fragment of a black sphere, balanced on the figurine's outstretched right hand, no doubt symbolizes the conquered sun of the past. Its placement may have been inspired by the dictum that Malevich introduced as the motto of UNOVIS, which Lissitzky had inscribed on numerous publications beginning in 1920: "Let the Overthrow of the Old World of Art Be Traced on Your Palms!" The presence of this black sliver of a sun completes the play of harmoniously integrated forms, the red and the black, circle and square,

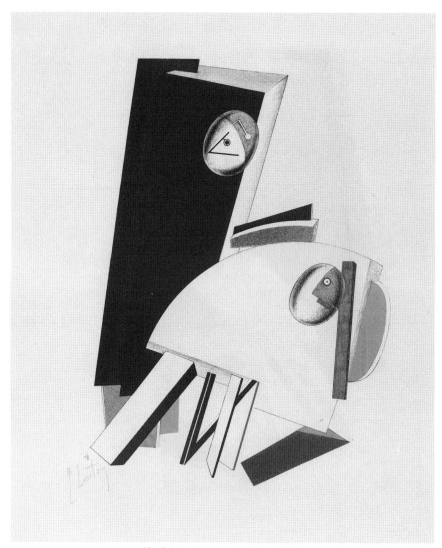

10-13. Lisstizky, *Anxious Ones*, 1923.

stability and dynamic movement. Lissitzky's The New occupies so little mass, and arrives with such élan, that it is difficult to remember he was meant to be a puppet, moving by virtue of electromagnetic currents that further signify the triumph of technology, and of Communism, over nature. Whereas Malevich's *The New* had been a relatively minor character in an opera dominated by Futurist Strongmen and the Aviator, Lisstizky makes him the principal avatar of the Future, repositioning him as the final, messianic figurine in his lithographic portfolio.

Like its predecessor, Lissitzky's *Victory Over the Sun* celebrates the triumph of technology over nature and continues to draw on Futurist myths of fusion with machines, conquest of time and space, and constituent violence as the primary

vehicles for social and political transformation. In addition to the symbolic capture and imprisonment of the sun, Lissitzky's portfolio retains its predecessor's all-male cast, thereby explicitly gendering the future. It also preserves the conflict between the backward-looking *Anxious Ones* (fig. 10–13), the *Old Man*, and the *Troublemakers*, exemplars of cowardly, weak, bourgeois, and (now) anti-Communist forces, and those fully dynamic, youthful figures who have become integrated with machines and electricity, and who already embody the revolutionary ideals of the society to come. The emergence of *The New*—a solitary, de-subjectified, heroic figure whose mechanically assembled, precisely rendered forms evoke the thrill of velocity—remains contingent on the defeat of the enemy—the bloated, gravity-bound representatives of the past, the tottering old ones who require spectacles and move backward, indeed all those feeble individuals who remain linked to tradition and anxious about the advent of the New. In returning to such Futurist themes in the aftermath of war and revolution, Lissitzky's puppet portfolio provides a glimpse of a divided society, and of what must still be fought in order to achieve the complete or perfected post-revolutionary subject—one whose triumphant arrival was not yet an accomplished fact in 1920, or even in 1923. Here the notion that the construction of the new world will necessarily entail the violent destruction of the old, which was central to pre-War Futurism, takes on a specific political and historical resonance that is nearly masked by the playful, seemingly childlike forms of Lissitzky's figurines. In his children's book of 1922, *About Two Squares*, Lissitzky employed a similarly simple but highly symbolic set of graphic forms and colors to picture the violent triumph of Communism over its enemies, a triumph that ushers forth the clear establishment of a "red" world order.

The antinomic violence celebrated by Kruchenykh's 1913 *Victory Over the Sun*, in which Futurist Strongmen effectively declare a state of exception and engage in civil war in order to topple the sovereignty of bourgeois logic and aesthetic values, assumed new meaning after the October revolution. In 1922, the German jurist Carl Schmitt famously published his apology for such a suspension of law and seizure of power with the phrase, "Sovereign is he who decides on the exception."[14] Schmitt may have been responding, at least in part, to Walter Benjamin's text of 1921, "Critique of Violence," in which the author declares, "All violence as a means is either lawmaking or law-preserving."[15] As Benjamin further explains, the origin of law lies in violence, and it is through violence that the law reaffirms itself. As such, he argues, it forfeits all validity. Utopia, as Benjamin acknowledges through a citation to Georges Sorel, is essentially law making, hence its incompatibility with true anarchist revolution. He concludes with the scandalous assertion that solving the problems of the world requires the divine manifestation of a violence beyond the justification of means and ends, beyond the law, a violence that is ultimately law destroying.[16] For the mystical, anarchist Benjamin of 1921, the coming of the Messiah would be abrupt, causing a rupture in human temporality that would release a pure, immediate, divine violence so as to create a timeless realm of crystalline perfection, what he sometimes called "the time of the Now."[17] Benjamin equates this divine violence outside the law, which nonetheless intervenes

in human history, with revolutionary violence, which he calls "the highest unalloyed violence by man." [18]

Such reflections respond to the historical crises of the early 1920s, in which the law making and law sustaining power of violence, in Russia, Germany, and elsewhere, had come clearly into view. Like Benjamin, Lissitzky seems to celebrate the function of revolutionary violence, a manifestation of Messianism, to overturn existing law; however, in the context of the October Revolution, such violence was quickly justified in conventional mythical terms as the ethical conflict of the new and the old, the forward-looking Communist and backward-looking bourgeois or Menshevik. What had been a fantastic allegory of the destruction of the old world of appearances, conventional meaning, and logic in Kruchenykh's 1913 *Victory over the Sun* now became a tale with a more immediate political referent and meaning. Ultimately, Lissitzky's *Victory Over the Sun* seeks to give visual form to this new law and the utopian violence that sustains it, through a reenactment of what was by then, paradoxically, a return to the future.

11. Revisiting Indeterminacy: On Morton Feldman, Earle Brown, and the New York Painters

David Ryan

In the hothouse of the twentieth-century New York avant-garde, interdisciplinary convergences could thrive, be taken in stride, and dissolve into a blur of period generalization. David Ryan, a painter and composer-performer, whose own musical practices are influenced by the music of Feldman and Brown, looks into the ethos of abstract expressionist painting, in its fluorescence in the 1950s, as influencing these principal American modern classical composers soon to come. What the composers found inspiring in Pollock's painting—as in relation to Brown's dynamic approach, even in conducting—is probably less surprising than Ryan's reminders of Calder, who was part of the woodwork, with his contingent, ever asymmetrically configured mobiles. John Cage has a certain centrality here, partly in connecting back with Marcel Duchamp, partly as contemporaneous with the painters, and partly as connecting forward with these younger composers also concerned with indeterminacy. But Brown and Feldman were not mere followers. For one thing, Brown's resort to a principle of uncertainty may even have antedated Cage. Differences between chance and indeterminacy are considered, as well as differences between Brown's and Feldman's senses of abstraction. These "art" composers were also aware of jazz, but Ryan does not follow the jazz line into the free jazz of still younger musicians, because he is concerned to clarify the direct and important influence of abstract expressionist painting on the formation of this still happening, but considerably less understood, concert music. — J.M.

———

How do we aesthetically reactivate works for ourselves, as viewers or listeners? Is there an escape from the generic cultural inscription process, or the limitless archive to which contemporary practice seems in thrall? This will be a moot point insofar as it looks to the dual deadening processes of canonization and museum-ification that may mark the fate of all significant art. Yet we can say that indeterminate music as well as mid-twentieth-century abstract painting attempted to circumvent these

processes, not only by questioning completeness but also by leaving the question of formation open to fresh interpretation in performance. If indeterminate music attempted this directly with its form, Abstract Expressionism could be said to have allowed its very content to remain open, indeterminate, or unstable.

Of course, canonization happened long ago with Abstract Expressionism, and more recently—to an extent, it is still in process—to the New York School of composers around John Cage (1912–1992), including Earle Brown (1926–2002), Morton Feldman (1926–1986), David Tudor (1926–1996), and Christian Wolff (b. 1934). With the composers, this has meant a more protracted, tortuously slow embrace by established concert halls, orchestras, festivals, CD companies, books, and researchers, because of these composers' implicit challenge to musical taste, convention, and tradition, as against the protectionist conservatism implicit in the craft, teaching, and dissemination of conventional music. This in itself was reason enough why the "loose community," as Irving Sandler has put it, of the New York painters in the early 1950s was more accommodating and congenial to these composers than was the musical scene at the time. Cage had already established himself as an important part of that community, giving talks at the original artists' Club on Eighth Street and at its later reincarnation; he was teeming with ideas and always willing to communicate his artistic credo, which was increasingly foreign to the musical establishment at that time. This was the milieu that Morton Feldman and Earle Brown joined in 1950 and 1952, respectively.

Feldman and Brown came from quite different backgrounds: The former, a native New Yorker with a strong but softly spoken Brooklyn accent, was a big and bulky man, myopic, with thick glasses; the latter, wiry and animated, from a provincial town in Massachusetts, arrived in New York after a teaching stint in Denver, with his first wife, the dancer Carolyn Brown, at the invitation of Cage and Merce Cunningham, to join the group. Perhaps it is fair to consider the contrasting physical demeanors of the men somehow making their way into their music: the stasis and quietude of Feldman, the wired acrobatic intensity of some of Brown's music. Those early years of activity, marked by intense innovation, were not without their tensions: Feldman and Brown were for some years estranged as a result of an argument about the French composer Pierre Boulez (b. 1925) who, unbeknownst to Brown, had criticized Feldman's compositions.[1] Actually, Boulez was in 1950 and 1951 an absent friend of the group, at least in Cage's mind; by a stretch, we might even imagine Brown, with his mathematical bases at the time, filling the systematic Boulez' shoes.[2] But the group was certainly moving in a contrary direction from Boulez' position and could scarcely have met with his approval even in its formative stages.

When Brown joined this circle, it had already seen several significant musical milestones besides Cage's development of chance composition. For one, Feldman had already produced his famous graph scores, the early "Projection" series, and throughout the 1950s, several music projects brought these New York composers together. These included the Project for Music for Magnetic Tape, in which Brown played a key role; music for Merce Cunningham's dance troupe; David Tudor's

concertizing; Boulez' visit to New York in 1952—all besides the relationship with the visual arts. Even before joining Cage, both Feldman and Brown already had connections with literature and art: the composer Ernest Bloch (1880–1959) had encouraged the youthful Feldman to connect with other artistic practices,[3] and Brown, who had a friendship with Max Ernst from the late 1940s, when he also enthusiastically discovered Pollock, found interdisciplinary esthetics a strong unifying element in the group, and he would recall,

> What primarily brought John, Morty and myself together was that we were so influenced by arts other than music; you know, I was influenced by Calder and Pollock, Morty was influenced by Guston and Rothko amongst others, John was influenced by Duchamp and other people. That's what made us as a group or assemblage so unique because we were more influenced by the visual arts and poetry, John and I by James Joyce and Gertrude Stein.[4]

Also, Cage had scored music for films and radio broadcasts on Calder and Kenneth Patchen, and Feldman scored Hans Namuth's famous film of Pollock painting (passed over by Cage because of his personal dislike of Pollock the man), and these were also strong personal connections for Brown.

But it was the community of the New York Abstract Expressionists, through Cage's introductions, that became decisive in the development of both composers. Christian Wolff once described Feldman's attachment to the decade of the 1950s as some kind of "garden of Eden"[5]—which Feldman suggested several times in his lectures and talks:

> What was great about the fifties is that for one brief moment—maybe, say, six weeks—nobody understood art. That's why it all happened. Because for a short while, these people were left alone. Six weeks is all it takes to get started. But there's no place now where you can hide out for six weeks in this town.[6]

This idea of forgetting in order to find one's (authentic) self was marked in the existentialist debates among the painters, especially in the view of Harold Rosenberg, rather than that other preeminent critic of Abstract Expressionism, Clement Greenberg. As Irving Sandler points out,

> Existentialism was very much in the air during the late forties and well into the fifties, and artists and critics often borrowed from its terminology, speaking of painting as an unpremeditated "situation" in which a creatively "committed" artist "encountered" images of "authentic being." The process of self-creation was a solitary one of "struggle," fraught with "anxiety," even "anguish." More than all commentators, Rosenberg considered existential experience to be the mainspring of action painting, elevated above picture-making, aesthetic performance, or any received ideas imposed from without.[7]

Feldman absorbed these debates, and we sense such ideas in his work within his different phases; for example, his rejection, in his earlier work, of imposed systems (and hence his rejection of Boulez), and the notion that if ideas appear they do so through the actual material process of making. He once recalled, "Here I am, three quarters of the way through a big piece—if you're gonna have an idea—you'd better have one now."[8] When the artist is immersed in the material, what defines the singularity of the piece will be revealed through the artist's continued navigation of it; as Robert Motherwell suggested of the New York painters, they "tr[y] to find out what art is precisely through the processes of making art. That is to say, one discovers, so to speak, rather than imposes, a picture."[9] Even Feldman's later, more gridlike compositions, where the analogy is a weave as in the woven rugs that he later collected—a fluid stitching of musical space and time—still maintain this unpremeditated entry into the material.

Both Brown and Feldman responded to Pollock's painting. Feldman recalled,

> As I came to know Pollock better—especially from those conversations where he would relate Michelangelo's drawings or American Indian sandpainting to his own work—I began to see similar associations that I might explore in music. . . . Pollock placed his canvas on the ground and painted as he walked around it. I put sheets of graph paper on the wall; each sheet framed the same time duration and was, in effect a visual rhythmical structure. What resembled Pollock was my "all over" approach to the time-canvas.[10]

Equally can we see Brown thinking through and responding to similar ideas, although with a markedly different effect and feel. Brown responded primarily to the web, the mesh of events that occurs in a Pollock, where the interplay of the precise and the indeterminate may also bring to mind jazz. Pollock himself was obsessed with jazz and the potential analogy of its free, unaligned, overlapping sonic fields. (Brown, a lifelong fan, was professionally involved with jazz as a sound engineer.) The lessons of Pollock, already a legendary figure somewhat distant from the downtown scene by 1952—notably with scale, overall field, and physicality—are dealt with quite differently by Brown, yet perhaps also deducibly from the ethos of the artists: "Not to impose an emotional atmosphere upon the material but to observe the emotional atmosphere of the material results (new and unexplainable relationships and emotional complexes . . . the tentative, unforeseen, implicit),"[11] and, in turn, developing a working amalgam of Calder in sculpture as well as Pollock in painting:

> For me, the mobility (or mutability) of the work had to be activated during the *performance* of the work (as in a mobile of Calder), and expressed spontaneously and intensely by the performer, as in the immediacy of contact between Pollock and his canvas and materials. . . . Its impact was considerable and lasting. The dynamic and free look of the work, and the philosophical implications of Pollock's work and working processes, seemed completely right and inevitable. In a sense it looked like I wanted to hear as sound and seemed to relate to the "objective" compositional

potential of Schoenberg's "twelve equal tones related only to one another"
. . . even though the painting technique was extremely spontaneous and
subjective.[12]

Whereas Feldman responded to the field as a fixed, delimited, durational unit,
Brown's response to Pollock took a more phenomenological and dynamic approach
involving freedom to wander around the paint-skein complexes that make up the
allover surfaces, and so to engage the physical orientation of the viewer. In fact, his
later conducting practices could also be seen to come directly out of Pollock: watch-
ing Brown conduct (after 1960, he often conducted his own ensemble pieces) was
rather like seeing somebody sculpt something in real time, shaping the music, and
making crucial on-the-spot decisions. Brown's technique was not at all a matter of
beating out time but rather of providing razor-sharp cues, aerial traceries shaping
gesture in performance, while nimbly indicating which part of the score was acti-
vated at what point with the five fingers of his left hand.

The formation was akin to Pollock's brushes or sticks moving rapidly over the
surface without actually touching it, yet initiating an almost electric "contact"
between the surface and the artist or implement. Such was Brown's approach to
the materiality of ensembles and conducting. In Denver, Colorado, before coming
to New York, Brown had also made paintings in a drip manner "to get the feel" of
this technique. Small-scale and on cardboard, they seem equally to be a product of
his contact with Max Ernst (as in a small dripped figure painting entitled *Pierrot*) as
much as with Pollock. Another piece from 1951 (household paint on square card-
board) is constructed in three layers: the first layer is a thin black, intricate arma-
ture; the second, a more open silver-gray web; the third, a layer of red varied both in
terms of its thickness (or rather allowed to be more "uncontrolled") and its stability
on the surface, for the red has a glutinous and bleeding quality. Yet Brown manages
to maintain a dialogue between the different interacting gestural layers while effect-
ing a slightly off-center and shimmering quality. In an untitled work of 1951(fig.
11–1), he attempts a different kind of balance, with a horizontal fragment at the
bottom, sitting within the width of the card support, and above, loosely horizontal
and vertical demarcations in dialogue—not a rectilinear grid but rather floating
blocks. These types of formal "condensations" of area and space are prophetic of
what Brown would soon realize much more fully in his mature musical works.

Clearly, both Feldman and Brown wanted to develop situations akin to the newly
found physicality of the New York painters at the time. Feldman suggested in his
oft-cited statement, "The new painting made me desirous of a sound world more
immediate, more physical than anything that had existed heretofore."[13] Brown
formulated a similarly decisive statement in an early notebook entry of 1952: "I
want to get the time of composing closer to the time of performing."[14] Both
composers' earlier scores are open to outside actuality by their leaving aspects of
the notation open, and (more so than either Cage or Wolff) both were interested
not so much in pre-compositional plans or structural containment of sounds as in
new forms of engaging directly with the materials and corresponding patterns of

11-1. Earle Brown,
Untitled (Denver 1951),
1951.

growth or assemblage: for Feldman, mainly at the compositional stage; for Brown, equally in performance. Feldman's graph pieces, such as *Projection 1* (1950), and Brown's *Folio* (1952–53) would be initial answers to their searching. New ways of thinking about how sound can be mobilized within its spatial context found parallels with the new freedoms in painting. The forms of artists such as Kline or de Kooning were contingent on the working sessions: ever-varied U-turns of addition and subtraction, clarification, and obfuscation produced a specific set of pictorial relations. Likewise, the search for "direct" sound also developed an intensification of performance and risk.

There is in both Brown and Feldman a balance between their senses of subjectivity and of objectivity. Brown appears less existentialist in general outlook, and more pragmatic—we would now perhaps suggest that he was interested in the language of the materials as "intensity" and "affect," whereas Feldman's strength, as Frank Denyer suggested in speaking of his early work, "derives from his paradoxical ability to be committed to his own interior poetry and yet simultaneously embrace the detached and abstract aural relationships which arose when certain compositional controls were abandoned and sounds liberated from the demands of overt self expression."[15] From quite early on, both composers moved between totally determined and indeterminate music—as in Feldman's *Projections, Intersections,* and *Intermissions* in the early 1950s. Brown produced his notational experiments in *Folio* (1952–53), but he soon moved away from the total indeterminacy of *December 1952* and *Four Systems* (1954) and toward more flexibly determined music (*Music for Cello and Piano*, 1955, and *Indices*, 1954). The main freedom was now in a space-notated rhythm: visual proportions on the page translated into sonic relationships—for example, a relationship between the variable visual space between notes as proportional silence rather than a metric system of barred, divisible, counted units. Although Feldman abandoned his graph music by the mid-1960s (and it was already scarce enough after the early 1950s), Brown continued to synthesize graphic and traditional notational elements until his last works, attempting to find a median point between calculation and construction, and indeterminacy and spontaneity: "open form."

If all of this points to indeterminate procedures, what exactly do we mean by that term? It derives from experimental physics, particularly Werner Heisenberg's views on quantum theory. How and why it was adopted by the New York composers is unclear, except for analogous ways that space and time remain, ultimately, in Heisenberg's view, indefinable, and, importantly, that the operation of the experiment will always be influential in the outcome. Heisenberg suggested a theoretical limit to measuring momentum among atomic particles, beyond which indeterminacy was the inevitable uncertainty principle. The term became closely associated with Cage because of his 1958 Darmstadt lectures on Indeterminacy, and consequently Cage was seen to be its initiator in musical terms.

However, Brown, in his prefatory note to *Folio*, a key early work of 1952, clearly expresses an involvement with a notion of indeterminacy: "All the characteristics of sound—frequency, intensity, timbre, modes of attack-continuation-decay—are

infinitely divisible continua and unmeasurable."[16] *Folio* by Brown is, as the title implies, a collection of single sheets, and it includes seven pieces exploring flexibility in a variety of ways. The first three pieces act as a sequence, following the dates in which they were made (*October 1952; November 1952 ["Synergy"]; December 1952*): these form a "progression from specificity to almost the utmost non-specificity, in other words taking more and more information away from the musician and therefore inviting . . . the musicians to be creative themselves."[17] The remaining pieces include two indicated only by metronome markings, *MM = 87* and *MM = 135*, both composed rapidly and spontaneously so as to be "in that sense performances, rather than compositions,"[18] and two further experiments: *Music for Trio for 5 Dancers* (sometimes referred to as *June 1953*), written for Carolyn Brown, and *1953*, a significant sketch for Brown's later *25 Pages*. Thus, we move from *October*, which is akin to a flexible, rather dissonant, prelude, on to the field-like *November*, and then to a "total graphic," the most famous, or infamous, of the set: *December 1952*, with its field of interacting rectangles (fig. 11–2). The rest of the pieces provide alternative methods of generating sounds and defining determinate/indeterminate conditions. *Folio* acted as sourcebook for Brown. He often referred other people to his notebook comments (eventually printed with the published score) as well as the pieces themselves.

11-2. Brown, "December 1952," excerpt from *Folio* (1952-53).

Now, it may be useful to distinguish different aspects of chance and indeterminacy. First, the final notated form of a work constructed by chance is no different from a subjectively controlled composition, yet its "unforeseen" manner of composing may well be classed as indeterminate (the tossing of coins, as in

determination by the *I Ching*, for example); not, however, the final piece. Second (and this includes some, though not all, of Brown's innovations), modes of composition can be "indeterminate in relation to . . . performance,"[19] whereby the performance itself is integral to how the composition manifests itself in a particular situation, as mentioned earlier. Here we have a situation whereby chance, contingency, or performer choice initiates a performance unique to a particular event—unlike, say, Cage's *Music of Changes*, of 1951, which, though composed using chance operations, will remain as consistent as a Beethoven sonata from one performance to the next. Often, to Brown's fury, chance, resulting from the dominance of Cage, was a catch-all for himself and Feldman (and the others), whereas in reality deliberate performer and interpreter choice seemed crucial to his own practice, as in a rather exasperated program note draft as late as the 1970s: "My music enlarges the potential for musicians to take a more creative role in the music; yet I am not interested in everybody just doing his thing. I didn't compose by chance. I composed what I wanted to hear."[20]

It is tempting to align Brown's production with the gesture painters, and Feldman's with the color field painters, similarly to the division often made between, for example, de Kooning, Kline, and Guston, and Rothko, Newman, Still, and Reinhardt. It was the former who attracted the early wave—a group of admirers, many of whom became the second generation, and perhaps Brown could also be seen as closer to Kline or de Kooning. There may well be an analogy between the ghost of a cubist armature in de Kooning's approach to composition and the phantom of serial techniques in Brown, as well as, in his later work, the rapid negotiation of different fields, textures, and dynamics of sound, which are collaged in performance by the conductor. This has more in common with the scarred, disrupted, and abrupt changes of space employed by the gestural painters. Feldman, however, veered throughout his career toward the smooth space—the exquisite floating, shimmering quality of sounds drifting, decaying, across sonic space.

I conclude by looking briefly at Feldman's conception of abstraction. The evidence, scattered throughout his writings (*Between Categories*, 1969; *After Modernism*, 1971), has an important bearing on his notion of abstraction as an operation, or a "passage," as he referred to it. In a late piece by Feldman, we sense an evolving process but also the formation of a palpable, almost living, breathing thing created over time. There is an overwhelming sense of one's not just listening to but rather *being with*, something in this late music, which Feldman would refer to as the Abstract Experience: a temporal and formal experience that will bind viewer and object, even if only momentarily. This entails both absorption and a stepping back from the process of wholly entering a world, in a process split between the persistent opacity of the material, its temporal formation, and a resistance to any smooth narrative (formal or otherwise) in relation to the formation of the work. Aspects of modernism willfully desire such falling back into nonsignification as part of the aesthetic process. In a notebook of Brown's, we sense something similar:

If it is possible to understand 1 2 3 4 5 it is possible to understand 9 1 3 6 8, but it's making a problem . . . to bring about "the crisis of consciousness

due in our time" (Max Ernst) . . . to allow the crisis is the thing now to do . . . and be appreciative of the unintelligible meaning, and *there* is the understanding.[21]

Feldman saw abstraction not as a "style" of working but more as a perceptual trait: It is only a small step from Vermeer, Piero della Francesca, and Rembrandt, according to him, to a Rothko or a Guston, because of what he calls this Abstract Experience—a transformation of the viewing or listening situation that has nothing to do with what we might superficially identify as the form of an abstract painting. His early approach to composition, with extremely low dynamics, a seeming sourceless approach to sound (though Feldman thought very much through instruments, they become almost defamiliarized portals for sounds-in-themselves), and an (almost) erasure of memory in regard to continuity, also sets the conditions for the late pieces. What we get in Feldman is something akin to a musical after-image—a leftover presence from one sound to the next, without any indulging in the usual composerly rhetoric, something rather more like the optical spaces in Pollock, or as Feldman himself suggested, the stained, soaked hues of Rothko, creating an ambiguous sense of surface and space. Both these painterly senses are important, and Feldman was perhaps the first composer to propose a working notion of an aural surface as integral to his practice. Writing in the early 1970s, he declared,

> Years ago there were procedures, questions of what you were going to put in and what you were going to leave out. Today there is no ritualistic way to "get there." It has to happen. It's the immediacy that counts. Whether that immediacy takes ten minutes or ten years is irrelevant. The leap into the Abstract is more like going to another place where the time changes. Once you make the leap there are no longer any definitions.[22]

Feldman's sense of abstraction, we can say, is more a sense of orbit around and through a set of practices. It also demands a different approach to time; and we might also think back to Rosenberg, who spoke of addressing a work in terms of "inception, duration, direction."[23] Feldman's approach to abstraction is not a theory to be applied, nor is it a completely known or determined set of principles to be imposed. It is for each painter or composer—and this is in the spirit of how Feldman discussed the Abstract—to find his or her own sense of abstraction through the processes of making: this is the only way to work beyond a classification or genre and to create a workable situation for abstraction in painting. "It has to happen," suggested Feldman, implying that we can't just figure it out without working it through in practice.

A couple of points might be developed further: first, this notion of a leap into the abstract, where there are no longer any definitions; second, the idea of *working through* toward abstraction. Both are, I feel, relevant in relation to a sense of indeterminacy, abstracting, and abstraction. Despite Feldman's laconic and conversational style, sometimes polemically blunt or playfully obscure, there is an attempt

to catch figures of speech for his practice without any analytical or theoretical baggage. The music, we might say, simply happens, and Feldman's playful verbiage tries to catch up with it without explaining it away. Thus he criticized process—and perhaps this is a residue of abstract expressionist thinking—as an end in itself (favoring anxiety over artistry); however, process through time (but not necessarily system) *enables* and thereby becomes the subject in itself, which is slightly different. Feldman's working method, especially in his late work, is famous for its flow, its lack of revision (supposedly), and hypnotic almost-repetitions of phrases of notes.

He once suggested, "Death seems the only distant enough metaphor to truly measure our existence . . . only the artist who is close to his own life gives us an art that is like death"[24]—certainly an extreme leap into the abstract. He was fascinated by the idea of an absorption in the work that was so complete as to be like a death; the late Stuart Morgan, a British art critic, drew a parallel with Feldman's friend Frank O'Hara's thought that only as "dead men [sic] do we create." Such a space creates a lacuna in the subject, where one becomes, or engages with, a broader sense of history beyond the personal. If we asked Cézanne, Feldman once said, "Are you Cézanne or are you history?" his answer would be, "Choose one at your own peril. His ambivalence between being Cézanne and being history has become a symbol of our own dilemma."[25] We might think, here, of Cézanne's own attempt to monumentalize nature from, paradoxically, his "petite sensation."

Traditional musical vocabulary doesn't always illuminate Feldman's work, and for all his talk, Feldman allowed a certain indistinctness to evolve (rather like the painters he so admired). "Just an investigation of material" he once described his work, "giving free vent, and not having a vested interest in a sense that material should go either this way or that way."[26] But though this no doubt reflects a debt to the painters, especially Guston, it also belies a constant anxiety in Feldman of finding the form of the piece; of making something happen. This is connected to that moving toward abstraction: "My dream always when I write, is that I want to do it abstractly. I feel that if you finally do it abstractly nothing could equal it. . . . So I have a total political conviction in the abstract sensation, without the help of an iconic, iconography, no matter how fantastic it is."[27]

The abstract artwork in this sense encompasses, and translates into, its own language, those infinitesimal residues that slip through the very net of language, all those affects that remain underground until articulated by the artwork, until they become concretized by the *quasi*-linguistic structures that the artwork enables. Feldman once famously commented, "I don't call a thing by a name," and this was important for him, in order to translate from a sense of sound, pitch, to intervals, and back. It was also realized in his enharmonic spelling of pitches in different contexts—an *b* and an E natural, or even a D##—which suggests a differentiation of the experience of those pitches, which are actually the same note on the piano, according to their relationship in time and harmonic context. But also, his aim was to discover the actual subject through these procedures of translation during the time of composition. When I referred to his processes as an *orbit*, this would include each of these processes—this moving across, through, and around materiality to form

something that pricks a recognition but remains an uncategorized emotion. *Orbit* is also used in the sense of allowing that essential feedback from the material, and this can mean an extremely intimate situation between maker and material, which is what Feldman himself demanded. This explains why he denied ideas or concepts but was involved in a realistic attention to the material at hand, as is explicit in a passage from his essay "After Modernism":

> We would like to surrender to this Abstract Experience. We would like to let it take over. But we must constantly separate it from the imagina-tion, or rather, that aspect of the imagination that is in the world of the fanciful. In my own work I feel the constant pull of ideas. On the one hand there is the inconclusive abstract emotion. On the other hand when you do something, you want to do it in a concrete, tangible way. There is a real fear of the abstract because one does not know its function. . . . The abstract, or rather, The Abstract Experience, is only one thing—a unity that leaves one perpetually speculating. . . . The Abstract Experience is a metaphor without an answer. Whereas the literary kind of art, the kind we are close to, is involved in the polemic we associate with religion, the Abstract Experience is really far closer to the religious. It deals with the same mystery—reality—whatever you choose to call it.[28]

Here Feldman suggests that the imagination, ideas, literary ideas, concepts (and these, for him, include known structures, procedures, or systems) become rather like the governance of religion, with its institutions, dogmas, excommunications, and so forth, whereas, the articulation, *through a work*, of this Abstract Experience approximates more to the religious experience in itself. This leads back to the ques-tion of time and abstraction, and an extended discussion, outside of the scope of this essay, would have to include Earle Brown's conception of a single work accom-modating different models, or modes, of time. To this we can add the sense that the indeterminacy and abstraction of Brown and Feldman folds onto the abstract and metaphysical subject matter of the Abstract Expressionists, indeterminate in itself. Perhaps through the lens of the New York composers we might discover a vantage point where it can be experienced afresh?

12. Drawing on Mies's Wall in Houston

Alan Johnston

The Caroline Weiss Law Building at the Museum of Fine Arts, Houston, has two additions by Ludwig Mies van der Rohe, both with long, bowed facades: Cullinan Hall, 1958, and the posthumous Brown Pavilion, 1974. Closing off as it did the space between two fanning wings of an older building, the first must have derived from a famous 1933 project for the Reichsbank, before Mies left Berlin; and then the second took off from its Houston mate. On a wall in the latter, just over a decade ago, Alan Johnston executed the work discussed here, a mural drawing consisting of a big frame-like band with the inside divided by another vertical band, all executed in an unhurried mesh of fine pencil lines. All the more in the museum context, a Johnston Wall Drawing that was, so to speak, "all frame" would conceptually evoke the drawings in which Mies himself projected slim, naked structures in photomontages, indicating his defined space by rendering almost anything but the physical structure: studies not only for the Resor House, Jackson Hole, Wyoming, 1938, but also, appropriately enough, for a Museum for a Small City, 1948. Today Alan often works with contemporary architects, notably Neil Gillespie, of Edinburgh, and Professor Shinichi Ogawa, of Tokyo. To me, the obvious contrast between Gillespie's modest, practically Zen-vernacular Pier Arts Centre on the waterfront of Nordic Stromness, in the remote Orkney Islands, of 2008, and Ogawa's dry-ice svelte 150-Metre House, of 2012, very much commanding a vast landscape not far from Bangkok, illuminates the paradox of Johnston as a truly cosmopolitan artist whose restless nomadism seems bound up with the satisfaction of endless homecomings. — J.M.

Making a wall drawing on a full wall in a part of the Museum of Fine Arts, Houston, designed by Ludwig Mies van der Rohe, culminated a series of dialogues with architectural sites in my work, with related projects still ongoing. The drawing can be seen as consistent with such then-recent interactions of mine as a series of wall works done at Hans Schmidt's Haus Colnaghi, at Riehen, near Basel, of 1927, and installations in the house that the philosopher Ludwig Wittgenstein produced

for his sister in Vienna, finished in 1928, and at Inverleith House, built in Edinburgh in 1774 by David Henderson.

Museum mural drawings, however, have comprised a noteworthy category of my work, beginning with a group exhibition in 1973 at the Städtische Kunsthalle, Düsseldorf. From a year later, this one category issued in sixteen one-person and ten group museum shows, including the Orkney Islands and many other sites in the British Isles, Canada, Czech Republic, Iceland, Ireland, Japan, and the United States. The Houston piece was mounted in the most architecturally distinguished work of architecture; though I have also done wall drawings in many other significant modernist buildings besides museums, including others by Mies—an architect who is a particular favorite of mine, and Joe Masheck's too. At the moment I am engrossed in a large and permanent museum mural under the vaults of the cafe in the Tate Britain, in London, where I have also had a wall drawing of 2002.

The Houston drawing was a significant challenge, befitting the nature of that building wall, built by an architectural artist whom I am not alone in admiring as a great definer of spatial clarity. My work on the project began in 2001. The actual drawing was executed on a wall measuring 108 x 336 inches, on the lower floor of the Brown Pavilion, and formally exhibited from March 17 to June 30, 2002—"Hume's Evidence" seems to have been the official exhibition title, though the work itself is also known as *Wall Drawing* (fig. 12–1).[1] This large, lightly pencilled drawing was formed within the full perimeter of the wall itself, subtly claiming it. That what might have looked to a casual glance like a two-light open frame was really a matter of *almost* central division, and it created focal tension; the viewer's discovery of this slight ambivalence was heightened through the expectation of symmetry in Mies's classical structure.

It was Masheck, in his essay on the installations of my work at Haus Wittgenstein, in Vienna, and the eighteenth-century Inverleith House, from the time of the David Hume, who focused my thoughts on the nature and possibilities of what can be called a window/mirror analogy.[2] In *An Enquiry Concerning the Principles of Morals* (1751), a text in which "architectural imagery serves Hume, however ironically, as so much rhetorical embellishment, 'classical' . . . at that, . . . [showing] Hume at home with such material," the Enlightenment philosopher includes under "Why Utility Pleases" (sect. v) an architectural reflection of interest in view of the rectangular fenestration of Haus Wittgenstein: "What praise, even of an inanimate form, if the regularity and elegance of its parts destroy not its fitness for any useful purpose! A building, whose doors and windows were exact squares, would hurt the eye by that very proportion; as ill adapted to the figure of a human creature, for whose service the fabric was intended."[3] Hume here conveys a sense of admirably practical but not mechanically inhumane fenestrational form. I have actually used this as a sustained visual metaphor in all my wall drawings made in the past twenty years, and it provided the internal design idea for the wall drawing in Mies's Brown Pavilion of the Museum of Fine Arts, Houston.

As in other drawings, a restrained and perhaps ambivalent idea has been developed in pencil as a "shadow without object."[4] The result is a composed and passive

neutrality or uncomposed stillness. Philosophically, it calls forth an observation on the making of the wall works. From the earliest stage in my work I have pursued an engagement with both architecture and drawing, taken together, as propitious conditions of making. From my first exhibited wall work, at Bei Konrad Fischer, in Düsseldorf, in 1973, and onward, the works in question, which are in all senses drawing, have been engaged in bringing out the spatial confines of the architectural context as a structural necessity in defining the physical form of the work.

Furthermore, Masheck asserts that the window motif may be more than a stylistic leitmotif and that, in generating the design of the work, it makes for certain continuities and patterns. For example, in his catalogue essay for my exhibition (or installation) of paintings in Haus Wittgenstein, he alludes to two traditions of fenestration: "the box," which is the form represented in the architecture of Inverleith House, by way of Robert Adam and Rome, and the form of the elongated European, or Continental, window, as in Haus Wittgenstein. In fact, over time the form of my wall works has lost the "box" window, perhaps as a choice, for I think of the continuity of a Humean-Wittgensteinian association as reflecting philosophical influence from Hume to Wittgenstein. In any case, Mies's work at the Houston museum partakes of this distinction, not directly through the Vienna house, at least as part of "the modern." This includes various shared classical architectural traits, such as those that show Miesean influence and continuity. Hence the Houston mural drawing belongs to the continuous flow of an architectural tradition of austerity that can even incorporate the inessential, though not the superfluous or the decorative.

"The house, in fact, is a private vision of eternity, in which the spirit freed at last from practical constraints, communes narcissistically with itself as mirrored in its own creations. It is not a house, still less a home but a temple of art, a hermetic, ideal world permeated by a mortuary hush": here Masheck is quoting, as he says, "no archival account of the Wittgenstein House when new, but rather a contemporary description of a building that influenced the Viennese 'Secession' modernism from which the anti-ornamental architecture of Adolf Loos 'further seceded.' In point of fact, it is a then recent description of the house of the architect Charles Rennie Mackintosh, in turn-of-the-century Glasgow," which also speaks of "cool, uncluttered, airy rooms in muted monochrome. Everything tends to white or black. Ornament is sparse. Most of the walls are bare . . . the drawing-room is simply space punctuated by objects. Everything tends to extremes, but the unity of style is absolute."[5] Nevertheless, this description relates very closely to what I felt in Vienna while I was working in the Wittgenstein House.

In Houston, however, I was experiencing another, different "temple," and in its austerity Mies's temple had a more tempered "hush"—a public hush, one might say, where the sought-for, remote autonomy of response seemed close to an inevitable effect. So the desired ambivalence followed from the drawing, as much as creating a void.

This observation asserts something of considerable import for the formation of the work, and led Charles Esche to generate an interesting contribution to the understanding of this aspect of my drawing practice: "Alan Johnston's work is, at

12-1. Alan Johnston,
Wall Drawing,
Houston, Museum
of Fine Arts, Law
Building, 2001
(effaced by mid-2003).

times, almost invisible—but almost is not invisible at all. At a time when our lives are saturated by commodified images, looking at a simple drawing that relies so much on what we, as viewers bring to it, becomes a test not just of our perception but of our whole system of value." The same writer brings in a philosophical notion of perception itself, and visibility, understanding that the drawing provides ambivalence and yet fixedness too, in its complementarity of form and void. And its prominent quality of being almost nothing in terms of means significantly evokes Mies van der Rohe's famous dictum "Less Is More," insofar as here "the least is the most." Esche continues, "What we see, how we see it and even whether we register it all are consciously determined, a mirror of our private self in a way and a measure of our understanding of order, space and structure. It is the economical way in which this act of self-awareness is achieved that makes Johnston's work so extraordinary and effective."[6]

As an aesthetic and cultural assertion, this installation has had a particular resonance for my practice in general and its tactile exploration of spatial form. I myself would compare the work of the Japanese poet Sesshu (1420–1506). As Neil Gunn has written, "Certainly it is not a fear in Zen, which uses words like Emptiness, Nothing, the Void, quite commonly, but always in the paradoxical sense that Emptiness is not emptiness, space is not Void, yet, again, that they are these in the moment before they are not. To take the further step and hold these ultimate opposites in unity may be a true experience, but if so its expression—the communication of such a state of being—can never be more than a hint by the use of paradox."[7]

13. Afterlife of the *Black Quadrilateral*

Marjorie Welish

If Kazimir Malevich's Black Quadrilateral *in several versions is often misconstrued as a Russian nihilist matter of denial and negation, the influence of the image has proved curiously fecund: With it, the demise of the picture proved hardly to mean the demise of painting. Malevich himself followed up his multiply iterated "end, end, end," which was also a revving up, with a long stream of beautiful post-death-of-the-picture Suprematist paintings. So if the* Black Quadrilateral *was a resurrection as well as a death, interest in tracking its afterlife in painting and sculpture is certainly called for. Marjorie Welish, however has taken onto a meta-critical comparative plane a range of six critical views of it and works by later artists influenced by it, including three positions concerning Hubertus Gassner's 2007 Hamburg exhibition "Das schwarze Quadrat: Hommage à Malewitsch." Her essay is about how critical responses to that extraordinary* Black Quadrilateral *interpret it ideologically differently and, complicating the matter, how several critics treat recent artifacts having the same motif but maybe not otherwise akin to the* Quadrilateral. *Marjorie is notably especially interested in interpretive rhetorics and frameworks: In her* Signifying Art: Essays on Art after 1960 *(Cambridge University Press, 1999) she herself writes at least twice each, but differently, on several basically stylistically consistent contemporary artists. The present speculative paper looks at passages in recent writings that call upon the* Quadrilateral *to testify to some meaning to which the respective writers are predisposed. Welish wants to know how the critic's point of view is discernible: What key term or word string will indicate his or her orientation. Seeking to know how critical writing on abstract art can "control for sense" serves here to highlight a pluralism of approach to the often elusive "content" of nonobjective art (and the value thereof); for while each critic discussed references Malevich's same basic image, and descendents imputed to it, especially by Gassner, what matters here is how each does so through predispositions both rhetorical and ideological. — J.M.*

How can writing on abstraction control for sense? The problem seems to be this: Assuming abstraction in visual art to be that art which is free of subject matter yet entailing some content qualified as form, how can writing—a verbal medium, unlike the visual object it addresses—establish *criteria* for description? More specifically, how can art writing control for sense, let alone meaning, with regard to Malevich's *Black Quadrilateral* in any of its several versions? As an object that initiated and then confronted an ever-changing cultural avant-garde, the *Quadrilateral* image, while readily identifiable in appearance, is not so self-evident in its reality as "an ikon of new art." An icon of what? Of the content of form as such? Of economy? Of action? A chimera for meaningful futurity in the here and now? As described by others, the *Quadrilateral* is notoriously set in and among contrarily interpreted senses.

We shall consider under what terms a few authors' descriptions comprehend the image. Without being a survey of the literature or of the monographs on Malevich, this speculative paper takes a look at some passages in recent writing that call on the *Quadrilateral* to testify to some meaning to which the respective writers are predisposed. My hypothesis is that as readers we can discern writers' theoretical or ideological commitment, not only in statements but also through vocabulary that suggests categorical knowledge *in favor*; certainly we are vigilant to biases and prejudices, which leave subjective traces of a writer's field of inquiry and collective authority. By what key term or word string does the author designate his orientation?

―――――

Even writers on Malevich's *Quadrilateral* sympathetic to his art nonetheless interpret it from diverse disciplines. (Respecting their nudity, as it were, let's leave them anonymous—at least for the while, as the mention of proper names prompts shortcuts through to authorship.) Can we, then, ascertain the controls for sense?

From our initial cluster of writers, here is this from Author Number One:

> Given his volatile venturing from style to style and his deference to creative absurdity, it is not hard to guess the enthusiasm with which Malevich invented a style, suprematism—less a style, he said, than a penetrating metaphysical insight—that includes all the worlds in a zero point of art: the all creative shape of the square, at first a red square on a white field, then a black one on white, and finally just white on white. In praising suprematism, Malevich declares that out of the zero point of the black square a vocabulary of colored forms can be developed to the point of achieving "absolute" creation. Concentrating within itself eternal universal space, suprematism, he says, "transforms itself into color totality and expresses *everything* within the universe."[1]

From this brief passage we extract the following. Apparently prejudiced against modern art (note the phrase about Malevich's "deference to creative absurdity") but

biased toward Malevichean metaphysics ("less a style than a metaphysical insight"), this author is most likely not an art historian, for he is seen to control sense from without the work. Interested in reinforcing a metaphysical sense of mathematical entities as real and capable of being enlisted to distance thought from naturalism in a timeless state, yet suffused with revelation, he chooses to take platonically the informing content of the abstract form. This author further controls for sense by means of general and universalizing patterns of similarity and difference, suggested even in this brief passage, that are substantiated throughout his very broad treatment of the topic: the ineffable in comparative cultures, with the author as an undisguised neo-humanist assigning a metaphysical function—not an art historical place—to artworks.

In itself, the passage is inconclusive, of course. We learn elsewhere that in the book from which this writing comes this person, a scholar of comparative civilizations, is especially concerned with pursuing a philosophy of the ineffable: not only that peoples have belief, yes, but also how their myths and fictions condition belief; showing how language seeks to represent the ineffable, yet also the failure of its representing such in differing cultures. So this author's writing on abstraction controls for sense by the authority of a framework of comparative culture. The title of the chapter in which Author Number One's excerpt appears is "The West: Intimations of Neo-Platonism," and under this rubric the author assigns Malevich a European orientation. Other chapters indicate a very broad taxonomy of ineffably directed worlds. These are characterized as "the fertility seeking, community binding" places of Africa; "the dramatic art leading to rapt identification and releasing equanimity" of India; the "interlocking vital forces" of China; and "the indescribable, if often sadly pleasurable overtones and undertones" of Japan. [2] Through these characterizations of the ineffable, Author Number One seeks to accord cultural differences equal footing and to give equal claim to culturally inscribed metaphysics wherein incommensurables abound. He does not control meaning through facts: not on the level of data will understanding resolve itself, he says, and rather assumes that as different as cultures may be, it is possible to find common cause in the relation of "art to mystical or transcendental experience."[3] How does the meaning of this cast of ineffability comport with other accounts? There is much to dispute in the term *West* as assigned to Malevich, and were the cultural categories in Malevich's cohort investigated for pan-Slavic tendencies, the metaphysical value of *West* would require adjustment.[4]

———

Author Number Two also addresses the sense and meaning of the *Quadrilateral*. Deriving from public art lectures, one of which concerned Malevich, his words quoted here are directed to a nonspecialist audience, as he reviews the artist's stylistic development, leading to "showing . . . totally abstract works, dominated in the catalogue by the *Black Square*, which was hung, icon-like, across the corner of his space. Following Futurist practice, the paintings were accompanied by a manifesto.

The *Suprematist Manifesto* (originally entitled *From Cubism to Suprematism in Art, to the New Realism of Painting, to Abstract Creation*) is, in a sense, Malevich's literary masterpiece."[5] Concerning this Manifesto for Malevich, "He was dazzled and excited by the appearance of Cubist art, but was apprehending it through a Futurist aesthetic—an aesthetic that was in many ways antithetical to its aims."[6] On behalf of Malevich's futurist tendencies:

"Art," Malevich insists, "is the ability to construct . . . on the basis of weight, speed and movement." In the same way the *Black Square* was the most reduced, the most minimal canvas yet to have been produced, but we find its author declaring that "art should not proceed towards reduction, or simplification, but towards complexity." Relatively recent X-ray examination has revealed that the black square in fact obliterates a composition of coloured shapes underneath it. And to understand its meaning for Malevich we need to appreciate the fact that for him it represented a dynamically charged synthesis of all his own previous pictorial achievements and was capable of being split apart once more to produce hitherto unimagined pictorial configurations.[7]

Author Number Two arrives at meaning first by referring to the photographic documentation of "0.10: The Last Futurist Painting Exhibition," in Petrograd, December 1915, and then by describing the disposition of the painting as a sign traditionally religious, now still sacred, as its traditional function is transposed to another space: the exhibition room, newly consecrated in virtue of this disposition. Unlike Author Number One, this author relies on factual data from historical sources in visual and verbal documents, to control for sense and for meaning. What lies beyond these remarks is that in contrast to the first, this author enumerates elements in the metaphysical cocktail informing Malevich's *Quadrilateral* in order to pass on without expecting that these elements cohere. At one point he writes, "By the time that Malevich had produced the *Black Square*, and its accompanying verbal pyrotechnics, he had been influenced also, often at second hand, by a vast, amorphous body of philosophical and speculative literature."[8]

As for the enigma of the spiritual formation, the author acknowledges a panoply of sources by name, and the nature of these in their particulars, without pretending to synthesize these on behalf of coherence, either theological or ideological. Rather, this author assumes the centrality of art historical style. Cubism is the indispensable term for modernism in a stylistic sense, a reference point for gauging matters as Cubist space becomes infused with Futurist dynamics derived from the Italian program of the machine age. Then, specifying the terms of style, with formal elements privileged, the writer pays special attention to technique, and in so doing marks technique as integral to the formation of the avant-garde. Ignoring any studio practice as trial and error, not to mention an economic context marked by sheer privation and scarcity of materials, our author argues for the avant-garde impetus of Malevich's painting by imputing all potentiality to what lies beneath the overpainting.

The author is an English art historian from the generation that encouraged first-hand observation and active painting practice, or at least he assumed these experiences to be direct forms of knowledge. Evidently, this person's consideration of how we are to interpret Malevich's intentionality arises by way of truth "apprehended through immediate perception."[9] Modernist art is his broad field, with Cubism at the center and its discursive formation given priority. Art historical style and empirical research in the practice of painting direct this author's connoisseurship. Although the approach may not be as formalist as that of Roger Fry on drawing, he does understand that technique that organizes the painted surface signifies something more than craft—rather, that the brushwork conveys a discernible sense-making world. Distinguishing this author's work is an emphasis on the name and nature of surface, which for him is a palpable substance. He emphasizes this without invoking the ideological schism between surface and color, Constructivism and Suprematism, so often heavily invested in the term *faktura*.

Our third contestant begins his review of a major retrospective of the art of Malevich in this way:

> If the idea of monochrome painting occurred to anyone before the twentieth century, it would have been understood as a picture of a mono-chrome reality and probably taken as a joke. Hegel likened the Absolute in Schelling to a dark night in which all cows are black, so a clever student in Jena might have the bright idea of painting an all-black picture titled *Absolute with Cows*, witty or profound depending upon one's metaphysics.
>
> Only in the most external and superficial respect does Kazimir Malevich's 1915 black square painted on a white ground belong to this history. For one thing, Black Square is not a picture; it does not, in other words, depict a black square outside the frame. One of its immense contributions to the concept of visual art lies in the fact that it liberated the concept of painting from that of picturing and thus opened up a new era in the history of art.[10]

Our first informant assumed an anthropological framework; then, with our second author came an art-historical knowledge; and now a narrative informed through a sense, if not of teleological necessity, then of a program more binding than historical contingency. Here, knowledge is constrained by frames of reference in time. Not an art historian by training (though having set out as an artist), this writer has demonstrated a keen interest in major plot lines in history, especially when definitions become contested. Learned in philosophy and having written on historical narrative as such, he has transferred such interests to writing on art.

At any rate, this occasional piece on Malevich is expedient, in part mandated by journalism, in part sanctioned by the great early modernist moment whose conflu-ence of aesthetics and ideology produced a crux in narratives converging by way

of artistic expression, in that artifactual superstar, the famous *Quadrilateral*. This object seems at once to organize social forces and inspire, in perpetuity, a futurity for the here and now. Well, these are my words, not this last author's words; indeed, he would deny that the artist can imagine a future he does not already have access to through his present contemporary conception of things. But he does organize his journalistic review around this artifact, with that choice selecting a certain vantage point to represent, as well as its career, the meaning of the career for art history (note the phrase, "it liberated the concept of painting from that of picturing and thus opened up a new era in the history of art"). Parenthetically, let us note that when we write on Jackson Pollock it is most often *No 1A*, 1948, and a very few of Pollock's works that have installed a perspective on the sense and significance of his art for the selective narrative called art history. So, even as the *Quadrilateral* may be a snapshot of a temporal practice, it has also pride of place in the narrative of that practice, as an "Opus 1" of a visual sort. First, last, definitive, are temporal markers for narratives, as they are here in this review.

To return to this last author's point: As a narrative is knowledge informed through the constraints of time, this painting is not just any painting but embodies a singular decisive formalism. This writer's choice of the word *painting* designates a crucial term for an abstract world furnished with formalist modernism for which *Black Quadrilateral* would hold the place of origin.

Am I correct in observing that the terminological distinction between *picture* and *painting* carries more theoretical weight for American aesthetics than for British aesthetics, and so for the most influential narratives of formalism? Even the *British Journal of Aesthetics* is apt to favor the term *picture* for any canvas. The narratives by which art history selects, interprets, and organizes have long noted that while the manufacture of pictures and paintings happens all the time, the signifying event that lends antagonistic status to the pair of terms *picture* and *painting* reads otherwise. Indeed, for this latter writer, the contemporary return of "picturing" as such is a significant event. This is significant not because anyone can make illustration whenever he or she wants but because if postmodernism has anything to contribute to the historical narrative, it is through the term *copy* and its avatars *appropriation, duplication,* and *simulation,* in popular culture and open-source pasts in the present. This writer is known to dwell on the meaning of copies in art as re-presentation converges on *simulation,* and how acts of simulation undermine a history of art as a narrative constituted of perceptual strategies.[11] Beyond this, the author controls for meaning in abstraction by distinguishing, as well as picturing from painting in general, painting from picturing as specifically manifest now in a present other than that of past picturing. He considers this a question of possible frames of reference available at time past, time present, but not time future—to which we have no access but retrospectively.[12]

———

For those of us interested in how modernism defines itself and gives an account of its history through catastrophic cultural shocks, it is commonplace to contend with several narratives running in disjunctive parallel or playing tag.

Part ideology and part history, modernism has shown itself to thrive under different interpretations, and with de-centering foci in time and place; multilinear cultural change is familiar and was, indeed, hard-wired into the original conception of the Museum of Modern Art under its first director, Alfred Barr, who positioned the museum at the intersection of several modern worlds, with Suprematism and Constructivism represented through masterworks he himself had gathered on a visit to Russia with Jere Abbott in 1927–28, the Soviet stylistic foci of Suprematism and Constructivism vying with Symbolism and Cubism for consideration as definitive modernism in America's scheme of things.[13]

Language reflects on the contested site of modern art. How can it control for sense, let alone meaning, in visual abstraction, when art history is no longer the assumed discourse for considering art and is made further problematic now that we are given to question the very idea of an explanatory account. These days, language finds a way of addressing the *Quadrilateral* and its aftermath not through explanations but through interpretative descriptions that proliferate and may have a capricious effect on what was once taken as definitive. It is possible to argue that in a postanalytic situation the rise of descriptions has abetted opportunistic pluralism of the market as well as pluralism of worlds for culturally ramified situations

To be specific, the 2007 exhibition "Das Schwarze Quadrat: Hommage an Malewitsch," conceived for the Hamburger Kunsthalle, featured a Malevich *Black Quadrilateral* from 1923, augmented with many works by him, by El Lissitzky, and by other contemporaries. Yet the exhibition continued to unfold with some torqued sense of legacy thereafter, through modernity's avatars and through postmodernist works having principally black and square properties.

———

Let us consider how two writers reviewed this exhibition devoted to the *Black Square* and its recent reception. Writing independently, they came to divergent critical assessments of how well the exhibition ministered to the definitive object, the *Quadrilateral*.

The first, a Russian art historian of Soviet avant-garde art and culture, assumes a modernist position and judges the show deficient, though not owing to Gregor Schneider's rendering of the Mecca Kaaba, a forty-six-foot cubical volume redone as a reduced sculptural volume outside the museum. She does not object, as others had, to the possibility of Schneider's work provoking protest, nor to a possible Orientalism gesturing to cultures foreign to the artist who made the work (this work actually being well received by the local Muslim community). She does not object to its being an homage to an artifact not needing Malevich to justify it. Indeed, our art historian finds this work quite in keeping with Malevich's artistic intentions. Instead she voices objections on other grounds:

>This sculpture [*Cube Hamburg*, 2007] . . . sounded a religious note before visitors had even made it inside the museum. The problem with applying Russian-style messianic rhetoric to Malevich's painting, however, was evident in a small section of the exhibition devoted to the artist's course after the revolution, when his work became increasingly ideological as he expanded his focus from painting to design and architecture, which he saw as the ultimate arena for Suprematism. Several reconstructions of Malevich's architecktons, three-dimensional plaster studies, were exhibited next to Rodchenko's and Gustav Klutsis's "spatial constructions" (also reconstructions), thus bringing to the fore without actually addressing the theoretical and formal differences between the two major movements in the history of the Russian avant-garde, Suprematism and Constructivism. . . . Distinctions among artistic strategies were similarly ignored in the next room . . . , where along with one of Malevich's architecktons, were works by Richard Serra, Sol LeWitt, Donald Judd and Carl Andre . . . historical schisms are certainly in need of reevaluation; the exhibition, however, simply chose to ignore them.[14]

At issue here is the art historian's objection to the curatorial merging of Suprematism and Constructivism as though ideological difference does not matter. She also finds objectionable the arrest of Malevich at that mystical focus imputed to his art, which leaves his own successive ideological development unarticulated. Or, as she cites Vavara Stepanova to introduce her position, "'If we look at the square without mystical faith, as if it were a real earthy fact, then what is it?' This reluctance to accept the Black Square on a strictly formal basis has endured."

For this Soviet-born art historian, formalism is the new art for which the *Black Quadrilateral* would be an icon (in the sense of the figure of speech); yet, even so, the content of that formalism changes over time, as she implies that Malevich outgrew Futurism for Socialist purposiveness.

Elsewhere she has written on Malevich and film, and on the role of montage in Soviet politics. Yet although she may be biased toward Constructivism, here she does not advocate for an ideological rehabilitation of Malevich—just that, if the *Quadrilateral* on exhibit was to be acknowledged in homage, then the Suprematism needed the problematic social history enfolding Malevich's position, and involving a dialectical position of Constructivism to articulate how that homage might play out in public space or collective action.[15] Controlling for the ineffable, then, is not synonymous with controlling for abstraction.

But it is not as though the director of the Hamburg Kunsthalle, who organized "Black Square: Homage to Malevich," is unaware of this. For he has written academic monographic studies on Rodchenko and has contributed essays on Constructivism to coauthored avant-garde studies on the changing cultural policies toward the arts for the exhibition catalogue *The Great Utopia* mounted at the Guggenheim, and indeed he has written often on European modernism in general. For this curator, the iconology of the *Quadrilateral* is that of a "passage

into another, spiritual world" and functioning as the icon it is, it acts out a "visual representation of the next world in this world."[16] So, let us bring the curator into this dialogue.

If the contested ground of modernism typically plays out in ideological wars between Suprematism and Constructivism, at least for the sake of this show the curator holds both positions at once. Elsewhere, too, in writing on Malevich's paintings, he speaks of their *faktura*—a term usually reserved for the Constructivists' "assembly of textures."[17] Here, he speaks to Malevich's way of building his surfaces as the artist's "intuited facture." (Recall, by the way, the English art historian mentioned earlier whose consideration of Malevich's "surface" did not refer to the term *faktura*, hence did not link Malevich's meaning of surface to the turf wars for which *faktura* is a provocative term.[18]) The curator's naming *faktura* as an integral property of Malevich's painting is a curatorial prerogative with stylistic but also ideological consequences, as it locates a position for *Quadrilateral* in the slipstream of interpretation and reception. The issue here for both historian and curator might well lie in how they interpret the rhetoric of Malevich's built things: that even as Malevich refused the Productivist positivism and utility,[19] he himself, in his production of didactic charts as well as through the act of building architecktons, accommodated constructivist actuality. If that's the reasoning, then the curatorial initiative of mixing things up may be well sanctioned.

———

Even so, let's hear from our last writer, an art and architectural historian and critic. Actually, both these last art historians write for international art–savvy audiences and publish in appropriate magazines, although one for a magazine with far more global reach. Although inconclusive, yet again key terms emerge to indicate referential contexts and theoretical frameworks. Anyway, our final writer, too, has noted the nondoctrinaire gathering of Suprematist and Constructivist works, but he is relieved to welcome some tolerant view of the "two-party system," as he says. He writes,

> For Malevich, . . . there was nothing antisocial, let alone counter-revolutionary, in advertising that you were aspiring to the most exalted form of plastic art. What this definitely entailed, he said, was the supremacy of directed intuited feeling, and in its several incarnations the famous *Black Square* painting was the blazon of this seminal movement whose extended afterlife the Hamburg exhibition invited one to rethink.[20]

This art historian organizes his review in a rough chronology. He initially speaks to the core "mini-retrospective" of Malevich and his primary students, mentioning excellent works by Olga Rozonova and Nikolai Suetin and, noting the Constructivist Gustav Klutsis and the Lissitzky whose "Prouns"—an amalgam of Suprematist and Constructivist ideal and real space—in which both parties have interests. What this author then does is to follow the show as, he says, it "spirals away" from the

Suprematist point of reference, which prompts his giving judicious partial scores to a number of the curator's selections.

An art historian educated to trust knowledge as rendered through style as embodied in specific artworks, he proceeds through the show to make stylistic discriminations on a case-by-case basis. So he says,

> As for later Malevichian episodes, [the] best curatorially negotiated case' was that of the '60s iconoclasts of still doggedly pure, however absurd, painting—"pure" in the sense of free: not hermetic but unbeholden. Yves Klein and Lucio Fontana made very good appearances in this context, uncompromised by their ironies. Gunter Uecker seemed more dubious, his blunt materialism being at odds with anything like a Malevichian idealism. . . . The question of whether Minimalism, when rigorously defined, so precluded painting that even Ad Reinhardt and Robert Ryman are not really Minimalists, still reverberates with the question of object-based constructivists having superseded painting-centered suprematism.[21]

The historian's most analytical side comes out in defense of stylistic categories: Suprematism may not be converted into Constructivism through mere format; there is a content to form, and that is its integrity. So he is not happy to go along with what is falsely deemed Minimalism as a term too loosely conferred on all things simple: Minimalism as a style has its genealogy in actual, built artifacts (that is, sculpture), not formalist compositions (that is, paintings). Given that the names Suprematism, Constructivism, and Minimalism still obtain as stabilizing definitional core meaning, he resists curatorial misreadings of categories to justify permissive postmodernism.[22] Yet the same author judges the show to be "not only intellectually ambitious but artistically stimulating," with his "only general criticism concern[ing] a perhaps too acquiescent compliance with the prevalent presumption that the great modern tradition plotted out so broadly in the exhibition may have begun with pure painting but wound up with anything but."[23]

From this author's perspective, then, the more the exhibition "spirals away" from the dedicated *Black Square*, the more these problematics are apt to show themselves as distortions of Malevichean style. Elsewhere, this author, trained as a generalist in the history of European art from the eighteenth century through twentieth century, has made specific discoveries in the sources of Picasso's *Guernica*, written conspicuously on Cézanne, and in an official capacity has taken initiatives in criticism by tracking studio practice of then still-unknown contemporary artists.

Meanwhile, the curator's phrase "intuited facture" is quite distinct from the art historian's characterization of the canvas surface by way of "directed intuited feeling." Marked here is the value placed, in the first instance, on the sensation, in the latter instance, on expression, and the aesthetic ideologies to which these objectives commit. In a telling locution, the curator's catalogue essay justifies the inclusion of Lucio Fontana's pierced or slashed canvases in the show. According to him, a loose analogy may be made between Fontana's penetrating virgin canvases as marking life's entrances and exits and Malevich's paintings as membranes that mark and

breech the death of the old illusionist art to attain to the birth of imaginary space beyond.[24] Malevich's view that canvas is a membrane is taken quite literally by Fontana, who in expressing this does demonstrate a figuratively distinct and consequently contrastive metaphysics to that of Malevich. Is there an implicit curatorial play on "disillusion" here? On the curator's account, that the sensuous contents of the form change with generations of artists, then, is inevitable, while what holds firm is that there be a radical act that changes states of affairs.

The greatest difference between the two historians is in the meaning ascribed to *Quadrilateral* itself: With her formalism declared, the Soviet historian explicitly disputes the curatorial assumption of a content concerning mystical passage to a world beyond our own, and while overlooking salient post-Minimalist social objects constructed of cooperative behavior, she judges the show lacking in works reflecting cultural politics for Malevich in 1920. Meanwhile, by contrast, with his phrase that locates meaning in "intuited feeling," our final art-historian witness takes the measure of modern and contemporary European and American art quite differently; for he takes sense and meaning of the *Quadrilateral* otherwise—deriving Suprematism itself from a spiritual Symbolist poetics rendered revolutionary as nonobjective, in painting made manifest in 1915—a designation holding firm through time and changing worlds.

———

Given the reviewers' responses to the exhibition, we might gather that they were expecting certain definitions to obtain across the lineage. At issue for them was, to what were those artifacts clustered in homage referring? Not at all certain, what with the thematic show's conflation of homage with coincidental resemblance, was that the actual *Quadrilateral* in any of its several incarnations was indeed the thing to which the various modern and contemporary artifacts referred in terms of sense. A case in point is Allan McCollum's extended production of cast objects called "Plaster Surrogates," 1982 to 1986, with which the curator tried to make the case for relevance even as issues of duplication and simulation express a wholly changed social world under capitalism.[25] However, both reviewers disagree. In a more inflected way of putting the issue, McCollum allows a mass-market version of collectivity in production in which the only thing that does change is the format, with a built-in but inessential "picture" frame. Moreover, let us take note of this ironic return of a distinctly nonpictorially void "picture" to parody a standard still aspired to in painting. Complicity or critique? Of the market? But of Malevich, of his *Quadrilateral*, too? At any rate, both our art historian critics imply, without stating this directly, that controlling for meaning cannot be achieved by assuming that contents pertaining to the *Quadrilateral* inform McCollum's somewhat look-alike artifacts just for exhibiting black quadrilateral properties.

On this last point, the curator has made a preemptive strike in his catalogue introduction. He promises that his exhibition's homage will confine itself neither to a "phenomenology of the square in art, nor confine itself to the color black" but

will issue in "interpretations" by individuals involved in "a broader update of the archetype or the idea of [the *Black Quadrilateral*]."[26] Although consistency in format might facilitate a more forcible emergence of theoretical differences among artifacts, the sheer variety of formats and modalities of all sorts reads as mere miscellany. The rhetoric informing this curatorial will to mix theoretically distinct artifacts is a kind of cosmopolitanism, but one that, as it passes from modern to postmodern ideology, represents multicultural and pluralist stylistic and social considerations, and curatorial permissiveness is construed by the historians as a loss of control over meaning.

How, then, *can* writing on abstraction control for sense? Even prior to curatorial writing in catalogues and press releases, the apparatus of exhibitions that immediately controls for sense is the title of the exhibition itself. Thus, when the very title of the exhibition is "Black Quadrilateral," the term is deemed binding by sophisticated spectators, who look for the social contract to be borne out in the selection; moreover, a subtitle announcing "Hommage" raises expectations that contemporary artists will directly address the meaning of the definitive artifact. But the words *homage, lineage, legacy,* and *response* all convey different kinds of reception to the *Quadrilateral*'s aftermath, with these aspects of aftermath variously read out in the curatorial selection of works. Surely, for art historians and curator alike, indeterminacy with an acceptable range of interpretation allows some loose control over sense and reference. However, even when believing themselves to be tolerant of curatorial possibilities, art historians may judge that a curator's use of words should be other than an indeterminate instruction, a poetic analogy, or an ironic aphorism. Here, the curator ups the ante with significant linguistic slippage when he names his show in macaronic fashion, involving German, French, and Russian. The rhetorical question is, is indeterminacy a problem that inheres with sending and receiving cultural messages of any kind?[27]

Thus, how writers control for meaning in abstraction is compounded in the instance of the *Quadrilateral*. Not only is its meaning a moving target, as its creator, susceptible to rapidly changing styles and ideologies, confers meaning to ineffable worlds in rapidly changing times, and not only does the definitive nature of the icon in its abstraction incite subsequent attention by contemporary and future artists to respond with readings and misreadings, inspired and not. But in the throes of a postmodernity, which in its extreme pluralism proliferates permissive descriptions in lieu of definitions, and displays a variety of museological perspectives toward the fugitive experimental shows possible in programs of *Kunsthallen*, authors control meaning through worlds salient for them. Their language directs our attention to aspects of the ineffable grounded in their worlds.

At least we have entertained that possibility in our respondents, who were, in order of appearance: Ben-Ami Scharfstein in his *Art Without Borders: A Philosophical Exploration of Art and Humanity* (2009); John Golding, in his Mellon Lectures subsequently published as *Paths to the Absolute* (2000); Arthur C. Danto, as originally published in *The Nation* (August 18 and 25, 2003), and then in *Unnatural Wonders: Essays from the Gap between Art and Life* (2005); Hubertus Gassner, director of

Hamburger Kunsthalle, organizer of the exhibition and author of some entries in the catalogue *Schwarze Quadrat: Hommage an Kazimir Malewitsch* (2007); Margarita Tupitsyn, "Black Square: Hommage à Malevich," Hamburger Kunsthalle, Hamburg," in *Artforum* (September 2007); and Joseph Masheck, "Black Square," in *Art Monthly* (London; July-August 2007).

14. Men of Saturn: Styling "Bohemian" Melancholy in the Seventeenth Century

Martha Hollander

We can become so inured to a familiar view, however true, that we fail to appreciate something seemingly at odds with it. On first hearing, my colleague Martha Hollander's almost ethnologically interpretive paper about a certain habitus *of seventeenth-century arty lifestyle rendered in portraiture seemed to discount the primary iconographic importance of Dürer's 1514* Melancholia I, *specifically its head-on-hand and arm-on-elbow pose as emblematizing a specific melancholy of "heavy" thought (as my generation used to say) in creative gestation. Now I see that any such difficulty of mine was no simple matter of formalism versus iconographics. While I tend ordinarily to agree with Nelson Goodman (significantly, a collector of highly stylized ornamental art) in seeing art as such as mainly a matter, not of "communication" but of "cognition in and for itself"* (Languages of Art, *1968), here on the iconographic side even I find myself drawn into the case of the poet Donne. I would suggest that the Latin inscription—"illumine tenebr[as] nostras domina"—indicates no simple off-color parody of a Psalm, but a more Manneristic play on Donne's role as an Anglican priest familiar with the appeal "for ayde against all perils" in Evening Prayer: "LYGHTEN oure darckenesse, wee beseche thee (O Lorde) and by thy greate mercye defende us from all perils and daungers of this nyghte" (Book of Common Prayer, 1552); the 1560 Latin version likewise gives "ILLUMINA . . . tenebras nostras." Then too, why shouldn't Martha's iconographic view carry contrasting interest of its own as substantiating a general "bohemian" theme of artist self-presentation two hundred years before Romantic bohemianism as such, as the Wittkowers may well have warranted? Certainly the theme as she unfolds it has tantalizing contemporary resonance, reminding us of such fashions as "anti-tie" turtlenecks for well-behaved beatniks, raggedy army clothes for anti-Vietnam intellectuals, and now even uptight all-black outfits for "creative" professionals self-certifying as bourgeois-reliable. All the more interesting, then, to see a comparable semiotic in the time of Rembrandt. — J.M.*

Joseph Masheck, a scholar of the modern period in one sense, and I, of the early modern in another, have talked quite a bit as colleagues about his studies with Rudolf Wittkower. Joe has characterized Wittkower as "ultra-Warburgian," not limited to the classical tradition but employing a cosmopolitan view of art. Although I come from another generation, I also consider myself a Wittkower student of sorts. The magisterial work he wrote with his wife Margot, *Born under Saturn: The Character and Conduct of Artists*, was the first art history book I ever read, at the age of twelve. I had opened it thinking it would be about astronomy or science fiction, and I was intrigued by what I found. Wittkower's wide-ranging spirit, so sympathetic to the complexities of artists' lives and ideas, has shaped my own pursuit of art history. This essay pays homage to a way of thinking about art, which I believe Joe and I share.

The first illustration in Wittkower's *Born under Saturn*—used on the cover of the 1969 paperback edition—is a 1596 engraving by Zacharias Dolendo after Jacques de Gheyn. A classically nude figure is seated on the terrestrial sphere, his head cradled in his hand, surrounded by a desolate mountain landscape under a night sky. With downcast eyes, he holds a sphere and a pair of compasses. De Gheyn's image of somber contemplation, accompanied by both moody landscape elements and instruments of scientific inquiry, is an allegory of melancholy, the affliction of body and spirit, which became a cultural phenomenon of great range and complexity.[1] An inscription below, by Hugo Grotius, reads, "Melancholy [*atra*, or darkness], the deadliest plague of soul and mind, often oppresses men of talent and genius." Now, Wittkower's account of artists focuses, in part, on the nature of melancholy; his outline of "the Saturnine temperament" summarizes the ancient doctrines of the humors and their interpretations by Renaissance writers, and the relation between the physical affliction and artistic creativity.[2]

Briefly, melancholy was thought to be caused by an overabundance of the element earth, or black bile, in the body, leading to lowering of the spirits. Melancholics suffered from mood swings, loss of appetite, sleeplessness, pallor, and fainting. In his great compendium *Anatomy of Melancholy* (1621), Robert Burton describes the humor as an essential part of the human condition: "no man living is free, no stoic, none so wise, none so happy, none so patient, so generous, so godly, so divine, that can vindicate himself; so well composed, but more or less, some time or other he feels the smart of it. Melancholy in this sense is the character of mortality."[3]

Yet this humanity is strictly masculine and, furthermore, limited to exceptional men. Juliana Schiesari has shown that the view of melancholy as strictly male is based on a misogynist Aristotelian tradition. As for eminent women, their superiority is circumscribed by Renaissance commentators in the usual feminine attributes of modesty and personal virtue.[4] Images of melancholy men, whether in allegories such as De Gheyn's, or in portraits and self-portraits, proliferated in the sixteenth and seventeenth centuries. The head-on-hand pose seen in De Gheyn's print appears everywhere in early modern imagery, spread internationally via the rapidly expanding print industry.[5] The masculine types essentially fall into two broad categories: the pining lover and the man of learning. Both share a

preoccupation of spirit and mind, in withdrawal from regular society. Artists, of course, were often afflicted with melancholia—the focus of Wittkower's work—which at its extreme was even linked with demonic possession.[6] Nonetheless, the physical and emotional anguish appeared to be worth it. What Douglas Trevor has called the "reinvention of sadness," as described in late sixteenth- and early seventeenth-century literature, became a desirable condition.[7]

Women, essentially exempt from the culture of melancholy, were chiefly portrayed as allegories of the masculine condition, such as the dejected muse, head-on-hand, in Dürer's far-reaching original. Artists such as Domenico Fetti and Hendrik Terbrugghen combine the instruments of art and science with a woman moodily contemplating a book or a skull, which has led such figures to be mistaken for images of Mary Magdalene.[8] Modern feminine melancholy appearing in Dutch genre scenes is understood as an erotic condition only: a sickness induced by the effects of the humors on suppressed sexual feelings. Women actually afflicted with the disease are shown in bed, or sitting wearily at a table, with doctors examining their urine.[9] The Saturnine head-on-hand pose is used to depict sleep as well as suffering: sleeping maidservants, for example, as associated with drunkenness, idleness, and sexual promiscuity.

Although the allegorical maidens wear historicized drapery or turbans, and the contemporary drunken maids are conspicuously missing their modest *fichus*, sartorial signs of melancholy are expressed not in women's fashion but in men's. Along with the masculine slant of melancholy, men's clothing essentially dominated the world of dress until the end of the seventeenth century: fashion was simply the domain of men. In the earlier seventeenth century, two alternative identities for Renaissance men, warrior and lover, were reimagined as aspirations of the upper-middle-class educated man, versed in languages, aware of science, politically skilled, a collector of art, books, and natural history, with military experience or at least training in swordplay.[10] A man's clothing reflected his station and taste, ensuring that his body was as well ornamented as his mind and sword were sharp, and being melancholic was an element in this compendium of attributes. The art of the seventeenth century reveals how international was the cultural phenomenon of melancholy, with double valences of unrequited love and intellectual intensity. The mode was closely linked with characteristics of clothing, accessories, and pose: the imaginative fantasy of men's fashion.

Beginning in the mid-sixteenth century, clothing had become associated with extremity, daring, elements of fantasy, and gender-bending. The first conscious manipulation of melancholy as a visual style was the effete brand of masculinity—what Christopher Breward calls "indolent power"—favored at the late Elizabethan and early Jacobean English court: padded torsos, tight waists, elongated silhouettes, and a plethora of elaborate patterns and textures.[11] In the course of the seventeenth century, new fashions registered the idea of melancholy even more, with its visible signs not only in gesture (the melancholic head on hand) but specifically in clothing. Like mourning, melancholy had its own, less codified dress code, as well as poses and attributes.[12]

A perfect illustration of this style is an even earlier early-modern analogue to De Gheyn's Saturn: the famous anonymous late-sixteenth-century portrait of John Donne, in the National Portrait Gallery, London, in which the 23-year-old poet stares moodily out from an oval frame (fig. 14–1). With arms folded, he wears a large soft hat, a cloak over one shoulder, and long, loose hair. His exquisite starched collar is undone, and lace lies underneath while loose band-strings hang down over his chest in an angular shape, setting off his sharp nose. The Latin inscription, "Lady, lighten our darkness," suggests that the picture may have been a gift to a lover. Donne helped to design this image and referred to it in his will as "the

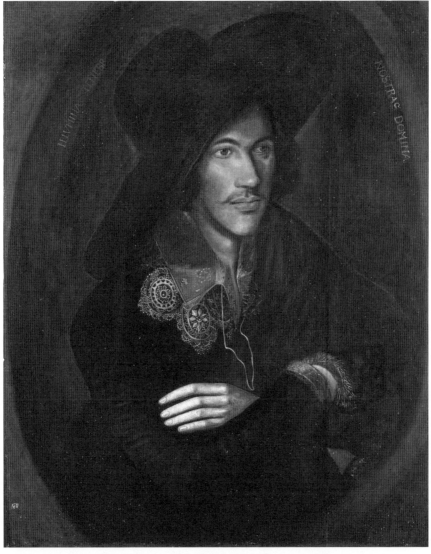

14-1. Unknown artist, *Portrait of John Donne*, c. 1595.

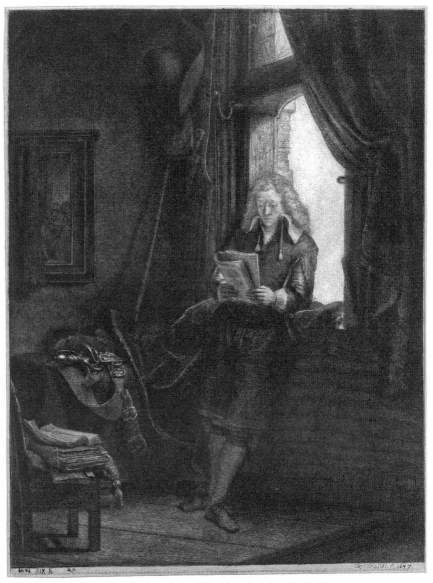

14-2. Rembrandt van Rijn, *Portrait of Jan Six*, 1647.

picture of myne which is taken in the shaddowes."[13] As a young law student with diplomatic ambitions, a reader and writer of poetry, a traveler and lover of women, and later a soldier, Donne epitomized the middle-class masculinity of the age. Here he is a moody lover, his gaze fixed on a distant point. His dishevelment speaks to his preoccupied state, and the darkness surrounds him.[14] Instead of the night sky and veil in De Gheyn's image, his black hat frames his head and melts into the shadowy background. Rather than classically nude, he is the epitome of sober chic.

Donne's portrait—which one curator called "the poster boy of the English

Renaissance"—epitomizes *the* desirable look for European men, which continued, with few variations, into the late seventeenth century.[15] Fashion, though French dominated, was, like the culture of melancholy, conspicuously international. Styles of clothing spread rapidly throughout the courts, and farther via travel and prints. Trends in clothing and behavior were enthusiastically adopted by young men as transmitters of cultural novelty. Furthermore, as the French language permeated the educated classes,[16] French innovations in clothing spread rapidly.

The pervasive style of men's clothing in the seventeenth century was known as *negligence*, or *lossigheyt* in Dutch—everywhere overtaking the crisp, buttoned-up Spanish manner of the Renaissance.[17] Portraits and genre images alike feature a large-brimmed hat at a tilt; doublet left partly unbuttoned at the bottom, sometimes with slashes, to allow the shirt to poke out; a soft collar with loose or undone strings; and long flowing hair. Men wore their cloaks in ways for which they weren't designed: hanging or draped over one shoulder, folded up and tucked in their breeches to reveal the lining, or wrapped entirely around their bodies.

The effect of dishevelment was an important factor of the new fashion. Nicolas Faret observes in 1630, "the young men of the Court . . . drowne halfe their statue in great bootes, somtimes they plunge themselves down from the armepits to the heeles in their breeches, and sometimes they drowne all the fashion of their faces in the brimmes of their hats, being as broad as the Parasolo of Italy."[18] Although large baggy clothes and loose hair were much mocked in the anti-fashion rhetoric typical of the period, these elements became increasingly acceptable as the century went on.[19] Thanks to the portrait innovations of Anthony Van Dyck in the 1630s and 1640s, disarray came to mean not only the high-minded preoccupations of creativity but also the flowing fabric of neoclassical figural drapery—as aesthetic link with a lofty past.[20]

As Roy Strong first showed a half-century ago, the roots of the fashionable melancholy type extend back to a portrait imagery disseminated at the English court by the brothers-in-law Marcus Gheeraerts and Isaac Oliver.[21] In these courtly portraits, aristocratic men are depicted in open shirts, in miniature half-length, surrounding by flames, or lying down near their discarded swords in a soulful parody of dead soldiers. Donne's portrait is a precocious version of this type. (Isaac Oliver produced a far more conventional portrait of Donne twenty years later, wearing a stiff ruff and a goatee [1616; London, National Portrait Gallery].)

The pining suitor was also popular in Dutch scenes of flirtation and music-making, less as a portrait formula than as a common masculine type.[22] Beginning in the early 1600s, the lone man appears in groups of flirting couples.[23] The type endures throughout the century, variously listening to women play music (Metsu, *The Cello Player*, London, Buckingham Palace), smoking (Dirck Hals, *Merry Company*, ca. 1630, Fine Arts Museums of San Francisco), or sitting with head on hand, looking away from the others (Vermeer, *Girl with a Glass of Wine*, 1660, Herzog Anton Ulrich-Museum, Brunswick). The typical costume for these sad men is not the hanging band-strings but a large hat or long hair to hide their faces from the rest of the company.

As if inspired by Donne's portrait, Samuel Rowlands' long satirical poem of 1615, "The Melancholie Knight," describes the fashionable melancholic:

> His face being masked with his hat pull'd down,
> and in doublet without gowne or cloak,
> his hose the largest ever came to town,
> and from his nostrils came much stinking smoake . . .

and later, "His head hung downe, his armes were held acrosse." This description—which Faret's description of huge trousers and hat would echo—sums up the essence of fashionable melancholy: dressed in newfangled wide trousers, arms folded, his face obscured by his hat brim, smoking.[24] As evident in Donne's portrait, the large hats coming into fashion at the end of the sixteenth century were appropriated into melancholic imagery, shading the eyes as the head was lowered, set off by the new fashion in long, loose hair. Thus, the large hat, along with shadows, falls of hair, and an inclined head, created a dramatic and elegant mode for hiding the eyes and shadowing the face.

The knight's "stinking smoake" was by this date a typical attribute of the melancholic. Tobacco, associated with the "hot" humoral nature of masculinity, was thought to be a cure for melancholy yet was also linked to meditation.[25] Rowland's entire "Melancholie Knight" is framed by a narrative about needing a smoke. Rowland even manages to insert the word "skull," referring to that other accompaniment of the melancholic:

> I haue a melancholy Scull
> Is almost fractur'd tis so full
> To ease the same these lines I write,
> Tobacco boy a pipe, some light. ("To Respectiue Readers," ll. 11–14)

Given the associations of melancholy with creation, as in this verse, the fashionable melancholic can be accompanied by books, globes, and other instruments of science or music, along with skulls and discarded swords. Skulls, formerly emblems of medicine as well as of mortality, as in images of saints and hermits (such as Saint Jerome), become secularized in the sixteenth century.[26] Youthful and distinguished men alike were portrayed with skulls (Hamlet's address to Yorick's skull is an enactment of this association). Discarded swords also appear as melancholic attributes, related to a lack of resolve and of aggression as also suggested by either a head-on-hand pose or folded arms.[27] Here is Rowland again:

> Rapier lie there, and there my hat and feather,
> Drawe my silke curtaine to obscure the light,
> Goose-quill and I must ioine a while together:
> Lady forbeare I pray, keepe out of sight. ("Melancholie Conceits," 30)

Rowland's verse focuses on the speaker's physical withdrawal into a quiet space, as well as his isolation from his public self and from love and war.

The most pervasive, yet subtle, mark of melancholy is the undone collar, which provides such a piquant detail in the portrait of John Donne. The moody, ambiguous shading of the eyes was set off by the dazzling white of linen shirts, collars, and

cuffs. Back in the late sixteenth century, when tight clothes were still fashionable, looseness could signify emotional disturbance.[28] Yet forty years later, the undone collar, like unbuttoned doublets and cloaks bunched around the waist or flung over one shoulder, became a detail of raffish masculine elegance. It could still function as a sign—a grace note—of mental preoccupation, if not of Hamlet's frenzy, then of creativity. This is particularly noticeable in portraiture as an advertisement of social rank and intellectual credibility.

In general, shirts and collars were important expressions of masculinity. In the early sixteenth century, men's necklines were low and horizontal, exposing the upper half of the chest. After about 1525 the neckline went back up, with increasing constriction, and finished with a band around the neck, fastened with strings or buttons. The open collar—sartorial embodiment of Castiglione's *sprezzatura*—was already a fashionable element, forming an attractive contrast with the stiff and padded torso. (The rage for novelty and experimentation in dress led women for the first time to adopt some features of male clothing: some Italian and English portraits of women show the artful display of loose band-strings, often in two or more rows.[29]) After starched ruffs were more or less abandoned by the 1620s, the simply constructed collar became the preeminent style of neckwear for the seventeenth century. This "falling ruff" or "falling band" (*beffen* in Dutch) could be made of linen or lace, attached to the shirt with strings, which were sometimes tucked back into the doublet or allowed to rest on top, and decorated with tassels. Erotic attention focused on exposing the shirt instead of bare skin. Henceforth, the shirt was a man's most important emblem of sexuality, class, and even character.[30]

A quick tour of Dutch portraits from the mid-seventeenth century reveals glimpses of linen at the wrists and neck, or poking through unbuttoned or slashed doublets. The combination of undone collar and artfully hanging band-strings was clearly an appealing variation, just as it had been for Donne a half century earlier. The eminent men painted by innovative portraitists such as Frans Hals, Bartholomeus van der Helst, and Frans van Mieris set off their black and gray costumes with opened collars, hanging band-strings, and often large tassels. The appeal of this small affectation is understandable: the interplay of rumpled white linen and black broadcloth or velvet is very striking. Some of these solid citizens are men of learning; others are businessmen. They appear either in a contemplative pose, perhaps in the head-on-hand pose of Saturn, or in the midst of movement, such as turning or rising from a chair, or looking up from work.[31]

Rembrandt was markedly aware of changing fashions in self-presentation, with which he experimented throughout his career. In an etching of 1647, he portrays his friend and patron Jan Six reading at a window (fig. 14–2). At this particular moment Six's intellectual life supersedes his riding, hunting, and military rank. Leaning on a windowsill, he abandons these active pursuits for an interlude of reading, his hat hung high on the wall behind him along with his hunting knife. His fur-lined cloak drapes elaborately around him, while his sword and bandolier repose on a table. (Recall Rowland: "Rapier lie there, and there my hat and feather.") A pile of books rests on a chair. He is also standing by the window with a deceptively

informal air, although his precisely angled feet and graceful carriage still suggest a public pose: the gentleman's *contrapposto*.[32] David Smith has observed that the portrait is highly unusual for its portrayal of privacy: Six is lost in his book, precluding any kind of rhetorical address to the painter or viewer.[33] Like the speaker in Rowland's verse, he is physically withdrawn from society. The etching is also curious because of his clothing: Six too wears his collar open, with the band strings conspicuously hanging down.

It is clear from preparatory drawings that the open collar was considered part of this ensemble from the beginning. Six's band strings are clearly hanging down in the black chalk drawing, and in the wash drawing a fully open jacket and collar are visible.[34] Rembrandt also did a quick sketch of Six reading, from this same period; as in the finished etching, his open collar allows his head to sink comfortably between the sides of his doublet.[35] Ten years later, Rembrandt etched a portrait of his friend Abraham Francen, apothecary and art collector. Again we see a cultured professional in the act of contemplation, this time seated at a table looking at a picture, with collar undone and band strings hanging.

Assembling the variations in their self-promotional iconography, artists often portrayed themselves with open collars, emphasizing their self-image as preoccupied intellectuals in addition to their social or professional status.[36] What Wittkower called "bohemianism" in one form or another persisted in cosmopolitan seventeenth-century culture. Artists portrayed themselves, and allegorical versions of themselves, in a variety of melancholic costumes and accouterments.

This is especially notable in Dutch self-portraits. Gerard Dou's allegorical self-portraits are among the most elaborately stage-managed in all of early modern painting.[37] Their influence can be observed throughout a half century of artist self-presentation. In one such self-portrait from the mid-1660s, in the Salzburg Residenzgalerie, the artist leans out of a stone niche,[38] wearing his typical combination of a jeweled sixteenth-century cap with contemporary clothes, and his band strings loop gracefully down from his undone collar, gleaming against his shadowed, receding torso (fig. 14–3).[39] In his self-portraits, Dou rarely uses hanging band-strings; regardless of headgear, he usually appears in a doublet without a collar—although the doublet itself is often slightly open at the neck. He often combines this generic contemporary garment with a robe based on elements of academic costume and a working artist's gown, sometimes belted with a sash. [40] The sixteenth-century hat, sometimes adorned with jewels, completes the picture.[41]

The creativity suggested by Dou's blended costume is reinforced by his pose and expression. This is creativity of a sober and preoccupying sort: the artist leans out of the niche like Donne emerging from his oval frame, holding his brushes and palette, but pausing in his work. An unfinished painting on an easel can be discerned in the dim background, along with a classical column and drape, and a globe, an attribute of scholarship and collecting. Over the easel is a parasol, which Dou reportedly used to keep paintings free of dust. A frequent element in the background of his pictures, it suggests the single-minded industry with which he approached his work, what

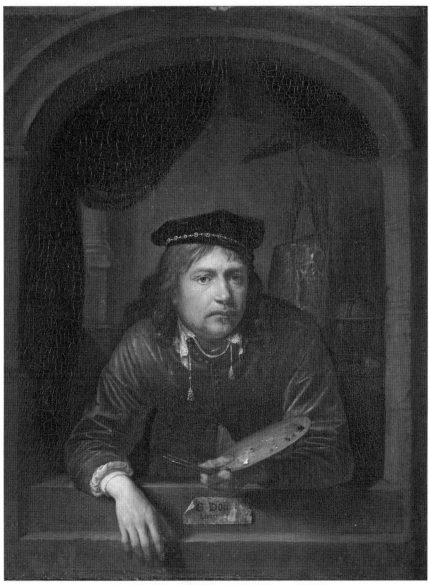

14-3. Gerard Dou, *Self-Portrait at a Window*, 165[?].

Wittkower calls his "mania for cleanliness."[42] Yet for the moment he has paused from work, his hand drooping languidly as he leans forward to stare abstractedly out the window. (This detail, unusual in Dou's self-portraits, recalls Van Dyck's motif of graceful, aristocratic hands.) The frowning intensity of Dou's gaze, even more intense than Donne's, expresses the burden of the melancholic condition.[43] Where Donne is a lover, Dou is a craftsman and thinker; yet both brood.

Self-portraits by two other Rembrandt students, Carel Fabritius and Ulrich Mayr, show not only the mandatory long hair but dramatically open shirts.[44]

Fabritius presents himself in a low-cut costume resembling a sixteenth-century doublet, open to reveal his bare chest.[45] A *pentimento* reveals that he widened the opening of his shirt.[46] Ulrich Mayr presents himself holding an ancient bust, wearing a simple shirt that emphasizes the classicizing effect of white linen.[47] These states of manly disarray, even undress, evoke the timelessness of classical draped nudity along with qualities of intellectual or artistic preoccupation.[48] (The draped effect of Jan Six's cloak in Rembrandt's etching serves the same purpose.) Sure enough, there is little difference overall between Fabritius' and Mayr's classicizing self-images and Isaac Oliver's late Elizabethan court portraits of open-shirted lovers.

As Mayr's self-portrait demonstrates, loose linen and open collars are particularly apt signs of creative melancholy because they represent the closest thing to classical drapery. It should be remembered that shirts were regarded as underclothing; the frank display of linen became a kind of substitute for bare arms, which were rarely seen in contemporary clothes and considered unseemly.[49] Thus the open collar itself becomes a kind of shorthand; and behind the concept of nonchalance is the fashionable notion that too much care for one's appearance is inappropriate and unmanly. So the open collar and hanging band-strings, or the more ostentatiously open shirt, evoke the creative and intellectual aspects of melancholy while maintaining gentlemanly decorum.

This brief sketch of melancholy costume is intended to raise rather than answer some questions. How do sartorial choice and behavior interact with their artistic display? When elements of clothing or gesture appear in works of art, how do we interpret them? What constitutes a pleasing aesthetic, and what signals a message of self-presentation beyond the assumed values of sexuality, power, and wealth? How do we adjust our intentions when considering formal portraits, allegories, genre scenes, and their intended audiences? In approaching early modern images of idealized manhood, distinguishing and identifying the concepts of *dress* and *melancholy* is difficult precisely because they become so entwined in seventeenth-century masculine self-creation. For all their aspiration to wealth, sobriety, and virility, the learned and industrious *bourgeoisie* wanted to be men of Saturn—if not in life, afflicted by what Wittkower calls "the sinister ancient god," then in the imaginative realms of fashion and art.

15. Modernist Art-School High Jinks in 1908

Margaret Stewart

When Margaret Stewart told me about a cache of photographs of some of the earliest women students at Edinburgh College of Art, a century ago, sort of vamping for the camera in what sounded like art-historically significant postures, it was clear that she, a classicist concerned with the nineteenth-century notion of Edinburgh as "Athens of the North," deserved to be encouraged to publish this material. In terms of cultural style, an earlier nineteenth-century French "Parnassan" literary classicism, abstract-evocative in nature, had fed into a more international and intermodal symboliste poetics that was met late in the century by the affirmative artificiality and high formalism of postimpressionism as the first radically modern movement in painting. It certainly sounded like these posey photographs had something to do with that, on a fascinatingly accessible local level. I knew from experience that Margaret not only has an amazingly thorough knowledge of the ECA's purpose-built original building but she also is a sometime-curator of the College's cast collection, which, if I have this properly engraved in my Centenary Fellow's memory, includes an almost unique complete first-generation set of direct casts of the Parthenon frieze given by Lord Elgin himself to the predecessor school of the ECA, most of it built into the sculpture court at the College. It seemed time that these interesting photographs, at once art and documentation, were published, and Margaret Stewart has indeed proved uniquely placed and capable of conveying their self-consciousness of style and reiterative-parodic aspect, as well as their sense of an early modernism on the margins of Europe, with Edinian local history entailed, in as it were bifocal culture-historical view. — J.M.

———

This short essay in Joe's honor is by way of thanking him for his warm interest in Edinburgh College of Art, and in particular for the many stimulating conversations and lectures he shared with us as the College's Centenary Fellow—a fellowship that also resulted in his publishing an architectural history essay about our 1907 building.[1]

The photographs discussed here have been known to us at the College for many years but have never been published (figs. 15–1 to 15–5). Their appeal is obvious to all historians of art, all artists, and indeed all of artistic persuasion. The humor—possibly ironic, as Joe has suggested—the surreptitious smoking—a most unladylike conduct for Edinburgh girls at any time but particularly in the Edwardian period—and the allure of an unsolved mystery make them irresistibly intriguing. At first glance, they might seem to represent mere high jinks; however, even as student high jinks they embody subtle meanings, and, as we shall see, they allude to events in the history of the College and to the status of art in Scotland in the period.

Showing Joe these photographs produced a vertiginous range of suggestions from him, including references to eurhythmy, anthroposophical themes related to physical movement in Rudolf Steiner's teaching, the Swiss painter Arnold Böcklin, and freemasonry. He responded with typical verve to my mentioning symbolism: "I always resort to *symbolisme* when necessary, in order to indicate that I don't just mean 'using symbols' and because this term, admittedly borrowed from literature, at least keeps a place for 'postimpressionism' as in fact ANTI-impressionist (Roger Fry was right!), in that it turns FROM nature, through stylization, TO the decorative-abstract. That's why/how I think of the great early modern 'Frenchie' artists in portrait reliefs on the piers of the Glasgow School of Art lobby as arch-POST-impressionists."[2] So, here, "symbolisme" it shall be.

I cannot follow up all the suggested sources here, but I would like to attempt to place the photographs in their Scottish context. The references are both overt and covert, personal and more widely referential.

The three girls smoking in the photograph (see fig. 15–1) were painting students.

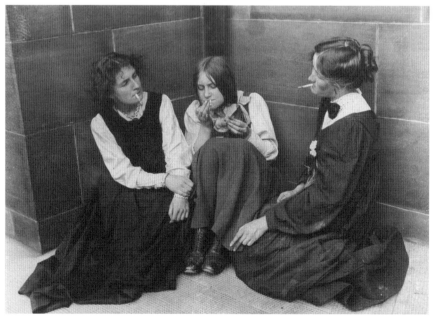

15-1. Unknown photographer, Three female students smoking at Edinburgh College of Art, c. 1908.

They are, from left to right: an unidentified student, Dorothy Johnstone, and Helen Urquhart. The next two photos (see figs. 15–2, 15–3) have the same three girls holding a T-square: Helen Urquhart on the left, an unidentified female student in the center, and Dorothy Johnstone on the right. The painter and designer Robert Burns (1869–1941), who was their tutor at the College, is seated on the chair. He faces straight to the front in figure 15–2, and to his right (our left) in figure 15–3. Notice how the poses change between these two photographs: even the hands shift in direction, although the fingers remain outstretched. Burns's hands are crossed in his lap in figure 15–2, and they point straight along his legs, in profile, in figure 15–3. In the background of both is the masons' stoneyard at the rear of the new west end of the College building, which was completed by 1907.

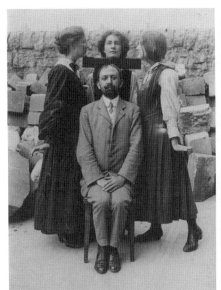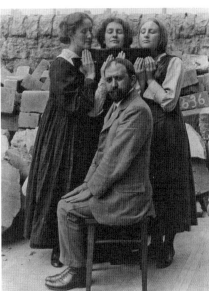

15-2. Unknown photographer, Three female students with a mason's T-square and the artist Robert Burns facing forward, at Edinburgh College of Art, c. 1908; 15-3. with artist Robert Burns facing left.

In both of these photographs, the three students together hold a large, forty-eight-inch T-square of the type used by stonemasons, which they have clearly borrowed for the shot. Their resting their chins on the ends of the upper flange of the centrally positioned T-square gives a controlling symmetry to the composition while it converts Burns's stool into a Charles Rennie Mackintosh–type of high-back chair. In figure 15–3, Burns's facing left breaks this symmetry. Notice here how the girls' hands now support the flange of the T-square: their fingers point upward while the angle of their gaze is downward, to the top of Burns's head. Possibly Burns has just been "enthroned and crowned" by his artistic muses. But why use a mason's tool for this?

The T-square and the building site are significant, as they refer to two initiations: the new building and the inauguration of a new art institution and,

by extension, a new art. The new college replaced its predecessor art school in Edinburgh, the Trustees' Academy, and a new building was provided on a new site at Lauriston, in Edinburgh. The ceremony of laying the cornerstone, which took place on July 11, 1907, was attended by George, Prince of Wales (later King George V). It was conducted according to Masonic ritual: the Prince of Wales can be seen holding a mason's mallet. The T-square appears again, with other architectural instruments, in a group photograph taken on the main staircase of the new building (fig. 15–6). The three female students and Burns appear in this photograph as well, and now the two students seated on the floor are holding compasses and a triangle.

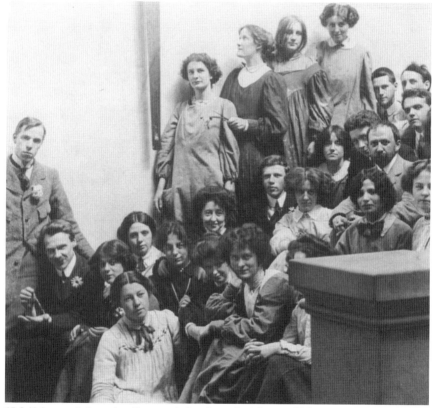

15-6. Unknown photographer, Group portrait on the main staircase of Edinburgh College of Art, 1908.

Burns was a painting lecturer at both institutions, the old and the new.[3] He was appointed head of painting and drawing at the new College in 1908, and it seems this promotion is alluded to in figures 15–2 and 15–3.[4]

Helen Urquhart and the unidentified student in figure 15–7 had been students at the Trustees Academy before it closed in 1907, and they were photographed on the landing outside the Sculpture Gallery in the Royal Institution building shortly before the interior was reconstructed for use by the Royal Scottish Academy. Notice their fine clothes, their sketchbooks, and their elegant poses. This picture does not

possess the conscious stylization, formality, or meaningfulness of a *symboliste* image. Nevertheless, it is not hard to imagine that Burns was the *deus ex machina* of this photograph, too; here, youth and beauty wait serenely for entry to one of the most grandiloquent and exclusive galleries of sculptural casts in Europe at that date. But the elegiac mood suggests a farewell; indeed, the students may not be waiting to enter but may be locked out of the gallery on the eve of its destruction. If we compare this figure with figures 15–1 to 15–6, we can see that a transformation has taken place between the old Edinburgh art order, with its elegant building and elegant people, and a new artistic order where paint-spattered smocks and high jinks demonstrate that the

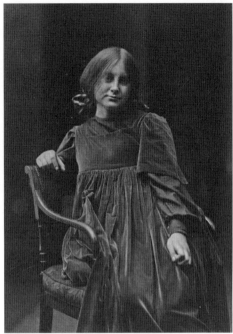

15-5. Unknown photographer, *Portrait of Dorothy Johnstone*, 1909.

girls are no longer inhibited by the Romantic passivity of the lady artist but are now active participants, and even tomboy rebels, of the new art (fig. 15–1). The mood of ridicule and antiauthoritarianism might be attributed to Burns, as he was notoriously intolerant of officialdom.[5]

A studio photograph of Dorothy Johnstone (1892–1980) from December 1909 (fig. 15–5)[6] possesses a powerful psychodynamic undertow of self-realization, an image of a young woman artist on the brink of a new age. The pose resembles that in the famous photograph of the artist Margaret Macdonald Mackintosh seated in the studio drawing room of the house that she and her architect-husband Charles Rennie Mackintosh created together in Glasgow (fig. 15–8). It is quite likely that Dorothy knew this photograph through her friendship with a fellow student at Edinburgh, the Glasgow girl Cecile Walton, daughter of Burns' old painting tutor at Glasgow, E. A. Walton, or through her friend Mary Newbery, the daughter of Mackintosh's patron and the headmaster of the Glasgow School of Art, Fra Newbery.[7] Dorothy and Cecile were frequent guests of the Newbery family in Glasgow when the Mackintoshes were still living in the city. Dorothy Johnstone was born in Edinburgh in 1892; her father, George Whitton Johnstone, was a landscape painter, and her maternal uncle was the artist James Heron. Dorothy matriculated at the Edinburgh College of Art in 1908 when she was sixteen years of age.[8]

Dorothy herself was recognized as precociously gifted, and she was appointed to the staff of the College in 1914. She exhibited at the Edinburgh Group exhibition in 1912 and 1913, joining the group after the end of World War I. In 1912, Dorothy

15-7. Drummond Young, Two students at the Trustees Academy in the Royal Institution building, Edinburgh (now Royal Scottish Academy), c. 1907.

also exhibited *The Broken String* at the Royal Scottish Academy, and her painting *Marguerites* was one of her most important works. Mary Newbery, Cecile Walton, and Dorothy were prominent among the women members of the Edinburgh Group in 1920. Their work was described as "unique rather than universal," and as possessing a "pagan brazenness rather than parlour propriety."[9] After the custom of the day, Dorothy was obliged to resign her post on her marriage to a fellow member of the painting staff, D. M. Sutherland, in 1924.[10] In that year, *The Studio* magazine described her as "a brilliant daughter of Scotland."[11]

Figure 15–4 is a photograph taken beside the main door of the new College building. Why do the figures face in different directions? Why do the two on the

outside have their legs bent up, and the one in the center, her legs extended downward? And why are they holding onto the wall? Are they preventing it from flying away, or being lifted by it? This photograph may be a play on words: an architectural elevation is, after all, a wall that rises up while being rooted in the ground; it might also refer to Burns's "elevation" to head of school, and it might also be mimicking the up-and-down movement of a lift or elevator.

The 1908 photographs symbolize the initiation of a new educational and even a proto-feminist order in art in Edinburgh, but they also demonstrate a sophisticated understanding of art nouveau and *symboliste* art, with all the new movements implied about liberating society from the shackles of tradition, in which the imagery of women was a vital emblem of personal, sexual, and artistic liberty, and the route to a new creativity in art. Indeed, Scotland had been in the vanguard of the new art, competing and contributing to its development from the early 1890s. European contemporary art had been a powerful stimulant to Mackintosh's circle, which included the Newbery and Walton families. On seeing one of the 1908 Edinburgh photographs, Joe immediately made the connection with Ferdinand Hodler's symmetrical compositions of ritualistic gesture. These are strikingly similar to the graphics produced by Mackintosh's circle in the 1890s, the so-called Spook school, who

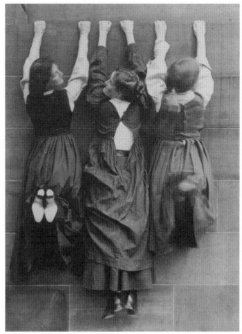

15-4. Unknown photographer, Three female students hanging by their fingertips on the entrance wall of Edinburgh College of Art, c. 1908.

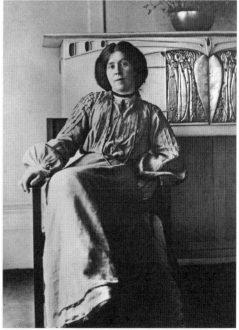

15-8. Thomas Annan, *Portrait of Margaret Macdonald Mackintosh*, c. 1895.

understandably preferred to call themselves The Immortals (fig. 15–9). Mackintosh and his future wife Margaret Macdonald were the artistic driving forces of this group, and they were drawing on the Continental art journals, on their friends in the Vienna Secession, and from such arcane sources as Rosicrucianism, Egyptology, and *Japonisme* for unconventional imagery.[12] And it seems that stylized mock rituals of the sort depicted in the 1908 photographs and in photographs such as this one of The Immortals, where we see Mackintosh "enshrined" by his female companions, were more pervasive in art circles in Scotland at this period than we might previously have thought, before the phenomenon had been analyzed by the Scottish filmmaker and historian Tim Neat in a brilliant study of *symbolisme* in Mackintosh's circle: his book *Part Seen; Part Imagined* (1994).[13]

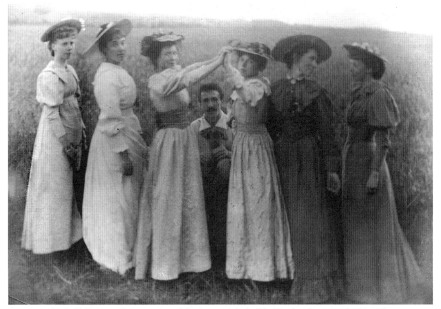

15-9. Unknown photographer, 'The Immortals,' with Charles Rennie Mackintosh.

We may never know who pressed the shutter, but it seems likely that it was Burns who devised and composed these photographs. Burns had been a fellow student of Mackintosh at the Glasgow School of Art, and while there he had received encouragement from Cecile's father, E. A. Walton. Burns spent 1890 to 1891 in Paris with Charles Mackie, his teaching colleague at the former Trustees Academy in Edinburgh who had certainly met Gauguin and was therefore close to the wellspring of European *symbolisme*, and whose work demonstrated influences from the Nabis.[14] Burns purchased a large number of Japanese prints in Paris, which helped him evolve his own precociously art nouveau graphic style. There he drew *Natura Naturans* (fig. 15–10), which was not printed until 1895 in Patrick Geddes' *The Evergreen, a Northern Seasonal*. Remarkably enough, Burns even contributed to the journal of the Vienna Secession, *Ver Sacrum*. But the rectilinear compositions of the 1908 photographs (figs. 15–1 to 15–5) show an influence from the

Glasgow style that is not evident in Burns's sinuous graphics. After his return to Edinburgh, Burns became a leading figure in the Celtic Revival and a member of Patrick Geddes' Edinburgh circle,[15] teaching at Geddes' Old Edinburgh School of Art from 1893, designing costumes for pageants, and collecting Scots ballads.

In 1898, Burns and his fellow Edinburgh artists joined with Phoebe Traquair and John Duncan to form a new artists' society in Glasgow. The group included the leading Glasgow artists Francis and Jessie Newbery (of the Glasgow School of Art) and Cecile's uncle, the designer George Walton.[16] All these Scottish artists shared an interest in *symbolisme* and the Celtic revival. One significant aspect that Burns shared with Mackintosh

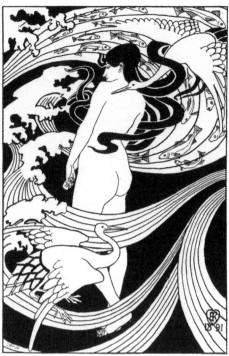

15-10. Robert Burns (artist), *Natura Naturans*, 1891.

was the symbolic and inspirational potential of women in art, both as subjects— as in Burns' *Natura Naturans*—and also as artists. Images of women nude and clothed were highly significant in European *symboliste* art, as well as in the circle of Mackintosh in Glasgow.[17] Although women underpin *symboliste* art in the period, both as figures of biological creation and as inspirers of art, beyond such artistic circles female liberty, sexual and political, was judged as decadent. [18] However, Geddes was an advocate of anarchist thinking, and his Edinburgh Summer Schools were attended by French radical thinkers. Jacques Élisée Reclus and the militant anarchist libertarian Augustin Hamon supported the idea that the regeneration of modern life was dependent on decay as the result of contemporary decadence, in what for Geddes was a biological cycle of nature. (The more widely held view in Britain was that the anarchist movement was a poisonous bearer of decadence as simply a categorically evil thing.)

From as early as 1895, Robert Burns's graphics do indeed show a strong awareness of European *symbolisme*, and particularly an awareness of Fernand Khnopff, James Ensor, and Gustav Klimt. Despite such cosmopolitan awareness of the new Continental art on his part, his painting class tended toward the traditional, favoring the Italian Renaissance masters.[19] He seems, however, to have excelled as an art teacher, recognizing Dorothy Johnstone's talent very early in her studentship. Later, another of his students, Anne Redpath, became one of the leading painters in Scotland of the twentieth century.[20] As an illustrator and graphic designer,

Burns was innovative, and his *Natura Naturans* even had considerable influence in Europe.[21]

In all, these 1908 student photographs, very possibly by Burns, contradict the all too prevalent and too long held, simplistic, art-historical view that juxtaposes conservative Edinburgh with avant-garde Glasgow. Further research along these lines will deepen our knowledge, so that in time we may come to see Edinburgh College of Art, a century ago, as a place, like the Glasgow School of Art, that was a good deal less conservative than once believed and where radical art and radical ideas flourished early on.

16. Non-Mimetic "Imitations": The Modernist Topos of Barbarian Numismatic Copies

In memoriam David L. Craven

Joseph Masheck

For a decade since he came to Hofstra, Aleksandr Naymark and I spoke about collaborating somehow on the present subject, on which we could always find ourselves sportively at loggerheads: not because he is a numismatist and I a critic of abstract art, but because of the problem of formal value. Sasha had been schooled in a Soviet Union defoliated, in its supposed dialectics, of the idealism of formal values in abstract art. His own father, a major poet, was conversant with the original Russian formalists; nevertheless, contemporary art was essentially a matter of realism relieved merely by naturalism. So the theme of the Celtic copies of classical coins as non-mimetic often surfaced in our give-and-take, as a high modernist topos advancing the cause of abstract form in Western modernism during the period of our older and younger youth on both sides of the Cold War. Finally, when Sasha organized an international conference at Hofstra on "The Eurasian Steppe as Contact Zone," for January 2010, it was obviously time for me to compose and deliver the paper that follows, here and now in an elaborated form developed six months later for a lecture at Edinburgh College of Art.

I have quibbled over whether to say "topos" or "trope" in the title. But this is not a question of motifs, however figurative, such as the nostalgia of all Romantic ruination: it is an active call for new forms as various as Kandinsky's or Miró's, and as such a topos whose own significance plays out in the topic and theme of formal freedom in abstract art. We can even say that whereas Malraux's immediate numismatic objects would ordinarily have constituted mechanical reproduction pure and simple—classical coins as multiple micro-sculptures—now they read otherwise: his Celtic types were welcome not only to diverge radically from their models but also to become new rhizomic points of endless variation.

During modernism's popular heyday in the 1950s and 1960s, at least every other schoolboy might have been fascinated by those "Celtic imitations": coins minted from the third to second century BC onward, as looser and looser copies

of copies of Greek coins of Philip II of Macedon, in the fourth century BC, and his son Alexander the Great. Well, every other *New York* schoolboy, for in these parts it was exciting to be picking up on abstract art. When a fellow college freshman—today, an abstract painter—showed me Gombrich's brand new *Art and Illusion* (1960), I was sufficiently drawn to his presentation of Celtic numismatic imitation to be confused by why anyone might *not* like seeing the standard head of some deity or ruler or horse break down into a play of *pure forms*. We will catch up with Gombrich, as well as with André Malraux, with whose enthusiasm for the imagic degeneration, and on a good day, re-formalization, of the Celtic numismatic copies Gombrich was at odds.

Speaking of schoolboys, I might give some background to my early interest in the larger subject at issue here. I was introduced to art history by a man who studied the Eurasian migrations, of which the Celtic coin is like an extreme Western appendix: John F. Haskins' passion for such must have been stimulated when serving as a Flying Tiger for the Chinese army before the United States entered World War II. On my own, I happened on *Philosophy of Art History* (1958), where Arnold Hauser points up how, with a grassroots social aspect, Migrations work brought into Western Christian art something that had played "no important part" in classical art—namely, "decorative form and abstract beauty of line . . . whether its invention be ascribed to the Germanic tribes themselves—that is to say, to their Sarmatian teachers—or traced back to Roman provincial art."[1] After college, on my first trip to Europe, I was so anxious to get into the Migrations art in the Vienna museum that I broke the turnstile!

Little could I have known that, thanks to Haskins' own teacher at New York University, Alfred Salmony, Scythian and Steppes art had already appealed to certain New York artists. The abstract painter Ad Reinhardt, whose nearly monochrome "black" paintings are some of the most important modernist works of 1960 and thereabouts, studied under Salmony; and the Lithuanian-born "Fluxus" founder George Maciunas took to Salmony's lectures and proceeded to make complex charts of Eurasian Migrations art. To judge from *Salmony's* catalogue introduction on Sino-Siberian art, a field in which few objects had definite dates or points of origin, he was looking for the big picture: common Neolithic underpinnings, a racial melting pot, the ironic cultural conservatism of migratory society (notably of metalsmiths).[2] However anxious he seems to have been about abstraction taking the upper hand, Salmony was interested in formal "deterioration" per se.

Of course, no modern critic could ever have applauded numismatic formal breakdown had not Romanticism undermined the hegemony of classical form as normative standard and raised the rival standard of—can we say—Gothic "beauty." The critical Gothicism of Ruskin's *Stones of Venice* (1851–1853) is still inspiring, with its "Conclusion" condemning "the whole mass of architecture, founded on Greek and Roman models" as "utterly devoid of all life, virtue, honourableness, or power of doing good," and asserting that classicism seems "invented . . . to make plagiarists of its architects, slaves of its workmen . . . an architecture in which intellect is idle, invention impossible."[3] Ruskin would have seen the freewheeling Celtic

renderers as *anything but* plagiarists even if he was not prepared to countenance departure from normative nature. As for the importance for later formalism of representational breakdown in the literary *Décadence*, Tolstoy actually compared decadent artiness to counterfeit coinage: "To say of such a work that it is good because it is poetic—meaning that it resembles a work of art—is the same as to say of a coin that it is good because it resembles a real one."[4] Believe it or not, this is Tolstoy faulting Goethe's *Faust* for being not being original—as if Shakespeare wrote off the top of his head! Eventually, early modern British formalism featured an enthusiasm for Scythian and Steppe art, well before the postwar face-down between Malraux and Gombrich.

––––––––

That partisans of modern art have actually *liked* the barbarian "bad copies" of ultimately Greek coinage might seem perverse, but even in English "Augustan" literary classicism, before the Romantic cult of the ruin, there was dispassionate curiosity about the numismatic degeneration of form. Joseph Addison observes, in a posthumous text written between about 1701 and 1703, a decline in the quality of Late Roman numismatic relief, to a point where, "you see the face sinking by degrees in the several declensions of the empire, till about Constantine's time it lies almost even with the surface of the medal. After this it appears so very plain and uniform, that one would think the coiner looked on the flatness of a figure as one of the greatest beauties in sculpture." Not that flatness is necessarily a bad thing for the metaphysics of representation: Addison recounts the shock of a Greek Orthodox priest at "the extravagance of the relief, as he termed it," in a painting by Titian: "You know, says he, our religion forbids all idolatry: We admit of no images but such as are drawn on a smooth surface: The figure you have shown me, stands so much out to the eye, that I would no sooner suffer it in my church than a statue."[5] (This is clearly the view of the old icon-painters and their modern admirers.)

Addison knew Bishop Berkeley, and both held to a doctrine of the arbitrary nature of the sign. Berkeley's 1709 *Essay towards a New Theory of Vision*, where the flatness of painting concerns the parity of sight and sign, was itself likely influenced by Nicolas Malebranche (*De la Recherche de la Vérité*, 1674),[6] who not only subscribed to the same proto-modernist doctrine but connected it tellingly with the flatness of painting. For after saying that "the connexion between the word and the thing is arbitrary and man-made," Malebranche says that if someone doesn't know how things relate in physical terms, he can "speak to him in the universal language that God has established," meaning the interactive visual language of signs, demonstrating by "bring[ing] him to the fire, and show[ing] him a piece of painting."[7] Because this entails looking at the surface in the material glare of the fireplace, it suggests an ebbing away of the haptic reality of things. Like the copied coins whose sources can be traced even though obscure, we may imagine a momentary intermediate condition of relief, where the signified thing had ebbed away while leaving its concreteness to the sign. Suffice it to add that at several points in his important

later *Alciphron* (1732) Berkeley employs numismatic figures of striking, wear, and tokenage.[8]

In 1755, Johann Joachim Winckelmann, the founder of critical art history, whose studies embraced ancient numismatics, addressed "negligences" in even the most famous Greek artworks, citing a "well known" inferiority of "workmanship (*Arbeit*) on the reverse of the finest coins of the kings of Syria and Egypt" compared with "the heads of these kings portrayed on the obverse."[9] Stimulated by reading Winckelmann in Rome in 1786, and obsessed with morphology, the poet Goethe began to project a more evolutionary numismatic that would "[classify] coins historically by certain specific characteristics, on similar lines to Linnaeus's classification of plants."[10] Coleridge, also interested in the Linnaean system, offers a nice numismatic trope for the flow of prosaic speech: "in real life," with "words used as the *arbitrary marks* of thought," he notes "our smooth market-coin of intercourse, with the image and superscription worn out by currency."[11]

The greatest Romantic painter, Delacroix, found in certain numismatic objects an appeal of anciently sculpted surfaces polished by centuries of handling and ripe with visual nuance. In 1825, he produced six fine lithographs showing clustered enlargements of ancient medals, less decrepit than venerable. Each sheet of several little bas-reliefs is a shallow still life with images of the individual specimens as plaques in frontal display. Here, the young Romantic artist played with visible passion on material normally of classical-antiquarian interest: civic yet personally scaled objects of direct haptic access to the ancient past. Thanks to his handling of the lithographic crayon, the numismatic images-within-the-image, mostly of figures, look, if anything, more like admiring "rubbings" than illegible patches of forms on coins worn down flat. Indeed, the faces and bodies seem swollen with vitality in Delacroix's twice-removed but first-handedly painterly documentary renderings.[12] Joyce Howell has pointed out that Delacroix "sought out and made a point of including indications of age . . . violent mutilations as well as effects of gentler wear"—and this twelve years before the first numismatic catalogue to illustrate signs of wear.[13]

Romantic national pride in the Celtic past also inspired a spirited Delacroix lithographic image of a shaggy *Vercingetorix*, the last Celtic chief to be defeated by Julius Caesar, booming like an oversized vignette on an otherwise classically lettered page of *Voyage en Auvergne* (1829), part of Isidore-Justin-Séverin, Baron Taylor, and Charles Nodier's *Voyages pittoresques et romantiques dans l'ancienne France* (1820–1878),[14] as if to stand up against prejudice, on the other side of the Channel, against "roving Celtic hoards."[15]

What was needed for the non-mimetic numismatic "bad" barbarian copies to advance the cause of nonobjective form in modern abstract art was a "transvaluation" allowing of ever freer scope for aesthetic success or failure of the copies—in practice, less and less "copies" at all because ever more independent of the dutiful recapitulation of a model, including an ideal "nature" sacrosanct in a defunct classicism. These re-dos might then claim aesthetic potential as well as cultural conviction, over and against the ever more remote authority of classical

prototypes, and, finally, over and against description of the natural world as object of art at all. Better perhaps to resemble nature, not in its look but, as Aquinas had said, *in its mode of operation.*

––––––––

British empirical study of the numismatics of what was happening was ahead of aesthetic insight, so that initial understanding took a scientific rather than an artistic path. In 1849, when Sir John Evans addressed the Numismatic Society on the subject, many were surprised to hear that there had *even been* pre-Roman coinage in Britain. A generation later, Evans' paper with the Darwinian title "The Coinage of the Ancient Britons and Natural Selection" (1875) begins with an affirmation of native coinage and a review of the British Isles as long connected in antiquity— not only by later Belgic invasion but also early and long by the tin trade—with Mediterranean civilization (tin being required for bronze). There are obviously Roman inscribed coins, but also the curious uninscribed types that derive from the gold "stater" of Philip II of Macedon, which had became common even in the western Mediterranean in the second half of the fourth century BC.[16] By careful formal analysis, Evans details how, on the obverse, the head of Apollo (or Hercules) had its "wreath and hair . . . reduced to a regular system." As to the process of variation-selection, his evolutionary observations concern sheer technical imperfection as exaggerated in successively engraved new dies, a "tendency to variation . . . increased by the necessity of the dies being rather larger in diameter than the coins which were struck from them, so that the new dies were often copied from coins not showing the whole of the device" (even this would-be defect results in what to modern eyes will prove describable as a close-up effect), and the fact of models being "worn by circulation," and also foreign craftsmanship. The pessimism, at least, is Darwinian, though in speculating, in the face of "reversion," he tries to be upbeat about the decline from Greek to British form as allowing of a fresh evolutionary start.[17]

Augustus Pitt-Rivers' paper "The Evolution of Culture" appeared together with Evans' in the same 1875 *Proceedings of the Royal Institution of Great Britain*. Formal breakdown here is akin to relaxation of labor-intensiveness—a negative-abstract theme down at least to Franz Boas. Stylizations strike Pitt-Rivers as mutational if not unnatural: "pictorial representations . . . employed for other purposes than those for which they were originally designed, as in the case of ornamental designs." To Evans' numismatics of realistic degeneration Pitt-Rivers adds observations on "transformations" (presumably neutral) as in ornament on Papuan paddle blades. His tracking a head morphing in eleven stages from "realistic" through "conventionalized" leads him to attempt to reckon Greek antiquities in a similar fashion by re-sequencing plates in the then new English edition (1875) of Heinrich Schliemann's *Troy*.[18] Finally, however, he cannot take a Celtically morphed stater (major Greek coin) aesthetically seriously, as witty as he manages to be:

> The chariot and horses dwindled into a single horse, the chariot disap-
> peared, leaving only the wheels, the driver became elevated, not elevated

after the manner unfortunately too common among London drivers, but elevated after the manner of Spiritualists, except you see he had the precaution to take on a pair of wings, differing also from the London driver and the Spiritualists, inasmuch as instead of having lost his head he has lost his body, and nothing but the head remains; the body of the horse then gradually disappears, leaving only four lines to denote the legs.[19]

Following Evans, Charles Francis Keary, an antiquarian who also wrote libretti for the modernist composer Frederick Delius, illuminated the status of the Celtic imitations, but still quite without esteeming their ostensible dilapidation. In the last and most developed of three numismatic "morphological laws," Keary speaks of "the peculiar sort of morphology shown when a barbarous or semi-barbarous people, incapable of inaugurating or much modifying a coinage of its own, takes as a model the money of some other state and makes either imitations or reproductions of it [N. B.] in descending order of degradation." One discovers "a series of successive degradations which are very curious and interesting to trace," including "Gaulish or British." In 1886, this was at least an expression of curiosity, all the more significant in a classicist who had already written a guide to Italian medals in the British Museum and, in *The Morphology of Coins* (1885–86), declared: "The whole of the coinage of [Gaul] may be said to consist of imitations, more or less rude and degenerate of the Macedonian *philippus*."[20]

Henry Balfour, first curator of the Pitt Rivers anthropological museum, published *The Evolution of Decorative Art* (1893), in which, in a three-phased evolution of decorative form, the final, sophisticated phase entails "unconscious variation," for which ineptitude is only one potential cause, through "successive" copies.[21] Balfour was one of those who experimented with having people successively copy others' drawings. So, too, did the ethnologist Alfred C. Haddon, whose *Evolution in Art: As Illustrated by the Life-Histories of Designs* (1895) reports on a *ronde* of subjects, in his case redrawing what started out as a line image of a helmeted, barechested bust of Patroclus from Aegina, and emerged, eleven reincarnations later, as a draped lady with a decorative hat.[22]

Social scientists' tracking of "evolution in art" must not have reassured those who thought, at the turn of the century, that modern culture was degenerating much as had classical culture at the hands of the old European tribesmen. Can formal invention justify apparent dilapidation, disintegration, degeneration—of classical models? This is where modernity must inevitably upset conservative culture, although sometimes reactionaries partake of their own time unawares. Thus Max Nordau, in his shamelessly anti-modern *Degeneration* (1892–93), cannot escape an occasional timely insight: begrudging evolution to art, he can't help but acknowledge something of a progressive dematerialization or sublimation motivating the shift toward eventual abstraction.[23] At points, Nordau's rabidly anti-modernist project, with nothing but regret for the modern breakdown of classical form into, for him, superficial triviality, comes curiously close in practice—as if on opposite but parallel courses—to an affirmative modern concern with ornamental surface in

the work of the great Viennese ornamental theorist Aloïs Riegl.

Tellingly, in view of Riegl's contemporaneous 1893 study closely concerned with acanthus ornament, *Stilfragen* (Problems, or Questions, of Style), one reads in an essay titled by Nordau under precisely that rubric, "The Question of Style," "For two thousand years artists of all sorts have made a decorative use of acanthus leaves in countries where no human eye has ever had an acanthus leaf before it. . . . From imitation to imitation the outlines, which no comparison with the actual model corrected and restored to accuracy, became more inexact and grotesque. . . . This is then called improving upon the natural form, and people even discover a particular beauty in it: a striking proof of the ability of mankind to make a virtue out of necessity."[24] Likewise in opposition, in the very time of Malraux's public embrace of Celtic numismatic degeneration, was one who should have known better, having enshrined a copy of Riegl's *Spätrömische Kunstindustrie* (1901) on a lectern in his study: Bernard Berenson, in whose *The Arch of Constantine; or, the Decline of Form* (1954) Riegl is as much as dismissed. One quip will do: The Parthian and Sassanian art of Iran, declares Berenson, shows, besides dependence on Greece, a mere "originality due to incompetence."[25]

———

Many a modernist work, especially of surrealist ilk, will be seen to resemble the still fascinating "Celtic copies" illustrated in thrilling photo blow-ups in volumes advocating for a modern view of art published from about 1947 to 1957 by André Malraux, novelist and political figure. A remarkably close parallel obtains between one such coin and a transitional Kandinsky (in which expressionist form-clusters condense into a firmer construct: *In the Black Circle*, painted at the Weimar Bauhaus in 1923 (figs. 16–1, 16–2). Similarities include a surprising number of particular formal elements as well as the overall formal gestalt: In no particular order, the following: patches of crossing sticks, darkened circle-and-dot motifs, pairs of

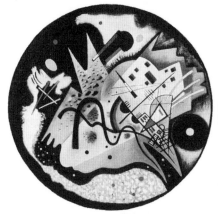 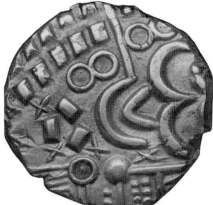

16-1. Wassily Kandinsky,
In the Black Circle, 1923

16-2. Celtic coin in André Malraux,
Les Voix du silence 1951

sweeping curves, fusions of a segmental curve and a stick, ranges of raised rectangular forms such as little platforms or mesas, patches of rounded pebble-like forms, and gouges and irregular slicing to the image's edge. As uncannily close as it comes to the coin in question, it is not that this abstract painting copies a particular coin, but that it redeems a category of (negatively) decrepit classical form as (positively) liberated from representational duty, with downright lyrical formal potency. The formal conviction of the modernist work justifies, as it were, the ebbing imitativeness of the coin, which seems too canny to be, again and again, inadvertent.

Riegl's concern with Late Roman metalwork facilitated attention to European barbarian art, including Celtic, as linked by the great Eurasian migrations with the old art of the Steppes, a subject that held surprising interest, with consequent importance for modernist connoisseurship of the Celtic imitations, for the foundational English formalists a generation before Malraux's Celtic-coin thematic. Addressing Scythian art in the May 1923 number of *The Burlington Magazine*, Roger Fry followed with interest M. I. Rostovtzeff on the impact of Sarmatian art with the collapse of the Roman Empire. He also devoted a chapter to "Scythian and Chinese" in a general readers' book (*The Arts of Painting and Sculpture*), in 1932; and in Fry's Slade Lectures, at Cambridge (1933–34), the Migrations metalwork of the Steppes comes in for extremely high praise, rivaling that of Greece and Egypt. In another book for the general reader, *The Meaning of Art* (1931), the anarchist modernist Herbert Read was so enthusiastic about Eurasian nomadic art that he wanted to hold Persian art in its debt, as mere relay. "The abstract principle was characteristic of the northern nomadic races and geometrical art stretched across the continents of Europe and Asia from Ireland to Siberia. . . . This . . . is . . . in a sense the most ubiquitous of all arts. . . . The most we can say is that the artists of one race were the bearers of it, that they found it in the mysterious plains of Central Asia, and, in the course of their wanderings and influence, made it an international style."[26] A piece of visual documentation from Malraux's moment of the late 1940s is the cover illustration of the 1949 Pelican paperback of Read's meaning as designed by the great German typographer Jan Tschichold, featuring a second-century BC to second-century AD Ordos bronze ornament in the British Museum.

An interesting ancillary document in the literature of Celtic imitations is Franz Boas' classic anthropological study of Native American art of the Northwest Coast, *Primitive Art*, published in Europe as well as the United States in 1927. Aware of Balfour's seeing "the most astonishing transformations" in setting native artists to copy and recopy a design, he nevertheless knows that the locus classicus of the problem "is that of the degeneration of Greek coins when copied by Keltic imitators which led to a complete disruption of the original design." "Disruption" here seems more clinical than pejorative because Boas is so nonjudgmental that even when "factory production" involves "slovenly execution" in latterday Mexican painted pottery, he finds it interesting that "rapidity of manufacture" thereby makes for a certain individuation, and we shall find corroboration of this view in an unexpected twentieth-century source. For Boas, some engraved snake motifs on shell disks from the mound builders of Tennessee (second-century BC to fourth-century

AD, contemporaneous with Celtic coinage) imply linkage without implying progression or regression. Beside a set of small openwork ornaments with an even more stylized coiled-animal motif from sixth- to fifth-century BC in northern China, his Native American pieces look more naturalistic and the Asian ones more abstract, yet Boas hesitates to impute a developmental sequence, even "the gradual breaking up of realistic form and the development from it of a conventional form."[27]

Contemporaneously with Boas' study, deliberate breakup and reconstitution is seen in contemporary Surrealism as a radical form of the modern sense of art as a play of material signs; (so in 1946 Jean Arp took one of his own woodcuts made in 1920 for a book of poems by Tristan Tzara, tore it up, and rearranged the parts to make the collage *Torn Papers*). The Surrealists were important for qualifying the Celtic breakdown of classical numismatic form as a good thing, with positive modern potential. Having contributed numismatic articles and reviews to the scholarly journal *Aréthuse*, Georges Bataille published a text, "The Academic Horse" in the first issue of his journal *Documents*, in 1929, illustrating it with at least one formal "deformation" of a once Greek horse image on a Gallic Celtic coin. Asking the reader to think of Gallic culture as an imposition by settlers upon natives, Bataille is unsatisfied by the idea that the coins show "habitual barbaric deformations resulting from the clumsiness (*maladresse*) of the engraver"; no, here the "crazy horses" imagined by every little tribe are the result not of "technical default" but of "a positive extravagance" of anarchistic imagic breakdown and rearrangement.[28]

There even seems to be carryover of the modern appreciation of the Celtic-copy type into the Surrealist aspect of Picasso, who from about 1926 produced an image type built up of arrays of hefty lines punctuated at their intersections and termini by heavy dots. Many works from the period between the Wars on, especially faces of a closed but rubbery character, or drawn with loose loops in an inky manner or with a heavily laden brush, have a ropey linear quality like the forms on the Celtic coins. For example, *Head of a Weeping Woman*, 1937, one of the drawings for *Guernica*, has arrays of pronglike curves, with dots or "pearls" at their ends, filling out a rubbery head in profile. Later heads in profile, painted in a manner as ruggedly spirited as the supposedly degenerate profile heads on the obverse of the Celtic coins, such as the beautiful *Head of a Woman (Dora Maar)*, of 1941, are similar and can even be said to sport something like a serrated edge, left and right.

By 1949, Celtic numismatic degeneration, as a modernist theme with its vivid evidence of signs liberated as forms, was already sufficiently associated with André Malraux (who had already served as minister of information in de Gaulle's postwar government) for a medal alluding in style to the Celtic copies, designed by the great Surrealist painter André Masson, to be struck by the Paris mint (in silver and bronze). The obverse has a frontal portrait of the man of letters encircled by his name; the reverse, a seated figure in profile within a wild array of welted lines inescapably reminiscent of the broken Celtic forms as freely disposed in the surface, including a sunburst motif fairly typical of the coins.[29]

Finally, then, we catch up with André Malraux, the activist man of letters who, in the postwar fluorescence of modern art, seemed practically as well known as Picasso, and who was responsible for bringing to a wide audience what was now a recognizable Celtic-copy thematic advancing the basic modern non-mimetic sense of form. Malraux had set out in 1935 on a major project of art-historical writing, the voluminous output of which, from 1947 to 1957 and beyond, is a bibliographical nightmare, for material, including the Celtic coinage, was used and reused, as if people could not get enough of it.[30] He devotes a considerable portion of *The Twilight of the Absolute* (1949), the third and last volume of his *Psychologie de l'art*, on which the popular *Voices of Silence* (1951) would soon be based, to, in both places, still striking photographic enlargements of the Celtic copy coins, showing how within the bounds of Gaul various Celtic tribes had appropriated and "recompose[d]" the stater of Philip II of Macedon creatively. If the appearance of a visage fades, Malraux (who happily juxtaposes old European tribal with African tribal art) is prepared to applaud: "the piece takes on a striking modernism (*un saisissant modernisme*)." Indeed, "the engraver is obsessed with the round surface which he is covering with an array of violent lines, just as the modern painter is with the rectangle of his canvas." It's not so much a question of "an eye here and a nose there" as a "menacing sickle" shape and a "concave ring" in complementary formal conjunction with a "convex boss." To ask if such a revision was the result of extreme "clumsiness (*maladresse*)" or "regression to the very limit of nothingness" on the part of engravers (who often continued to furnish a more traditional horse on the reverse) becomes a rhetorical question. Although Malraux would prefer to disassociate the Gallic Celtic coins from art of the Steppes, he is clearly concerned with a general phenomenon: "Everywhere the horse breaks up into fragments, as does the human face, and, like it, ends up as a disjointed ideogram"[31]—which to the modernist, however, means into a more or less auspicious form-complex.

Sir Ernst Gombrich's rebuff to modernist enthusiasm for the Celtic imitations, for purporting to be formally astute and thereby akin to abstract art, in his 1956 Mellon Lectures at the National Gallery in Washington, published as *Art and Illusion* (1960), was clearly a riposte to the popular Malraux from a doggedly representationalist, hence anti-modernist, point of view. For Gombrich could not conceive of the Celtic imitations as *non-mimetically good*, only as *badly mimetic*. His oldest citation is to a 1901 article, "The Genesis of the Medieval Artistic Outlook," by Julius von Schlosser, as reprinted just about when Gombrich was studying with him, in 1927. But if Schlosser had been interested so early in the Celtic-coin problem, why wasn't his student? By then, Schlosser was concerned with "what . . . was called 'the conceptual image (*Gedankenbild*),' . . . the way . . . the child does not imitate but creates symbols."[32] This does not seem an adequate reason, because conceptualization too is anti-naturalistic insofar as it is an abstraction.

Curiously, however, being Schlosser's student meant not being the student of the popular Josef Strzygowski, whose lectures nevertheless attracted young Gombrich. What was the fascination? "He was a fanatical opponent of the classical tradition, he hated Roman art, and he thought that only the art of the nomads was creative."

Being tempted by Migrations (i.e., Eurasian tribal) art from the straight and narrow path of orthodox classicism must have made it blushingly unlikely that the naughty Celtic imitations could ever inspire in Gombrich the sympathetic modernity that Malraux proved capable of stirring in even the common reader. Gombrich attacks the Malraux-modern position in this way: "The copies of classical coins by Celtic and Teutonic tribes have become fashionable of late as witnesses to the barbaric 'will-to-form.' These tribes, it is implied, rejected classical beauty in favor of the abstract ornament. Maybe they really disapproved of naturalistic shapes, but if they did we would need other evidence." The statement sounds at once so contentious, and so final, that one may well overlook the illogical assumption that a situation in which "being copied and recopied the image became assimilated into the schemata of their own craftsmen" necessarily contradicts, whereas it may actually *demonstrate*, the imprecise copying as indeed "witness[ing] to the barbaric 'will-to-form.'" Gombrich wants to be able to say, pejoratively, that all the Celts, in their sloppy copying, manage to demonstrate is that "the 'will-to-form' is rather a 'will-to-conform.'"[33] However, despite its appeal to other cultural conservatives in the gallery, the wisecrack does not serve to convince the judge, who must wonder why, by Professor Gombrich's testimony, this fellow named Constable isn't guilty of schematic conformism, too,[34] not to mention the role of conforming in Gombrich's own famous process, propounded in *Art and Illusion*, of "making and matching," for which the present writer has more than once pointed to a possible source in a text by the semanticist and conservative American politician S. I. Hayakawa.[35] At any rate, with modern abstract art in mind, Arthur C. Danto has observed of Gombrich, "One can only wish that this remarkable eye and mind . . . had not been in servitude to a theory which has blinded both to one of the most fascinating periods in the history of art, the period he and we have been living through for decades."[36]

Not very long before postmodernism undermined any idealist claims or pre-rogatives of abstract art as modernism in purest form, rendering its defense against conservatives such as Gombrich moot, a brilliant general exposition of abstraction once again appealed to the "Malrauvian defense" of the Celtic coins: Dora Vallier's *Abstract Art* of 1967. How right it seems to lead with a beautiful Scythian bronze standard from Peter the Great's collection in St. Petersburg, and then three numismatic examples from the Cabinet des Médailles of the Bibliothèque Nationale (also Malraux's source), each from a different Celtic tribe. One, a famous example from the Nervii, is said to consist of the "same elements" as an Atrebates coin showing "laurel-wreathed head with profile missing," only "transformed into ideogrammatic expression." Fortunately for posterity, Vallier scrupulously avoids the fate of empty decorativeness that is so often presumed to be the only destiny of nonobjective art, now that transcendental aspiration is disallowed. No, such ancient Celtic abstraction has nothing in common with all repeating ornamental form that "starts from a stylized realistic motif, then loses itself in the symbol, and . . . survives as a meaningless apparent abstraction": that (here) "routine" form of abstraction, "which has persisted from the dawn of civilization down to our time" in craft work, which,

however, "has nothing to do with art," to which "industrial production, when all else had failed" (!) had finally "put an end" (Vallier). [37]

———

Today, the question of tribal revisions and creative renditions of once classical numismatic forms and wider matters of tribal nomadic art extending back across Eurasia cannot be raised without acknowledging that such production is implicitly celebrated in a body of cultural theory bearing on the world's global political realities. I speak, as an amateur, of the part of Giles Deleuze and Félix Guattari's *A Thousand Plateaux* (1980) called *Nomadology: The War Machine.* For these thinkers, nomadic-tribal society as such is a war machine, a reflexive organum dead-set against empire, archetypally so in Central Asia (even one as ignorant as I of Deleuze and Guattari's larger project can infer the implications of such thought for any war "against" Afghanistan). That may not have been the situation of the Western Celts, but it must be Deleuze and Guattari's vital appreciation of the hand-worked, anticlassical spirit of Gothic that encourages me to savor a hydraulic smoothness in the strong percussive forms of the most lively Celtic imitations, whose use-polished surface so suits the loose archipelagos of detached forms sprung up in welt-like relief from a boundless surface. They were talking about ornamental metalwork, but their sense of an osmosis between imperial and barbarian traits is stimulating in respect to the creatively active, one could say transitive, numismatic breakdown by Celtic artisans of once highly classical numismatic models. [38] What seems so subversive is a shift as radical as from model to anti-model, from law to freedom as Kant might have put it.

Where have we heard such empathy for the nomadic, even specifically the Steppes-nomadic (with a like mystique of "numbers" in the bargain), before? Of Velimir Khlebnikov, the futurist "poet of the Steppes," who already spoke of the nomadic "war machine" in the revolutionary period, it is said that, by a new way of thinking the division of time, he "rearranges scattered points into new correlations, revealing the rhythmic vibrations that are seen to underlie them."[39]

Finally, there is an important work of our own age that does not look ostensibly like the coins and might have seemed (*except that surfaces can be more about resistance than we thought*) little more than a matter of cosmetic surface effect, but to which much of what we have been thinking about formal breakdown in numismatic repetition surprisingly applies. For we have not seen the end of non-mimetic copying.

In my own art-critical experience, well after Malraux's presentation supported the general case for self-sufficient abstract form in painting, a generalized form of non-mimetic copy took on an ironic afterlife in New York in the work of Andy Warhol, partly as parodic "faking-out" of the then critically dominant mode of abstraction known as color field in the 1960s, to which all formalist criticism deferred. I speak of the paintings consisting of images repeated from the same silkscreen while running repeatedly out of ink or pigment, so that in reiteration the

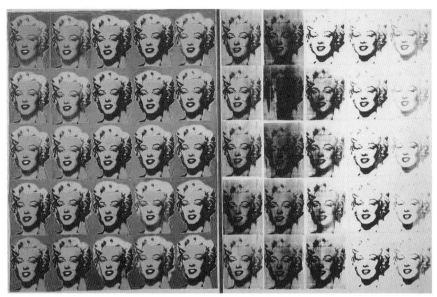

16-3. Andy Warhol, Marilyn Diptych, 1962.

image seems to be wearing thin, not unlike copying a worn coin and then minting copies of *that* (fig. 16–3). After all, how readily we find ourselves thinking, before the barbarian imitations, of an *n*th-generation Xerox. The real irony in Warhol's silk-screening of paintings was in how radically it outwitted mechanical reproduction by allowing that even such imprecision as Boas didn't hesitate to call "slovenly execution" might amount to a funky mechanical process, in a wily way producing not bad exact copies but unlimited unique "originals." I remember not understanding until I found myself fascinated by a crisp new matchbook advertising the U. S. Air Force, which was so badly printed that only half the text had made it onto the cover, split between something like "RCE" bled off at left and "U. S." at right, and I caught myself wanting to preserve it in philatelically "mint" condition. Yes, the old copied coins had done duty on behalf of an ideal of abstract form that is at least less commonly overlooked since Malraux than the abstract or ironically abstract aspect of Warhol still is. In the grand *Marilyn Diptyich*, of 1962, in the Tate Modern, London, a cookie-sheet of high-color "lyrical" Marilyns is countered at right by the somewhat funereal successive fadeouts of the image in a grisaille of newsprint black. Many may wonder how what looks formally decrepit can be aesthetically excellent; some, in doing so, may find themselves pondering again André Malraux's aesthetic mobilization of Ina Bandy's stunning close-up photography of what might otherwise have seemed insignificantly mutant Celtic "imitations."

It is not possible to review the later critical literature here, but it will be helpful to contrast briefly three writers, representing the 1970s, 1980s, and 1990s, on the theme of Celtic numismatic degeneration. In an engrossing survey, *Celtic Art: An Introduction*, Ian Finlay writes sympathetically on the coin problem in 1973: "The Gaulish artist used the animal only as his starting point, and sometimes nearly

dismembered it or caused it to explode into an almost unrecognisable pattern over the surface of the coin. It remains in some strange way a horse though virtually disembodied, and affords some of the most extraordinary examples of the Celt's passion for abstraction." Interestingly enough, "As Roman domination of Gaul progressed, a tendency towards true portraiture crept into the drawing of the heads"— that is, into previously de-Hellenized representations of the rulers. Finlay can speak of "dismemberment," whether of faces, animals, or chariots and yet maintain, "The fragmentation is certainly not the outcome of any ineptitude on the artist's part," and even had its own symbolic recognition value for "the users of the coins."[40]

In 1987, the belletristic writer Guy Davenport engaged the Celtic coins in glossing a drawing of such a coin by himself, for the dedication page of his book of essays *Every Force Evolves a Form*: "[The Celtic smith who cut the die for this silver coin was trying to make iconographic sense of others derived from a stater of Philip II of Macedonia, which bore a head of Hermes on one side and a winged horse on the other. Copy after copy, over centuries, provincial mints on Aquitania had already misread the face of Hermes as a lion's head, as sun and moon, or as so many abstract lines and dots. Here Hermes' profile has become the head and forelegs of a horse, his hair and neck its rump and wing. . . . All art is a dance of meaning from form to form.]" One of the Davenport essays has something akin the Celtic-copy motif marking the beginning of an essentially Romantic anticlassicism setting out from "Gaulish attempts at Roman sculpture."[41]

In case the younger generation thinks the battle is long over and the oldsters just keep talking to themselves about the great old fight for modernism, I point to a distinguished Oxford historian of Roman art. According to Martin Henig, in *The Art of Roman Britain* (1995), "The Celtic smith ornamented a narrow range of objects connected with warfare and the feast. He did not, and was not expected to, comment on that life." Since when, however, is illustration the only imaginable or admissible form of artistic comment on life? "Is the abstraction of Celtic art overstressed . . . ?" Such art, we are told, "was far too limited in scope and so the naturalism offered by Classical, humanist art would not have been something to avoid but something to master. . . ." After a few centuries of making coins that might have amazed Kandinsky, the poor plugging Celtic smiths might be good enough to make something respectably classifiable as British imperial coinage, second-class provincial, of course. To say that "an art which can be accused of offering 'simply pattern' must [lack] the essential human dimension of sympathy . . ." will be news to every expressionist. Indeed, according to Henig the whole of modern aesthetic primitivism is misguidedly infantilistic: "To cling to the primitive, as . . . many 'modern' artists have done, or to abstraction over representation, has an element of clinging to the nursery. . . . The Romans . . . can . . . be seen . . . as most useful nurses helping to lead a culture in an adolescent stage of development . . . towards the adult world of amenities [—*amenities!*—], literacy and the arts of civilization."[42] What is important is, it would seem, what the nice people like: "The classicizing preferences of the highest levels of society, in south-eastern Britain at any rate, is reflected in the coinage. The most widespread and best-known coin-type, with

its hackneyed and degenerate renderings of Philip II of Macedon's gold stater, no longer pleased the most culturally advanced rulers of late Iron Age Britain . . ."[43]

And yet, even a conservative may—to paraphrase Doctor Johnson on the mind of Newton—gain ground gradually upon modernity. In his introduction Henig reflects that whereas "Roman Britain has until now been beneath the notice of professional art historians," only recently, it seems, have such scholars as Claire Lindgren—one of our Hofstra colleagues—and E. J. Phillips managed to open to his view a certain lumping "virtue of necessity" for which in his own fashion he can almost bring himself to thank modernists: "The awkward figure modeling and stylization of certain sculptures, the very 'ugliness' despised by [R. G.] Collingwood are selected as distinctive features of a legitimate provincial style. The influence of modern art, such as the sculptures of Henry Moore and [*backsliding!*] Elizabeth Frink may be important here."[44] Even to an antiquarian, it seems, the formal vicissitudes of modernity have had something to teach; while in our day even numismatists find the Celtic imitations "fascinating . . . apparent abstractions." [45]

———

This essay may be faulted by some for not engaging with Walter Benjamin's "Work of Art in the Age of Mechanical Reproducability" (1936). In our time, resorts to Benjamin's distinction often seem to me crypto-nostalgic. It isn't only that coins from antiquity and old master prints have "aura," it's also that the photography at issue in 1936, not to mention practically everything mechanical, now has the rational-made-physical charm of the analogue: a palpably chemical gelatin print as ontologically as the oil-on-panel Mona Lisa. In the face of all virtual imagery (which by comparison might as well be an imaginative projection of our own imagination), an old print can be at least relatively auratic, especially an autographic one. Indeed, the very term "holographic," which always meant an autographic manuscript in a writer's handwriting, now does ironic duty as indicating full-fledged—and need-less to say virtual—illusions. As for the Celtic coins, as Warhol might have said: "Well, how many originals would you like!" At least Benjamin's message has not been worn down by circumstances as much as Marshall McLuhan's, who, believe it or not, meant by "the visual" mere typography! On much the other hand, Warhol offers painting as populistically cheapened, one might have said, by silkscreen, yet with a sheer plethora of "states"—an aspect of the connoisseurship of printmaking normally considered rarefied. Benjamin's thought might have us take the Celtic coins as evincing only, if anything, a charm of romantic ruination; but in the face of the digital, as well as in the shadow of Warhol, we must attend to the discrete varia-tions, good and bad, in these very archly hand-done abstract numismatic forms as what, at least for the moment, might be a last possible auratic effect.

NOTES

1. J. Masheck, "Ernst Bloch: A Glaring Omission in *Spe Salvi?*" *Religious Socialism* 31, no. 1 (2007-08), 12-13.
2. Masheck, "On Kuspit, Kant, and Greenberg," in D. Craven and B. Winkenweder, eds., *Dialectical Conversions: Donald Kuspit's Art Criticism* (Liverpool: Liverpool University Press, 2011), 119-35.
3. D. Kuspit, "Preface" to Masheck, *Historical Present: Essays of the 1970s* (Ann Arbor: UMI Research Press, 1984), xi, xii-xiv. In the original: "the oneness of art's power to create a sense of dealing with the essential and to spiritually personalize."
4. Interview of Meyer Schapiro by the present author, Rawsonville, Vermont, July 15, 1992.
5. Masheck, "Five Unpublished Letters from Ad Reinhardt to Thomas Merton and Two in Return," *Artforum* 17, no. 4 (December 1978), 23-27; introduction repr. as "Two Sorts of Monk: Reinhardt and Merton," with postscript, in *Historical Present*, 91-96.
6. Craven, *Abstract Expressionism as Cultural Critique: Dissent During the McCarthy Period* (Cambridge: Cambridge University Press, 1999), 88-89, 139.
7. Masheck, "A Humanist Geometry," *Artforum* 12 (March 1974), 36-39; repr. in A. B. Sandback, ed., *Looking Critically: 21 Years of Artforum* (Ann Arbor: UMI Research Press, 1984) and as "Mangold's Humanist Geometry" in Masheck, *Historical Present*, 103-07.
8. [These later developed into a Columbia graduate lecture course, which posthumously became *Selected Lectures of Rudolf Wittkower: The Impact of Non-European Civilizations on the Art of the West*, ed. D. M. Reynolds (Cambridge: Cambridge University Press, 1989).—ed.]
9. R. Wittkower, *Allegory and the Migration of Symbols* (London: Thames and Hudson, 1977); idem, *Selected Lectures of Rudolf Wittkower: The Impact of Non-European Civilizations on the Art of the West*, D. M. Reynolds, ed., foreword by M. Wittkower (Cambridge: Cambridge University Press, 1989). See also Masheck, "Rudolf Wittkower," in *Encyclopedia of Aesthetics*, M. Kelly, ed., 4 vols. (New York: Oxford University Press, 1998), 4: 470-72.
10. Masheck, "Iconicity," *Artforum* 17 (January 1979), 30-41; repr. in his *Historical Present*, 209-28, here p. 209.
11. Idem, "Mangold's Humanist Geometry," *Historical Present*, 103-05.
12. Ibid., 103, 107 n.6.

CHAPTER 1

1. J. Masheck, "On Kuspit, Kant and Greenberg," in D. Craven and B. Winkenweder, eds., *Dialectical Conversations: Donald Kuspit's Art Criticism* (Liverpool: Liverpool University Press, 2011), 119-35.
2. Ibid., 124, quoting R. G. Collingwood, "Outlines of a Philosophy of Art" (1925), in A. Donagan, ed., *Essays in the Philosophy of Art* (Bloomington: Indiana University Press, 1964), 122.
3. Ibid., 124-25, quoting Collingwood, *The Principles of Art History* (New York: Oxford University Press, 1958), 145.
4. Internal references to the *Critique of Pure Reason* follow, with occasional modification, the P. Guyer and A. Wood translation (New York: Cambridge University Press, 1998), according to the customary citations of Kant's original pagination of his first (A) and second (B) editions.
5. Kant had stressed the theme of locating objects of experience in relation to where I find myself at least since 1770, in the Inaugural Dissertation where we find a closely related passage: "For I may not conceive of something as placed outside me unless by representing it as in a place which is different from the place in which I myself am, nor may I conceive of things out-side one another unless by locating them at different places in space"; I. Kant, *Theoretical Philosophy, 1755-1770*, D. Walford, trans. and ed., in collaboration with R. Meerbote (New York: Cambridge University Press, 1992), 395 (§15A, 2:402).

6. H. Allison, *Kant's Transcendental Idealism: An Interpretation and Defense* (New Haven: Yale University Press, 1983, rev. ed. 2004), 99. See also A. Melnick, "The Consistency of Kant's Theory of Space and Time," in his *Themes in Kant's Metaphysics and Ethics* (Washington D.C.: Catholic University Press, 2004), 3-20.

7. C. Parsons, "The Transcendental Aesthetic," in *The Cambridge Companion to Kant*, P. Guyer, ed. (New York: Cambridge University Press, 1992), 70.

8. I discuss the Metaphysical Exposition in greater detail in "Poincare, Kant, and Mathematical Intuition," *The Review of Metaphysics* 62 (June 2009), 779-801; the present paragraph draws on that discussion.

9. Masheck, "Kuspit," 131, 132.

10. C. Greenberg, "Modernist Painting": *Arts Yearbook* 4 (1961), 102-08, here p. 106. As is well known, Greenberg published this piece in multiple venues between 1960 and 1966, making important revisions along the way, but I do not think these revisions bear on our topic. For a discussion of the history of its publication, see F. Frascina, "Institutions, Culture, and America's 'Cold War Years': the Making of Greenberg's 'Modernist' Painting," *Oxford Art Journal* 26, no. 1 (2003), 69-97.

11. Greenberg, op. cit., 104.

12. It does not of course follow that three-dimensional space must, as Kant thought, conform to Euclidean axioms, postulates, and proofs. Greenberg's comment about the difference between pictorial and three-dimensional space takes us right up to one of Kant's most notorious mistakes in the first *Critique*: that physical space must be Euclidean (see, A25/B41ff)—an error that Kant scholarship seems now to have moved beyond. Greenberg does not write of Euclidean space and so does not make Kant's error. I take up these issues in "Poincare," esp. 780 n. 5.

13. M. A. Cheetham discusses, elsewhere in Greenberg's work, "what Kant would have to assess as a lapse into empiricism"; *Kant, Art, and Art History: Moments of Discipline* (Cambridge University Press, 2001), 91.

14. Greenberg, *The Collected Essays and Criticism*, vol. 3: *Affirmations and Refusals, 1950-1956* (Chicago: University of Chicago Press, 1995), 167-68.

15. Masheck, "Kuspit," 131.

16. C. Holty, "Mondrian and Current Painting," *Arts Yearbook* 4 (1961), 74-76, here p. 74.

17. For Kant, figures in pure geometry and the pure intuition of space are *totems*, whose parts are "possible only in the whole." By contrast, an empirical object is a *compositum*, "a whole made possible by the sum of its parts" A438/B466 (see also B201-2). For comment, see C. Parsons, "Arithmetic and the Categories," *Topos* 3 (1984), 109-21.

18. Modernism "uses the characteristic methods of a discipline to criticize the discipline itself, not in order to subvert it, but in order to entrench it more firmly in its area of competence"; Greenberg, "Modernist Painting," 103.

19. Masheck, "Kuspit," 129.

20. R. Descartes, "Reply to the Second Set of Objections," in *The Philosophical Works of Descartes*, vol. 2, E. S. Haldane and G. R. T. Ross, trans. (New York: Cambridge University Press, 1977), 38.

21. Whether this makes the "I" in the judgment "I think" a conceptual representation of a singular term is a related but independent question.

CHAPTER 2

1. J. Ruskin, *Fors Clavigera*, July 1877, in *The Works of John Ruskin*, E. T. Cook and A. Wedderburn, eds. (London: Allen, 1903-12), 39 vols.; all in-text Ruskin citations to this edition.

2. D. L. Craven, "Ruskin vs. Whistler: The Case against Capitalist Art", in *Art Journal* 37, no. 2 (Winter 1977-78), 139-43; L. Merrill, *A Pot of Paint: Aesthetics on Trial in Whistler v. Ruskin* (Washington, D.C.: Smithsonian Institution, 1992); J. A. McN. Whistler, *The Gentle Art of Making Enemies* (London: 1890).

3. "No mode of execution ought ever to be taught to a young artist as better than another; he ought to understand the truth of what he has to do, felicitous execution will follow as a matter of course; and if he feels himself capable of getting at the right at once, he will naturally do so without reference to precedent. He ought to hold always that his duty is to attain the highest result he can . . . but that no one has any business with the means or time he has taken. If it can be done quickly, let it be so done; if not, let it be done at any rate. For knowing his way he is answerable, and therefore must not walk doubtingly; but no one can blame him for walking cautiously, if the way be a narrow one, with a slip on each side. He may pause, but he must not hesitate." From Ruskin, *Modern Painters*, vol. 2 (4:286n).

4. W. M. Thackeray, "May Gambols; or, Titmarsh on the Picture Galleries," in his *Ballads and Miscellanies* (London: Smith, Elder, 1899), 419-45, here 440.

5. See for example T. Pickeral, *Turner, Whistler, Monet* (London: Flame Tree, 2005); J. Lewison, *Turner, Monet, Twombly* (London: Tate, 2012).

6. C. Hussey, *The Picturesque: Studies in a Point of View* (London and New York: Putnam's, 1927); A. Ballantyne, *Architecture, Landscape and Liberty: Richard Payne Knight and the Picturesque* (Cambridge: Cambridge University Press, 1997).

7. Ruskin's "The Poetry of Architecture," was first published in parts in 1837-38 in *The Architecture Magazine*, and appeared first as a book in a pirated edition in the United States in 1873.

8. Ballantyne, *Architecture*, 149; idem, "The Picturesque and Its Development," in *Blackwell Companion to Art Theory*, P. Smith and C. Wilde, eds. (Oxford: Blackwell, 2002), 116-24; here 121.

9. Ibid., 116-17.

10. S. Rogers, *Italy, a Poem* (London: Edward Moxon,1830) with illustrations by Turner, Thomas Stothart, and Samuel Prout.

11. T. Hilton, *Ruskin: The Early Years* (New Haven: Yale University Press, 1985).

12. J. M. W. Turner, entry in Royal Academy exhibition catalogue, 1840; cited in A. Wilton, *Painting and Poetry: Turner's "Verse Book" and his Works of 1804-1812* (London: Tate Gallery, 1990), 180.

13. C. Kingsley, "Alton Locke" (1848) in Ruskin, *Works*, 5:205.

14. M. Gregg and G. J. Seigworth, eds., *The Affect Theory Reader* (Durham, N.C.: Duke University Press, 2010).

15. K. Clark, *Ruskin Today* (London: John Murray, 1964).

16. C. Gleadell, "How Tracey Emin Lured Buyers From Kate Moss to Charles Saatchi," *Art and Auction* 20 (January 2013); www.artinfo.com/news/story/857213/artist-dossier-how-tracey-emin-lured-buyers-from-kate-moss-to; accessed February 3, 2013.

CHAPTER 3

1. É. Zola, *L'Oeuvre* (1886), trans. T. Walton (Ann Arbor: University of Michigan Press, 1968), 42.

2. D. Kuspit, "Visual Art and Art Criticism: The Role of Psychoanalysis," *Art Papers* 15, no. 6 (November-December 1991), 29.

3. Numerous biographies devote significant attention to these years. This essay is informed by the work of J. Rewald, *Paul Cézanne: A Biography* (New York: Simon & Schuster, 1939), and "Cézanne and His Father," in his *Studies in Impressionism* (New York: Thames and Hudson), 1985, 69-101; A. Vollard, *Paul Cézanne: His Life and Art*, trans. H. van Doren (New York: Nicholas Brown, 1923); G. Mack, *Paul Cézanne* (New York: Knopf, 1935); and G. Weisberg, "Painting as Autobiography: Cézanne's Early Work," *Arts Magazine* 63 (May 1989): 55-57. Valuable for Cézanne bibliography is J. Wechsler, *The Interpretation of Cézanne* (Ann Arbor: UMI Research Press, 1981).

4. Among the more useful chronologies of the 1860s in the painter's life: Rewald's biography (215-221); Mack's biography (399-404); E. Schmitt, *Cézanne in Provence* (New York: Prestel,

1995), 103-11; M. T. Lewis, *Cézanne Early Imagery* (Berkeley: University of California Press, 1989), 211-25; F. Cachin, *Cézanne* (New York: Abrams, 1996), 528-69; and L. Gowing, *Cézanne: The Early Years 1859-1872* (New York: Harry N. Abrams, 1988).

5. Rewald, ed., *Paul Cézanne: Letters* (1941), trans. M. Kay (New York: Da Capo, 1995).

6. Qu., Rewald, "Cézanne and His Father," 69.

7. T. Reff explains: "[Cézanne's] fear of his powerful bourgeois father, with whom he was already struggling for independence, and his permanent sense of failure in his father's eyes are well known . . . even as a man of forty he would labor desperately to conceal from the latter the existence of his mistress and child"; "Cézanne's *Dream of Hannibal*," *Art Bulletin* 45, no. 2 (June 1963), 148. See also Mack, chs. VII, XI, XXVI.

8. "Song d'Annibal" appears in a letter sent to Zola on November 17, 1858. The poem "Tells of a . . . hero who, after being entertained royally, falls asleep and dreams that his father appears before him to issue moral injunctions on filial and civic duty." Reff interprets this poem in regard to paternal admonitions against masturbation. He never links the poem to Cézanne's paternal portraits executed four and eight years after composing it; instead, he relates it to *Afternoon in Naples* and *The Orgy*, works produced more than twelve years afterward. Reff determines that the poem reveals Cézanne's "unconscious desire to eliminate his own father as a rival and a threat." My argument contends that Cézanne's animosity toward his father manifests itself in his paternal portraits just as it does in this poem. See Reff, 148-52.

9. M. Schapiro, "The Apples of Cézanne," in his *Modern Art: 19th and 20th Centuries* (Selected Papers, 2) (New York: Braziller, 1978), 5.

10. L. Venturi, *Art Criticism Now* (Baltimore: Johns Hopkins University Press, 1941), 47.

11. Rewald, "Cézanne and His Father," 76.

12. J.-P. Sartre, *Baudelaire*, London: 1964.

13. Weisberg, "Painting," 57.

14. R. Niess, *Zola, Cézanne, and Monet: A Study of L'Oeuvre* (Ann Arbor: University of Michigan Press, 1968), 90.

15. See Rewald, *Paul Cézanne*, and "Cézanne and His Father."

16. Weisberg, "Painting," 57.

17. S. Geist. *Interpreting Cézanne*. (Cambridge: Harvard University Press, 1988), 45.

18. Rewald, *Cézanne: Letters*, 33. Letter dated December 7, 1858.

19. Ibid., 81. Letter dated April 22, 1861.

20. Rewald, *Cézanne*, 215.

21. Cézanne as quoted in Mack, *Paul Cézanne*, 117, 434; see also Rewald, *Cézanne* (1939), 29.

22. Gowing, *Cézanne*, 70. *Winter* is inscribed and dated on the lower left: "Ingres 1811"; the other three are each inscribed "Ingres" on the lower right.

23. Rewald, *Cézanne: Letters*, 122; letter dated to the first few days of July 1868.

24. Ibid., 46.

25. A. Smith. *The Newspaper: An International History* (New York: Thames and Hudson, 1979), 114.

26. R. Simon, "Cézanne and the Subject of Violence," *Art in America* 79, no. 5 (May 1991), 131.

27. S. Eisenman, "The Failure and Success of Cézanne," *Nineteenth Century Art: A Critical History* (New York: Thames and Hudson, 1994), 339.

28. Zola, *Therese Raquin* (1867), trans. L. Tancock (New York: Penguin Books, 1962), 54.

29. See M. T. Lewis, "Savagery Redeemed: A Reinterpretation of *L'Événement*," in *Cézanne's Early Imagery*, 151-92.

30. Rewald, *Cézanne: Letters*, 117; letter dated Friday, November 2, 1866.

31. Ibid., 118.

32. Gowing, *Cézanne*, 96.

33. Ibid.

34. Reff, "The Pictures within Cézanne's Pictures," *Arts Magazine* 53, no. 10 (October 1979), 92.

35. Geist, *Interpreting Cézanne*, 34-35.

36. Weisberg, "Painting," 55.

37. R. de Livois, *Histoire de la presse française* (Lausanne: Éditions Spes, 1965), 281; Zola's debut occurred on January 5, 1865.

38. Rewald, *Cézanne: Letters*, 107; an open letter from Zola to Cézanne dated May 20, 1866. Zola's metaphors of war merit consideration: "Do you realize that we were revolutionary without knowing it? I have now been able to say aloud what for ten years we have been saying quietly to each other. The noise of the battle has penetrated to you—hasn't it?"

39. Gowing, *Cézanne*, 15.

40. Arts Council of Great Britain, *Renoir* (New York: Abrams, 1985), 184 (cat. entry).

41. Weisberg, "Painting," 55.

42. Schapiro, "Apples," 10.

43. Reff, "Cézanne, Flaubert, St. Anthony and the Queen of Sheba," *Art Bulletin* 44, n. 2 (June 1962), 113.

44. T. J. Clark, "Freud's Cézanne," *Representations* 52 (Fall 1995), 102-105.

45. S. Freud, *The Ego and the Id* (1923) (New York: Norton, 1960), 22.

46. Ibid., 44.

47. Zola, *L'Oeuvre*, 37.

48. Clark, "Freud's Cézanne," 103.

49. Ibid., 104.

50. Freud, *Ego and the Id*, 24.

51. H. Marcuse, *Eros and Civilization: A Philosophical Inquiry into Freud* (Boston: Beacon, 1955), 95-96.

52. Ibid., 97.

53. Ibid., 75.

54. Ibid., 84.

55. Ibid., 97.

56. Rewald, *Cézanne: Letters*, Letters 145, 187, 189, 205, and 170, 177, 211, respectively.

57. Marcuse, "The Obsolescence of the Freudian Concept of Man," in his *Five Lectures* (Boston: Beacon, 1970), 47.

58. Simon, "Cézanne," 123. The following paraphrases Simon's discussion of this lost painting.

59. See M. Bodelson, "Gauguin's Cézannes," *Burlington Magazine* (May 1962), 208. Bodelson quotes from a description written by Karl Madsen, but her citation references a secondary source: H. Bramsen in *Aartiderne* 7 (1949): 99.

60. Simon, "Cézanne," 124-25.

61. For more information, see Reff, "Pictures," 90-104.

62. Geist, *Interpreting Cézanne*, 36.

63. Rewald, "Cézanne and His Father," 92. It merits noting that Paul Cézanne himself was an illegitimate son as well.

64. Marcuse, *Eros*, 100.

CHAPTER 4

1. Rainer Maria Rilke, *Letters on Cézanne* (1892-1910), trans. Joel Agee (New York: North Point Press, 2002), 67.

2. "Rappelez-vous l'objet que nous vîmes, mon âme, / Ce beau matin d'été si doux: / Au détour d'un sentier une charogne infâme / Sur un lit semé de cailloux"; C. Baudelaire, "Une Charogne," in his *Oeuvres Complètes*, C. Pichois and J. Ziegler, eds., Bibliothèque de la Pléiade (Paris: Gallimard, 1975-76), 1: 31; my translation.

3. Darin Barney, in his *The Network Society* (Cambridge: Polity, 2004), 156, speaks of differing relationships formed in communities: "For some, community requires 'thick' relationships of mutual moral obligation, bound by strong, enduring multiplex ties and practices that define social roles, norms and identity, and are not easily broken. For others, 'community' can feature relatively 'thin' relationships comprised of voluntary, revocable, dynamic ties based on shared individual interests and needs."

4. Slavoj Žižek, *Tarrying with the Negative: Kant, Hegel, and the Critique of Ideology* (Durham, N.C.: Duke University Press, 1993), 131.

5. See for example, T. J. Clark's "The Environs of Paris," in M. T. Lewis, ed., *Critical Readings in Impressionism and Post-Impressionism: An Anthology* (Berkeley: University of California Press, 2007), 101-45.

6. Qu., Joseph Masheck, *C's Aesthetics: Philosophy in the Painting* (Philadelphia: Slought Foundation; Bryn Mawr, Pa.: Bryn Mawr College *Visual Studies Center*, 2004), 54.

7. Qu., Ibid., 57.

8. Ibid., 70-71. Further to this point, Masheck writes, "Certainly spontaneity is a complex question in respect to C. The solemnity of many works of his maturity would seem to rule it out. However bracing spontaneity must have been for some impressionists, it was probably advantageously challenging for C, who of course could always find contemplative retreat in the studio, composing his more readily controllable still lifes. Yet somehow the demand for spontaneity under Pissarro's impressionist tutelage was vitally necessary before he could proceed to find his authentically serious, not merely inhibited, self. Even *en plein air*, C spent much time making scrupulous adjustments to a particular painting; so that as regards its 'rate' of construction, its real-time execution, such a work might not be considered spontaneous at all. It must have been a beneficial challenge for C to have to be spontaneous enough to qualify as a proper impressionist: not having been suited for it, he had the tenacity to proceed to a mode that could not have developed without impressionism but that put no premium on spontaneity: postimpressionism, which would prove considerably more rationally engaging than spontaneous" (78).

9. Louis Althusser and Étienne Balibar, *Reading Capital*, trans. Ben Brewster (London: Verso, 2009), 210.

10. So Žižek argues in *Tarrying with the Negative*: "In *Reading Capital*, Louis Althusser endeavored to articulate the epistemological break of Marxism by means of a new concept of causality, 'overdetermination': the very determining instance is overdetermined by the total network of relations within which it plays the determining role. Althusser opposed this notion of causality to both mechanical, transitive causality (the linear chain of causes and effects whose paradigmatic case is classical, pre-Einsteinian physics) and expressive causality (the inner essence which expresses itself in the multitude of its forms-of-appearance). 'Expressive causality', of course, targets Hegel, in whose philosophy the same spiritual essence—'zeitgeist'—allegedly expresses itself at the different levels of society: in religion as Protestantism, in politics as the liberation of civil society from the chains of medieval corporatism, in law as the rule of private property and the emergence of free individuals as its bearers. . . . It should be clear, now, that the Althusserian critical attribution to Hegel of 'expressive causality' misses the target: Hegel himself articulated in advance the conceptual framework of Althusser's critique; i.e., his triad of formal, real, and complete ground corresponds perfectly to the triad of expressive, transitive, and overdetermined causality. What is 'complete ground' if not the name for a 'complex structure' in which the determining instance itself is (over)determined by the network of relations within which it exerts its determining role?" (140).

11. Althusser and Balibar, *Reading Capital*, 208.

12. Cited in R. Shiff, *Cézanne and the End of Impressionism* (Chicago: University of Chicago Press, 1986), 151.

13. Control can be understood here specifically as protological control, which "brings into existence a certain contradiction, at once distributing agencies in a complex manner while at the same time concentrating rigid forms of management and control." As well, we can think about one aspect of this organization and management as the means of power relations, in particular "the principle of distributed sovereignty, the idea that control and organization are disseminated outward into a relatively large number of small, local decisions." See A. R. Galloway and E. Thacker, *The Exploit: A Theory of Networks*, (Minneapolis: University of Minnesota Press, 2007), 31, 46. These local decisions can, in fact, be seen to be "based on a kind of economy of power relations which does not posit a structure but rather posits a tension between nodes, setting up the whole topology of the network as antagonistic and asymmetric"; see K. Eriksson, "On the Ontology of Networks," *Communication and Critical/Cultural Studies* 2, no. 4 (December 2005), 312.

14. Eriksson, "Ontology," 316.

15. Maurice Merleau-Ponty, "Cézanne's Doubt," trans. Thomas Baldwin, in his *Basic Writings* (London and New York: Routledge, 2004), 281.

16. Ibid., 279.

17. G. W. F. Hegel, *Phenomenology of Spirit*, trans. A. V. Miller (Oxford: Clarendon, 1977), 113.

18. Qu., Merleau-Ponty, "Cézanne's Doubt," 276-77.

19. Quentin Meillassoux, *After Finitude: An Essay on the Necessity of Contingency*, trans. Ray Brassier (New York: Continuum, 2009), 60.

20. For example, see the analysis of Flaubert's novel and its influence on Cézanne's painting of the same subject in Lewis, *Cézanne's Early Imagery* (Berkeley: University of California Press, 1989), 181-85.

21. Roger Caillois, "Mimicry and Legendary Psychasthenia," trans. John Shepley, *October* 31 (Winter 1984), 12-32, here 31. The passage cited by Caillois can be found in G. Flaubert, *The Temptation of Saint Anthony*, trans. Lafcadio Hearn (New York: Modern Library, 2002), 190.

22. Joachim Gasquet, *Joachim Gasquet's Cézanne: A Memoir with Conversations*, trans. Christopher Pemberton (New York: Thames and Hudson, 1991), 168.

23. Gilles Deleuze and Felix Guattari, *A Thousand Plateaus: Capitalism and Schizophrenia*, trans. Brian Massumi (Minneapolis: University of Minnesota Press, 2005), 150-53).

24. Deleuze and Guattari, *Anti-Oedipus: Capitalism and Schizophrenia*, trans. Robert Hurley, Mark Seem, and Helen R. Lane (New York: Penguin, 2009), 12.

25. Deleuze and Guattari, *Thousand Plateaus*, 161.

26. Merleau-Ponty, *The Visible and the Invisible*, trans. Alphonso Lingis (Evanston, Ill.: Northwestern University Press, 1969), 127, 83-84. Note the discussion of Merleau-Ponty's concept of flesh in G. Harman, *Guerrilla Metaphysics: Phenomenology and the Carpentry of Things* (Chicago: Open Court, 2005), 52-54.

27. Gasquet, "*Cézanne*," 166-67.

28. Marc Augé, *Oblivion*, trans. Marjolijn de Jager (Minneapolis: University of Minnesota Press, 2004), 57.

29. Deleuze and Guattari, *Thousand Plateaus*, 150.

30. Qu., Merleau-Ponty, "Cézanne's Doubt," 273.

CHAPTER 5

1. I. Campbell and A. MacKechnie, "The 'Great Temple of Solomon' at Stirling Castle," *Architectural History* 54 (2011), 91-118.

2. Nicholas of Lyra's *Postilla super totam Bibliam*, on the dissemination of which see E. A. Gosselin, "A Listing of the Printed Editions of Nicolaus de Lyra," *Traditio* 26 (1970), 399-426. The first edition of the Bible to include the *Postilla* and woodcuts, printed by Anton Koberger in Nuremberg in 1481, was reprinted and imitated many times (Gosselin, "Listing," 408, no. 25).

Some manuscripts of the *Postilla* include crude illustrations but these do not appear to be the inspiration for the Koberger woodcuts: see F. Pereda, "Le origini dell'architettura cubica: Alfonso de Madrigal, Nicola di Lira e la 'querelle salomonista' nella Spagna del Quattrocento," *Annali di Architettura*, XVII (2005), 21-51.

3. The woodcut illustrated here is from Gaspard Trechsel's *Biblia Sacra cvm Glossis Interlineari & Ordinaria: Nicolai Lyrani Postilla & Moralitatibus, Burgensis Additionibus, & Thoringi Replicis*, 7 vols. (Lyons, 1545), which circulated in Scotland in the sixteenth century. The bindings of the Glasgow University copy we illustrate (Sp Coll Bh6-a.3-8) bear the stamp of James Beaton, Archbishop of Glasgow (on whom, see M. Dilworth, "Beaton, James (1524–1603)," *ODNB*, online edition, Oxford University Press, Sept 2004 [www.oxforddnb.com/view/article/1825, accessed July 9, 2010]).

4. See R. Fawcett, "The Medieval Building," in *King's College Chapel, Aberdeen, 1500-2000*, J. Geddes, ed. (Leeds, 2000), 34-61.

5. J. G. Dunbar, *Scottish Royal Palaces: The Architecture of the Royal Residences during the Late Medieval and Early Renaissance Periods* (East Linton, Scotland, 1999), 44-45.

6. Ibid., 27-30.

7. Fawcett, "Medieval Building," 47-48.

8. The daughter was Madeleine de Valois; Dunbar, *Scottish Royal Palaces*, 36.

9. J. Higgitt, "The Dedication Inscription," in *King's College Chapel*, Geddes, ed., 66-73; J. Geddes, "Appendix: The Proportions and Solomon's Temple," in *King's College Chapel*, 61-63; I. Campbell, "Bishop Elphinstone's Tomb," in *King's College Chapel*, 115-29, at 123-25; G. P. Edwards, "William Elphinstone, His College Chapel and the Second of April," *Aberdeen University Review* 51 (1985), 7-9.

10. Nor is there anything in the descriptions in 2. Chron. 3 or Josephus' *Antiquities* 8.3.

11. *New English Translation of the Septuagint* (Oxford, 2009), 3 Reigns 6, v. 4, p. 302. (http://ccat. sas.upenn.edu/nets/edition/11-3reigns-nets.pdf).

12. These were most commonly interpreted as symbolizing the love of God and the love of neighbor, both necessary to enter the Kingdom of Heaven, which the Temple represents, but other meanings are proposed: Walafrid Strabo, *Glossa Ordinaria*, III Regum, ch. 6, v. 31 in *Patrologia Latina*, CXIII, col. 591.

13. *New English Translation of the Septuagint*, 3 Reigns 7, v. 39, p. 304.

14. The earlier Geneva Bible (1560), p. 153, renders 1 Kings 7:4 as "And the windows were in three rowes, & windowe was over against windowe in three rankes."

15. An alternative explanation is that, although the Vulgate was the canonical bible of the Latin Church until the Reformation, versions of pre-Jerome Latin biblical translations, called collectively *Vetus Latina*, could still be found, and it may be that one of these had something similar to the Septuagint reading, which was then interpreted as paired or biforate windows; until an edition of the *Vetus Latina* 1 Kings has been published this must remain speculation.

16. Ovid, *Ex Ponto* 3.3.5: "nox erat et bifores intrabat luna fenestras"; A. H. Smith, *A Catalogue of Sculpture in the Department of Greek and Roman Antiquities, British Museum*, 3 vols. (London, 1892-1904), 3, no. 2190, 240-44.

17. M. Cortelletti, "Nuove indagine sulla chiesa di S. Maria delle Grazie di Grado," in *Archeologia dell'Architettura* 8 (2003), 181-208.

18. C. Nordenfalk, "The Apostolic Canon Tables," *Gazette des Beaux-Arts*, ser. 6, 62 (1963), 17-34.

19. R. L. S. Bruce-Mitford, *The Art of the Codex Amiatinus: Jarrow Lecture 1967* (Jarrow, 1978); P. Meyvaert, "Bede, Cassiodorus, and the Codex Amiatinus," *Speculum* 71 (1996), 827-83.

20. Bruce-Mitford, *Art of the Codex Amiatinus*, 2-4 and 14-15. One could also note in passing the resemblance to the common Anglican post-Reformation practice of framing the Ten Commandments in a double-arched frame in the reredos behind Communion Tables.

21. This spans fols. IIv and IIIr. See J. O'Reilly, "Introduction" in Bede, *On the Temple,* trans. S. Connolly (Liverpool, 1995), lii-lix; also O'Reilly, "'All that Peter stands for': The *Romanitas* of the Codex Amiatinus Reconsidered," in J. Graham-Campbell and M. Ryan, eds., *Anglo-Saxon/ Irish Relations before the Vikings, Proceedings of the British Academy 157* (Oxford, 2009), 367-95 at p. 389.

22. Bruce-Mitford has argued plausibly that the folio with the contents page was originally fol. 3r and that the plan of the Tabernacle was on the central opening of the gathering, on fols. 4v-5r. Meyvaert, "Bede, Cassiodorus and the Codex Amiatinus," 860-66, fails to discuss Bruce-Mitford's suggested ordering and proposes another where there is no close relationship between the contents page and the Tabernacle plan. He also argues (853-60) that the *Codex Grandior* had separate illustrations of the Tabernacle and the Temple.

23. W. Cahn, "Solomonic Elements in Romanesque Art," in *The Temple of Solomon: Archaeological Fact and Medieval Tradition in Christian, Islamic and Jewish Art,* ed. J. Gutmann (Missoula, Mont., 1973), 46-72, at p. 56; S. Tuzi, *Le Colonne e il Tempio di Salomone: La Storia, la Leggenda, la Fortuna* (Rome, 2002), 86.

24. H. M. Taylor and J. Taylor, *Anglo-Saxon Architecture,* 2nd ed., 3 vols. (Cambridge, 1980-84), 1:443; C. B. McClendon, *The Origins of Medieval Architecture* (New Haven and London, 2005), 187.

25. Taylor and Taylor, op. cit., 1:345; R. Stalley, *Early Medieval Architecture* (Oxford, 1999), 125.

26. Cahn, "Solomonic Elements," 52.

27. McClendon, *Origins,* 187-94.

28. *Abbot Suger on the Abbey Church of St.-Denis and Its Art Treasures,* Erwin Panofsky, ed., 2nd ed., G. Panofsky-Soergel, ed. (Princeton, 1962), 105; see also L. H. Stookey, "The Gothic Cathedral as the Heavenly Jerusalem: Liturgical and Theological Sources," *Gesta,* 8 (1969), 35-41.

29. *Biblia Sacra* (Lyons, 1545; see n. 3 above): II, fol. 133r., col. 1: "Apocal. xxi.e. 'Et civitas est in quadro posita'; Sciut enim ecclesia hinc per templum intelligitur sic ibi per civitatem significatur."

30. Such as the Canonica of S. Agnese fuori le Mura and the Ospedale di S. Spirito; V. Golzio and G. Zander, *L'Arte in Roma nel secolo XV* (Bologna, 1968), 48-51.

31. E. Battisti, "Il Significato simbolico della Cappella Sistina," *Commentari: Rivista di critica e storia dell'arte* (1957), 96-104.

32. Personal communication, 2011. On Perugino's role overseeing the decorative scheme of all the Sistine chapel walls, see A. Nesselrath, "Perugino nella Cappella Sistina," in *Pietro Vannucci "il Perugino": Atti del Convegno internazionale di studio 25-28 Ottobre 2000,* L. Teza, ed. (Perugia, 2004), 91-104.

33. A. Myln, *Vitae Dunkeldensis ecclesiae episcoporum: a prima sedis fundatione, ad annum M.D.XV* (Edinburgh, 1831), 28.

34. L. J. Macfarlane, *William Elphinstone and the Kingdom of Scotland, 1431-1514: The Struggle for Order* (Aberdeen, 1985), 291-97.

35. H.-D. Fernandez, "Avignon to Rome: The Making of Cardinal Giuliano della Rovere as a Patron of Architecture," in *Patronage and Dynasty: The Rise of the Della Rovere in Renaissance Italy,* I. Verstegen, ed. (Kirksville, Mo., 2007), 63-88, at 64-67.

36. Campbell, "New St. Peter's: Basilica or Temple," *Oxford Art Journal* 4, pt. 1, (1981), 3-8; M. Tanner, *Jerusalem on the Hill: Rome and the Vision of St. Peter's Basilica in the Renaissance* (London, 2010).

CHAPTER 6

1. For Le Corbusier and Amédée Ozenfant's discussion of Purism in relation to Cubism see Le Corbusier and A. Ozenfant, *La Peinture moderne* (Paris: Crés, 1925); for the contemporary debate on the issue see E. Blau and N. Troy, eds., *Architecture and Cubism,* (Cambridge, Mass.:

MIT Press, 2001); for a fine discussion of Le Corbusier as a painter in still life and other genres, see M. Krustrup, ed., *Le Corbusier Painter and Architect* (Aalborg [Denmark]: Nordyllands Kuntsmuseum, 1995).

2. A recounting and excellent discussion of this debate is B. Reichlin, "Une petite Maison on Lake Leman: The Perret-Le Corbuiser Controversy," *Lotus* 60 (Milan, 1988), and the same writer's "The Pros and Cons of the Horizontal Window," *Daidalos*, no. 13 (1984); also, for his own account: Le Corbusier, *Almanach d'Architecture moderne* (Paris: Crès, 1928; repr. Paris, Altamira, F.L.C., 1998), 96.

3. In reference to Madame Savoye's car window by Le Corbusier's studio, see R. A. Etlin, *Frank Lloyd Wright and Le Corbusier: The Romantic Legacy* (Manchester: Manchester University Press, 1994).

4. Le Corbusier, *The City of Tomorrow and Its Planning*, trans. F. Etchells (Cambridge, Mass.: MIT Press, 1971), 179.

5. Ibid, 175.

6. Le Corbusier, *Le Poème de l'angle droit* (Paris: Teriade, 1955); from section A3, "Environment": "Repose supine sleep-death / With our backs on the ground... / But I am standing straight / Since you are erect you are also fit for action"; translation thanks to Kenneth Hylton.

7. Le Corbusier, *Towards an Architecture*, trans. John Goodman (London: Getty Trust, 2007), Part 1.5.3, p. 231.

8. Le Corbusier, *City of Tomorrow*, 231.

9. Le Corbusier, *Towards an Architecture*, 188.

10. Le Corbusier, *Modulor 2*, trans. P. de Francia and A. Bostock (Cambridge, Mass.: MIT Press, 1968), 214-15.

11. The palace is unbuilt, but it was temporarily mocked up in *papier-mâché* for the fiftieth anniversary of the city when I observed its effect.

12. M. Tafuri and F. dal Co, *Modern Architecture 2* (New York: Abrams, 1979), 319.

13. Le Corbusier, *Talks with Students* (New York: Princeton Architectural Press, n.d.), 32; on p. 54, we learn he was sitting at his table.

CHAPTER 7

1. A. Robbe-Grillet, *La Jalousie*, (Paris: Minuit, 1957); in English, *Jealousy*, trans. R. Howard (New York: Grove, 1959). The present text trans. Jonathan Quinn in *Texttreue: Notizen zum Thema Beobachtung und Beschreibung eines Hauses in einem Roman* (Prague: National Gallery, 1997), with minor modifications. [Robbe-Grillet's title no doubt puns on the louvered "jalousie" window, in tropical climates of wood but also, with less import for the peeping theme, quite popularly of glass in 1957 in France as well as America.—ed.]

CHAPTER 8

1. See J. Black, "Portraiture," in Black and B. Martin, eds., *Dora Gordine: Sculptor, Artist, Designer* (London: Dorich House Museum, Kingston University, and Philip Wilson, 2007). This volume is the most comprehensive published study of the artist's biography, chronology, and reception, along with a catalogue raisonné of her sculpture and bibliography.

2. S. A. Mansbach, *Modern Art in Eastern Europe, from the Baltic to the Balkans, ca. 1890 to 1939* (Cambridge: Cambridge University Press, 1999); also J. Howard, *East European Art 1650-1950* (Oxford: Oxford University Press, 2007).

3. Black, "Portraiture"; also idem, "Collecting Connoisseurs and Building to House a Collection: The Intriguing Case of Dora Gordine (1895-1991)," *Journal of the History of Collections* 21, no. 2 (2009).

4. Gordine's "modest modernism" may be compared with that of the Swedish sculptor Carl Milles (1875-1955) in the older generation, in contrast with the modernism of her English

contemporary, Barbara Hepworth (1903-1975). Whereas Hepworth's rigorously avant-garde work was constantly embattled in a basically conservative British culture, Gordine's more restrained modern style(s) garnered enthusiastic support, especially among an elite group of patrons to which she had easy access through her husband's connections.

5. For an introduction and overview of the size, character, and history of Jews in late nineteenth-century Latvia, especially Courland, see *The YIVO Encyclopedia of Jews in Eastern Europe*, 2 vols., (New Haven: Yale University Press, 2008), entries on "Courland" (1: 357-58) and "Latvia" (1: 996-1000). For a discussion of the choices made by Dora Gordine and her siblings regarding relocation as Jews in the political turbulence of World War I and its revolutionary aftermath in the Baltic lands: Black, "Portraiture," 21-23.

6. See the essays by each of these scholars in Black and Martin, *Dora Gordine*.

7. For a brief discussion of Young Estonia as a cultural and political formation: Toivo U. Raun, *Estonia and the Estonians*, 2nd ed. (Stanford, Calif.: Hoover Institution Press, 1991), esp. 87, 91-94. The volume also contains a helpful and comprehensive bibliography.

8. Mansbach, *Modern Art*, esp. 141-78.

9. For a general discussion of the role of African masks in classical modernism: W. Grossman, *Man Ray, African Art, and the Modernist Lens*, International Arts & Artists (exhib. cat.) (Minneapolis: University of Minnesota Press, 2010); for a discussion of Matvejs and Latvia, see also proceedings of the accompanying conference of 13-14 November, 2009: *African Art, Modernist Photography, and the Politics of Representation* (Washington: Phillips Collection, 2009), especially the presentations by Z. S. Strother ("Africa in the Photography and Art Criticism of Vladimir Markov and Carl Einstein, c. 1914-15") and Mansbach ("Response to the Papers," focusing on Markov and primitivism).

10. In addition to his innovative work for the Riga Artists' Group's designs for the Latvian opera, theater, and ballet stages, Suta was a cofounder in 1924 of the Baltars porcelain manufactory. In fact, it was he who proposed establishing Baltars as a means of disseminating modernist-designed articles of everyday use. Inspired both by the nativist arts-and-crafts movement, which advocated the medium of ceramics to promote awareness of the national folk culture, and by the inventive Suprematist porcelain being produced (mostly in 1923 and 1924) by Russia's modernists, Suta and his colleagues made effective use of ceramic ware to propagate the evolving Latvian culture. The name "Baltars" was coined to signify a melding of Baltic tradition and the new art forms then being articulated.

CHAPTER 9

1. F. Grafe, "Doktor Caligari gegen Doktor Kracauer, oder Die Errettung der ästhetischen Realität," *Süddeutsche Zeitung*, no. 48, February 25, 1970; repr. in her *Licht aus Berlin: Lang, Lubitsch, Murnau, und Weiteres zum Kino der Weimarer Republik*, E. Patalas, ed. (Berlin: Brinkmann und Bose, 2003), 14. "Wenn man Bewegungen empfindet auf expressionistischen Bildern, liegt es am Rahmen, an der angehaltenen Bewegung, die ihn zu sprengen droht, an der Spannung zwischen Ruhe und Bewegung. Diese Malerei zu animieren kommt der Erledigung ihrer Basis gleich. Wie die Fotografie den Naturalismus überbot, wird im *Caligari* die bewegte Malerei ad absurdum geführt." All English translations from the German are my own unless otherwise noted.

2. D. Wye, *Kirchner and the Berlin Street*, exh. cat. (New York: Museum of Modern Art; London: Thames and Hudson, 2008).

3. The term anticipates by some seventy years the title of Gilles Deleuze's first volume on cinema, which in its German edition is translated *Bewegungsbild*. G. Deleuze, *Das Bewegungsbild: Kino I*, 6th ed. (Frankfurt am Main: Suhrkamp, 1996; English ed.: *Cinema I: The Movement* Image (Minneapolis: University of Minnesota Press, 1986). For early references to "Bewegungsbilder," see T. H. Mayer, "Lebende Photographien" (1912), and V. Klemperer, "Das Lichtspiel" (1913),

in F. Güttinger, ed., *Kein Tag ohne Kino: Schriftsteller über den Stummfilm* (Frankfurt am Main: Deutsches Filmmuseum Frankfurt, 1984), 77, 126. On Bergson, Marey, and avant-garde painting see M. Braun, *Picturing Time: The Work of Etienne-Jules Marey (1830–1904)* (Chicago: University of Chicago Press, 1992), 264-318. For an excellent account of the representation of movement during this period, see T. Gunning, "Cinema and the New Spirit in Art within a Culture of Movement," in B. Rose, ed., *Picasso, Braque and Early Film in Cubism*, exh. cat. (New York: Pace Wildenstein, 2007), 17-33.

4. Sketchbook 156, text printed in G. Presler, *Ernst Ludwig Kirchner: Die Skizzenbücher. "Ekstase des ersten Sehens." Monografie und Werkverziechnis* (Davos: Kirchner-Verein, 1996), 415.

5. E. L. Kirchner, "Über Leben und Arbeit," from *Das Werk* (1930), as cited in L. Grisebach and A. Meyer zu Eissen, eds., *Ernst Ludwig Kirchner: 1880–1938*, exh. cat. (Berlin: Nationalgalerie, 1979), 97-98.

6. Illustrated in D. E. Gordon, *Ernst Ludwig Kirchner* (Cambridge, Mass.: Harvard University Press, 1968), pl. 30; cat. 161. References to catalogue raisonné hereafter cited as "Gordon" followed by catalogue number.

7. See, for example, Gordon 288, 290, 291.

8. W. Gropius, "Der stilbildende Wert industrieller Bauformen," *Jahrbuch des Deutschen Werkbundes* (Jena: Diedrichs, 1914), 32.

9. G. Lukács, "Gedanken zu einer Ästhetik des Kinos," in Güttinger, *Kein Tag ohne Kino* (Frankfurt am Main: Deutsches Filmmuseum Frankfurt, 1984), 194-200; here 198. One of the sensations of the 1913 season was a film by the director Max Mack, *Wo ist Coletti?* (Where is Coletti?), which was shot on location in Berlin and included just such a chase scene, filmed with the camera mounted at the rear on the upper deck of a Berlin omnibus, capturing a gaggle of pedestrians following in hot pursuit. The film premiered in Berlin on April 4, 1913. See H. H. Prinzler, *Chronik des deutschen Films, 1895–1994* (Stuttgart: Metzler, 1995), 27.

10. See *Straße* (*Street*, Gordon 53); also *Strassenbahn in Dresden* (*Streetcar in Dresden*, Gordon 99).

11. For *Five Women on the Street* and *Leipziger Straße with Tram* see Wye, *Kirchner and the Berlin Street*, 3 and 18, fig. 2.

12. In his 1925 text "Das Werk," included in his diary manuscript. Grisebach, ed., *Ernst Ludwig Kirchners Davoser Tagebuch: eine Darstellung des Malers und eine Sammlung seiner Schriften*, 2nd rev. ed. (Ostfildern: G. Hatje, 1997), 72.

13. Grisebach, *Ernst Ludwig Kirchner: Großstadtbilder* (Munich: Piper, 1979), 49, citing the 1910 Baedeker to Berlin.

14. Kirchner did not limit this dynamic compositional device to *Potsdamer Platz*; it appears in other paintings and prints of 1914. In *Gastanks with Suburban Railway* (Gordon, 385), for example, on the lower right the speeding train becomes isomorphic with the dynamic semicircular arc of the railway, which is reinforced by the ovals of the gas tanks themselves.

15. Kirchner exhibited the two paintings together in the 1916 Berlin Freie Sezession exhibition; they were his only submissions. On this see S. Simmons, "Ernst Kirchner's Streetwalkers: Art, Luxury, and Immorality in Berlin, 1913-16," *Art Bulletin* 82, no. 1 (March 2000): 139, 148 n. 187.

16. C. W. Werner Haxthausen, *Modern German Masterpieces*, Bulletin of the Saint Louis Art Museum (1985), 49.

17. "Die Arbeit E. L. Kirchners," in E. W. Kornfeld, *Ernst Ludwig Kirchner: Nachzeichnung seines Lebens: Katalog der Sammlung von Werken von Ernst Ludwig Kirchner im Kirchner-Haus Davos* (Bern and Fribourg: Kornfeld / Office du livre, 1979), 344. Kornfeld, the first to publish the manuscript, writes that Kirchner "probably put it on paper in 1925 or the summer of 1926," without giving any reason for that dating. Yet this cannot be correct, since Kirchner makes a reference to Kandinsky's *Punkt und Linie zu Fläche* (*Point and Line to Plane*), which appeared

only in mid-October 1926. Will Grohmann wrote that Kandinsky's book was published to coincide with the opening of the "jubilee exhibition" organized by the Galerie Arnold in Dresden to mark the artist's sixtieth birthday. The exhibition opened on 16 October 1926. See Grohmann's review, "Austellungen: Dresden," *Der Cicerone* 18, no. 20 (October 1926), 682.

18. Gordon 288.

19. E. Panofsky, "On Movies," *Bulletin of the Department of Art and Archaeology of Princeton University* (June 1936), 7-8.

20. See Gunning, "Cinema and the New Spirit in Art," 28-29.

21. Kirchner, letter to Botho Graef, September 21, 1916, in *Ernst Ludwig Kirchner: Der gesamte Briefwechsel*, H. Delfs, ed. (Zürich: Scheidegger und Spiess, 2010), 1:144-145.

22. Gordon 427; color illustration in Wye, *Kirchner and the Berlin Street*, 7.

23. H. Bergson, *Creative Evolution*, trans. A. Mitchell (Mineola, N.Y.: Dover, 1998), 302.

24. Ibid., 305. On Bergson, movement, and cinema, see Deleuze, *Cinema I*, 1-11.

25. P. Cabanne, *Dialogues with Marcel Duchamp*, trans. R. Padgett (New York: Da Capo, 1987), 29.

26. Bergson, *Matter and Memory*, trans. N. M. Paul and W. S. Palmer (New York: Zone Books, 1988), 20-21.

27. C. Einstein, *Die Kunst Des 20. Jahrhunderts*, Propylaen-Kunstgeschichte (Berlin: Propylaen, 1926), 62-63.

28. A first version of this paper was presented at a symposium held in conjunction with the exhibition "Kirchner and the Berlin Street" at the Museum of Modern Art, New York, on October 17, 2008. I wish to thank the other participants in that event, Reinhold Heller, Katharina Henkel, Jill Lloyd, Sherwin Simmons, Katharina Sykora, and Deborah Wye for their comments on that occasion.

CHAPTER 10

1. For more information on this exhibition, see *Victory Over the Future: Russian Pavilion; 53rd International Art Exhibition, La Biennale di Venezia 2009*, A. Petrova, ed. (Moscow: Multimedia Art Museum, 2009).

2. On the contemporary interest in transformative re-enactment and its emancipatory agency (in comparison to simulation, "slavish" reproduction, or repetition), see S. Lütticken, "Introduction," and "An Arena in Which to Reenact," in *Life, Once More: Forms of Reenactment in Contemporary Art*, Lütticken, ed. (Rotterdam: Wim de With, 2005); R. Blackson, "Once More . . . With Feeling: Reenactment in Contemporary Art and Culture," *The Art Journal* (Spring 2007), 28-40; and R. Schneider, *Performing Remains: Art and War in Times of Theatrical Reenactment* (London: Routledge, 2011).

3. Among those artists working in the "'medium'" of re-enactment, some key figures include Marina Abramovic, Omer Fast, Luca Buvoli, and Jeremy Deller.

4. F. T. Marinetti, "The Founding and Manifesto of Futurism," *Le Figaro* (Paris), February 20, 1909; in *Futurism: An Anthology*, L. Rainey, C. Poggi, and L. Wittman, eds., trans. L. Rainey (New Haven: Yale University Press, 2009), 51.

5. Lenin made this statement in a lecture on November 21, 1910 (or earlier). It was published in 1920 in the pamphlet *Current Questions of the Party's Present Work*. For the text of the lecture, see V.I. Lenin, *Collected Works*, 4th English ed., vol. 31 (Moscow: Progress Publishers, 1965), 408-461.

6. For an annotated English translation of the text, along with a facsimile of the original Russian publication and interpretive essays, see *Victory Over the Sun: The World's First Futurist Opera*, R. Bartlett and S. Dadswell, eds. (Exeter: University of Exeter Press, 2012).

7. A. Kruchenykh, "Victory Over the Sun," trans. E. Bartos and V. N. Kirby, *The Drama Review (TDR)* 15, no. 4 (Autumn 1971), 109.

8. Kruchenykh, *Our Arrival: From the History of Russian Futurism* (Moscow: "RA," 1995), 60.
9. F. Jameson, *Archaeologies of the Future: The Desire Called Utopia and Other Science Fictions* (London: Verso, 2005), 60.
10. For information on this performance, see A. Shatskikh, *Vitebsk: The Life of Art*, trans. K. F. Tsan (New Haven, Yale University Press, 2007), 94-100.
11. For illustrations of Vera Ermolaeva's set design and costumes, see N. Firtich and D. Ungurianu, eds., "From Gogol to *Victory over the Sun:* Trajectories of the Russian Avant-Garde, Collection of Essays," special issue, *Transactions*, 35 (2009), section VII.
12. On Gastev and Soviet debates on labor efficiency and streamlining, see K. E. Bailes, "Alexei Gastev and the Soviet Controversy Over Taylorism, 1918-24," *Soviet Studies* 29, no. 3 (July 1977), 373-94.
13. For an "electrograph" of a hand that captured the electricity within it in the form of a halo of sparks, see H. Schnauss, *Photographischer Zeitvertreib: Eine Zusammenstellung einfacher und leicht ausführbarer Beschäftigungen und Unterhaltungen mit Hilfe der Camera* (Düsseldorf: Ed. Liesegang [firm], 1890, 1893); after the author's death, the book was republished by Félix Nauman in a revised and expanded version under the title *Im Reiche der Kamera* (Leipzig: Liesegang, 1912).
14. This is the opening line of Carl Schmitt's *Political Theology: Four Chapters on the Concept of Sovereignty (1922)*, trans. and with an introduction by G. Schwab (Chicago: University of Chicago Press, 1985), 5; see also the discussion of Schmitt's theories in G. Agamben, *State of Exception,* trans. K. Attell (Chicago: University of Chicago Press, 2005).
15. W. Benjamin, "Critique of Violence," in his *Reflections: Essays, Aphorisms, Autobiographical Writings,* trans. E. Jephcott (New York: Schocken Books, 1986), 287.
16. Benjamin, "Critique," 297.
17. Benjamin, "Theses on the Philosophy of History," in his *Illuminations: Essays and Reflections,* H. Arendt, ed., trans. H. Zohn (New York: Schocken Books, 1969), 261.
18. Benjamin, "Critique," 300.

CHAPTER 11

1. This is described in D. Nicholls, "Getting Rid of the Glue: The Music of the New York School," in S. Johnson, ed., *The New York Schools of Music and the Visual Arts* (New York: Routledge, 2002).
2. It is interesting to witness Cage's shifting views of Boulez: In those early years, Boulez remained in some ways a key protagonist. Henry Cowell's early essay in 1951 on the Cage group examines Cage, Feldman, Boulez, and Wolff. Cage, in a letter roughly contemporary with Cowell's essay, talks about proposing to David Tudor a series of concerts featuring the same group of composers.
3. Ernst Bloch replied to a telegram from the eighteen-year-old Feldman who was presumably asking for lessons. Bloch gently castigates Feldman for his urge to create "a new world," and goes on: "I have learned more about [true principles] in scientific ... ethnological studies ... or the literary works of Flaubert and others—Rodin, Gauguin, Van Gogh—than in musical treatises. . . ."; correspondence in the Morton Feldman Collection of the Paul Sacher Foundation, Basel, Switzerland. Thanks to Dr. Felix Meyer for permissions.
4. From an interview with the author, 1995.
5. Conversation with the author, 2006.
6. M. Feldman, "Give my Regards to Eighth Street," in his *Essays,* W. Zimmermann, ed. (Kerpen [Germany]: Beginner, 1985), 78. For an excellent in-depth overview of Feldman's relationship with the painters, see J. W. Bernard, "Feldman's Painters," in Johnson, *New York Schools.*
7. I. Sandler, *The New York School: The Painters and Sculptors of the Fifties* (New York: Harper and Row, 1978), 48.

8. Extract of an interview broadcast on BBC Radio 3 in conjunction with a performance of *Bass Clarinet and Percussion* (1981) in the 1990s.

9. Robert Motherwell, "The New York School," in *The Collected Writings of Robert Motherwell*, Stephanie Terrenzio, ed. (New York: Oxford University Press, 1992), 78.

10. Feldman, "Crippled Symmetry," in his *Essays*, 136.

11. Earle Brown, notebook entry of 1959; quoted in "Form in New Music," a lecture given at Darmstadt in 1965; Earle Brown Music Foundation, Rye, New York. Thanks to Thomas Fichter and Susan Sollins-Brown at the Foundation for Permissions for this and succeeding manuscript sources, and the reproduction of Brown's painting.

12. Brown, "The Notation and Performance of New Music," lecture given at Darmstadt in 1964, repr. in *The Musical Quarterly* 72, no. 2 (1986), 180-201.

13. Feldman, "Autobiography," *Essays*, 38.

14. Brown, statement from a notebook of 1951-52, quoted in "Interview with John Yaffe 1995," in CD booklet *Music for Pianos 1951-1995*, New Albion Records, San Francisco, 1996.

15. F. Denyer, "Feldman's Search for the Ecstasy of the Moment," in CD booklet with Feldman: *The Ecstasy of the Moment*, Etcetera, 1995.

16. Prefatory Notes to *Folio*, (from notebooks 1951-2) Associated Music Publishers (Schirmer), 1961.

17. Interview with author, 1995.

18. Prefatory Notes to *Folio*, Associated Music Publishers (Schirmer).

19. Cage's phrase used in his "Indeterminacy" lecture of 1958, reprinted in *Silence* (1961; London: Marion Boyars, n.d.).

20. Draft for a program note for the London Sinfonietta, Earle Brown Music Foundation, Rye, New York.

21. Brown, notebook entry 1955, quoted in "Form in New Music," lecture given at Darmstadt, 1965, Earle Brown Music Foundation, Rye, New York.

22. Feldman, "After Modernism," in his *Essays*, 107.

23. H. Rosenberg, "The American Action Painters," *Art News*, December 1952 rep. in *Abstract Expressionism a Critical record*, D. and C. Schapiro, eds. (Cambridge University Press, 1990), 79.

24. Quoted in an interview with Stuart Morgan reprinted in the concert brochure for Dal Niente Projects, London, 1998, unpaginated.

25. Feldman, "Between Categories," in *Give My Regards to Eighth Street: Collected Writings of Morton Feldman*, B. H. Friedman, ed. (Cambridge, Mass.: Exact Change, 2000), 89.

26. Feldman, "Toronto Lecture," in *Morton Feldman Says*, C. Villars, ed. (London: Hyphon, 2008), 144-45.

27. Ibid., 144-45.

28. Feldman, "After Modernism," in his *Essays*, 107.

CHAPTER 12

1. Information kindly provided by David Aylsworth, collections registrar of the Museum, in emails of April 2012; it seems that the work had the status of a curatorial exhibit in a project space and was later painted over.—ed.

2. G. E. Davie, "The Mirror Theory: Hume and Smith Against Derrida," in his *A Passion for Ideas: Essays in the Scottish Enlightenment*, Murdo Macdonald, ed. (Edinburgh: Polygon, 1994), 135-49.

3. Excerpted from a long note in Masheck, "Alan Johnston at Haus Wittgenstein," in *Alan Johnston: Haus Wittgenstein / Inverleith House*, A. Johnston and P. Nesbitt, eds. (Edinburgh: Royal Botanic Garden, 1999), unpaginated, with ref. to D. Hume, *An Enquiry Concerning the Principles of Morals*, J. B. Schneewind, ed. (Indianapolis: Hackett, 1983), 39. On the Wittgenstein house,

see now Masheck, *Adolf Loos: The Art of Architecture* (London: I. B. Tauris; New York: Palgrave MacMillan, 2013), ch. 8, "The Wittgenstein House as Loosian." —ed.

4. "Shadow without Object," a solo exhibition of my work, was organized by Anne-Marie Bonnet at Selected Art Models, Cologne, in November 2003; see also V. Stoichita, *A Short History of the Shadow* (London: Reaktion, 1997). The title comes from a description by Sean Shanahan of one of my wall drawings.

5. Masheck, "Alan Johnston," quoting R. A. D. Grant, "Home Truths: Charles Rennie Mackintosh and the House Beautiful," in D. Knowles and J. Skorupski, eds., *Virtue and Taste: Essays on Politics, Ethics and Aesthetics in Memory of Flint Schier*, Philosophical Quarterly Supplementary Series (Oxford: Blackwell, 1993), 111-23.

6. C. Esche, statement in V. Button, C. Esche et al., *Intelligence: New British Art 2000* (London: Tate Gallery, 2001).

7. N. M. Gunn, "Highland Space," *The Scottish Review* (1972); see also Johnston: "Visual Thinking," in K. Okutsu, ed., *Patrick Geddes: "By Leaves We Live,"* (Edinburgh: Edinburgh College of Art; and Yamaguchi [Japan]: Yamaguchi University and Yamaguchi Institute of Contemporary Arts, 2004).

CHAPTER 13

1. B.-A. Scharfstein, *Art without Borders: A Philosophical Exploration of Art and Humanity* (Chicago: University of Chicago Press, 2009), 407.

2. Ibid., 428-29.

3. Ibid., 32.

4. Malevich could be said to be open to the East, if for no other reason than, as W. Sherwin Simmons writes at the time of the "0.10 Last Futurist Painting Exhibition," 1915, Malevich was in contact with pan-Slavic anti-Western European Velamir Khlebnikov, mathematician, poet and visionary, as the latter was writing his prose work *KA* about the radical mono-theology of Akhenaten. In *KA*, Simmons argues that "Khlebnikov confers superheroic status to Akenhaten for martyrdom to the cause for bringing to Egypt the worship of one god—a conceptual-break through in ineffable thought forms. One might say that in citing this source for Christianity Khlebnikov is deriving the West from the East and so inverting cultural dominance." This affiliation had its effect on Malevich's intention for the *Black Square*. W. S. Simmons, Chapter IV, "The New Laws of Transrationalism: 1914-1915," *Kasimir Malevich's "Black Square" and the Genesis of Suprematism 1907-1915* (New York: Garland, 1981). From John Milner, *Kasimir Malevich and the Art of Geometry* (New Haven: Yale University Press, 1996), comes the belief that resistance to the imputed dominance West European culture may be evidenced in Malevich's attempt to calculate his geometry according to traditional Russian number systems. Indeed, Milner tries to demonstrate Malevich's attempt to fuse Russian number systems and Greek ratios from which to derive the new forms for art—although this interpretation by Milner is refuted by Yve-Alain Bois. See www.bookforum.com/archive/ win_03/bois.html. More salient still is the nongeometric content of Form for which the *ikon* is the incarnate surface. Our author might then tell us how this Eastern fact changes his basic metaphysical premise.

5. J. Golding, *Paths to the Absolute: Mondrian, Malevich, Kandinsky, Pollock, Newman, and Still*, rev. ed. (Princeton: Princeton University Press, 2000), 58.

6. Ibid., 60.

7. Ibid., 62.

8. Ibid.

9. Ibid., 70. Here he mentions late nineteenth-century theories of economy of Richard Aventarius. For a theoretical justification of the abstract sense Malevich imputes to surfaces, Golding

writes, "Hegel believed painting the most abstract of the visual arts, conveying as it does the sensation of an illusion on a flat surface," *Paths*, 74.

10. A. C. Danto, "Malevich," in *Unnatural Wonders: On the Gap between Art and Life* (New York: Farrar Strauss, 2005), 251.

11. Danto, *Transfiguration of the Commonplace* (Cambridge, Mass.: Harvard University Press, 1981) is a philosophical consideration of re-presentation from Nietzsche transferred to the concerns the world of the copy. *Copy* is crucial for Danto in that it changes the terms of sense when applied to referents, the sensible properties of which are the same, or at least the palpable difference is, in his words, "indiscernible to the eye." Danto puts Warhol's "Brillo Boxes" at the center of his theory, these being the definitive exemplary objects even though the term *copy* has been the preoccupation of Duchamp's appropriations. The term *copy* is the key term in a much ramified discussion in postmodernist art and its locution as applied to modernist style. (Noteworthy on the subject is John Searle, who, in his 1984 Rath Lectures, concerns himself with the meaning of verbal distinctions between duplication and simulation, and the confusions for cognitivism that arise from the merging of the terms. See his *Minds, Brain and Science* [New York: Penguin, 1989]).

12. But to come around: positivist analysis of surface conditions (see earlier Golding notes) does not concern the philosopher or journalist here, for beyond definite attribution of the *Black Square* to Malevich, craft is not the point (i.e., anyone can paint a square black, but not anyone can conceive it: authorship remains lodged in the conceptual originality of the object).

13. From an unpublished interview with William Lieberman and myself concerning the Museum of Modern Art and its decision in 1929 to designate the origins of modern art for the sake of starting a collection. Thus, the origin of modern art identifies Symbolism (and also names Expressionism, in some accounts) as its point of reference.

14. M. Tupitsyn, "'Black Square: Hommage à Malevich': Hamburger Kunsthalle, Hamburg," *Artforum*, September 2007, p. 465.

15. On the issue of the free legacy of Constructivism, although this critic does accord Bruce Nauman's work credibility for a performance in actual space, she overlooks Franz Erhard Walter's post-minimal social object: a construction wherein four persons each sitting at a corner of a black square cloth hold a dialogue in full view of the public. (Another of Walther's pieces shows a cube being built by way of cooperative action as each of four people holds black cloth to "construct" a corner while a fifth person beholds the cube so constructed.) The critic in question, Margarita Tupitsyn, does criticize the absence of Russian contemporary art in this "Black Square" exhibition.

16. As Tupitsyn quotes it in her review.

17. Citing V. Markov is C. Lodder, *Russian Constructivism* (New Haven: Yale University Press, 1983), 13.

18. For Markov, *faktura* derives directly from the assemblage of incrustations constructing embellishing the *ikon*; for Curator Hubertus Gassner, too, *faktura* is manifestly palpable and materially physical, not formal. This last point is emphatically made by the Russian Formalist linguists, Gassner writes, as Shklovskii argues concerning their *faktura*, "Tatlin's and Al'tman's material compositions as the most convincing examples of the definition of art. Suprematism, on the other hand, belongs to the 'Symbolist school of painting,' and is 'essentially "ideal" painting' since it strives to symbolize ideas through colors and abstract shapes instead of emphasizing the properties of the material and thereby differentiating and intensifying the tangible values of *faktura*." See Gassner, "The Constructivists: from Modernism to Modernization," *The Great Utopia: The Russian and Soviet Avant-Garde 1915-1932* (New York: Guggenheim Museum, 1992), 310.

19. For an incisive discussion of this Suprematist resistance to mechanization, see Gassner, "The

Constructivists," 307. Despite the practical utility they espoused, Gassner has elsewhere argued that "a closer inspection of Constructivist productive art can show how its manufacturing methods and products contain a utopian surplus value that transforms even the individual utilitarian object into a *pons pro toto* of a cosmos harmonically structured by rhythmic movements. The utopian surplus lends these objects their aesthetic and ethical value and even bathes them in an aura of artistic autonomy—precisely the quality the Constructivists struggled to nullify on their flight into functionalism." See "The Constructivists: from Modernism to Modernization," 299. So Gassner's exhibition in Hamburg may well be intended to cross-examine the dialectic of Suprematism and Constructivism for rhetoric not entirely confessed.

20. J. Masheck, "Black Square," *Art Monthly* (London), no. 308 (July-August 2007), 11-14, here 12.

21. Ibid.

22. See also other writings by Masheck discussing this issue, for instance, the chapter "Loos and Minimalism" in his *Adolf Loos: The Art of Architecture* (London: I. B. Tauris; New York: Palgrave MacMillan, 2013).

23. Masheck, "Black Square," 14.

24. H. Gassner, "Introduction," *Das Schwarze Quadrat: Hommage an Kazimir Malewitch* (Hamburger Kunsthalle, Ostfildern [Germany]: Hatje Cantz, 2007), 10. In the view of curator Gassner, Fontana expresses Malevich's radically changed state of affairs: as splitting old illusionist art on this side from the birth of art that exists in imaginary space beyond.

25. Gassner, *Schwarze Quadrat*, 154; entry by Gassner, "Micha Kubell, Allan McCollum."

26. Op. cit., "Introduction," 11. What the curator promises is "The variety of aspects exhibited will give homage, neither in a phenomenology of the square in the art, nor confine itself to the color black, in this very encyclopedic survey of the art created since 1915. What will be shown is a selection of art created since 1915 that have ventured interpretations. As individual as these positions are, they remain mostly involved in a broader update of the archetype or the idea of it." The curator does disallow the interpretation that with the Black Square or skewed White on White, Malevich painted his last picture, with these artifacts representing nothing and emptiness. As with the word *Minimalism* applied to simple shape to indicate simple form, the content of that shape is conflated with matters contrarily meant. See further discussion concerning this issue in chapters on the artifacts of Donald Judd, in M. Welish, *Signifying Art: Essays on Art after 1960* (New York: Cambridge University Press, 1999).

27. Putting the issue more sharply, the title is agit-prop, deployed to convey the sense and significance of the exhibition in inspiring terms. Why not restrict the meaning to control for sense: "Black Square: Homage, Critique and Parody" would be a reformulation of the social contract named in the title to reflect the nature of the relationship established between the definitive Black Square and its unruly futurity. Alternatively, the more general "Black Square and Its Aftermath" would designate reception without the qualifying rhetorical guidance. Yes, we know the role naming has in providing a hook for the public, and that's why the name Malevich is invoked in the show's subtitle. But in consequence of this marketing, whether Malevich or Suprematism or Black Squares of All Sorts is the ongoing subject remains a question in reviewers' minds.

CHAPTER 14

1. The great work on the iconography of melancholy is R. Klibansky, E. Panofsky, and F. Saxl, *Saturn and Melancholy: Studies in the History of Natural Philosophy, Religion and Art* (London, 1964), which builds on Panofsky and Saxl's early study *Dürers Melancolia I: eine quellen- und typengeschichtliche Untersuchung* (Berlin and Leipzig, 1923).

2. R. and M. Wittkower, *Born under Saturn: The Character and Conduct of Artists: A Documented History from Antiquity to the French Revolution* (New York: Random House, 1963), 102-08.

3. R. Burton, *The Anatomy of Melancholy: What It Is; With All the Kindes, Causes, Symptomes,*

Prognostickes, and Several Cures of It . . . , H. Jackson, ed., 3 vols. (New York: Dutton, 1932), vol. 1, 143-44.

4. J. Schiesari, *The Gendering of Melancholia: Feminism, Psychoanalysis and the Symbolics of Loss in Renaissance Literature* (Ithaca, N. Y.: Cornell University Press, 1992), 108.

5. One recent compilation offers dozens of "melancholy" motifs: M. Préaud, ed., *Mélancolies: Livre d'images* (Paris: Klincksieck, 2005); this book accompanied an exhibition at the Galeries Nationales du Grand Palais, in Paris, "Mélancolie: Génie et Folie en Occident."

6. See C. Swan, *Art, Science, and Witchcraft in Early Modern Holland: Jacques de Gheyn II (1565-1629)* (Cambridge: Cambridge University Press, 2005), 180-94, on the associations of melancholia and demonic possession, also as linked with art, via the devil-artist. For a case study of one artist, see M. J. Bok, "Was Hendrick Ter Brugghen a Melancholic?" *Journal of Historians of Netherlandish Art* 1:2 (2009) (http://jhna.org/index.php.past-issues/volume-1-issue-2/115-hendrick-ter-brugghen-melancholic; accessed February 5, 2012); for artists' portrayals of melancholy scholars and hermits, see L. Dixon, "An Occupational Hazard: Saint Jerome, Melancholia, and the Scholarly Life," in Dixon, ed., *In Detail: New Studies of Northern Renaissance Art in Honor of Walter S. Gibson* (Turnhout [Belgium]: Brepols, 1998), 69-82.

7. D. Trevor, *The Poetics of Melancholy in Early Modern England* (Cambridge: Cambridge University Press, 2004), 1.

8. For examples, Domenico Fetti (*Melancholy*, 1618-23, Paris, Louvre); Hendrik Terbrugghen (*Melancholy*, 1627-28, Toronto, Art Gallery of Ontario); on the Terbrugghen painting, see Bok (n. 6, above).

9. Jan Steen, for example, depicted numerous instances of the "doctor's visit"; these images were once erroneously thought to be about pregnancy; Dixon, *Perilous Chastity: Women and Illness in Pre-Enlightenment Art and Medicine* (Ithaca, N.Y.: Cornell University Press, 1995), 249-56, has demonstrated that they portray hysteria, caused by a lack of sexual activity.

10. H. Roodenburg, *The Eloquence of the Body: Perspectives on Gesture in the Dutch Republic* (Zwolle [Netherlands]: Waanders, 2004), 47-71.

11. C. Breward, *The Culture of Fashion.* (Manchester: Manchester University Press, 1995), 78.

12. Unlike the more abstract notion of melancholy, mourning dress was a social uniform, whose conventions regarding colors, fabrics and jewels were carefully followed. I. Groeneweg, "Court and City: Dress in the Age of Frederik Hendrik and Amalia," in *Princely Display: The Court of Frederik Hendrik of Orange and Amalia van Solms in the Hague* (Zwolle [Netherlands]: Waanders, 1997), 202-04.

13. T. Cooper with A. Fraser (foreword), *A Guide to Tudor and Jacobean Portraits* (London: National Portrait Gallery, 2012), 25.

14. As of this writing, the painting is undergoing extensive conservation to remove yellowed varnish and later restorations. The shadowy quality, however, has remained relatively unchanged. www.npg.org.uk/research/conservation/john-donne-and-his-picture.php; accessed June 1, 2012.

15. Ibid.

16. Among the elite, it was important to speak and write French. R. D. Dekker, "Egodocuments in the Netherlands," in E. Griffey, ed., *Envisioning Self and Status: Self-Representation in the Low Countries 1400-1700* (Hull: Association for Low Countries Studies in Great Britain and Ireland, 2000), 255-85, has noted that among the burgher classes, novels, even English ones, were read in French translations. Many felt that French was the best language of personal expression, and even wrote diaries in French.

17. On fashionable negligence: A. Ribeiro, *Dress and Morality* (Oxford: Berg, 2004), 84-87; M. De Winkel, *Fashion or Fancy: Dress and Meaning in Rembrandt's Paintings* (Amsterdam: Amsterdam University Press, 2004), 122-30.

18. N. Faret, *L'Honnête Homme* (1630), trans. E. Grimston (London, 1632), 354.

19. For an overview of anti-fashion rhetoric in the early modern period, see Ribeiro, *Dress*, passim.

20. On changes from buttoned-up to loose in male portraits in particular throughout the century, see A. M. Kettering, "Gender Issues in Seventeenth-Century Dutch Portraiture: A New Look," in R. E. Fleisher and S. C. Scott, eds., *Rembrandt, Rubens and the Art of Their Time: Recent Perspectives* (University Park, Pa.: Pennsylvania State University Press, 1997), 144-75.

21. R. Strong, *The English Icon: Elizabethan and Jacobean Portraiture*. London: Paul Mellon Foundation for British Art (New York: Pantheon, 1969).

22. J. B. Bedaux, "Minnekoorts- zwangerschaps- en doodverschijnselen op zeventiende-eeuwse schilderijen," *Antiek* 10 (1975), 17-42.

23. The type is also immortalized in love songs of the period: R. Nevitt, *Art and the Culture of Love in Seventeenth-Century Holland* (Cambridge and New York: Cambridge University Press, 2003), 69; 90ff.

24. On the appeal of the look described in Rowland's poem, see Ribeiro, *Fashion and Fiction: Dress in Art and Literature in Stuart England* (New Haven, Conn.: Yale University Press, 2005), 52-53.

25. Before the mid-1630s, it was also a sign of louche depravity; middle class users were meant to dissociate themselves from it. Because of the growth of the tobacco industry and pipe manufacture, for economic reasons tobacco gained respectability: I. Gaskell, "Tobacco, Social Deviance, and Dutch Art in the Seventeenth Century," in W. Franits, ed., *Looking at Seventeenth-Century Dutch Art: Realism Reconsidered* (Cambridge and New York: Cambridge University Press, 1997), 68-77, here 76; also, B. Roberts, "The 'Marlboro Men' of the Early Seventeenth Century: Masculine Role Models for Dutch Youths in the Golden Age?" *Men and Masculinities* 9 (July 2006), 76-94.

26. Summarized in Dixon (n. 9, above).

27. Artists in England and the Netherlands explored the genre of meditative portrait throughout the century, influenced by the sixteenth-century cult of melancholy in English portraiture. These soulful men are often shown with their swords at rest, such as Isaac Oliver's *Young Man Out of Doors* (1590-95, London, The Royal Collection) and *Edward Herbert, Baron of Cherbury*, lying on the grass under his shield in a eroticized echo of a dead classical hero (1610-14, Welshpool, Powis Castle). Jan de Heem's melancholy young man (*Young Student*, 1632) ignores the cavalry saber hanging up on the wall at the back and the cast-off sword resting against a chest. Near these abandoned weapons is a topical reference to battle: a portrait of Christian of Braunschweig, who led the Protestant armies of the Winter King.

28. As Aileen Ribeiro has pointed out, "In a period when clothes had to be tight and taut, unloosened and undone points might suggest perturbation of mind: this is what Ophelia refers to when she is frightened by the sight of Hamlet with his "doubet all unbrac'd" (II. i). Points, made of silk ribbon, often glittering, were both decorative and practical: their metal tips (aglets) must have made an attractive clicking sound when the wearer moved"; Ribeiro (n. 24, above), 42.

29. One striking example: In 1564, Sophonisba Anguissola portrays her sister Minerva in a restrained but expensive black dress whose open neckline reveals a high ruffled and embroidered collar, its three sets of band strings hanging open. In an echo of this hanging look, the elaborate pendant attached to her bodice trails four sets of looped golden chains (*The Artist's Sister Minerva Anguissola*, ca. 1564, Milwaukee Art Museum).

30. G. Vigarello, *Concepts of Cleanliness: Changing Attitudes in France since the Middle Ages*, trans. J. Birrell (Cambridge and New York: Cambridge University Press, 1988), 58-77. Clean linen became increasingly essential to self-presentation from the mid-sixteenth century.

31. Such presentations, as Ann Jensen Adams has suggested, reveal the new cultural preoccupation with reason and self-knowledge: *Public Faces and Private Identities in Seventeenth-Century Holland: Portraiture and the Production of Community* (New York: Cambridge University Press,

2009), 97-110 passim; on portraiture and melancholy, 97-98.

32. On the adoption of classical *contrapposto* for proper deportment, specifically through the art of dancing, see H. Roodenburg, *The Eloquence of the Body: Perspectives on Gesture in the Dutch Republic* (Zwolle: Waanders, 2004), 89-90.

33. D. R. Smith. "I, Janus: Privacy and the Gentlemanly Ideal in Rembrandt's Portraits of Jan Six." *Art History* 11 (March 1988), 42-63, here 50.

34. Rembrandt, *Jan Six*, black chalk, Amsterdam, Six Collection (Ben. 749, verso, black chalk, 31.1 x 9.5 cm., Amsterdam, Fodor Collection).

35. It is impossible to tease out the actual relationship with the etching; on a discussion of possible links, see Smith, n. 33, esp. 53-54, about the possible links between this drawing, its verso, and the finished etching.

36. Such intimate portraits were probably circulated as gifts; see M. Zell, "The Gift Among Friends: Rembrandt's Art in the Network of His Patronal and Social Relations," in A. Chong and M. Zell, eds., *Rethinking Rembrandt* (Boston: Isabella Stewart Gardner Museum; Zwolle [Netherlands]: Waanders, 2002), 173-93.

37. I have studied Dou's allegorical artist-type, along with his complex manipulations of iconography, in M. Hollander, *An Entrance for the Eyes: Space and Meaning in Seventeenth-Century Dutch Art* (Berkeley: University of California Press, 2002), 48-76.

38. G. Groschner, T. Habersatter, and E. Mayr-Oehring, eds., *Masterworks: Residenzgalerie Salzburg* (Salzburg: Residenzgalerie, 2002), 12.

39. Dou's mastery of complex allegorical imagery belies the common assumption that he paid more attention to his meticulous technique than his subject; see, for example, J. Wadum, "'Dou doesn't paint, oh no, he juggles with his brush': Gerrit Dou, a Rembrandtesque 'Fijnschilder,'" *Artmatters: Netherlands Technical Studies in Art* I (2002), 62-77.

40. Hollander, "Vermeer's Robe: Costume, Commerce, and Fantasy in the Early Modern Netherlands," *Dutch Crossing* 35, no. 2 (July 2011), 177-195, here 190-91.

41. On the evolution of the *tabbaard,* see De Winkel, "'Eene der deftigsten dragten': The Iconography of the 'Tabbard' and the Sense of Tradition in Dutch Seventeenth-Century Portaiture," *Nederlands Kunsthistorisch Jaarboek* 46 (1995) (*Beeld en Afbeeld in de Nederlandse Kunst, 1550-1750*), 145-167. Dou also uses the hanging band-string motif in his *Self-Portrait* of 1665 (oil on panel, arched top, 59 x 43.5 cm., Boston, private collection)

42. Wittkower and Wittkower, *Born Under Saturn*, 72.

43. Dou had a particular focus on scholars as subjects, owing in part to his attempts to establish networks of patronage in the university community in Leiden. See S. D. Muller, "Young Scholar in His Study: Painters and Scholars Learning the Art of Conversation in Early Seventeenth-Century Leiden," in H. P. Chapman and J. Woodall, eds., *Envisioning the Artist in the Early Modern Netherlands / Het beeld van de kunstenaar in de vroegmoderne Nederlanden.* Zwolle [Netherlands]: Waanders), 293-313.

44. De Winkel, *Fashion or Fancy: Dress and Meaning in Rembrandt's Paintings* (Amsterdam: Amsterdam University Press, 2004), 167.

45. Lisa Pincus has suggested that he wears laborer's clothing: "Masculinity Bared: The Self-Portraits of Carel Fabritius," Renaissance Society of America conference, March 22, 2007.

46. F. J. Duparc, with contributions by G. Seelig, and A. van Suchtelen, *Carel Fabritius 1622-1654* (Zwolle [Netherlands]: Waanders, 2004), 113; entry by Ariane van Suchtelen.

47. U. Mayr, *Self-Portrait with an Ancient Bust,* 1650 (Nürnberg, Germanisches Nationalmuseum); reproduced in W. Sumowski, *Gemälde der Rembrandt-Schüler,* vol. 3 (Landau: Edition PVA, 1983), 2010, pl. 1476.

48. Mayr often portrayed himself in historical dress, sometimes with a robe or armor. For example, the dress in his *Self-portrait as the Young Alexander* is very similar to that in his painting of John the Evangelist (Augsburg, Evangelisch St. Ulrich), who has a pen behind his ear

and wears what is clearly a contemporary shirt, collarless, undone, with a generic robe over it; see Sumowski, op. cit, 2210, pl. 1475. The same costume appears in *Philosopher with Skull* (Brunswick, Herzog-Anton-Ulrich Museum).

49. De Winkel (n. 17, above), 107, on Rembrandt's curious choice of costume for Aristotle in *Aristotle with a Bust of Homer*. On Van Mander's dislike of bare arms and classical drapery, see K. van Mander, *The Lives of the Illustrious Netherlandish and German Painters; from the First Edition of the Schilder-boeck (1603-1604); Preceded by the Lineage, Circumstances, and Place of Birth, Life and Works of Karel van Mander, Painter and Poet, and likewise his Death and Burial; from the Second Edition of the Schilder-boeck (1616-1618)*, Hessel Miedema, ed., 6 vols. (Doornspijk [Netherlands]: Davaco, 1994-99, 1:152.

CHAPTER 15

1. J. Masheck, *The 1907 Building: Observations of a Friend of the House*, Edinburgh College of Art Occasional Papers in Architectural Art 1 (2008).
2. Email message from Masheck to Stewart, January 6, 2012
3. D. Macmillan, "A New School of Art: The Foundations to the 1960s," proof of an essay for *Revel: The Spirit of Edinburgh College of Art* (2009), n. p.
4. M. Forrest, *Robert Burns, 1869-1941: Artist and Designer* (Edinburgh: Bourne Fine Art, 1983), n. p.
5. Ibid.
6. Aberdeen (Scotland) Art Gallery and Museums, *Dorothy Johnstone, A.R.S.A, 1892-1980* (Aberdeen: Aberdeen Art Gallery and Museums, 1982), 6.
7. Ibid., 5.
8. Ibid.
9. W. Hardie, *Scottish Painting 1837-1939* (London: Studio Vista, 1976), 100.
10. David Macbeth Sutherland was Head of Gray's School of Art, Aberdeen from 1933 to 1948. Their son was the distinguished Scottish diplomat Sir Iain Sutherland, of Aberdeen.
11. P. Bourne, *Anne Redpath, 1895-1965* (Edinburgh: Atelier, 2004), 14.
12. T. Neat, *Part Seen, Part Imagined: Meaning and Symbolism in the Work of Charles Rennie Mackintosh and Margaret Macdonald* (Edinburgh: Canongate, 1994), 21.
13. Ibid.
14. Hardie, *Scottish Painting*, 83, 85. Burns also contributed two prints, entitled *The Vintage* and *The Passer-by*, to Patrick Geddes's *The Evergreen: A Northern Seasonal* in the Autumn 1895 number. See www.archive.org/stream/evergreennorther02gedduoft.
15. For Patrick Geddes see www.patrickgeddestrust.co.uk/, and www.dundee.ac.uk/main/about-patrick-geddes.
16. J. Kemplay, *The Paintings of John Duncan, a Scottish Symbolist* (San Francisco: Pomegranate Art Books, 1994), 21.
17. For French artists in Geddes' circle in Edinburgh, see F. Fowle and B. Thomson, eds., *Patrick Geddes: The French Connection* (Oxford: White Cockade and the Scottish Society for Art History, 2004).
18. R. Nicholson, "'From Fever to Fresh Air': *The Evergreen, The Yellow Book*, and the Threat of Decadence," *Journal of the Scottish Society for Art History* 9 (2004; The Arts and Crafts Movement; Patrick Geddes and France), 64.
19. Bourne, *Anne Redpath*, 11.
20. P. Long, *Anne Redpath, 1895-1965* (Edinburgh: National Galleries of Scotland, 1996), 10. For Burns after he left Edinburgh College of Art in 1919, see J. Lindsay, "Robert Burns and the Crawford Family: A Study of Patronage," *Journal of the Scottish Society for Art History* 3 (1998; Patronage and Collecting).
21. Nicholson, "'Fever to Fresh Air,'" 67.

CHAPTER 16

1. A. Hauser, *The Philosophy of Art History* (1958; New York: Knopf, 1959), 311, 313.

2. A. Salmony, *Sino-Siberian Art in the Collection of C. T. Loo* (1933), 2nd ed., Bruce L. Miller, ed. (Bankok: SDI Publications, 1999), 58.

3. J. Ruskin, *The Stones of Venice*, 3 vols. (ed. 1886; repr. Mineola, N.Y.: Dover, 2005), 3:194.

4. L. Tolstoy, *What Is Art?*, trans. R. Pevear and L. Volokhonsky (Harmondsworth: Penguin, 1995), 88.

5. J. Addison, "Dialogues upon the Usefulness of Ancient Medals; Especially in Relation to the Latin and Greek Poets" (1721), in *The Miscellaneous Works of Joseph Addison*, A. D. Guthkelch, ed., 2 vols. (London, 1914), 2:274-93, Dial. III, pp. 392-93, orthography modernized.

6. G. Berkeley, *Philosophical Works; Including the Works on Vision*, M.R. Ayers, ed. (London: Dent; Totowa, N.J.: Rowman and Littlefield, 1975), 39, 44. See. A. A. Luce, *Berkeley and Malebranche: A Study in the Origins of Berkeley's Thought* (1934), 2nd ed. (Oxford, 1967), 42.

7. Luce, op. cit., 43, quoting Malebranche, *The Search for Truth*, trans. T. Taylor (Oxford and London, 1694), Bk. I, sect. 13, with further refs.

8. Berkeley, *Alciphron; or, the Minute Philosopher: In Focus*, D. Berman, ed. (London and New York, 1993): 35 (I.9), 44 (I.12), 88 (IV.4).

9. J. J. Winckelmann, *Reflections on the Imitation of Greek Works in Painting and Sculpture*, with trans. by E. Heyer and R. C. Norton (La Salle, Ill.: Open Court, 1987), 5 (Engl.), with 4 (Germ.).

10. J. W. von Goethe, *Italian Journey (1786-1788)*, trans. W. H. Auden and E. Mayer (New York: Schocken, 1968), 136 (entry of December 3, 1786), 139 (December 20). Goethe hoped to have a copy made: how one wishes to know whether anything of Celtic *décadent* ilk was included.

11. S. T. Coleridge, *Biographia Literaria* (1817), J. Shawcross, ed., 2 vols. (Oxford: Clarendon Press, 1907, repr. 1969), 2:39, 98; emphases in original. Coleridge had a firm sense of the arbitrary nature of the linguistic sign.

12. L. Delteil, *Delacroix: The Graphic Work; A Catalogue Raisonné*, trans. and ed. S. Strauber (San Francisco: Alan Wofsy Fine Arts, 1997), cat. nos. 42-47, pp. 104-21.

13. J. B. Howell, "Delacroix' Lithographs of Antique Coins," *Gazette des Beaux-Arts*, 6th per., 124 (July-August 1994), 15-24, esp. 18, 24 n. 17.

14. Delteil, *Delacroix*, no. 90, pp. 226-27. The study of Celtic coinage has distinct phases. According to Robert Forrer, "Keltisches Münzwesen," in M. Ebert, ed., *Reallexikon der Vorgeschichte*, 15 vols. (Berlin: de Gruyter, 1924-32), 6:301-26 (bibl. at end), after an antiquarian inquiry by a colonial administrator soon to take over Québec for Louis XIV, Claude de Bouteroue d'Aubigny, *Recherches curieuses des monoyes de France* (1666), early scholarship dates in French to the period of Romantic nationalism, 1837-44; then there was German as much as French, with some English (Beale Post; Sir John Evans), Italian, and Hungarian, down to the First World War. This Robert Forrer (1866-1947), an art historian and archaeologist, here records his own work on Celtic numismatics from 1884, with recent books in 1925, and 1926.

15. More appealing, in the face of all we hear about the French right's "Rappel à l'Ordre" campaign after World War I, is a certain pro-Celtic (hence anti-Roman, anti-classical) cultural patriotism during the War: for example, the Third Symphony of Vincent d'Indy (op. 70), 1916-18, titled *Sinfonia brevis (De bello gallico)*. Indeed, just before the War, in opposition to the rightist politics and cultural classicism of Action Française, a significant intuition-attuned (and Bergsonian) alternative to the established rationalist-classicist justification of modernity had arisen, notably in the theorizing of the cubist painter Gleizes. See M. Antliff, "Cubism, Celtism, and the Body Politic," *Art Bulletin* 74 (1992), 655-68.

16. The late-Greek to Roman ambiguity of sources in respect to copies has been coordinated succinctly with respect to the Eravisci Celts, where Budapest is today: "The mints of the Eastern Celts were first inspired by Macedonian styles but by the end of the La Tène period the

coins ... were in ... imitation of the Roman denarius." From a display in the National Museum, Budapest, seen in May 2013.

17. J. Evans, "On the Dates of British Coins," *Numismatic Chronicle* 12 (1850), 127-36; then idem, "The Coinage of the Ancient Britons," *Proceedings of the Royal Institution of Great Britain* 7 (1875), 476-87, here 481-84, 486.

18. A. L.-F. Pitt-Rivers, "On the Evolution of Culture." *Proceedings of the Royal Institution* 7 (1875), 496-520 with pls. i-iv, repr. in his *The Evolution of Culture and Other Essays*, J. L. Myres, ed. (Oxford: Clarendon Press, 1906), 39ff, here 40-43.

19. As quoted in P. Steadman, The *Evolution of Designs: Biological Analogy in Architecture and the Applied Arts*, Cambridge Urban and Architectural Studies 5 (Cambridge: Cambridge University Press, 1979), 106, where the given bibliography is ambiguous.

20. C. F. Keary, *The Morphology of Coins* (repr. fr. *Numismatic Chronicle*, 3rd ser., 5 [1885], 165-98; 6 [1886] 41-95; Chicago: Argonaut, 1970), 9-10, 18. In regard to Celtic copying Keary defers to Evans as having "worked out" the "gradual degeneration" of the famous slater of Philip II of Macedon, "and also its further degradation in the hands of the Britons who copied from the Gaulish money"—plus Germanic coins likewise derived (18).

21. This discussion depends on Steadman, *Evolution*, here esp. 104.

22. Ibid., 104-05 with fig. 18 (left).

23. M. Nordau, *Degeneration*, 2nd ed. (1893), trans. (1895; New York and London: Appleton, 1912), 83, 545.

24. Nordau, "The Question of Style," in his *On Art and Artists*, trans. W. F. Harvey (London: Unwin; Philadelphia: Jacobs, 1907), 44-55, here 52-54.

25. B. Berenson, *The Arch of Constantine; or, The Decline of Form* (London: Chapman and Hall, 1954), 45.

26. H. Read, *The Meaning of Art* (Harmondsworth, Middx: Penguin, 1956), 60.

27. F. Boas, *Primitive Art* (New York: Dover, 1955), 130-33, 141-43.

28. G. Bataille, "Le Cheval académique" (1929), in his *Oeuvres complètes*, 12 vols. (Paris: Gallimard, 1970—), 2, *Premiers Écrits: 1922-1940*, M. Foucault, ed. (1970), 159-63, here 160. What seems an original illustration to the article is a good example of the problem of how, immediately forms are liberated from resemblance, they may accrue unwanted significations: among the forms seen floating free in the surface is a symmetrical, double-curving, vessel-like ornament which could easily suggest a boat, but which numismatists consider a ladle (called a *simpulum*), in the example at hand, a denarius of Julius Caesar, probably a mint mark; *qua* form, however, it might as well be a displaced classical calyx ornament of Greek derivation.

29. R. Passeron, *André Masson: General Catalogue of the Sculptures*, trans. M. Gallusi (Turin: Il Quadrante; New York: Marisa del Re Gallery, 1988), figs. 166, 167, on p. 193.

30. In brief (using first-ed. dates but English-translation titles): *The Psychology of Art* (1947-49), which appeared in three volumes: *Museum without Walls*, *The Creative Art*, and *The Twilight of the Absolute*; then this three-volume work expanded as *The Voices of Silence* (1951); after a picture book on sculpture (*Le Musée imaginaire de la sculpture mondiale*, 1952-54), another general art history: *The Metamorphosis of the Gods* (1957; revised ed., 1974-77), with a revision of the first part of *The Voices of Silence* appearing as *The Museum Without Walls* (1965).

31. A. Malraux, *Psychologie de l'art*, 3 vols. (Geneva: Skira, 1947-50), 3, *La Monnaie de l'absolu*, "Deuxième Étude," 189-206; here, 203-04.

32. E. H. Gombrich, *Art and Illusion: A Study in the Psychology of Pictorial Representation*, Bolllingen Series 35/5 (New York; Pantheon, 1960), 341, n. to p. 64.

33. Ibid., 64-65.

34. A major witness on the other side of the Celtic-coin affair should have been called: the great anarchist modern art theorist Herbert Read, for his appreciation of the aesthetically advantageous tendency towards degeneration of represented natural form on objects of use, articulated

in a discussion of neolithic painted pottery in his *Art and Industry* (1954): "[A]s it might be formulated: 'Ornament, if left to itself, tends to become abstract, because the psychological necessities are most appropriately and most economically supplied by abstract ornament'"; *Art and Industry; the Principles of Industrial Design* (New York: Horizon, 1954), 91-93, here 93n. Read's non-perjorative use of "slurring" is also found in the discourse of Celtic numismatic degeneration.

35. S. I. Hayakawa, "The Revision of Vision," in Gyorgy Kepes, *Language of Vision* (Chicago: Theobald, 1944), 8-10, here, 8: "What is true of verbal languages is also true of visual Languages: we match the data from the flux of visual experience with image-clichés, with stereotypes of one kind or another, according to the way we have been taught to see." There is an echo in both of Kant on the formation of taste, whereby "the artist, after he has practiced and corrected it by means of various examples of art or nature, holds up his work, and after many, often laborious attempts to satisfy it, finds the form that contents him ..." (Ak 5:312); I. Kant, *Critique of the Power of Judgment*, trans. Paul Geyer and Eric Matthews, ed. Guyer (Cambridge: Cambridge University Press, 2005), 191.

36. A. C. Danto, "E.H. Gombrich," *Grand Street* (New York), 2, no. 2 (Winter 1983), 120-32, here 132.

37. D. Vallier, *Abstract Art*, trans. Jonathan Griffin (New York: Orion, 1970), pp. 6 (captions to figs. 5, 6), 5, respectively.

38. G. Deleuze and F. Guattari, *Nomadology: The War Machine*, trans. Brian Massumi (New York: Semiotext[e], 1986), 85 Further: "it is generally difficult to distinguish between what comes from the nomads as such, and what they receive from the empire with which they communicate, which they conquer or integrate with. There are so many gray areas, intermediaries and combinations between an imperial army and a nomad war machine that it is often the case that things come from the empire first" (91).

39. Harsha Ram, "The Poetics of Eurasia: Velimir Khlebnikov Between Empire and Revolution," in Madhavan K. Palast, ed., *Social Identities in Revolutionary Russia* (Basingstote [Hants]: Palgrave, 2001), 209-31, here 224; and by a new reckoning of time he "rearranges scattered points into new correlations, revealing the rhythmic vibrations that are seen to underlie them." We think again of the coins, especially in their Celtic *renditions*. Khlebnikov's fascination with projectable numerical structures led the contemporary English constructivist Anthony Hill to produce laminated plastic geometric reliefs as 'Hommages à Khlebnikov,' in 1975-76; and while an aspect of Hill's work derives from "graph theory," which might seem calculated, hence at odds with the nomadological spirit of resistance, the artist chooses freely from among the complex alternative moves in the same logical "tree" of seven points connected by six lines, none crossing.

40. I. Finlay, *Celtic Art: An Introduction* (London: Faber and Faber, 1973), 72, 95.

41. G. Davenport, *Every Force Evolves A Form: Twenty Essays* (San Francisco: North Point Press, 1987), dedication page; the essay, "What Are Those Monkeys Doing?"

42. M. Henig, *The Art of Roman Britain* (Ann Arbor: University of Michigan Press, 1995), 21-23.

43. Ibid., 28.

44. Ibid., 10.

45. P. Brunn, "Two Facets of Ancient Monetary Economy; Celtic Imitations and Roman Rigid Formality," reviewing a thesis by I. Lukanc surveying many more Celtic imitations than ever canvassed before (*Les Imitations des monnaies d'Alexandre le Grand et de Thasos*, 1995), and noting how the Romans sometimes made Greco-barbarian imitations to satisfy expectations of local circulation, possibly including Balkan Celts as well as Gaulic; *Arctos: Acta Philologica Fennica* (Helsinki), 30 (1996), 21-31, here 30.

CONTRIBUTORS

Andrew BALLANTYNE, Professor of Architecture at Newcastle (U.K.) University, author of many books on architecture including *Architecture, Landscape and Liberty: Richard Payne Knight and the Picturesque* (Cambridge, 1997); *Architecture: A Very Short Introduction* (Oxford, 2002); *Architecture Theory: A Reader in Philosophy and Culture* (Continuum, 2005); and *Deleuze and Guattari for Architects* (Routledge, 2007), working on a general history of architecture, taking a series of narratives across the whole of human cultural development.

Ian CAMPBELL, F.S.A. Scot., is Professor of Architectural History and Theory, in the Edinburgh School of Architecture and Landscape Architecture, at the University of Edinburgh, focusing on Italian and Scottish Renaissance architecture. Principal author of *The Paper Museum of Cassiano dal Pozzo: Ancient Roman Topography and Architecture* (Harvey Miller, 2004), he was in 2010–12 the Rudolf Wittkower Guest Professor at the Bibliotheca Hertziana, in Rome.

David Lee CRAVEN (1951–2012), late Distinguished Professor of Art and Art History at the University of New Mexico, died suddenly only a month after our symposium. His publications included more than ten books and one hundred fifty articles on such areas as Latin American art history, Abstract Expressionism, and postcolonialism. In particular, his *Abstract Expressionism as Cultural Critique: Dissent During the McCarthy Period* (Cambridge, 1998) and *Art and Revolution in Latin America, 1910–1990* (Yale, 2002) are essential contributions. David was a longtime member of the *Third Text* advisory board, and a vigilant defender of under-represented voices in higher education.

Deborah GANS, F.A.I.A. an architect in New York, is Professor of Architecture at Pratt Institute and a scholar of Le Corbusier. Her book on visiting all the sites of the master is now in its third edition: *Le Corbusier Guide* (Princeton Architectural, 2006).

Terry F. GODLOVE, Jr., is Professor of Philosophy at Hofstra University. He is author of *Religion, Interpretation, and Diversity of Belief* (Cambridge, 1989), of *Kant and Meaning of Religion* (I. B. Tauris, forthcoming), and of articles in epistemology and the history of modern philosophy.

Charles W. HAXTHAUSEN is Robert Sterling Clark Professor of Art History at Williams College. The editor of *The Two Art Histories: The Museum and The University* (Yale, 2002), he has published widely on modern and contemporary German art and criticism, from Paul Klee to Sigmar Polke.

Martha HOLLANDER is Professor of Art History at Hofstra University. She is the author of *An Entrance for the Eyes: Space and Meaning in Seventeenth-Century Dutch Art* (University of California Press, 2002) and other essays on early modern Dutch art and culture.

Alan JOHNSTON, an artist who has exhibited throughout Europe, the United States and Japan, has lately been working on an installation at the Tate Britain, in London, and several exhibitions in Berlin. A recent publication is *Drawing a Shadow: No Object* (Henry Moore Institute, 2010). Johnston lives in Edinburgh.

František LESÁK is Professor Emeritus of Three-Dimensional Design in the Faculty of Architecture of the Technical University of Vienna. His objects and sculptures, drawings and prints, have appeared in numerous solo gallery and museum exhibitions in Europe and the U.S.A., including the Stedelijk Museum, Amsterdam (1977), the Walker Art Center, Minneapolis (1980), a retrospective at the National Gallery in Prague (1997), and the Künstlerhaus, Vienna (2001).

Steven Henry MADOFF, executive editor of *ARTNews* from 1987 to 1994, has written on contemporary art for a variety of journals. Founding chair of the Masters Program in Curatorial Practice at the School of Visual Arts, New York, he has edited *Art School: (Propositions for the 21st Century)* (M. I. T., 2009).

S. A. MANSBACH, Professor of the History of Twentieth-century Art at the University of Maryland, focuses on the genesis and reception of "classical" modern art in Central and Eastern Europe, with publications including *Standing in the Tempest: Painters of the Hungarian Avant-garde, 1908-1930* (Santa Barbara Museum of Art and M. I. T., 1991) and *Graphic Modernism: From the Baltic to the Balkans, 1910–1935* (New York Public Library, 2007). He has taught in Germany, Poland, Hungary, and South Africa, and served as founding dean and director of the American Academy in Berlin.

Joseph MASHECK, F.S.A. Scot., honoree and editor, is Professor of Art History at Hofstra. A sometime editor-in-chief of *Artforum* and Guggenheim Fellow, he has been a Visiting Fellow of St. Edmund's College, Cambridge University. Books include *C's Aesthetics: Philosophy in the Painting* (Slought Foundation and Bryn Mawr College Visual Studies Center, 2004); *The Carpet Paradigm: Integral Flatness from Decorative to Fine Art* (Edgewise, 2010); *Le Paradigme du tapis*, tr. Jacques Soulillou (Musée d'Art Moderne et Contemporain, Geneva, 2011); *Texts on (Texts on) Art* (Brooklyn Rail, 2011); *Adolf Loos: The Art of Architecture* (I.B. Tauris, 2013).

Aleksandr NAYMARK, the organizer of the symposium, is an archaeologist who in the 1980s served to make the Moscow Museum of Oriental Art's field operation one of the largest in Soviet Central Asia; afterward he studied Central Eurasian Studies and art history at Indiana University, with a dissertation fellowship at the German Archaeological Institute. At Hofstra he is responsible for Eastern art history and contributes to the Middle Eastern and Central Asian Program. As a numismatist he has several times been a fellow at the Ashmolean Museum and St. Cross College, Oxford University.

Christine POGGI teaches modern and contemporary art history and criticism at the University of Pennsylvania. She is the author of *In Defiance of Painting: Cubism, Futurism, and the Invention of Collage* (Yale University Press, 1993), of *Inventing Futurism: The Art and Politics of Artificial Optimism* (Princeton, 2009), as well as essays ranging from the art of crowds, representations of madness, the nexus of modern art, labor, and technology, to recent performance art and the law.

David RYAN is a painter, art critic, and musician in London, and Reader in Fine Art at Anglia Ruskin University. He is author of *Talking Painting: Dialogues with Twelve Contemporary Abstract Painters* (Routledge, 2002).

Margaret STEWART, F.S.A. Scot., lecturer in architectural history in Edinburgh School of Architecture and Landscape Architecture, at the University of Edinburgh, is also honorary curator of the historic Cast Collection at Edinburgh College of Art. Her research interests include architecture and landscape design ca. 1700 and art and architecture in Scotland ca. 1900.

Marjorie WELISH, Madelon Leventhal Rand Distinguished Lecturer, Brooklyn College, has received grants for her art from the Adolph and Esther Gottlieb Foundation, Elizabeth Foundation, Fifth Floor Foundation, Pollock-Krasner Foundation, and Trust for Mutual Understanding. In 2006 she taught as a Fulbright Senior Specialist at the University of Frankfurt, and in 2010 at Edinburgh College of Art. *Signifying Art: Essays on Art after 1960* (Cambridge, 1999) collects her art criticism; and *Of the Diagram: The Work of Marjorie Welish* (Slought Foundation, 2003) compiles papers from a conference on her writing and art at the University of Pennsylvania.

Brian WINKENWEDER, Professor of Art History, chairs the Department of Art and Visual Culture at Linfield College, near Portland, Oregon. He is editor of *Art History as Social Praxis: The Collected Writings of David Craven* (Brill; forthcoming) and co-editor of *Dialectical Conversions: Donald Kuspit's Art Criticism* (Liverpool University Press, 2011). He is writing a biography of Hans Namuth and the reception of his photographs of Pollock painting.